modern*starts*

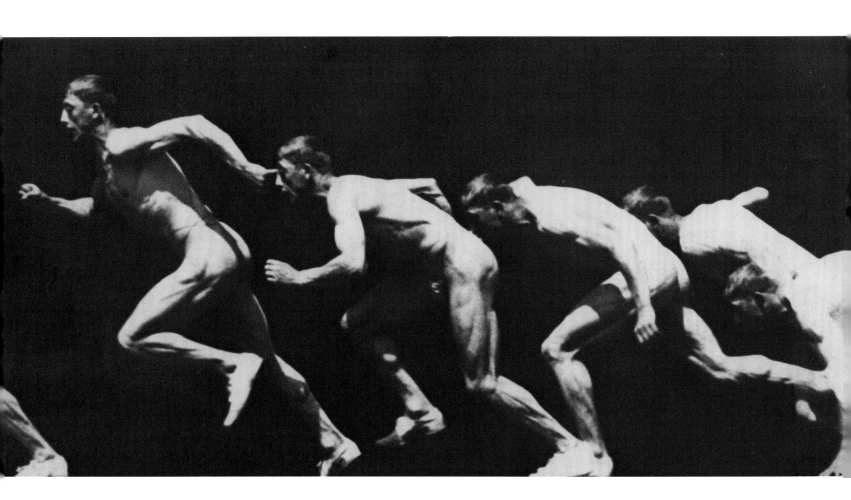

modern*starts*

PEOPLE · PLACES · THINGS

Edited by JOHN ELDERFIELD, PETER REED,
MARY CHAN, MARIA DEL CARMEN GONZÁLEZ

The Museum of Modern Art, New York

Published in conjunction with the exhibition Modern*Starts: People, Places, Things,*
at The Museum of Modern Art, New York, October 7, 1999–March 14, 2000,
organized by John Elderfield, Peter Reed, Mary Chan, and Maria del Carmen González

Published by the Department of Publications
The Museum of Modern Art, New York

Edited by Harriet Schoenholz Bee, David Frankel, Joanne Greenspun,
Jasmine Moorhead, and Laura Morris

Designed by Ed Pusz and Gina Rossi

Production by Marc Sapir, Christopher Zichello, and Christina Grillo

Printed and bound by Passavia Druckservice, Passau, Germany

This book was set in Emigre Filosofia, designed by Zuzana Licko, and in Adobe
Trade Gothic, by Jackson Burke. The paper is 150 gsm Biberest Allegro.

Library of Congress Catalogue Card Number: 99-74802
ISBN: 0-87070-025-1 (clothbound, MoMA/ Thames and Hudson)
ISBN: 0-87070-024-3 (paperbound, MoMA/ Thames and Hudson)
ISBN: 0-8109-6203-9 (clothbound, Abrams)
Second printing, 2000

Published by The Museum of Modern Art
11 West 53 Street, New York, New York 10019

Clothbound edition distributed in the United States and Canada by
Harry N. Abrams, Inc., New York

Clothbound edition distributed outside the United States and Canada by
Thames & Hudson, Ltd., London

COVER: Lucian Bernhard. *Bosch* (detail). 1914. Lithograph, 17⅞ x 25¼" (45.5 x 64.1 cm).
The Museum of Modern Art, New York. Gift of The Lauder Foundation, Leonard and
Evelyn Lauder Fund

FRONTISPIECE: Étienne-Jules Marey or Georges Demenÿ. Untitled. c. 1890–1900. Gelatin
silver print, 6¹⁄₁₆ x 14⅝" (15.4 x 37.2 cm). The Museum of Modern Art, New York. Gift of
Paul F. Walter

Printed in Germany

Modern*Starts* was conceived and organized by John Elderfield and Peter Reed with Mary Chan and Maria del Carmen González. Elizabeth Levine replaced Mary Chan in the final few months of the project. Administrative support was provided by Sharon Dec and George Bareford.

contents

Foreword

Modern*Starts* is the first of three cycles of exhibitions organized by The Museum of Modern Art under the banner *MoMA2000* to mark the millennium. Selected entirely from the Museum's extensive collection and presented over a seventeen-month period, these cycles of exhibitions will explore issues and themes in modern art through the filter of the Museum's holdings. Modern*Starts* focuses on the period 1880 to 1920, and will be followed by *Making Choices*, which will deal with the period 1920 to 1960. The concluding cycle, *Open Ends*, will examine the period from 1960 to the present. All three cycles take a multidisciplinary approach and include works of art from all of the Museum's curatorial departments: architecture and design, drawings, film and video, painting and sculpture, photography, and prints and illustrated books, presented in a series of synthetically organized exhibitions.

The chronological framework of the cycles is intended only as a convenient means of loosely organizing a considerable body of material into a coherent group of exhibitions. Over the last seventy years, The Museum of Modern Art has argued for an understanding of modern art through a carefully articulated history of this still-evolving tradition. By establishing a reading of modern art based on critical dates, styles, schools, and key artists, the Museum sought to make sense of the often competing and contradictory forces of this tradition. Modern*Starts*, *Making Choices*, and *Open Ends* build on this work but endeavor to provide a more interdisciplinary approach to the material. Each cycle explores relationships and shared themes as well as divergent movements and conflicting points of view by juxtaposing works of art in new and challenging ways. Individual exhibitions within each cycle concentrate on issues germane to the period under consideration, but the works of art chosen for these exhibitions often span the

century in order to reveal how themes from one moment either respond to earlier questions or effect later decisions.

Taken together Modern*Starts*, *Making Choices*, and *Open Ends* are meant to provoke new responses and new ideas about modern art. They are not meant to be overarching or definitive statements about modern art or even about the nature of The Museum of Modern Art's collection, but rather interrogatory ones that can help shape future issues and concerns to be dealt with as the next century unfolds. The ability of The Museum of Modern Art to embark on this initiative is the result of several generations of collecting that have allowed the Museum to acquire holdings of unparalleled richness and complexity. Indeed, many of the most important historical developments in modern art that have emerged over the last one hundred years are represented in the Museum's collection.

Alfred H. Barr, Jr., The Museum of Modern Art's founding director, spoke of the Museum's collection as being metabolic and self-renewing. While he meant this in terms of the Museum's ability to constantly acquire new works of art through the selective deaccessioning of its more historical holdings, the idea of an institution capable of considering and reconsidering itself in response to an on-going and continuous inquiry about modern art is central to any understanding of the Museum. There is within the Museum a lively debate about which artists to collect, which works of art to display, which exhibitions to mount. At the heart of these discussions is always the question of how to display our collection, what issues and themes to focus on, what juxtapositions and relationships to highlight or emphasize. Given the cost and complexity of making significant architectural changes to the Museum's galleries in order to create spaces that allow for different kinds of presentations of the collection, the changes effected by these debates can take years to be realized. Modern*Starts*, *Making Choices*, and *Open Ends* are thus a unique opportunity for the Museum to literally reconfigure many of its galleries and explore its collection in a way that is almost impossible to do on an ordinary basis. Each cycle should be seen as an experiment designed to offer a different reading or understanding of modern art while providing a more thorough investigation of the depth and breadth of our collection. In doing so we hope we will have turned the Museum into a laboratory where the arguments and counter-arguments, issues, and ideas of modern art can meet and be explored in a way that allows for the emergence of new approaches to our history, and, by extension, the history of modern art. This becomes especially important as the Museum prepares for a major architectural reconstruction, scheduled to begin when *MoMA2000* closes.

The idea for this series of exhibitions began more than four years ago when a retreat was held with seven chief curators of the Museum to consider what might be done in recognition of the closing of the century that saw the birth of modern art as well as the founding of The Museum of Modern Art in 1929. After extensive discussion we felt that for an extended period of time we should concentrate on our own collection, devoting to it the attention we would normally give to the development of a major loan show. We were attracted to this idea because it afforded us the opportunity to reconsider the way we present our collection to the public as well as the chance to look back, from the vantage point of the end of the century, over one hundred years of modern art while posing questions that would guide our thinking about modern art into the next century. We quickly realized that despite the synthetic dimensions of The Museum of Modern Art's

collection, no exhibition or series of exhibitions could ever hope to provide a genuinely comprehensive account of a tradition that is still very much alive and evolving. This led to the recognition that the greatest contribution that we could make at this time would be to show as much of the collection as possible, including both familiar and unfamiliar works of art, in new and imaginative ways that opened up possibilities for us, and our public, to examine in the future.

Given the magnitude of this task, the entire curatorial staff embarked on an extended review of the collection and worked together to create a comprehensive overview of what the Museum had acquired over the last seventy years. Subsequently, smaller working groups were asked to study specific aspects of the collection and report back to the full staff on their findings. Other research departments of the Museum, including conservation, education, the library, and the archives, were also invited to participate in these discussions. Eventually we decided that in order to examine the collection to the extent that we wished, we needed to use the Museum's galleries for this project and to divide the project into three separate cycles of exhibitions, each anchored around a chronological moment equal to roughly a third of the period covered by our holdings.

The organization of each cycle was entrusted to an interdepartmental team. Each of the teams was encouraged to pursue its own interests and ideas and to articulate them in unique and different voices. Taken together Modern*Starts*, *Making Choices*, and *Open Ends* are not meant to be read as a continuum, as if each were part of a larger, seamless whole; rather, they are meant to provide three separate and distinct "takes" on modern art as represented by our collection.

As noted above, *MoMA2000* evolved out of lengthy discussions with the Museum's seven chief curators, all of whom—Mary Lea Bandy, John Elderfield, Peter Galassi, Terence Riley, Margit Rowell, Kirk Varnedoe, and Deborah Wye—made important contributions to the form it took. Its overall coordination was provided by John Elderfield, in his capacity as Deputy Director for Curatorial Affairs from 1996 through 1998, and Beatrice Kernan, Assistant Deputy Director for Curatorial Affairs, assisted by Sharon Dec and Amy Romesburg, and working closely with Jennifer Russell, Deputy Director for Exhibitions and Collections Support, and Jerome Neuner, Director of Exhibition Design and Production. Modern*Starts* has been skillfully and insightfully directed by John Elderfield, Chief Curator at Large, and Peter Reed, Curator, Department of Architecture and Design, with Mary Chan, Curatorial Assistant, Department of Drawings, and Maria del Carmen González, in the Department of Education.

Glenn D. Lowry
Director, The Museum of Modern Art

Acknowledgments

ModernStarts forms the first of a three-part cycle of exhibitions, titled *MoMA2000*, that will explore the entire range of The Museum of Modern Art's collections. These exhibitions owe their existence to the leadership of the Museum's Director, Glenn Lowry, and chief curators, Mary Lea Bandy, John Elderfield, Peter Galassi, Terence Riley, Margit Rowell, Kirk Varnedoe, and Deborah Wye; to the energetic support of Beatrice Kernan and Jennifer Russell; and to the encouragement of the Museum's Board of Trustees, especially its President, Agnes Gund, and Chairman, Ronald S. Lauder.

The organizing committee of ModernStarts, assisted by Sharon Dec and George Bareford, and Elizabeth Levine, wishes to acknowledge the support and impetus it has received from the overall organization of *MoMA2000*, which extended to specific advice and encouragement for the ModernStarts project. We wish, additionally, to acknowledge the generosity of the many colleagues, friends, and supporters who made important contributions to this undertaking.

At The Museum of Modern Art, there are many people to whom we owe thanks. We list them, in the interdisciplinary and nonhierarchical spirit of this project, in alphabetical order within the categories of their contributions, rather than within their Museum departments.

This project occupied fully three years, but it took shape in the third year, owing mainly to the efforts of those who joined us as collaborators in making the primary individual contributions to this catalogue and to the exhibitions and education programs accompanying it: M. Darsie Alexander, Véronique Chagnon-Burke, Magdalena Dabrowski, Starr Figura, Sarah Ganz, Beatrice Kernan, Susan Kismaric, and Wendy Weitman. As the project developed, a second group of collaborators made crucial and substantial contributions in these same areas: Greg van Alstyne, Mary Lea Bandy, Elaine

Cohen, Judith Hecker, Kristin Helmick-Brunet, Paulo Herkenhoff, Claudia Schmuckli, Patterson Sims, Jennifer Tobias, and Deborah Wilk. We thank all of these colleagues for their support. Throughout the whole or parts of the three-year period, we benefited from the work of many other curators and educators who aided the development of the project, especially Pierre Adler, Maribel Bastian, Sally Berger, Josiana Bianchi, Jodie Cabe, Kathleen Curry, Fereshteh Daftari, Sarah Hermanson, Steven Higgins, Christel Hollevoet, Audrey Isselbacher, Diana Jensen, Carolyn Lanchner, Angela Lange, Barbara London, Jennifer Malone, Kynaston McShine, Elaine Mehalakes, Harper Montgomery, Christopher Mount, Abby Pervil, and Michelle Yun.

A special debt of gratitude is due to those who made this publication possible under the most trying of circumstances, especially those with whom we worked most closely in shaping its form and contents: our publisher, editors, designers, and book-production supervisors. They include Harriet Schoenholz Bee, John Calvelli, David Frankel, Joanne Greenspun, Christina Grillo, Nancy T. Kranz, Michael Maegraith, Jasmine Moorhead, Laura Morris, Ed Pusz, Gina Rossi, Marc Sapir, and Christopher Zichello. We also thank those who photographed, or arranged for the photography of, or secured permissions to reproduce, the works that are illustrated here: Nancy Adelson, Mikki Carpenter, Stephen Clark, Thomas Griesel, Kai Hecker, Kate Keller, Erik Landsberg, Kimberly Marshall Pancoast, Jeffrey Ryan, Eden Schulz, and John Wronn.

The preparation of the exhibitions, to which this publication forms an accompaniment, was unusually demanding for the Museum, and was only made possible by the support of many people, whom we gratefully acknowledge: the exhibition administrators, Kathy Bartlett, Eleni Cocordas, Maria DeMarco, Jennifer Russell, and Linda Thomas; those who helped us design the exhibitions: Andrew Davies, Jerome Neuner, Mari Shinagawa, and Mark Steigelman; those who helped us prepare and install them: Carey Adler-Jung, Charles Carrico, John Dooley, Chris Engel, Diane Farynyk, Stan Gregory, Jana Joyce, Linda Karsteter-Stubbs, Joe Militello, David Moreno, Pete Omlor, Peter Perez, Gilbert Robinson, Arthur Simms, Terry Tegarden, Harvey Tulcensky, John Walako, and Mark Williams; and the conservators: Karl Buchberg, Anne Carter, James Coddington, Lee Ann Daffner, Roger Griffith, Pat Houlihan, Erika Mosier, Ellen Pratt, and Lynda Zycherman.

The funding that made possible this publication and its accompanying exhibitions was secured through the efforts of Monika Dillon, Michael Margitich, and Rebecca Stokes; and was enhanced by those who developed products related to the exhibitions, or managed their distribution: Richard Dobbs, James Gundell, Kathy Krupp, Bonnie Mackay, and Lisa Polay. Those who helped publicize the project and assist the visitors include Elizabeth Addison, Elisa Behnk, Kena Frank, Joe Hannan, Anna Hammond, Graham Leggat, Melanie Monios, Lynn Parish, Diana Simpson, Mary Lou Strahlendorff, and Maki Ushiba. Its opening celebrations were managed by Ethel Shein. We thank all these colleagues most sincerely for their support.

Outside The Museum of Modern Art, we offer particular thanks to the three artists who created important installations for this project: Maria Fernanda Cardoso, Michael Craig-Martin, and Sol LeWitt. In addition we appreciate the assistance of Kiendl Gordon, Paul Hosking, Anthony Sansotta, and Susanna Singer. We also thank those collectors who generously lent us works that are promised gifts to the Museum's collection: Mrs. Melville Wakeman Hall, Janice Levin, Donald Marron, David Rockefeller, Sylvia Slifka, and Malcolm Wiener.

On July 26–27, 1999, the organizing committee of Modern*Starts* participated in a conference, devoted to *MoMA2000* in general and Modern*Starts* in particular, held in Caracas, Venezuela, under the auspices of the Fundación Cisneros. The aim of this conference was to share our work-in-progress with curators, critics, and educators in Latin America. We thank Patricia Phelps de Cisneros for generously making this event possible, Rafael Romero for organizing it, and, at The Museum of Modern Art, Jay Levenson and Carol Coffin, for supporting it.

Finally, we acknowledge those who have generously given financial support to our programs.

This exhibition is part of *MoMA2000*, which is made possible by The Starr Foundation.

Generous support is provided by Agnes Gund and Daniel Shapiro in memory of Louise Reinhardt Smith.

The Museum gratefully acknowledges the assistance of the Contemporary Exhibition Fund of The Museum of Modern Art, established with gifts from Lily Auchincloss, Agnes Gund and Daniel Shapiro, and Jo Carole and Ronald S. Lauder.

Additional funding is provided by the National Endowment for the Arts and The Contemporary Arts Council of The Museum of Modern Art.

The publication Modern*Starts* is made possible by The International Council of The Museum of Modern Art.

This has been a long and an extraordinarily complex project, of which it can accurately be said that The Museum of Modern Art has never attempted its like before. We have, therefore, been more than usually fortunate to have had the support of all those we have listed, and many more who we cannot list, including those closest to us, who have looked forward, sometimes undoubtedly with impatience, to the start of Modern*Starts*.

John Elderfield
Peter Reed
Mary Chan
Maria del Carmen González

modern*starts*

PEOPLE · PLACES · THINGS

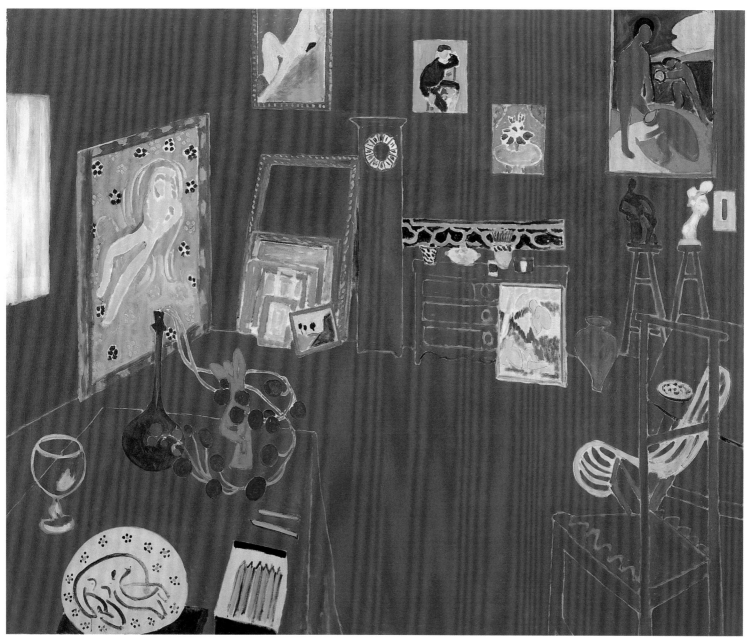

Henri Matisse. *The Red Studio.* 1911. Oil on canvas, 71¼" x 7'2¼" (181 x 219.1 cm). The Museum of Modern Art, New York. Mrs. Simon Guggenheim Fund

JOHN ELDERFIELD
PETER REED
MARY CHAN
MARIA DEL CARMEN GONZÁLEZ

Making **modern**starts

This book is an illustrated guide to the visual arts of the period 1880 through 1920 as represented in the collection of The Museum of Modern Art. It is an unconventional guide to this period, though, and not only because it includes some earlier and some later works. More significantly, while it contains virtually all of the well-known monuments of this period in the Museum's collection (and quite a number of lesser-known ones as well), they are not confined to their usual places. In fact, the usual places—the customary typologies, which bear names such as Fauvism, Cubism, and Futurism—are largely absent. So too is the usual path, a single, generally chronological route through these usual places. Instead, there are many different pathways to be explored; over twenty, in fact. Each of them will take the viewer through a group of works roughly similar in subject matter, and each is entirely independent and self-sufficient, which means that viewers may take them in any order, constructing from them their own larger routes in different ways.[1]

Each of these independent pathways corresponds to, but does not record exactly, an individual exhibition within a larger three-section exhibition titled Modern*Starts*, held at The Museum of Modern Art in 1999–2000. The choice of which individual exhibitions to see and in which order is also intentionally left to the viewer. At the same time, the three large, loose sections, called People, Places, and Things, are each intended to function as a whole. The exhibitions that comprise these three sections may also be taken in any order. People, Places, and Things are each presented here (and at the Museum) in the sequence that we think best helps the reader or the viewer navigate through its diverse materials. But the resource of each is as manifold as the connections that viewers make for themselves. This guide is, therefore, meant both to suggest routes through the three sections and to help viewers choose their own routes. Its short essays and notes function as the

This essay, written by John Elderfield, records how he and the other collaborators listed above conceived and carried out Modern*Starts*.

equivalent of listings of varying detail in a travel guide.[2] And its arrangement of illustrations is intended to convey visually the connections that we have noticed, in the hope that viewers will look at them, too, and look at them critically, as well as for the pleasure we hope that they will provide.

As the names People, Places, and Things suggest, the first focuses on images of the human figure; the second is dedicated to particular parts of space, represented and real; and the third presents objects, again both represented and real. Within these broad categories, the individual subject groupings are sometimes fairly restricted and straight-forward; for example, figure compositions, French landscapes, and chairs. More often, though, they are larger in scope (though not necessarily in size) and biased toward the thematic for the sake of a broader coverage; for example, posed and unposed figures in photographs, the conquest of the air, objects as subjects. A few groups concentrate on the work of one or two artists; some represent a very large number. All, however, are intended to provide, to a greater or lesser extent, unexpected pathways through their subjects, not just for the sake of being different, but in order to offer fresh ways of looking at, and thinking about, some very familiar works, as well as to introduce some unfamiliar ones. The pathways laid out here are offered as many explorations, and *for* exploration, not as finished maps, but as possible ways of proceeding.

This being so, it seemed useful, in this Introduction, to include a sort of mission statement, an explanation of how the concept for this project was arrived at: first, what we mean by calling it Modern*Starts*; second, how we shaped it; and third, why we decided to divide it into People, Places, and Things. We have said that the project is meant to involve the viewer by offering choices. This is made clear in the way it is presented, for it is not an anonymous, institutional creation, but the creation of individuals with different voices, different ideas, different questions to ask, and certainly not all of the answers; it is the creation mainly of the people whose names appear at the beginning of this Introduction, but also of our many collaborators, who are listed on pages 11–12. So, it seemed worth explaining our process as well as our intent. But viewers uninterested in the how and why might choose to make their first critical decision at this point. (This guide properly starts with People on page 33.)

Modern *Starts*

Our title is intended to convey two meanings: first, that the period 1880 to 1920, to which this project is devoted, is when the "modern" starts, when modern art starts; and, second, that there is not just one modern start but many modern starts, therefore many different versions of modern art. Our project is devoted to something that is at once singular and plural: to one period and to many parts of that period; to one movement and to the disparate strands that compose it; to one journey and to its branches and diversions; to one subject and to its multiple histories.

We assert that the "modern" starts in the period 1880 to 1920. We do so because this project draws solely upon the collection of The Museum of Modern Art. The Museum, founded in 1929, first devoted itself to the art of the preceding fifty years, which means that its collection, in the main, begins around 1880. The present exhibition is the first of three that examines its collection, in equal chronological divisions—1880–1920; 1920–1960; and 1960–2000. Thus, the precise period when the modern starts is

something we have taken as given, and do not argue for it here. But we do argue for the fact that, within this period, characteristics broadly understood to be modern start to appear—some having already appeared, and others having yet to appear. This is, unquestionably, a great period of transition, some would say revolution, in the visual arts with which we are concerned, and every work illustrated in this book, and every theme expounded in it, speaks, to a greater or a lesser extent, of the wish to make it new. This is, after all, the period that saw the emergence of, just among painters and sculptors, Henri Matisse, Pablo Picasso, Georges Braque, Piet Mondrian, Marcel Duchamp, Constantin Brancusi, Jean Arp, Joan Miró, Fernand Léger, Ernst Ludwig Kirchner, Oskar Kokoschka, Kasimir Malevich, Aleksandr Rodchenko, Giorgio de Chirico, and many others.

To look back upon this extraordinary period from the end of the twentieth century is, of course, very different from a close-up view. A decade or so after 1920, a highly sympathetic English critic, Herbert Read, observed that the changes it had brought were even more than revolutionary—which implies a turning over—and were actually catastrophic—which implies "an abrupt break with all tradition . . . The aim of five centuries of European effort is openly abandoned," he said.[3] From a present prospect, such an apocalyptic view seems not just hyperbole but sheer nonsense. Yet, we easily forget that those who lived through this period had the sense of participating in a very profound transition indeed. It is possible to argue quite strenuously about what Rimbaud precisely meant when he said, *"Il faut être absolutement moderne."* (It is necessary to be absolutely modern.) But there is not much doubt that Virginia Woolf was not just asserting, but reporting, something when she said, famously: "On or about December 1910 human nature changed . . . All human relations shifted—those between masters and servants, husbands and wives, parents and children. And when human relations change there is at the same time a change in religion, conduct, politics, and literature."[4]

Still, we cannot pretend that we are not looking back, and from our present prospect we cannot but see the continuity with the past as well as the change to the future. We want to acknowledge the change, and to celebrate it for its renewal. But we do not want to promote the myth of modern art as a "crisis," lest its celebration turn into what has been called a "dismissive glamorizing" of the modern, a "narrative sequestering" of it as a privileged, enclosed dislocation of that broad, deep stream of many and various narratives that make up what we are accustomed to call our culture.[5] This is one reason why, as we shall explain, we have chosen an organizing principle for this project that precedes modern art. But it also needs saying now that we do not sponsor any one definition of the modern, nor is it our intention to unroll a series, either of competing or of complementary definitions, that might together afford a comprehensive survey of this part of the modern period. Our aim has been to avoid the definitive, for its premature exclusiveness, and the comprehensive, for its impossible inclusiveness, and, indeed, to shun anything that might imply that a consensus exists on what the modern is and is not, either in its entirety or in this forty-year period. We cannot know what *is* its entirety, in order to form such a consensus, until the modern period ends; neither, therefore, can we yet hope to know what are the entireties, let alone the relative importance to the future of modernism, of the modern starts in the forty-year period 1880 to 1920. To pretend otherwise would be both prejudicial and misleading.

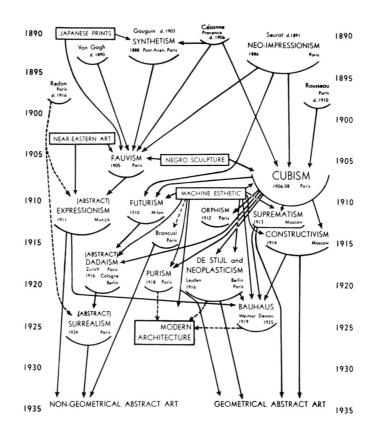

The diagram shows the following dated markers along both left and right margins: 1890, 1895, 1900, 1905, 1910, 1915, 1920, 1925, 1930, 1935.

JAPANESE PRINTS

Gauguin d. 1903
SYNTHETISM
1888 Pont-Aven, Paris

Cézanne
Provence
d. 1906

Seurat d. 1891
NEO-IMPRESSIONISM
1886
Paris

Van Gogh
d. 1890

Redon
Paris
d. 1916

Rousseau
Paris
d. 1910

NEAR-EASTERN ART

FAUVISM
1905 Paris

NEGRO SCULPTURE

CUBISM
1906-08 Paris

(ABSTRACT)
EXPRESSIONISM
1911 Munich

FUTURISM
1910 Milan

MACHINE ESTHETIC

ORPHISM
1912 Paris

SUPREMATISM
1913 Moscow

CONSTRUCTIVISM
1914 Moscow

Brancusi
Paris

(ABSTRACT)
DADAISM
Zurich Paris
1916 Cologne
Berlin

PURISM
1918 Paris

DE STIJL and
NEOPLASTICISM
Leyden Berlin
1916 Paris

BAUHAUS
Weimar Dessau
1919 1925

(ABSTRACT)
SURREALISM
1924 Paris

MODERN
ARCHITECTURE

NON-GEOMETRICAL ABSTRACT ART

GEOMETRICAL ABSTRACT ART

ABOVE: Alfred Barr's diagram from the jacket of his book *Cubism and Abstract Art*. 1936

OPPOSITE: Alfred Barr's plan of the second-floor galleries of the Museum, with key. 1967

So, if this is what we wanted to avoid, what did we want to achieve? We wanted to offer something that is questioning and partial, instead of something that pretends to be definitive and comprehensive. In doing so, we think that we are following leads set down in the period, which is a period not of one style and typology, but of many searches for a style and a typology–the Modern*Starts* of our title. The evidence of the period, at least, seems to be that the modern avoids the consensus of a prevalent style or typology; that, if it created one, it would deny itself and cease to be modern.[6] So how can it be told in one history?

The answer to this question, of course, is: very easily. We enjoy narrative continuity, and happily register events in an order of meaning that they do not possess as mere sequence.[7] But without narrative, there is no history. Our answer to this is to offer not one, but many narratives. This is not an original answer, but it remains a useful one. Only, it poses the further question: how might a sequence of events be divided into these many narratives? The answer for us, after much experimentation, was to use the subjects of the events (the works of art) to sort them by association into selective groups that function as narratives, insofar as all narratives are selective constructions, formed on the basis of what gets left out as much as what gets put in.[8] And, as we were doing this, we eventually settled on the three broad categories which we call People, Places, and Things, into which we sorted and arranged the individual narratives. There will be more about this organization and how it was constructed a little later. But now it needs saying that both of the afore-mentioned questions–how to tell one narrative and how to tell many–have a special, loaded significance for this project because, as mentioned earlier, this project is devoted to an examination of The Museum of Modern Art's collection.

We could hardly have attempted this project if the Museum's collection were not as broad, deep, and strong as it is. For a questioning, partial approach to have any credibility requires that it draws upon, and addresses, a pool of work that is broadly representative of the period of inquiry. We wanted to inquire about, and provide a partial account of, as much of the 1880 to 1920 period as possible. The Museum's collection has allowed us to do this, as no other collection could, through its familiar and its lesser-known works in all the mediums that the Museum collects in its six collecting curatorial departments: Painting and Sculpture; Drawings; Prints and Illustrated Books; Photography; Architecture and Design; and Film and Video. The collection has its biases, though, and we cannot but reflect them. The most noticeable must be the predominantly European, and particularly French, emphasis of the works conserved by the first of the aforementioned departments. But other factors, among them the paucity of early modern architectural drawings and the fact that the entire history of photography is reflected in the Museum's collection, skewed somewhat the balance of the material available to us. Still, there was far more than enough material to form the many narratives that compose this project, and even some extremely celebrated works either had to be, or were deliberately, excluded.

In forming, and then arranging, these many narratives, we have chosen to avoid doing so, in the main, along the lines that The Museum of Modern Art customarily does, which is in two ways. One way is according to the six divisions of medium named in the titles of the six collecting departments. We have avoided this approach, by and large, neither to dispute the value of historical, chronological, thematic, or technical presentations of the artistic mediums employed in our period, nor to make some point about the institutional history that led to the particular separations and combinations of mediums memorialized in these departmental titles. Rather, we wanted to inquire about, and provide a partial account of, the period 1880 to 1920 by drawing at will upon as many mediums as the collection allowed. We, therefore, made an inductive study of all the materials in all the mediums available to us, and then decided when we would present together works in different mediums and when we would present them separately. And when we do present works of one medium separately, it is not with the principal aim of offering an historical, chronological, thematic, or technical account of a particular medium, although such may be a result of the presentation; rather, we do so because a particular narrative seems to be better told in this way.

The second, and most famous (if not, infamous) way that The Museum of Modern Art has arranged its narratives has been to form small narratives that describe historical styles, movements, and, on occasion, individual achievements, and then blend them into a single, larger narrative that is part chronological, part historical.

The most famous such Museum of Modern Art narrative is the one that Alfred H. Barr, Jr., the Museum's first director, diagrammed on the jacket of his 1936 Museum publication *Cubism and Abstract Art*. Far too much has been written about this evolutionary chart, including the fact that it simultaneously can serve for the elaboration of a large number of individual narratives (the search for pure abstraction; the conflation of both individual and group experimentations; the history of "isms"; the victory of the avant-garde; and so on) and for emphasizing the overall narrative dimension of modern art, a notion of the modern as something to be explained by recounting its genealogical pedigree.[9] Unnoticed, though, in these discussions is that when Barr had to form a narrative in the galleries of the

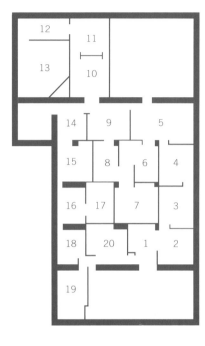

Jean (Hans) Arp. *Enak's Tears* (Terrestrial Forms). 1917. Painted wood relief, 34 x 23⅛ x 2 ⅜" (86.2 x 58.5 x 6 cm). The Museum of Modern Art, New York. Benjamin Scharps and David Scharps Fund and purchase

Museum, he found himself having to deal with what on paper could easily be left out. Thus, his second-floor installation, which began like his diagram with Cézanne, ends not with the neat polarity of non-geometrical and geometrical abstract art, but instead with "Realists and Romantics 1920–1940."[10] As idealism met pragmatism a compromise was found, which accommodated Walter Sickert as well as Gino Severini, and Maurice Prendergast as well as Pablo Picasso, and shaped all into one continuous, unbroken, more-or-less chronological installation that took the viewer through galleries devoted to individual styles, movements, generational and occasionally national groupings, and to a selected number of individual artists. Every succeeding long-term installation of the painting and sculpture collection has been a variation of this model, either more historical or more chronological, and together they have served to educate generations of visitors in a history of modern art.

We have avoided this approach neither to dispute the value of an historical and chronological account that concentrates on styles, movements, and individual achievements, nor to make some point about the Museum's institutional history. Rather, we wanted to inquire about, and provide a partial account of, the 1880 to 1920 period by setting aside this well-known history and returning its materials to a less orderly state before history had named and described the styles and the movements, and had celebrated certain of the individuals. We could not, obviously, return these works to their original freshness, but at least we could try to avoid some of their subsequent historical organization. Choosing a loose organizational principle that *preceded* them—the basic divisions of subject matter—rather than any principle that *succeeded* them, therefore suggested itself. Obviously, we could not pretend that their subsequent historical organization did not exist; we could not actually look *forward* on the period. But, by avoiding, where we could, succeeding organizational principles that had been based upon, and designed to account for, the work of this period, we might be able

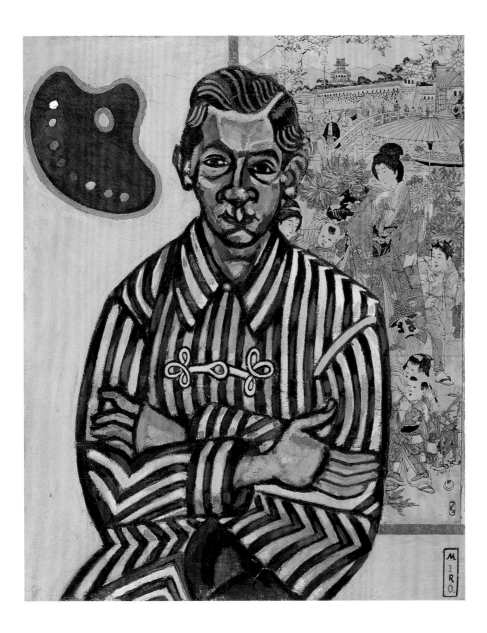

to maintain the fiction that the genealogies had not yet been created. It may not be possible to step outside the modern but it might be possible to imagine it before its futurism.

Joan Miró. *Portrait of E. C. Ricart.* 1917. Oil and pasted paper on canvas, 32⅛ x 25⅞" (81.6 x 65.7 cm). The Museum of Modern Art, New York. Florene May Schoenborn Bequest

Making Modern*Starts*

All this did not begin with the division into People, Places, and Things. It did not even begin as Modern*Starts*. Originally, it was thought that, at the end of the century, the Museum's examination of its *entire* collections from beginning to end might be examined thematically. Thus, the Museum's whole curatorial staff embarked on a study of large, overarching themes, from formal concerns, like developments in the use of color, to iconographic ones, like ways of picturing the city. And, in the end, we all did not so much abandon such approaches as realize some of their liabilities. Among them were, first, that they tended to be either formal or iconographic instead of blending the two; second, that they were hard to sustain for as long a period as a century or more—that a theme that was critical for one period of modern art was not necessarily critical for another; and, third, that

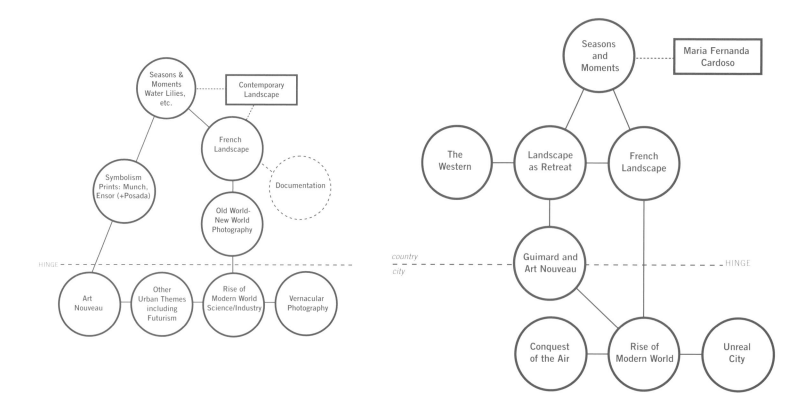

ABOVE, LEFT: **Early diagram of Places**

ABOVE, RIGHT: **Final diagram of Places**

their temporal attenuation might actually be one of the reasons for their methodological difficulty. Thus, it was decided to divide the whole exercise, which eventually we called *MoMA2000*, into three equal parts, and settled on the three equal chronological divisions of the 1880 to 2000 period covered by our collections as the foci for the three parts. Consequently, when we, the group devoted to Modern*Starts* (even before we called it that) began to work on the first period, 1880–1920, we inherited a number of proposals for thematic exhibitions that seemed particularly appropriate to our period, and began to generate others.

These came about in a variety of ways. It did not need much thought, or study of the collection, to realize that the Museum either owned or had promised to it an extraordinary group of French landscape paintings that had never been shown together, let alone with documentation of their sites (pp. 190–209). Looking through a chronologically arranged album recording paintings of the years 1910–19, and seeing on successive pages some extraordinary works all dating to 1914–Matisse's *View of Notre Dame*, de Chirico's *Gare Montparnasse*, Mondrian's *Composition V*, and Duchamp's *Network of Stoppages*–led to what eventually became the exhibition "Unreal City" (pp. 258–79). Our concern to show the unfamiliar as well as more familiar led to the idea of presenting together the icono-graphically related prints of James Ensor and José Guadalupe Posada (see pp. 74–83). A long-evolving proposal on vernacular photography led to what became titled "Rise of the Modern World" (pp. 230–51). Extended discussions about still-life painting led to that part of Things called "Tables and Objects" that includes tables as well as still-life paintings (pp. 312–25). The interdisciplinary composition of the core group helped. (One of us is a curator in the Department of Architecture and Design, another a curatorial assistant in the Department of Drawings, the third from the Department of Education, and the fourth is

unattached to any of the collecting curatorial departments, but has worked in the Departments of both Painting and Sculpture and of Drawings.) It also helped that our larger group of collaborators covered all of the curatorial and program departments of the Museum. Our aim, however, was not to represent equally all the curatorial departments in the chosen exhibitions and the works in them. It was to assemble, from all the proposals we generated or received, the exhibitions that we found most exciting and appealing, and that together formed an assembly that reasonably covered most of the important artistic currents of our period, and that was reasonably comprehensible as a whole as well as in its parts.

Thus, to answer the first of these requirements, we took a retrospective look at our period, and asked ourselves what we thought were the most important currents that needed to be addressed. And, to answer the second of these requirements, we followed the tradition of Barr's famous diagrams, and began to map out the relationship of our proposed exhibitions: but not, in the main, historically; rather, how they seemed *structurally* to relate to each other.

Our retrospective view suggested that we had to address four main subjects. The first was what had happened to figural representation in this period, and, most importantly, what changes were to be discovered in the expressive potential of represented figures and in figure compositions with narrative subject matter. The second was the big shift of focus in this period from representations of the country to those of the city: from the apparently escapist, mostly late-nineteenth-century representations of distant landscape sites to the beginning of the process of imaging the modern twentieth-century city, in its variety of faces, in the first two decades of the century. The third subject we believed we had to address was the creation of abstract art: its various sources and manifestations in this period; the difficulty of its comprehension, then and now; and how it opened onto the art of later periods. And, fourth, and finally, we knew we had to deal with how the idea of the object captured the aspirations of modernism in this period: from the *objet-tableau* (object-picture) of the Cubists to the idea of the *objet-poème* (object-poem) and the growth of experimental typography; and from extraordinary innovations in modern design to the creation of collage, and the wide use of new and unconventional materials in extremely objectlike sculptures. We, therefore, mapped out these topics in their parts, and then mapped out how a part of one topic might relate to a part of another.

It would be tedious to attempt to go through all of this process. But one example might serve to explain how we proceeded. An early diagram of what was then called Early Modern Sites—namely, the "country" part of the country-city polarity—shows that we had settled on the hybrid historical-contemporary exhibition on visionary, generalized landscape themes called "Seasons and Moments" (pp. 180–89). We had also decided on the French landscape exhibition and its complement that documented the landscape sites. We had started to think about a Symbolist print exhibition; and were considering a photography proposal, as well as something that featured contemporary landscape. Additionally, below the "hinge" (see diagram), we had begun to lay out four "city" subjects.

As it turned out, the separate photography proposal above the hinge was not adopted, but photographs were added to both "Seasons and Moments" and "Changing Visions: French Landscape Painting, 1880–1920." Additionally, the Symbolist print idea broadened into an exhibition called "Landscape as Retreat," which included artists from Paul Gauguin

to Emile Nolde (pp. 210–19), while Ensor and Posada became a separate exhibition in the People section. As for the elements below the hinge, we eventually realized that Art Nouveau organicism actually belonged *on* the hinge, not below it, being organic in subject but urban in context and sometimes industrial in means; this transformed into a small section devoted mainly to Hector Guimard (pp. 220–29). "Rise of the Modern World" became an examination of vernacular photography (pp. 230–51) and the small section on "The Conquest of the Air" (pp. 252–57) split off from it. The vague topic on urbanist themes transformed into "Unreal City," owing to the happy accident mentioned earlier of realizing the affinity of a group of 1914 paintings. Then the Department of Film came up with the idea of a study of the Western film (pp. 280–89) to add to the "country" side of the hinge. We had, by then, added some contemporary images of landscape to "Seasons and Moments," but felt that we still had not quite solved that problem when, at the eleventh hour, we were able to commission an installation called *Cementerio—Vertical Garden* from a young artist, Maria Fernanda Cardoso (pp. 166–69), and, with that, Places was completed.

This contemporary installation by Cardoso is one of three. There is also an installation by Sol LeWitt (complementing People; pp. 34–37),[11] and one by Michael Craig-Martin (complementing Things; pp. 292–95). We included these, as we included other, selected examples of contemporary art, not to suggest that they are "influenced by" or "react against" any of the historical works. In certain cases, most notably, perhaps, with the photography exhibition of posed and unposed figures, the intention was to assert a connection. But, by and large, what we wanted to assert, instead, was simply the persistence of the broad generic themes, and how they continued to form a useful "resistance" for contemporary artists, as they had for the historical artists in whose company they appear. And since The Museum of Modern Art is a museum of contemporary as well as of classic modern art, we felt that a few contemporary jolts might remind our viewers of that fact. (In the case of the installations, which occupy public spaces in the Museum, viewers literally enter the classic modern through the contemporary presentations, as a further reminder that this is how, metaphorically speaking, we approach the art of our past.)

As observed earlier, it had originally been our idea to devote a separate section to abstraction. We felt that this was necessary, not only because of the intrinsic importance to our period of the creation of abstract art, but also because of the difficulty of its comprehension, even now, nearly a century later. It took quite a long time before we realized that, by dealing with abstraction separately, we were creating enormous problems for ourselves, and quite possibly for the viewer, too. The problem of dealing with abstraction separately was that it had, of course, emerged *within* the context of the preexisting genres of figure, landscape, and still-life representations, and with the aid of (among other causes) the idea of artworks as objects that was important to our period. To have sequestered it would have been misleading. And to attempt to sequester it had been creating havoc in the planning, and imbalance in the organization, of our other sections, all of which required the representation of works of abstract art. Thus, we were left with three sections, on the themes of figural representation, the shift in focus from country to city, and the idea of the object; hence, People, Places, and Things.

Interestingly, when People, Places, and Things were composed in their final form, and mapped out a last time in order to create the diagrams published here, it became clear that something curious had happened. The diagrams resembled their subjects. People

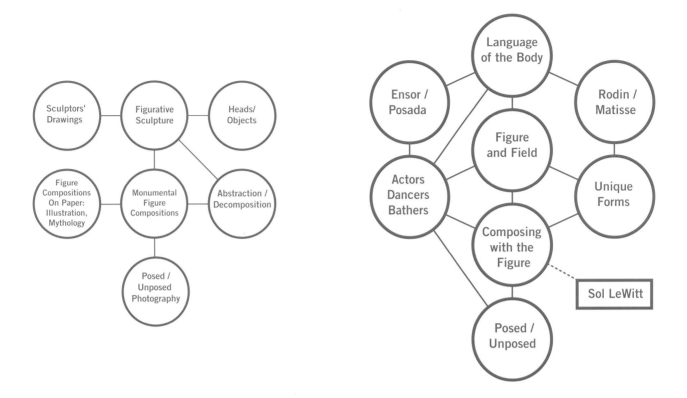

had become a neural network of utterly interconnected parts. Places had become a horizontal panorama (p. 24). And Things had become a dense, symmetrical object (p. 28). We did not plan it this way. It just happened.

People, Places, Things

Of all the disciplines that study our cultural patrimony, only the study of visual art announces itself as an historical study: art *history*. "Standardly," as Richard Wollheim has put it, "we do not call the objective study of an art the history of that art. We call it criticism."[12] He adds that the idea that the visual arts uniquely require historical study is something that actually requires historical explanation. Part of that explanation—for modern art history, certainly—is the history of and the history told by The Museum of Modern Art. (A larger part, of course, is the foundation of the modern study of art as a positivistic pursuit.) This being so encouraged us, in seeking an organizational principle for our study of early modernism, to attempt a nonhistorical study of it, a study that acknowledges the general way in which the visual arts, like all the arts, are connected with a tradition, but that does not make that into an organizing principle. After all, we were dealing with what now seemed, from the vantage point of the end of the twentieth century, a small forty-year period. We had isolated this small historical period, so why stretch it out historically? We, therefore, eventually fell back on the old organization of genres, or traditionally standardized types or classes of subject matter, which—before modernism upset things—were organized into a hierarchy that began with figure compositions and portraits, continued with landscapes, and ended with still lifes. Hence, People, Places, and Things.

We adopted this organization not only because (as observed earlier) it preceded the period of study. We also adopted it because it both persisted in this period—artists continuing

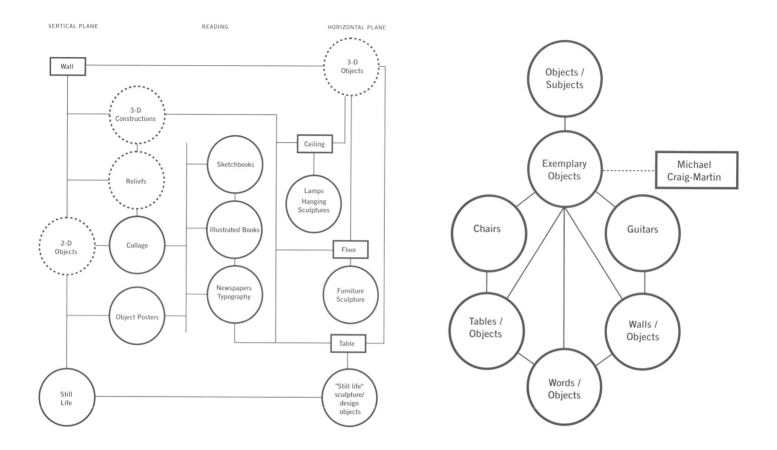

ABOVE, LEFT: Early diagram of Things

ABOVE, RIGHT: Final diagram of Things

to make images of people and places and things, as well as actual places and things—and because it was challenged in this period as it had never been challenged before. Thus, we not only trace the development and the mutations of these three genres; we also see them as a form of "resistance" against which modern forms struggle to find their definition, and thus open onto stylistic and typological experimentation. Thus, instead of offering the idea, say, that Matisse sat down to paint a Fauvist landscape, we offer instead the idea that he sat down to paint a landscape of a particular place that turned out in a particular way to have something to do with the place as well as resisted the appearance of the place. And thus we are interested in how his *Dance* (p. 131) and his *Moroccans* (p. 93) are both, in their different ways, revisionist interpretations of the elevated genre of figure composition, and how his *The Red Studio* (p. 16) is impatient with distinctions of genre, being a depiction of people, places, and things at the same time.

And so, we notice, because we are thinking in this way, is Joan Miró's *Portrait of E. C. Ricart* (p. 23). Obviously, it shows a person, the eponymous subject, but it also calls up a place in the depiction of the Japanese print—and Miró marks his identification with that place in the form of his signature below it—and, finally, it shows an object, his palette hanging on the wall, dotted with the colors that have composed this multi-generic picture. Now that we are accustomed to thinking in this way, we will notice that the palette on the wall bears an interesting resemblance to an exactly contemporaneous work, Jean Arp's *Enak's Tears* (p. 22), which, in the comparison, itself transforms into the artist's palette.

Some works thus refuse absolutely a generic classification. Among them are also those fully abstract works that cannot legitimately be related to figural, landscape, or still-life sources. Some can, of course, and we have, for example, sought to remind the viewer how Kasimir Malevich saw his own abstract paintings as belonging to a modernism that had just conquered the air (pp. 256–57). But we also wanted to assert that his paintings are objects in a way that paintings had not been before. To show his *Suprematist Composition: White on White* of 1918 (p. 31) with a geometric vase of 1902 by Koloman Moser (p. 31) is to assert neither influence nor congruence, merely that both belong to the modern object world, and that a work like the Malevich does belong to the world of objects as well as to the world of places, specifically to the world of Suprematist space. On the other hand, still-life paintings are included in the section devoted to the "Unreal City" because the still life has always been not only the objects but also the spaces that they occupy. There is nothing modern about this. In fact, most works in the Museum's collection created in the period 1880 to 1920 are readily classifiable according to the traditional genres, however much they stretch or subvert the conventions and the decorum of these genres. If that were not the case, People, Places, and Things could hardly have become our organizing principle.

As observed earlier, the diagrammatical organization of People turned out to show a neural network of interconnected parts, Places a horizontal panorama, and Things a dense, symmetrical object. People is, indeed, the most densely constructed, as its diagram indicates (p. 27). A diagram recording an early stage of its organization (p. 27) shows that we had difficulty with it until we abandoned our separate section on abstraction, and until we properly defined our section on objects. In its final form, it takes its organization from the relationship of different shapes assumed by the body. "The Language of the Body" (pp. 48–65) deals, in the main, with facial expression and with gesture. Related to it, the parts devoted to Ensor and Posada (pp. 74–83) and to Auguste Rodin and Matisse (pp. 66–73) examine questions of expression in relation to, respectively, imaginative illustration and sculptural portraiture, the latter also relating to another section on sculpture, this time of mostly the full-length figure (pp. 106–13). Related to that, as well as to "The Language of the Body," is the part on "Figure and Field" (pp. 114–25), which treats representations of postures adopted mainly by the single figure, while "Actors, Dancers, Bathers" (pp. 126–45) picks up on issues of both gesture and posture in specific depictive situations and has an obvious association with the section dealing with photographs of posed and unposed figures (pp. 146–63). And all of this circulates around "Composing with the Figure" (pp. 84–105), which presents monumental compositions of groups of figures, in the main, as well as their decomposed variants.

We have already looked at the development of Places, which led to its horizontally striated organizational diagram (p. 24), and all that needs to be added here is that, of the three sections, it is the one whose organization comes closest to the historical in its broad, two-part division of country followed by city, but whose elements are actually the most independent of each other. Thus, it is far from telling a single historical story, offering instead a sense of the wonderful contradictions and complications of the typical spatial intelligence of our period. In Wallace Stevens's words: "It is an intellect / Of windings round and dodges to and fro, / Writhings in wrong obliques and distances."[13]

Finally, Things is, as we have said, organized like a thing itself (opposite). It was, in fact, the section that gave us the most difficulty in its organization, until we settled, in one of

our diagrams, upon an order based on the physical placement of things. Thus, we established a simple polarity between objects placed in relation to a vertical plane, usually a wall, and objects placed in relation to a horizontal plane, either a table or the floor or (suspended from) the ceiling. This gave us a distinction between objects represented in two dimensions and relief sculptures, on the one side, and freestanding objects—and, to complicate things, representations of such freestanding objects, usually on tables—on the other. And, between the two poles, we placed objects to be read, either to be read on surfaces that were vertical (like posters on a wall) or to be read on surfaces that were horizontal (like books on a table). In the end, we did not adopt all the possibilities we had laid out in the early diagram, but it gave us what we were looking for.

Thus, we begin with a group of exemplary objects of all sorts (pp. 296–303), then we proceed in the two directions. Along the horizontal dimension, we find a section devoted to that archetypically modern design object, the chair (pp. 304–07), and another on the relationship of the object to the table (pp. 312–25). Along the vertical dimension, we find a section devoted to that archetypically modern sculptural object, the guitar (pp. 308–11), and another on the relationship of the object to the wall (pp. 332–39). Both dimensions converge in a section treating the relationship of object and word (pp. 326–31), which connects back, as does everything else, to the exemplary objects with which we began, including a section on "Objects as Subjects" (pp. 340–49), that relates design objects, sculptures, and photographs.

Obviously, these diagrams are plans of the relationship of ideas, and can no more directly translate into the layout of galleries, or of this guide, than could Barr's *Cubism and Abstract Art* diagram. But we wanted viewers who are interested in the ideas behind the planning of an exhibition to know how we arrived at the sections devoted to People, Places, and Things that comprise Modern*Starts*. (And since we can hardly offer this explanation in the Museum, we will present, alongside People, Places, and Things, a smaller exhibition called Making Modern*Starts* and that will deal with some of these issues.)

In offering this information, we also want to emphasize two important points, both of which were very well taken by the literary critic Northrop Frye in introducing his great *Anatomy of Criticism*.[14] First, for all our hesitations about the schematic nature of what we present, and for all the qualifications we probably should have made along the way, we are unable to apologize for classifying our material according to a fairly rudimentary, three-part system. As Frye says, "there is a place for classification in criticism," and any repugnance to it derives from "a failure to distinguish criticism as a body of knowledge from the direct experience of literature, where every act is unique, and classification has no place." Thus, we offer our classifications in the hope of aiding knowledge of our subject and, hence, appreciation of it. But, second, we must conclude with Frye: "Whatever schematization appears in the following pages, no importance is attached to the schematic form itself, which may be only the result of my own lack of ingenuity. Much of it, I expect, and in fact hope, may be mere scaffolding, to be knocked away when the building is in better shape. The rest of it belongs to the systematic study of the formal causes of art." And, we hope, to the continuing history of The Museum of Modern Art.

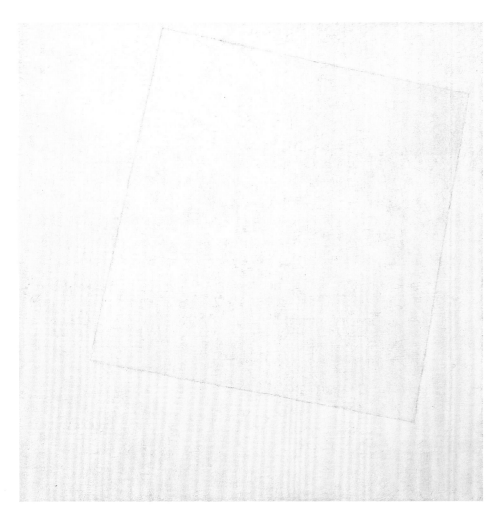

LEFT: Kasimir Malevich. *Suprematist Composition: White on White.* 1918. Oil on canvas, 31¼ x 31¼" (79.4 x 79.4 cm). The Museum of Modern Art, New York

BELOW: Koloman Moser. *Vase.* 1902. Colored glass, 5⅞ x 5⅞ x 5⅞" (14.9 x 14.9 x 14.9 cm). The Museum of Modern Art, New York. Estée and Joseph Lauder Design Fund

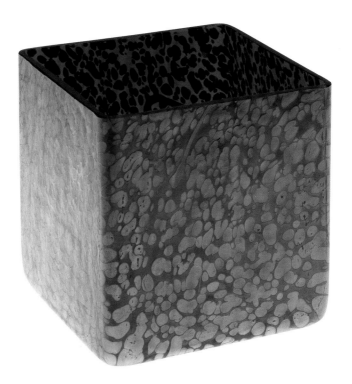

PEOPLE

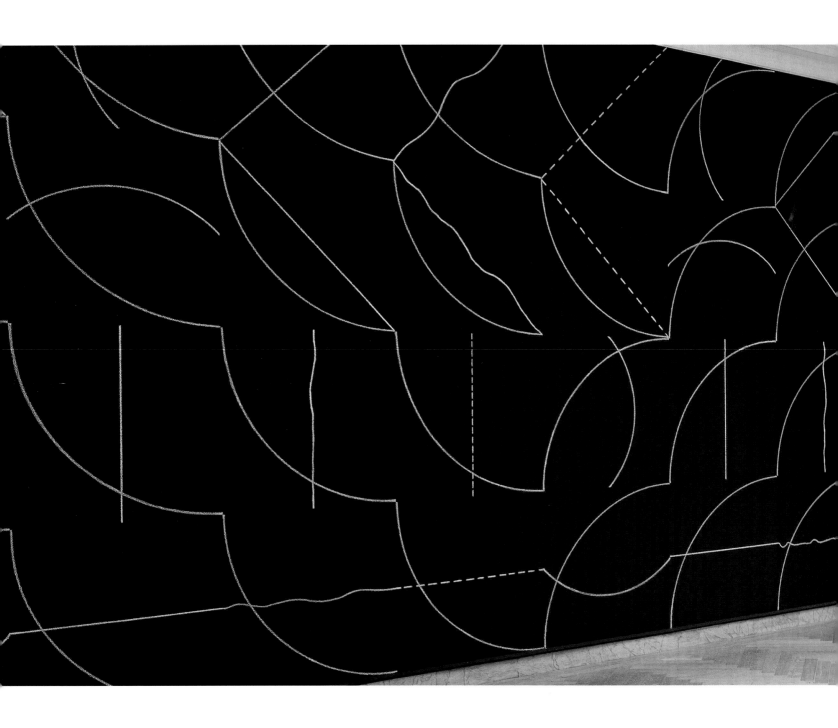

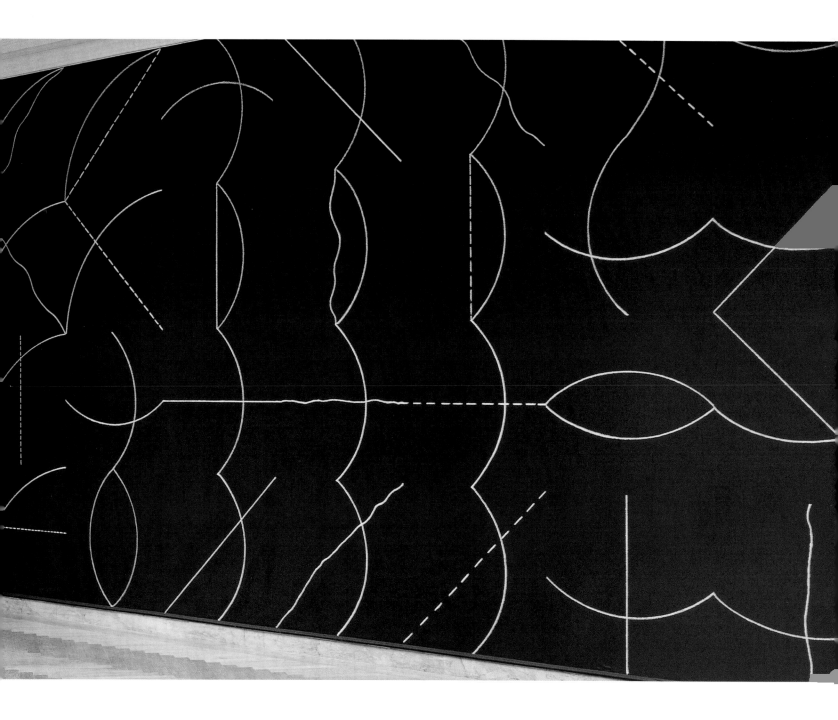

Sol LeWitt

On black walls, all two-part combinations of white arcs from corners and sides, and white straight, not straight, and broken lines

Sol LeWitt. *On black walls, all two-part combinations of white arcs from corners and sides, and white straight, not straight, and broken lines.* 1975. White crayon and black-pencil grid on black walls, dimensions variable; 11' 7" high, 154' ½" wide (353.1 cm high, 4,695.2 cm wide) in current installation. The Museum of Modern Art, New York. Fractional gift of an anonymous donor

PREVIOUS TWO PAGES: Detail of the work on view in *Sol LeWitt: Twenty-five Years of Wall Drawings, 1968–1993*, Addison Gallery of American Art, Phillips Academy, Andover, Massachusetts, 1993

ABOVE AND OPPOSITE: Details of the work on view in *Sol LeWitt*, The Museum of Modern Art, New York, 1978

A wall drawing first realized in 1975 by Sol LeWitt, this work must be re-created from his instructions for each subsequent showing. Executed in white crayon over a black grid on black walls, the drawing is composed of 190 combinations of four types of line, as described in the work's title. A diagram showing each line type and all possible combinations, illustrated below, accompanies the drawing, enabling comprehension of its underlying structure. Despite the logical method defining the drawing's properties, the experience of viewing the work is one of deep engagement and visual enjoyment. In the current exhibition, it is hoped that the viewer who encounters the drawing's grand scale and its sweeping arcs and lines on both physical and perceptual levels will find correlations to the corporeal.

LeWitt executed his first wall drawing in 1968. He has continued to make them to the present day, completing more than nine hundred. Inspired by Eadweard Muybridge's sequential photographs of a man running, LeWitt first embraced the notion of seriality in three-dimensional structures, examining various ways to order particular lines as a kind of narrative sequence. Attracted to the wall's potential as a two-dimensional surface, he adapted the basic geometric vocabulary of his sculpture, which is based on open, linear volumes, to drawing. In the early wall drawings, he focused on vertical, horizontal, and diagonal lines, later adding arcs and broken and curved lines. The choice of tonality evolved over the decades from black on white, to white on black, to primary colors, and, most recently, to quite rich, decorative colors. Each work paradoxically combines the "rigorous order of a simple repetitive system" with the "antiorder" of the infinite possibilities of line position, compositional relationships, and architectural contexts.[1]

Along with his three-dimensional structures, LeWitt developed the wall drawings under the rubric of conceptual art and the search for an alternative to painting. He maintained that the idea, as formulated in language, took precedence over the completed artwork: "The wall is understood as an absolute space, just like the pages of a book. One is public, the other private. Lines, points, figures, etc., are located in these spaces by the use of words. The words are the paths to understanding of the location of the points. The points are verified by the words."[2] In this sense, he has often been compared to a composer who creates a score for others to perform. Of the wall drawings, LeWitt has said: "I think of them like a musical score that could be redone by any or some people. I like the idea that the same work can exist in two or more places at the same time."[3]

—MARY CHAN

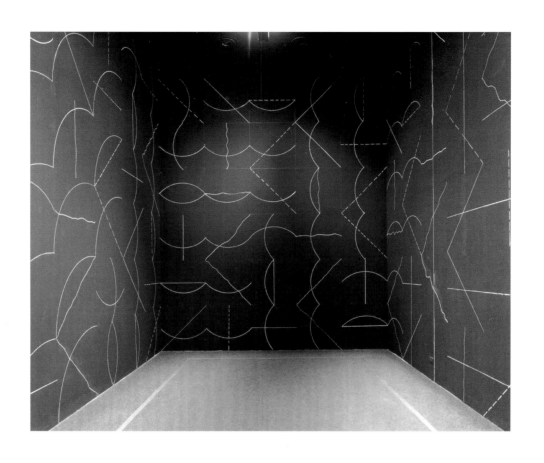

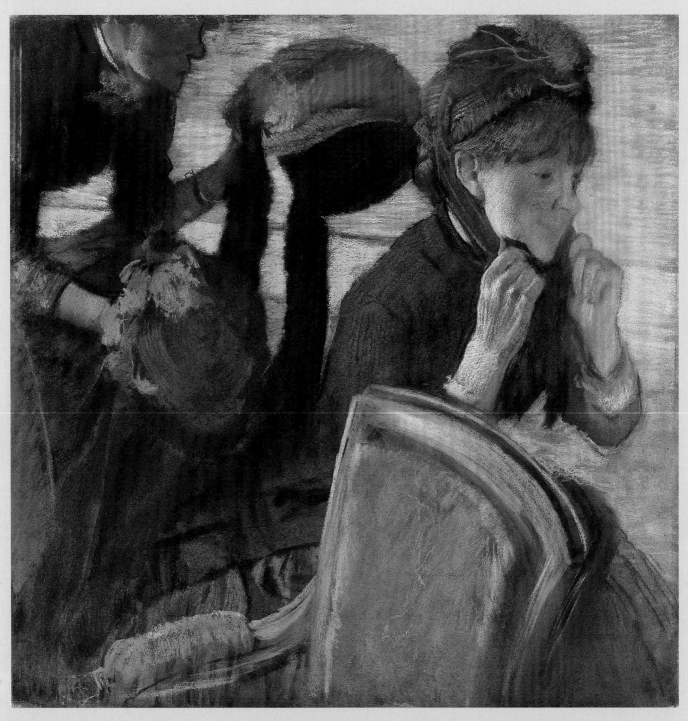

Hilaire-Germain-Edgar Degas. *At the Milliner's.* c. 1882. Pastel on paper, 27⅝ x 27¾" (70.2 x 70.5 cm). The Museum of Modern Art, New York. Gift of Mrs. David M. Levy

Representing PEOPLE
the story and the sensation

I don't want to avoid telling a story, but I want very, very much to do the thing that Valéry said —to give the sensation without the boredom of its conveyance.

Francis Bacon, 1966[1]

Of all images, those that represent the human figure are usually the ones that arouse the greatest emotional responses. Images that even, unintentionally, just hint at the human figure can provoke strong reactions: "Curves are too emotional," Piet Mondrian once said.[2] But the figural images that are among the most provocative are those that fragment, dissolve, or otherwise "distort" the figure, or those that show it in postures that seem incomprehensible, or in groupings or environments the reasons for which seem annoyingly obscure.

The painter Francis Bacon is quoted at the beginning of this essay as saying he does not want to avoid telling a story, but that he does want to give the "sensation" of a story. This sounds rather like the complaint that someone reads only for the story, and the story is the least part of the book. Yet, Bacon is not downplaying the narrative aspect of painting, but wanting it expressed as a "sensation," not as a prosaic account. Many of the artists in the period 1880 to 1920, to which this volume is devoted, would have agreed with him. And that is why their figural descriptions, and the stories that they describe, do not, sometimes, quite seem to make sense.

For example, most people who look at Edgar Degas's *At the Milliner's* of about 1882 seem to see first a single figure trying on a hat (she is, in fact, the American painter Mary Cassatt), and then the flat, linear, ribbonlike shapes—some formed by actual ribbons, others by arms and hands, and, prominently, by the edges of the furniture—that loop in interwoven chains around the composition, shooting past the second figure in the top left corner. The chain of elements seems to circulate endlessly, as if Degas wanted to prevent us from stopping to look for very long at any single area. It therefore takes a little while to disentangle this story about a customer and a shop assistant, and the memory of the first, pleasantly confusing sensation persists, and is renewed by our continued looking, even after we have made sense of the picture.

Such an effect is not new in principle to the period 1880 to 1920, only new in extent. The critic Michael Podro has recently written that part of the way that sophisticated paintings, of any period, engage us, is "through creating uncertainty; our engagement with them involves a continuous adjustment as we scan them for suggestions on how to proceed and for confirmation or disconfirmation of our response."[3] Effectively, they

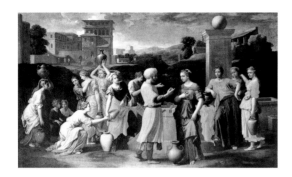

Nicholas Poussin. *Eleazar and Rebecca at the Well.*
1648. Oil on canvas, 46⁷⁄₁₆" x 6'6⅜" (118 x 199 cm).
Musée du Louvre, Paris

Henri Matisse. *The Moroccans.* 1915–16. Oil on
canvas, 71⅜" x 9'2" (181.3 x 279.4 cm). The
Museum of Modern Art, New York. Gift of Mr. and
Mrs. Samuel A. Marx

slow us down by, and for the purpose of, puzzling us. What is odd about the Degas, though, is how an increase in the velocity of the compositional circulation is what creates a delay in the delivery of the meaning.

The chainlike composition is actually a subversive adaptation of something very conventional, and of long use. In earlier, more traditional figure compositions, it was customary to link groups of figures in chainlike sequences formed by "positive bodies" in the composition, mainly the bodies and limbs of the figures, but also by any other volumetric elements in the work.[4] A classic example is Nicolas Poussin's *Eleazer and Rebecca at the Well* of 1648. Like most important figure compositions within the Renaissance tradition, it is an arrangement of figures whose bodily postures, gestures, and facial expressions are intended to convey legible meanings. Effectively, the representation of action stands in for the representation of diction; the bodies "speak" by their arrangements. It is not coincidental that this picture resembles a theatrical set. Acting and rhetoric (the art of debate) were influential on such works insofar as, for both, significant gestures and sometimes postures accompanied speech as a reinforcement, and sometimes a substitution, for it.

In the Poussin, then, linking positive bodies into chains is what conveys the story, the meeting of Eleazer and Rebecca; and Poussin cleverly offers at least three overlaid chains that tie the narrative together, place it within a credible space, and spread it across the flat surface. Each of the three chains contributes to all three functions, but each one of them has a principal role. The first, extremely linear chain, formed mainly by the limbs of the figures, has the principal function of unfolding the narrative. The second chain, a dislocated one formed by the heads, urns, and the sphere on the column, also helps to explain the narrative, but has the particular function of creating spatial depth, as the viewer is asked to jump visually between these elements and imagine that they are actually connected. The third chain is formed by the entire shapes of the figures that form a flat, friezelike arrangement, broken at the center by the forward-projected fragment of the frieze created by the two main protagonists and the space between them.[5]

If we look back at Degas's picture, however, we see that the artist has effectively taken only Poussin's first, very linear type of chain, and transformed its use, so that it does not form a logical narrative progression leading to a clear conclusion, but has kept it circulating endlessly, as if to prevent any conclusion. If we now look at Henri Matisse's *The Moroccans* of 1915–16 (see

also p. 93), which may, in fact, have been partially inspired by the Poussin, we see not linear chains but separated elements. The effect is somewhat akin to Poussin's second, dislocated kind of chain, and the viewer is similarly asked to jump visually between, and thus join spatially together in his imagination, the melons at lower left (a bit like Poussin's urns), the head of the Moroccan seated at lower right (a bit like a sphere on a column), and the architecture in the left background. But since, in the Matisse, there is no additional linear chain to carry the narrative, the effect is an extremely episodic one.

In the old, Aristotelian argument, episodes are constituent parts of an action, and an action can either be probable and necessary, in which case the episodes are in accord with principles of unity, or it can be without probability and necessity, in which case its episodes are merely "episodic."[6] In French academic theory, it was assumed that the more numerous the episodes, the more they needed to be ordered and structured to compose a unified work of art. Thus, the alternative to a highly ordered, unified arrangement of episodes was to reduce them in number. In principle, if not in practice, then, Matisse is following established opinion when he makes a picture from two pairs of contrasting colors (pink and green, and black and white), three main compositional zones, four melons, and four blue-and-white striped flowers.

He is also doing so when he uses black to simplify the composition, for it had long been common to simplify a composition by veiling forms in tonal shadow and to "paint up" the principal sequences. Besides, the protection of darkness was a traditional way of prolonging the viewer's attention before a painting, encouraging and extending its visual inquiry by making the experience of looking at it something akin to looking at something that is actually wrapped in shadow in the external world. It is not certain whether or not we are expected to read the black in *The Moroccans* as shadow, but in other modern paintings—Georges Braque's *Man with a Guitar* of 1911–12 (p. 46) is a good example—seeing the subject in the picture is rehearsed by our seeing a subject in the shadows surrounding it. The painting, which continues to puzzle, is meant to be a puzzle, like the puzzle of looking at something under obscure circumstances, or the difficulty of engaging with a hard-to-comprehend world.[7]

Turning back to Poussin's composition for a last time, and specifically to its two central figures, we may see an instructive comparison to Pablo Picasso's *Two Nudes* of 1906 (see also p. 118). Picasso has followed the third of Poussin's aforementioned compositional methods. He, too, has made a fragment

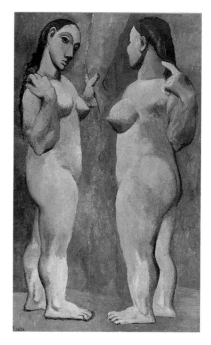

Pablo Picasso. *Two Nudes.* 1906. Oil on canvas, 59⅝ x 36⅝" (151.3 x 93 cm). The Museum of Modern Art, New York. Gift of G. David Thompson in honor of Alfred H. Barr, Jr.

of a frieze from the shapes of the two figures; he has also set them close to an architectural ground that is easily confused with the actual surface ground of the picture; and he has matched the facing contours of their bodies and the positions of their feet and hands. But, thus isolated from any larger narrative context that might explain them, the two figures in Picasso's painting illustrate not a conversation but, apparently, uncommunication, for it is impossible that there will ever be a consensus on what actually is happening here. The depicted gestures do not have specific meanings, as gestures in pictures, as much as words in sentences, are supposed to have. Sensation wins over story; narrative seems entirely to have broken down.

So it does in the many works illustrated in the following pages that either contain an obscure figural language of posture, gesture, and expression, or figuration that is not easily separated from the pictorial field that it composes. Picasso's painting puzzles in both ways—in its figural language and its figural composition—and so do many other works. But others puzzle in one or the other way, or mainly in one or the other way. The two ways are separable. Therefore, the remainder of this essay will, in the main, take a brief look at them separately in the hope of thus offering a possible route through the pages that follow.

In the Introduction to this book, it is observed that this particular section, which is devoted to People, conceptually resembles, appropriately, a neural network of interconnected parts. However, since the section had to be presented sequentially, it is designed in the following way. It begins with figural language: first, broadly, through the example of many artists ("The Language of the Body"), then specifically, in the work of two artists ("Expression and the Series: Rodin and Matisse"). Then, it moves on to works by two other artists whose languages have similar subjects ("Ensor/Posada"), before shifting the focus to a broad examination of figural composition ("Composing with the Figure"). It then returns to figural language, in the context of sculptures mostly of the single figure ("Unique Forms of Continuity in Space"), then examines how representations, mostly of the single figure, form figural compositions ("Figure and Field"), before considering three subject types that raise questions equally about figural language and figural composition ("Actors, Dancers, Bathers"). Finally, both subjects are explored in the medium of photography from virtually its beginnings, through the principal period of consideration here, into works of contemporary art ("Posed to Unposed: Encounters with the Camera").

As noted above, what now follows offers another route through this material, and while the route itself is not short, but long and circuitous, its description will have to be. I will consider figural language first, then figural composition, and thereby return to where this essay began. And I will take them in this order because, contrary to what it seemed earlier, narrative has not entirely broken down in the works illustrated in this section, and the succession of figural language and figural composition offers a useful, simple way of understanding why.

It is true that in the period 1880 to 1920, what previously had been taken, in the first place, as a figural language now becomes taken, at first, as a figural composition. Thus, the figural language seems to become "meaningless," as it is internalized in a vocabulary of colors and shapes, pictorially conceived. And the figural composition, too, becomes unfathomable once the traditional closure of narrative is thwarted, and the mobile play of perception is set against its ability to stop and to focus, and thus prevented from pausing to discover what things mean. And yet the pictorial presence of things always requires explanation. To make *visual* sense of them one must infer a cause.[8] Thus, we search for significance in the sequences of figural incidents. And we are, in fact, encouraged to do so to the extent that our expectation of significance is defeated at first glance. This so-called iconic defeat that modern art often imposes upon its viewers only keeps them coming back for more.

To become narratively engaged, we might say, is to become engaged with taking things in an order. Visual narrative may be defined as the pattern of visual things in a certain visual order, which pattern emerges summatively and recursively in the sequence of actions of looking, which sequence is the enactment, or performance, of a visual narrative.[9] This is more obvious in figure compositions than in compositions of a single figure. As Francis Bacon once said: "I think that the moment a number of figures become involved, you immediately come on to the story-telling aspect of the relationships between figures. And that immediately sets up a kind of narrative."[10] Yet, if the storytelling occurs in the looking, it will occur in looking at a composition containing a single figure as well as at a composition containing many. In making *visual* sense of any depiction, the visual sensation will cause us to become narratively engaged, as Bacon acknowledges in his statement quoted at the beginning of this essay.

A simple, traditional form of narrative engagement with a depiction of a single figure occurs when the figure is shown with one of its attributes, or characteristic accompaniments,

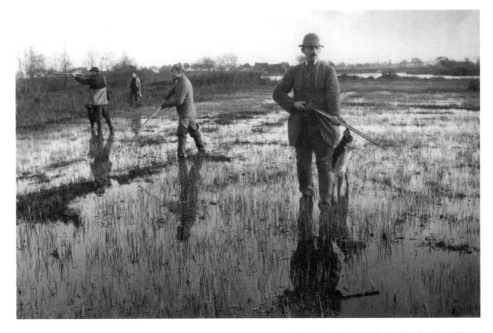

Peter Henry Emerson. *Snipe Shooting* from *Life and Landscape on the Norfolk Broads.* Before 1886. Platinum print, 7⁷⁄₁₆ x 11⁵⁄₁₆" (18.9 x 28.6 cm). The Museum of Modern Art, New York. Given anonymously

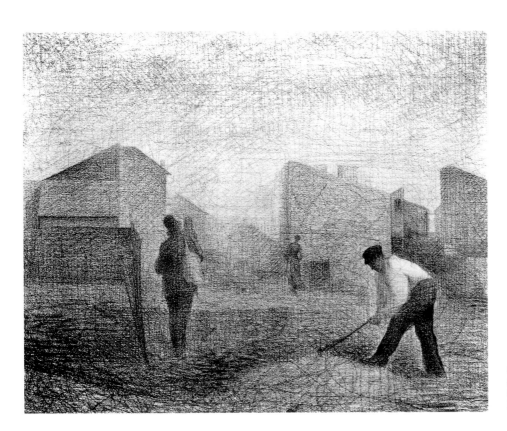

Georges-Pierre Seurat. *Stone Breaker, Le Raincy.* c. 1881. Conté crayon on paper, 12¹⁄₈ x 14³⁄₄" (30.9 x 37.5 cm). The Museum of Modern Art, New York. Lillie P. Bliss Collection

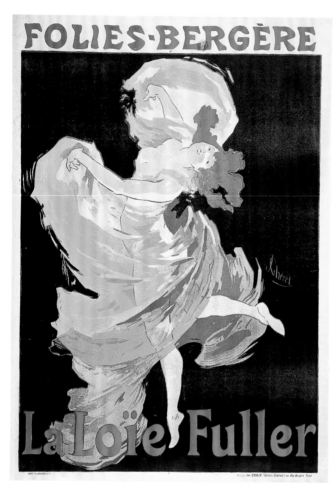

Jules Chéret. *Folies-Bergère, La Loïe Fuller*. 1893. Lithograph, 48½ x 34½" (123.2 x 87.6 cm). The Museum of Modern Art, New York

such as the pictures of Hamlet with a skull and a harlequin in a diamond-patterned costume, illustrated on page 126. But, more broadly, all visual representations may be thought to tell stories insofar as visual representational art has traditionally been defined, since Plato, as *mimesis* (a noun derived from the verb *mimeisthai*; to mime or imitate).[11] Figural art, certainly, has traditionally been thought of as silent storytelling through the representation of bodily performance. People enact the likeness of other people (put themselves in their places) the better to comprehend what they mean, and viewers are expected to put themselves in the place of the enacted, the represented likenesses, so that they themselves may enact and, therefore, comprehend what they mean.

Of course, figural representations have been made not with the aim of telling a story, but of recording an appearance. Some have been made virtually as ethnographical records. Peter Henry Emerson's photograph *Snipe Shooting* (p. 43), made before 1886, may be valued on that account alone. And figural representations have also been made virtually as abstract decorations. Georges-Pierre Seurat's drawing *Stone Breaker, Le Raincy* (p. 43) of about 1881 has been valued solely for that reason. Yet, not only is the one as abstractly and as ethnographically redolent as the other, both pictures have that expressive, empathetic aspect, which invites us to put ourselves in the place of the representation to imagine not only what the figures are actually doing but also the lives and the land. The photographer and the draftsman equally admired the work of Jean-François Millet, a socially concerned artist of the preceding generation, who, alas, was given to a certain sentimentality of representation. The objectivity of the later works—the objectivity of the record as well as of the means of the recording—marks them as modern. They draw unsentimentally upon the older idea of empathetic expression.

So do many of the works illustrated on the following pages, most notably, those in the section called "The Language of the Body." This section, in particular, makes abundantly clear that representations of the older figural mime, enacted through posture, gesture, and the disposition of facial features, continued to be made by a very wide range of modern artists, from Edvard Munch to Oskar Kokoschka and Paul Klee to August Sander. Yet, with the very critical exception of photographs—as evidenced by the section called "Posed to Unposed: Encounters with the Camera"—these tended to be early modern representations. And even in some of the earliest images, significant actions are described, but are shorn of obvious significance. Thus, we see pictured those privileged positions of the body by which human

personality and emotion explain themselves; only specific explanations are withheld, which further stimulates the desire to find explanations, or to remember the stories that the postures and the gestures used to tell.

Of course, all postures, gestures, and expressions are potentially ambiguous, but they are especially so when frozen in space, as they must inevitably be in single visual representations. To describe one unambiguously, therefore, requires attempting to convey the temporal sequence to which it belongs.[12] The "swish lines" derived from photographs of moving objects, now commonly used in comics, offer one solution: Umberto Boccioni adopted it in making his sculpture *Unique Forms of Continuity in Space* (p. 108). Another solution is to repeat the same figure, in different phases of the same action, in the same composition; this is common in Eastern and European medieval art and was pioneered in modern art by Eadweard Muybridge (p. 99). The most important, traditional approach in Western art, though, is the one noticed by the German eighteenth-century aesthetician G. E. Lessing, and known as the "Classical moment."

This requires posing a figure as if in a moment of time between one preceding and one succeeding intelligible movement. And it relies upon our reading the whole movement from our empathetic response to the shape of the figure as shown—its posture and gesture, the implied swing of its clothing, and the setting of its musculature— and usually from its relationship to other such shaped figures. This method, too, persists in early modernism; how else do we read the dance in Matisse's *Dance* (First Version) (p. 131)? But the method breaks down, in modern as well as earlier art, under certain circumstances. Seizing upon or encouraging its breakdown, in different ways, is a principal strategy in modern art for breeding ambiguity, of different types, in figural representations, and thus slowing the viewer down.

There are many different types of modern figural ambiguity, which have yet to be catalogued and their causes described. The following are the causes of merely seven types of such ambiguity, when a figural posture or gesture will fail to describe a legible movement. First, if the shape of the figure suggests that it has not moved recently, and is not about to, as in Jean Delville's *Expectation* (p. 114). Second, if the gesture is so extreme that we cannot imagine any future one, as in Constantin Brancusi's Study for *The First Step* (p. 125). Third, if the gesture is so overdetermined that we can imagine too many future ones, as with Picasso's *Two Nudes* (p. 41). Fourth, if we can believe that the gesture is there just for us to look at, as a design element, as in Matisse's *La Serpentine*

(p. 135), or, fifth, as a piece of theater, as in Paul Signac's *Portrait of M. Félix Fénéon in 1890* (p. 86), and not in order to convey a movement or a meaning. Sixth, if the figural shape continues to baffle us, even with the caption of the title, as with Johannes Itten's *Eavesdropper* (p. 98). And, seventh, if we cannot properly distinguish what looks like a gesture from other parts of the representation that do not seem to be gestures, as with Picasso's *Bathers in a Forest* (p. 138); that is, when we cannot properly distinguish the figural gestures from the figural composition.

The first six of these types of ambiguity require that the shape of the figure be sufficiently distinguishable in its viewing so that it then puzzles; the seventh type puzzles because the shape of the figure is not distinguishable. The first six, therefore, require a sufficiently illustrational art; they flourished in early modern drawing and printmaking more than they did in painting, and persisted in later modern photography far more than they did in the other visual mediums of representation. In the former, traditional allegory persisted, too. In the latter, the illustration of figural poses assumed a psychological significance that became rarer in the other mediums after 1920, at least, outside the "photographic" side of Surrealism. Moreover, whether or not figural poses *are* posed has been a persistent dilemma for viewers of photographs, as the concluding section of People demonstrates.

In painting and sculpture, certainly, whether such a question can be asked at all is one way of dividing more traditional and more experimental artists. Matisse spoke for the experimental side of his generation when he wrote in 1908: "Expression, for me, does not reside in passion bursting from a human face or manifested by violent movement. The entire arrangement of my picture is expressive: the place occupied by the figures, the empty spaces around them, the proportions, all of that has its share."[13] The result was, first, a certain figural anonymity—the blank face would become the characteristic mask of the modern representation—and, second, a predisposition for figural disguise.

Jules Chéret's poster of Loïe Fuller, made in 1893, shows the figure of the dancer both disguised and revealed by her costume, in reality as well as in the representation. Clothes have always had this dual function. Like so-called erotic books, at least in Roland Barthes's account,[14] they *represent* not so much the display as the expectation of it, the revelation of the body in the disguise of the body. "In other words," Barthes says, "these are books of Desire, not of Pleasure." So is Loïe Fuller's representation. And so are more difficult modern representations that disguise figures that are not in reality disguised, like Braque's *Man with a Guitar*, a

painting made eighteen years after the poster by Chéret. It creates the expectation of its undeciphering; as observed earlier, it analogizes the efforts of perception in obscure circumstances. Yet, the point is: if it is deciphered, it will be a disappointment. So it is a painting of Desire, not of Pleasure; of the desire, the expectation, of engaging with a hard-to-comprehend world, not of the doubtful pleasure of actually having to do so. Once again, the point of the narrative is the narrative delay.

This was usefully, if somewhat alarmingly, summarized by Kasimir Malevich in one of the pedagogical charts he created about 1925 to illustrate the theoretical efforts of the Institute of Artistic Culture in Leningrad. The title translates as *The influence of the additional element on the perception of the model* (or, the perception of the model in the painting changes under the influence of the "additional element," the sign or formula that refers to the organization of a particular stylistic type of painting, and that is shown beneath the illustration of the type of painting it refers to). This is an imposing "master-narrative" that describes a narrative delay, a gradual, temporal delay in the way that paintings deliver their meanings: from an academic drawing; to a Bather by Paul Cézanne; to a drawing after a painting by a minor Cubist, Henri Le Fauconnier; to a Picasso painting; to one of Malevich's own lithographs; to a composition by a Russian Cubist, Nadezhda Udal'tsova; to the Picasso *Card Player* (p. 96); to a drawing after another Cubist composition; to a drawing after a work by Theo van Doesburg; and finally to a Suprematist composition by Malevich himself. This narrative moves on regularly, ineluctably, predictably; and the "additional elements" tick like little clocks on time bombs beneath the images, as visible appearances explode and then disappear.

This is, of course, an early, biased, hindsight view on the period 1880 to 1920, albeit one that became very popular later. It took a very selective view of the period to get it to look like that. And yet it does capture the big shift from figural language to figural composition: how the represented (narrative) subject matter was internalized in the form of the execution, by composing the figure by composing the field itself. Effectively, the bodily postures and gestures, which, suspended in action, compose the shapes of the figures (and hence of the pictorial field) in Malevich's earlier examples, are seen to be the sources of the abstracted, linear, and planar scaffolds—"gestures"—that, in his later examples, compose the pictorial field. And, indeed, one of the most important innovations of this period was the internalization of represented, narrative subject matter within the form of the execution, which effectively reallocated the

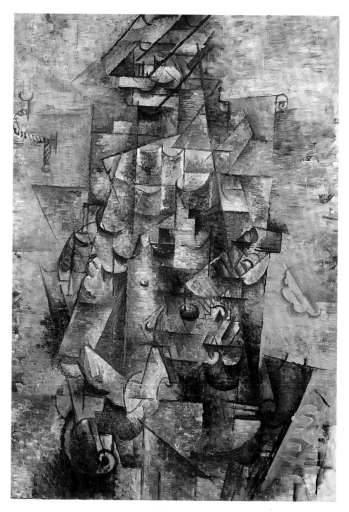

Georges Braque. *Man with a Guitar.* 1911–12. Oil on canvas, 45¾ x 31⅞" (116.2 x 80.9 cm). The Museum of Modern Art, New York. Acquired through the Lillie P. Bliss Bequest

DIE MALERISCHE NATURVERÄNDERUNG UNTER DEM EINFLUSSE DES ERGÄNZUNGSELEMENTS.

Kasimir Malevich. *Analytical Chart*. c. 1925. Cut-and-pasted papers and pencil and ink on paper, 21⅝ x 31" (54.7 x 78.6 cm). The Museum of Modern Art, New York

narrative component of a painting to its representation in the perception of the beholder. The artist thus challenges the beholder to encourage his participation, and elicits ever more from the beholder when he holds us by the intricate power of a narratable content. Only, that is now deep within the enacted form of the image—in the shaping of the lines, the composition, and the color—as within the writing of words.

There is, however, an obvious oddity to Malevich's chart. It describes a forward, temporal movement from the Academy to the new art, but, being a hindsight view, it was actually composed as a *reverse* narrative, from the new art *back* to the Academy. This being so, it could have been a much longer narrative, and have continued—not forward, obviously, but back— to place the new art in a line that continues even to the allegories and "history paintings" of the Renaissance and, beyond that, to the commemorative sculptures and reliefs of Roman, Greek, Assyrian, and Egyptian art. This chart, surprisingly, would probably only have needed to be about twice as large to encompass as many centuries as it now encompasses years.

This has to be a startling thought; it must encourage apocalyptic, divisive interpretations of modern art. Malevich intended such interpretations and leaves them with us as the period of our modern "starts" comes to an end. And he had good reason for his opinions. Yet, we have to ask ourselves: is it just our foreshortened view on our pre-modern past that allows such a possible compression of it, and our proximity to our modern past that stretches it out? Is the "truth" of Malevich's narrative compromised by the figurative works of this period, illustrated in this volume, that will not easily fit it, or are they just exceptions? Did later events support, or deny, the validity of the story that Malevich tells? And is this the only story that can be told from the figurative art of this period? Only this final question has a conclusive answer.

All the stories are written to help order, arrange, and thus explain the sensations. But art is about images, not explanations.

Mary Chan

Starr Figura

The Language
OF THE BODY

Human gesture, posture, and expression may refer to any physical movement or attitude, encompassing an isolated motion of the hand, the bearing of the entire body, or the composure of the face. All have the potential to communicate a social message or individual sentiment, whether voluntary, as in a knowing wink or a proffered handshake, or involuntary, as in a flinch of pain or an inclination of the head in sorrow. In some cases, gesture is performed in conjunction with speech, such as hand gesticulations; in others, it serves as an accessible replacement for speech, as in a posture that signals sexual availability or desire.[1]

In art of the Renaissance tradition, images of single and multiple figures were frequently understood by viewers through the figures' gestures, postures, and facial expressions. The bodies "spoke" through the way they were arranged. Pictures were meant to tell stories, usually to illustrate familiar texts from the Old and New Testaments, the lives of Christian saints, classical mythology and literature, and moral allegories. In subsequent centuries, important historical episodes and personages, themes of romantic poetry, and popular genre representations expanded the roster of appropriate artistic subject matter. Gesture played a critical role in such images to advance the narrative or moral drama of particular stories.

In depicting the human body's gestures and postures, artists took their inspiration from classical sculpture, from life, and

OPPOSITE: Egon Schiele. *Nude with Arm Raised.* 1910. Watercolor and charcoal on paper, 17½ x 12¼" (44.5 x 31.1 cm). The Museum of Modern Art, New York. Gift of Ronald S. Lauder

48

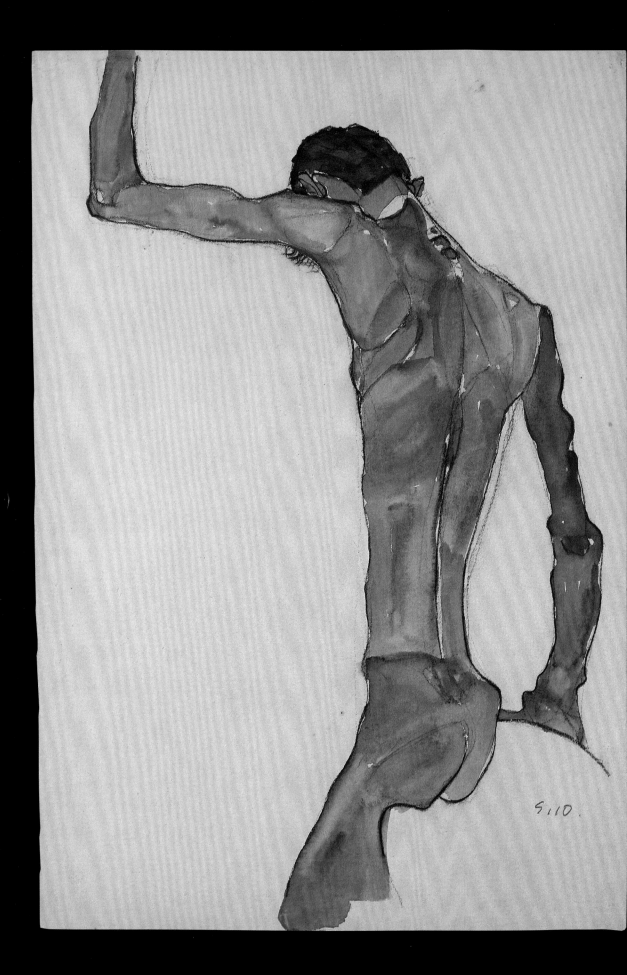

from the exaggerated body movements codified by the traditions of acting and rhetoric. Many gestures came to be recognizable conventions associated with particular emotions, thoughts, moral actions, or personalities. A seated female with her head bent downward, perhaps resting on a hand, represented melancholy; a man known for his intelligence might be portrayed with a hand supporting his chin or touching his temple. Certain poses also came to be associated with specific individuals. For example, a male figure, hand pointing upward, was often John the Baptist; a man and woman using their hands to shield their faces or bodies in shame could be identified as Adam and Eve during the expulsion from the Garden of Eden.

From the seventeenth through the nineteenth centuries, physiognomists advanced the notion that facial expressions could be classified and read as universal signs of character. In 1668 a lexicon of portrayals of the human face was devised by the French court painter and decorator Charles Le Brun. He recognized that in history painting, then the dominant genre, the figures' emotions needed to be clearly read by the viewer for the narrative to be properly understood. Published over the next century, his illustrated treatise equated combinations of facial features with specific states of mind.[2]

Artists working in the late nineteenth and early twentieth centuries assimilated the figurative conventions of their predecessors. However, their primary aesthetic motivation was not to depict the external world or to illustrate well-known texts, but rather to reach beyond known or visible reality to examine the subtle interior states of the human psyche. Two of the many forces that influenced the development of this introspective approach to art, beginning in the late nineteenth century, were the proliferation of photography as a means to apparently faithfully reproduce the external world and Sigmund Freud's theories about the significance of dreams and the unconscious. Photography and the science of psychology were often intertwined, with the camera used as a tool to record and reveal human behavior. Artists could look to the documentary resources of photography or, liberated from the dictum of following objective reality, work more imaginatively and conceptually.

The growing awareness that art could offer a key to the mind led to a radical change in visual expression. In particular, Symbolism, the movement that dominated the literary and artistic scene in Europe during the last two decades of the nineteenth century, and Expressionism, the predominantly German art movement of the first two decades of the twentieth century, were devoted to the evocation of inner feeling through outer form. Detailed or realistic renderings of the human body gave way to more generalized or idiosyncratic interpretations of the figure, many of which involved some exaggeration of form or color in order to heighten the emotional impact of the subject.

Not a specific style, Symbolism was more a set of attitudes toward form and content that emphasized subjectivism and personal imagery. Among the diverse artists who have been associated with it are Paul Gauguin, Vincent van Gogh, and Odilon Redon in France; James Ensor and George Minne in Belgium; and Edvard Munch in Norway. Paul Klee's early etchings from 1903 to 1905 and Pablo Picasso's Blue period works from 1902 to 1904 also reflect a sympathy for Symbolist ideas. In addition, photographers of the late-nineteenth and early-twentieth centuries, including Edward Steichen, applied the ideas of the Symbolist movement to their work. Indebted to the psychological and spiritual orientation of the Symbolist movement that preceded it, Expressionism involved greater, sometimes even crude, distortions of form and color in the service of direct and extreme emotion. Erich Heckel, Oskar Kokoschka, Wilhelm Lehmbruck, and Egon Schiele, among others, have been aligned with the movement.

While many of the gestures, postures, and expressions found in modern art are clearly indebted to artistic conventions of the past, they cannot be readily identified with particular narratives. Indeed, early modern artists deliberately cultivated a sense of vagueness, generality, or ambiguity, for these qualities enhanced the spiritual, mystical, and universal aspects of their art. Whereas images from earlier periods usually contain telling details in the form of backgrounds, costumes, and other paraphernalia, modern pictures are often remarkably limited in their use of props, concentrating instead on individual figures as distillations or evocations of essential moods or emotions. In a period that is probably most prominently associated with the development of abstraction, it is telling that the body remained a central and abiding motif. The humanistic impulse continued to guide artists into the twentieth century, but their representations of gesture and emotion elicit open-ended, even elusive, readings that often intensify the viewer's desire to further examine and reflect upon the human condition.

A STUDY BY MINNE FOR THE SCULPTURE *KNEELING YOUTH* AND AN etching by Munch, *At Night (Puberty)*, use gesture and pose to convey physical and psychological tension and inwardness. Both present a solitary figure whose posture is closed and self-protective. Minne's pencil drawing of a youth—head tilted in reverie and arms wrapped tightly around one another and hugging a reliquary close to his chest—is a sensitive evocation of spiritual withdrawal. Munch, whose art was largely concerned with his feelings about women, portrays an adolescent girl. Her anxiety about her future in a woman's body is conveyed through a wide-eyed stare, suggestive of immobility; tightly closed legs; and crossed arms, used to shield herself from the unknown. In both images, the figures have been stylistically elongated, creating a narrowness that reinforces the sense of self-enclosure established by their poses. Their nakedness also underscores the sexual vulnerability and self-consciousness of their gestures. Isolation and introversion, feelings generally associated with adolescence, were frequent subjects of the Symbolists as they searched for ways to withdraw from the material world and penetrate the spiritual.

LEFT: Edvard Munch. *At Night (Puberty)*. 1902. Etching, plate: 7¹³⁄₁₆ x 6⁵⁄₁₆" (19.8 x 16 cm). Edition: approx. 50. The Museum of Modern Art, New York. Gift of Mrs. Melville Wakeman Hall

ABOVE: George Minne. Study for the sculpture *Kneeling Youth*. 1896. Pencil on paper, 13⅜ x 7½" (34 x 19.1 cm). The Museum of Modern Art, New York. Gift in honor of Myron Orlofsky

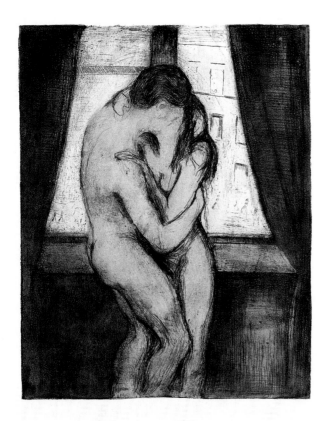

Edvard Munch. *The Kiss.* 1895. Etching and drypoint, plate: 13½ x 11" (34.3 x 28 cm). Edition: approx. 50. The Museum of Modern Art, New York. The William B. Jaffe and Evelyn A. J. Hall Collection

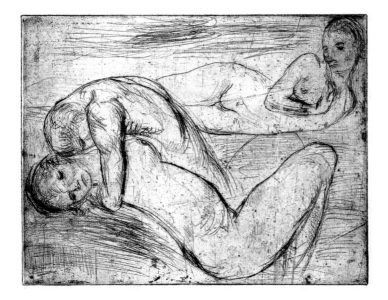

Wilhelm Lehmbruck. *Apparition.* 1914. Drypoint, plate: 7 x 9⅝₆" (17.8 x 23.7 cm). The Museum of Modern Art, New York. Gift of Samuel A. Berger

MUNCH'S *THE KISS* AND LEHMBRUCK'S *APPARITION* INCLUDE POSES representing consummated passion. The works reflect the modern impetus to explore the more primal and subconscious aspects of human behavior and the concurrent awareness of the psychological and emotional power of sex. In both images, bent elbows and knees create serpentine silhouettes in which two human figures seem to merge into one complete and uninterrupted form.

The reclining nude—whose sinuous curves and open limbs imply sexual invitation or offer the viewer visual pleasure—has been a favorite subject of artists since the Renaissance, when such masters as Giorgione, Titian, and Veronese delighted in rendering the soft, rounded flesh of their models. The three works reproduced at right demonstrate the ways in which modern artists have both extended and subverted this tradition. In *Virgin in the Tree*, Klee's academic training in human anatomy gives rise to a grotesque, satirical figure rooted partly in life and partly in the imagination. His eccentric and repulsive image parodies the aesthetic tastes and middle-class social mores of the period. In 1905 Klee observed: "The subject in itself is certainly dead. What counts are the impressions before the subject. The growing vogue of erotic subjects is . . . a preference for subjects which are especially likely to provoke impressions. . . . The school of the old masters has certainly seen its day."[3] Heckel's woodcut of Fränzi, a twelve-year-old he favored as a model, also represents a departure from the rounded, voluptuous forms typical of the sensual, reclining pose. Heckel's flat, angular treatment of her body was derived in part from his interest in primitive sculpture. Ernest J. Bellocq's photograph, one of about a hundred portraits of New Orleans prostitutes that he created around 1912, suggests that he had a friendly, straightforward relationship with this woman on the fringes of society. As in Édouard Manet's *Olympia* of 1863, Bellocq's frank, unsentimental eroticism repudiates the kind of idealized homages to classical goddesses that originally defined the tradition of the reclining nude.

Ernest J. Bellocq. Untitled. c. 1912. Gelatin silver
printing-out-paper print by Lee Friedlander,
1966–69, 7⅞ x 9⅞" (20 x 25.1 cm). The Museum
of Modern Art, New York. Gift of Lee Friedlander

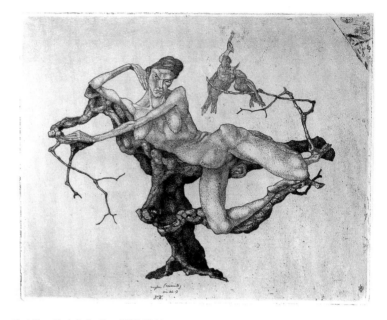

Paul Klee. *Virgin in the Tree.* 1903. Etching,
plate: 9⁵⁄₁₆ x 11¹¹⁄₁₆" (23.7 x 29.7 cm). Edition:
30. The Museum of Modern Art, New York.
Abby Aldrich Rockefeller Fund

Erich Heckel. *Fränzi Reclining.* 1910. Woodcut,
comp.: 8¹⁵⁄₁₆ x 16⁹⁄₁₆" (22.7 x 42.1 cm).
The Museum of Modern Art, New York. Gift of
Mr. and Mrs. Otto Gerson

THE PRINTS AND PHOTOGRAPH SHOWN HERE EMANATE FROM A LONG tradition of female figures personifying melancholy, in which a bent or downward-moving posture indicates grief or anguish. Van Gogh's *Sorrow* is a portrait of a woman named Sien, a pregnant prostitute who lived with the painter after she was abandoned by the father of her child. Although Sien's plight moved van Gogh deeply, he intended this work to transcend the personal and be instead an expression of universal human suffering. In Gauguin's *Watched by the Spirit of the Dead (Manao Tupapau)*, from a series of woodcuts based on his experiences in Tahiti, the subject's self-protective fetal position symbolizes the life cycle that is implicit in the title; it suggests mournfulness and retreat in the face of death. In Steichen's *In Memoriam, New York*, the misty atmosphere that envelops the nude reinforces the sense of longing and despair conveyed by the pose. The figure's nakedness in each of these three works helps to communicate the primal nature of the emotion she exemplifies. The fact that the face is not visible in any of the images heightens the feeling of the subject's withdrawal, and—in that the figure cannot be recognized as an individual—it furthers the universal implications these artists were seeking.

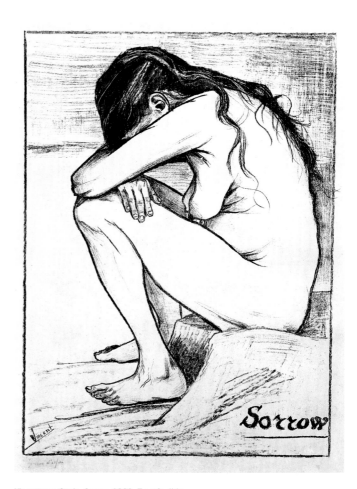

Vincent van Gogh. *Sorrow*. 1882. Transfer lithograph, comp.: 15⅜ x 11¹³⁄₁₆" (39.1 x 30 cm). Edition: approx. 3. The Museum of Modern Art, New York. Abby Aldrich Rockefeller Fund

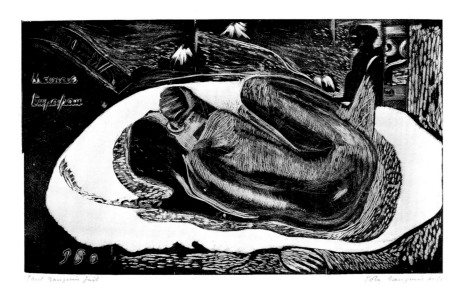

Paul Gauguin. *Watched by the Spirit of the Dead (Manao Tupapau)* from the series *Noa Noa*. 1893–94, published 1921. Woodcut, comp.: 8¹⁄₁₆ x 14" (20.5 x 35.6 cm). Publisher: Pola Gauguin, Copenhagen. Edition: 100. The Museum of Modern Art, New York. Lillie P. Bliss Collection

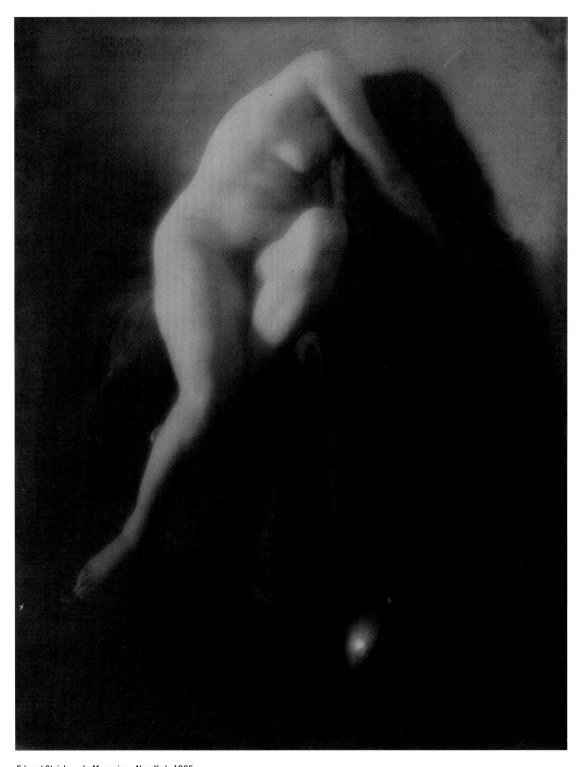

Edward Steichen. *In Memoriam, New York.* 1905.
Gelatin silver print, 19⅜ x 14½" (49.2 x 36.8 cm).
The Museum of Modern Art, New York. Gift of the
photographer

Frederick H. Evans. *Portrait of Aubrey Beardsley.*
c. 1894. Platinum print, 5⅜ x 3⅞" (13.7 x
9.8 cm). The Museum of Modern Art, New York.
Purchase

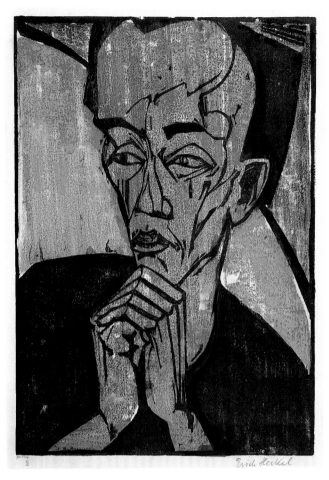

Erich Heckel. *Portrait of a Man.* 1919. Woodcut,
comp.: 18³⁄₁₆ x 12¾" (46.2 x 32.4 cm).
Publisher: J. B. Neumann, Berlin. The Museum of
Modern Art, New York. Abby Aldrich Rockefeller Fund

ARTISTS HAVE LONG RECOGNIZED THAT THE HANDS HAVE ALMOST AS MUCH expressive potential as the face. In the portraits above by Frederick H. Evans and Heckel, artists of widely different backgrounds and styles, the subjects' hands reinforce their contemplative, introspective facial expressions. Evans, who is best known for his architectural photography, commemorated his friendship with artist Aubrey Beardsley in this portrait. Beardsley holds his head in his long-fingered hands in a gesture that suggests both resignation and expectation, much as the Heckel portrait does. Evans stated that he believed a portrait should be "an evocation, true to the spiritual and mental as well as the physical."[4] Heckel's gaunt self-portrait, made when Germany was experiencing severe political unrest after the end of World War I, manifests a physical and spiritual weariness that was national as well as personal.

In the double portraits at right by Kokoschka and August Sander, the sitters do not look directly at each other, but their hand gestures indicate an intimate psychological communion. In Kokoschka's painting of the art historian Hans Tietze and his wife, Erica Tietze-Conrat, the subjects' nervous, sensitive hands are at least as significant as their faces. An electric tension is generated between their fingers, which approach closely without quite touching. Coming from a realist tradition, Sander, who attempted in his epic series of photographs *People of the Twentieth Century* to make a comprehensive portrait of the German people, approached art more pragmatically. With the belief that physiognomy held the key to understanding human nature, he strove to represent physical and social "types"—in this case, the painters Gottfried Brockmann and Willi Bongard—while also revealing the individual spirits comprising these types. For Sander, a subject's facial characteristics, posture, and gestures all served as windows to the soul.

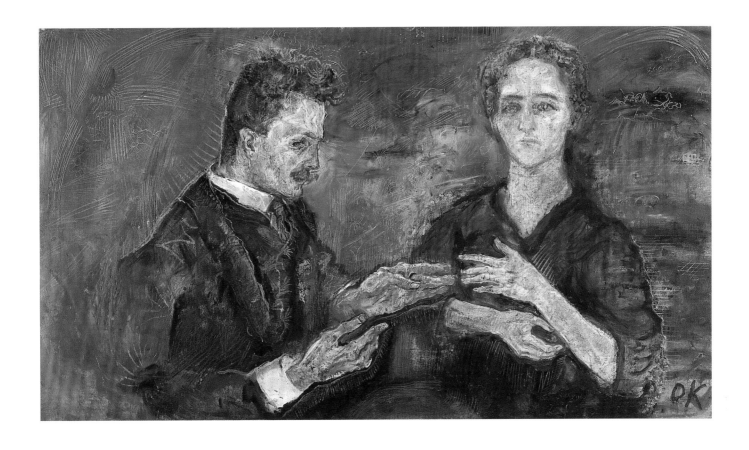

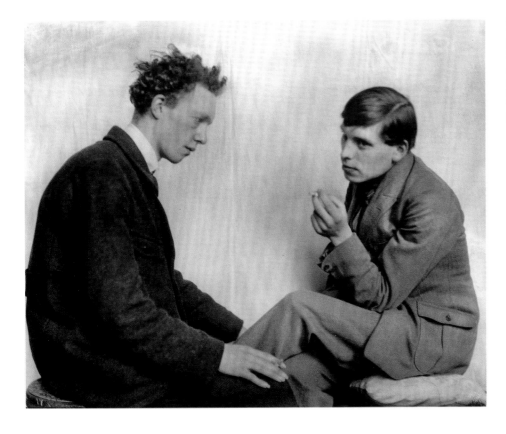

ABOVE: Oskar Kokoschka. *Hans Tietze and Erica Tietze-Conrat.* 1909. Oil on canvas, 30⅛ x 53⅝" (76.5 x 136.2 cm). The Museum of Modern Art, New York. Abby Aldrich Rockefeller Fund

LEFT: August Sander. *Bohemians (The Painters Gottfried Brockmann and Willi Bongard).* 1928. Gelatin silver print, 9⅛ x 11¼" (23.2 x 28.6 cm). The Museum of Modern Art, New York. Gift of the photographer

Paul Klee. *Comedian.* 1904. Etching and
aquatint, plate: 6 x 6⅝" (15.3 x 16.8 cm).
Edition: 50. The Museum of Modern Art, New York.
Abby Aldrich Rockefeller Fund

THE THEATRICAL DEVICE OF THE MASK, BY HIDING THE FACE, CONCEALS OR transforms one's true identity. Klee, in the etching *Comedian*, drew a parallel between the lifting of a mask and the act of self-revelation. The mask seems partially attached to the head of the grim actor underneath. Its smiling face has been interpreted as a representation of Klee's father, and therefore as a symbol of the artist's inability to free himself from the trappings of the bourgeois society in which he had been raised.[5] The caricaturelike features demonstrate Klee's penchant for subverting the classical ideal through satire and thereby probing the human condition.

Klee was influenced by Ensor, in whose work the mask was an integral subject. In Ostend, Belgium, Ensor lived above his mother's souvenir shop, with its inventory of elaborate masks sold for the town's boisterous carnival before Lent. For him, the carnival atmosphere represented social disarray and debasement. Following the death of his father in 1887, Ensor frequently used the skeleton in his artworks, as in the painting *Masks Confronting Death*, in which the central figure, donned in a skull, is surrounded by a crowd of hideously smiling, masked characters. Bathed in strong white light, the eerily bright colors enhance the sense of otherworldliness, and the masks themselves seem to unveil the grotesqueness of the people who wear them.

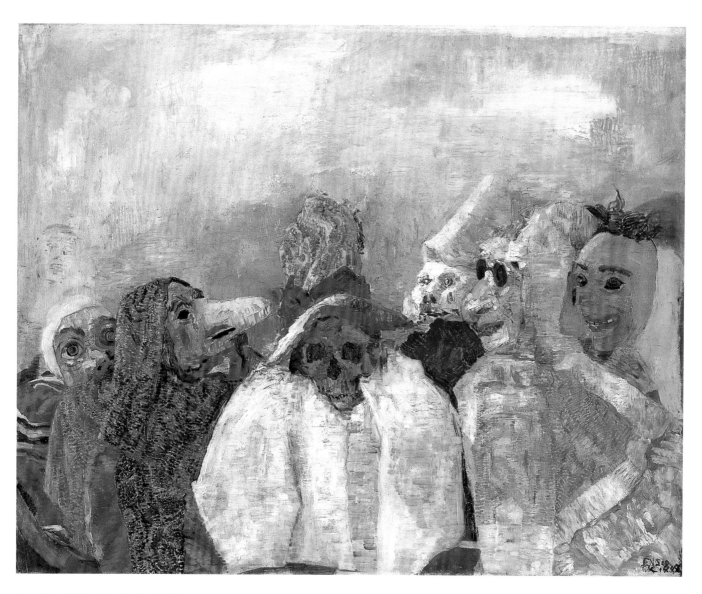

James Ensor. *Masks Confronting Death.* 1888. Oil
on canvas, 32 x 39½" (81.3 x 100.3 cm). The
Museum of Modern Art, New York. Mrs. Simon
Guggenheim Fund

Odilon Redon. *Egg*. 1885. Lithograph, comp.:
11⁹⁄₁₆ x 8⅞" (29.4 x 22.5 cm). The Museum of
Modern Art, New York. Gift of Peter H. Deitsch

Odilon Redon. *The misshapen polyp floated on the
shores, a sort of smiling and hideous cyclops,*
plate 3 from the portfolio *Les Origines*. 1883.
Lithograph, comp.: 8⅜ x 7¹³⁄₁₆" (21.3 x 19.8 cm).
Edition: 25. The Museum of Modern Art, New
York. Gift of Victor S. Riesenfeld

THE ROUND-EYED EGG SITTING IN ITS CUP AND THE GRINNING CYCLOPS
with bulging eye are but two of the numerous fantastic creatures
that populate Redon's lithographs and drawings. Redon
claimed that the beings he created were not far removed from
what could be observed in the natural world. He faithfully and
meticulously recorded his visions "by putting . . . the logic of
the visible at the service of the invisible."[6] Similarly, Klee's dis-
embodied, fierce-looking *Menacing Head*, crowned with an
antlered rodent, springs from a highly personal imaginary
realm. The exploration of the grotesque as well as the exagger-
ation of facial expression for its own sake make obsolete any
correlation between physical appearance and character.

Guillaume-Benjamin-Amand Duchenne de Boulogne, the
physician who invented electrotherapy, photographed the appli-
cation of electric shocks to patients' faces in an effort to find
physiological sources for emotional expressions. He wrote, "How
easy to determine the motion of the facial muscles! . . . We can paint
the expressive traits of the soul's motions on the human face, as
Nature herself does. What a source of new observations!"[7] Though
Duchenne de Boulogne's manipulations may have imitated au-
thentic emotions, today we do not see their results as revelations
of inner nature. Similarly, Marc Chagall's playful action of "making
a face" for pictorial effect in his self-portrait disallows a clear in-
terpretation of his personality. By contrast, Émile-Antoine
Bourdelle's *Beethoven, Tragic Mask*, the most emotive work from
his series of portrait busts of the composer, uses a distorted gri-
mace to convey his subject's brooding temperament and the
tragedy of his deafness. Bourdelle found correlations between the
grandiose music of the composer and the dramatic intensity in-
forming his own sculpture.

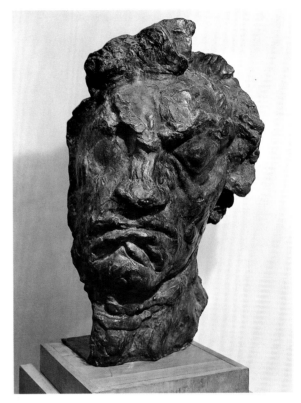

Marc Chagall. *Self-Portrait with Grimace.*
c. 1924–25. Etching and aquatint, plate: 14¹¹⁄₁₆ x
10¾" (37.3 x 27.3 cm). Edition: 100. The Museum
of Modern Art, New York. Gift of the artist

Guillaume-Benjamin-Amand Duchenne de Boulogne.
Fright from *Mécanisme de la physionomie humaine.*
1862. Albumen silver print from wet-collodion glass
negative, 4¾ x 3¹¹⁄₁₆" (12.1 x 9.4 cm). The Museum
of Modern Art, New York. Gift of Paul F. Walter

Émile-Antoine Bourdelle. *Beethoven, Tragic Mask.*
1901. Bronze, 30½ x 17 x 17¾" (77.5 x 43.2 x
45.1 cm). The Museum of Modern Art, New York.
Grace Rainey Rogers Fund

Paul Klee. *Menacing Head.* 1905. Etching, plate:
7¹¹⁄₁₆ x 5¾" (19.5 x 14.6 cm). Edition: 10. The
Museum of Modern Art, New York. Abby Aldrich
Rockefeller Fund

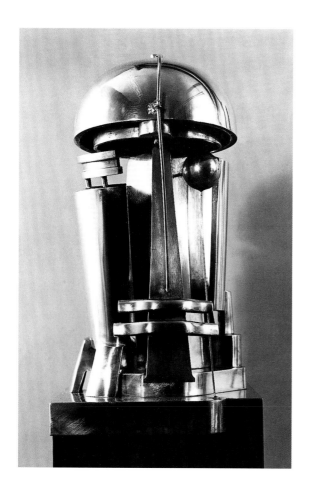

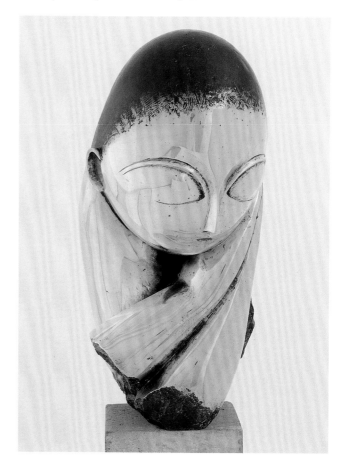

ARTISTS WHO PURSUED PURELY STYLISTIC INNOVATIONS, SUCH AS deconstructing and abstracting forms, often used the human figure as a point of departure. Cast in the same material, bronze, a sculpture by Rudolf Belling and one by Constantin Brancusi employ opposing languages—geometric and organic, respectively. Combining interlocking planes and the industrial, glossy finish of a machine, Belling's *Sculpture* resembles a futuristic robot. Brancusi's *Mlle Pogany*, a true portrait since it is based on several studies of the sitter and a marble sculpture carved from memory, is all curves, from the dominant pointed-oval eyes, arched brows, elongated neck, and upswept hair to the folded hands resting against the cheek. The highly polished areas contrast with the black patina of the hair, the latter an effort to simulate the sitter's likeness.

Incorporating the overlapping rectangular shapes of Cubist painting as well as collage elements, Picasso's *Student with Pipe* is a humorous approximation of a recognizable type, down to the pasted paper facsimile of the beret then worn by Parisian students.

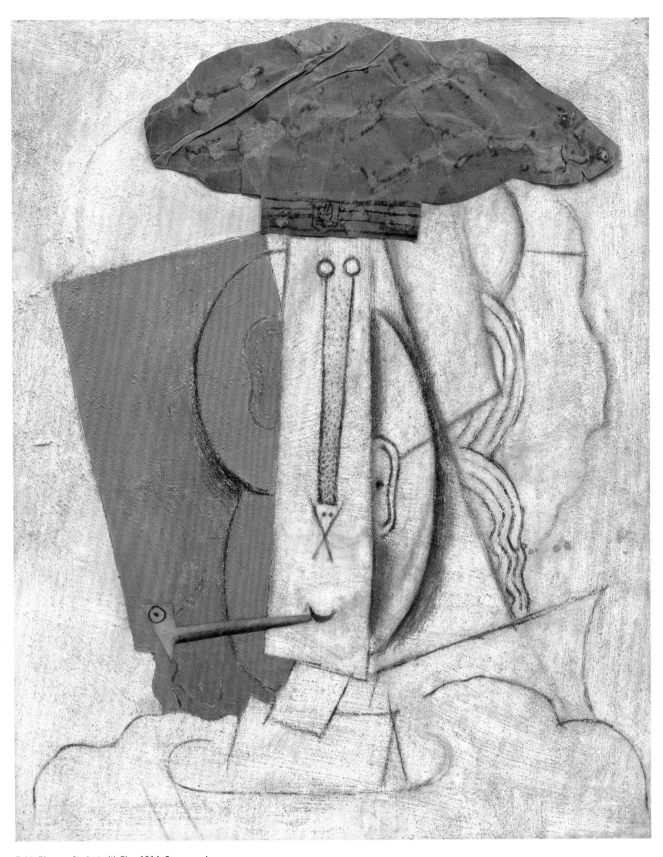

Pablo Picasso. *Student with Pipe.* 1914. Gesso, sand,
pasted paper, oil, and charcoal on canvas, 28¾ x
23⅛" (73 x 58.7 cm). The Museum of Modern Art,
New York. Nelson A. Rockefeller Bequest

Theo van Rysselberghe. *Self-Portrait.* 1888–89.
Pastel on paper, 13⅜ x 10⅛" (34 x 25.7 cm). The
Museum of Modern Art, New York. Gift of Mr. and
Mrs. Hugo Perls

Edvard Munch. *Self-Portrait.* 1895, signed 1896.
Lithograph, comp.: 18⅛ x 12¾" (46 x 32.4 cm).
Edition: approx. 200. The Museum of Modern Art,
New York. Gift of James L. Goodwin in memory of
Philip L. Goodwin

THE GAZE OF THE SUBJECT OF AN ARTWORK CAN CARRY POWERFUL
resonance. "Eye contact" encourages the feeling of a connec-
tion between the domain of the pictorial and that of the viewer.
A subject's averted eyes can suggest either avoidance or rev-
erie, which may tempt the viewer to invent a narrative.
Traditionally, artists' self-portraits have relied upon assertive
body language to project the desired image, yet in these depic-
tions of the self by Theo van Rysselberghe and Munch, the eyes
alone emphasize their strong, individual presences. The emer-
gence of the heads from darkness augments the aura of
seriousness and mystery. Van Rysselberghe's face appears in
the drawing's lower right-hand quadrant and is balanced by

the open window at upper left, while Munch's is positioned
centrally on the page. Munch's inclusion of a skeletal arm at
the bottom of his lithograph provides a clue to his intense anx-
iety over the prospect of death.

In *The Frugal Repast*, Picasso incorporated the unseeing and
seeing gaze in his depiction of an impoverished couple. The
man turns his head, which accentuates the dark socket of his
eye and implies sightlessness. The placement of his elongated
fingers touching the woman's arm and shoulder connotes a
closeness between the two that distances the viewer (a distance
accentuated by the table in the foreground), in spite of the in-
vitation presented by her calmly appraising stare.

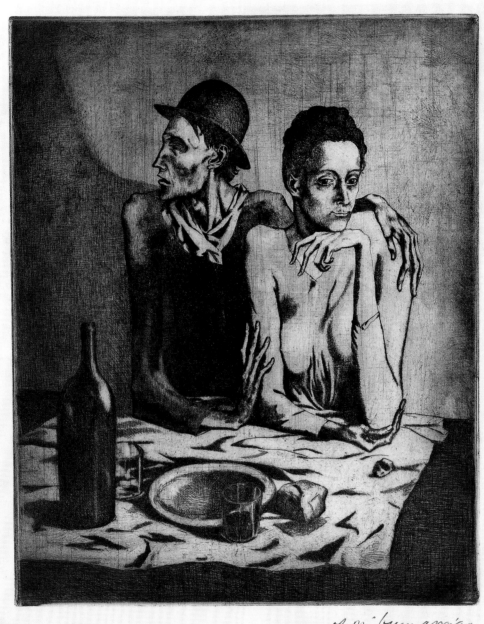

Pablo Picasso. *The Frugal Repast.* 1904. Etching, plate: 18³⁄₁₆ x 14⁷⁄₈" (46.2 x 37.8 cm). Publisher: Ambroise Vollard, Paris. Edition: proof before edition of 250.
The Museum of Modern Art, New York. Gift of Thomas T. Solley with Mary Ellen Meehan, and purchase through the Vincent d'Aquila and Harry Soviak Bequest,
and with contributions from Lily Auchincloss, The Associates Fund, The Philip and Lynn Straus Foundation Fund, and John S. Newberry (by exchange)

Beatrice Kernan

EXPRESSION *and the series*
Rodin and Matisse

Approximately twenty years separate two remarkable series of sculpted heads in the Museum's collection: the 1891–97 Auguste Rodin studies for the *Monument to Balzac* (commemorating the renowned novelist) and the 1910–16 Henri Matisse heads of Jeannette (sculptures that take as their subject a young neighbor of the artist). The two groups, each containing five works, differ significantly in the nature of their ambition. The Rodins are among numerous studies anticipatory to a final, public monument; the Matisses are the only representatives of an essentially private, contained undertaking, one with its own aesthetically self-willed progression and uncharted destination. Both sets of heads, nevertheless, share fascinating affinities and show the series as a powerful agent in the discovery of modern expression.

The Honoré de Balzac Commission and Rodin's Studies for Balzac's Head

In 1891 Rodin received a commission from a prominent Parisian literary society—the Société des Gens de Lettres—to design a public monument to Honoré de Balzac. The project had been under consideration, but unrealized, since the death of the controversial and influential writer in 1850. The forty-year deferral of the commission, and its assignment to Rodin, brought into artistic affiliation two towering and kindred talents of nineteenth-century France: Rodin, an unrivaled sculptor and master of the three-dimensional epic, and Balzac, the legendary author of the ninety-part literary tour-de-force *La Comédie Humaine.* The commission, which clearly challenged Rodin, inspired his most radical and daring sculptural achievement. The final work, the colossal *Monument to Balzac* (1898), embodies not only the creative genius of the author, but the majesty, force, and endurance of the artistic enterprise itself (p. 66).

Rodin devoted seven years and over one hundred known studies to the realization of the project.[1] When the final, plaster version was presented at the Salon of 1898, it was met by public vilification. The commissioners rejected the work as a crude sketch, failing to see in its deliberate lack of finish and its abstract primitive simplicity the sources of its power. Stung by the controversy, Rodin removed the work to his studio. "This work that has been laughed at," he said, "is the logical outcome of my entire life, the very pivot of my aesthetic."[2] The monument was not cast in bronze until 1931, nor erected in Paris until 1939.

The five studies for Balzac's head in the Museum's collection belong to an exhaustive inventory of works—both figure and head studies—that Rodin made before reaching his final conception. The evolution of the overall project shows, broadly, a progression from naturalism to subjective and synthetic interpretation. Rodin embarked on the commission with a formidable campaign of painstaking research, his own naturalist tendencies magnified by his admiration for Balzac as a founder of literary realism. In an effort to gain an understanding of Balzac's intellect and physical appearance, he immersed himself in Balzac's oeuvre and in writings on Balzac, consulted all surviving portrait images (p. 69), and traveled to Balzac's native Tours to study the traits and physiognomies of its inhabitants. He even secured the author's measurements from his long-retired tailor. In 1891, fully seven years before the project's completion, Rodin optimistically reported: "I am making as many models as possible for the construction of the head, with types in the country, and with the abundant information I have secured, and am still procuring, I have a good hope of the Balzac."[3]

Rodin's *Bust of the Young Balzac* (p. 68) and *Mask of Balzac Smiling* (p. 68) date from this early period of naturalist concern for the accuracy of physical detail.[4] Like many other early studies, they are believed to rely not only on surviving contemporaneous likenesses of Balzac, but also on the living, full-bodied models Rodin chose for their resemblance to these images. *Bust of the Young Balzac* appears to have as its source an unusually flattering, idealized image of the writer, still well-toned and handsome in his youth. A smoothly modeled, taut visage—with symmetrical, prominent cheekbones and even eyes held in a fixed gaze—is crowned and countered by carved rivulets of upswept hair. Even as Rodin searches for a resemblance to his deceased subject, a realist sympathy for his sitter emerges; the portrait's erect carriage and head-on stare suggest the self-consciousness of the nonprofessional model under the scrutiny of the Paris master.[5] *Mask of Balzac Smiling* reveals a detailed tactile charting of the round topography of the face of a local model, chosen too for his resemblance to an image of the author.

OPPOSITE: Auguste Rodin. *Monument to Balzac.* 1898. Bronze (cast 1954), 9'3" x 48¼" x 41" (282 x 122.5 x 104.2 cm). The Museum of Modern Art, New York. Presented in memory of Curt Valentin by his friends

ABOVE: Henri Matisse. *Jeannette (V).* 1916. Bronze, 22⅞ x 8⅜ x 10⅝" (58.1 x 21.3 x 27.1 cm). The Museum of Modern Art, New York. Acquired through the Lillie P. Bliss Bequest

Still faithful to accurate depiction, *Head* (c. 1893) signals a shift to a more symbolist and subjective conception. Rodin allows the modeling to become freer and more animated: the defined features of the preceding studies are softened and submerged in a modulated, continuous whole. The deliberate sense of unfinish—the emergence of features, cranium, and spirit from inchoate mass—focuses attention on the process of making, investing the work with poetic allusions to the mysterious procedures of the creative imagination. The subsequent *Bust* (c. 1894) portrays a more mature, robust Balzac. The volumes and features are now enlarged, the neck is thickened, and the somber mood intensified. If there is greater gravity in the increased sculptural mass, there is also a new plastic dynamism: swells of clay move light across the face to communicate the restive vitality of Balzac's intellect.

Throughout the project's evolution, Rodin revised and reconsidered the posture and public image he would assign his subject—the pose and the comportment of the figure that would carry the noble head. Figure studies, made in direct and syncopated correspondence to the head studies, show Balzac first in conventional dress then, alternately, in the Dominican habit that was his working attire or nude. *Naked Balzac with Folded Arms* (1892), dating between the Museum's second and third head studies, converts the

LEFT TO RIGHT: Auguste Rodin.
Bust of the Young Balzac. 1891. Bronze (cast c. 1971), 17¼ x 15¼ x 9¼" (43.8 x 38.7 x 23.6 cm). The Museum of Modern Art, New York. Gift of The Cantor, Fitzgerald Collection
Mask of Balzac Smiling. 1891. Bronze (cast 1970), 8¼ x 6⅜ x 5½" (21 x 16.2 x 14 cm). The Museum of Modern Art, New York. Gift of The Cantor, Fitzgerald Collection
Head. c. 1893. Bronze (cast 1971), 6⅞ x 5⅞ x 6⅜" (17.5 x 15 x 16.2 cm). The Museum of Modern Art, New York. Gift of The Cantor, Fitzgerald Collection

subject's challenging corpulence into an imposing strength (p. 70). *Headless Naked Figure Study for Balzac* (1896), made between the Museum's fourth and fifth head studies, depicts with idealized musculature, the young athletic Balzac, his virility candidly indicated by an autoerotic gesture (p. 70). The gesture—a reference linking creative and sexual potency—was ultimately subsumed in the final monument's emphatic axial thrust. There, the legendary robe that cloaks the figure seized in inspiration becomes a nearly abstract form, both colossal and volcanic.

Only the final study—the large, square *Head* (1897)[6]—prepares us for the savagely expressionistic monumental head that caps the summit of the final monument. Rodin returned to the French poet Alphonse de Lamartine's early, vivid description of Balzac's face: "The face of an element: big head, hair disheveled over his collar and cheeks, like a wave which the scissors never clipped."[7] Coarsely cut shocks of unkempt hair indicate the tidal pulls of artistic struggle, deeply hollowed eyes, penetrating depth of insight. A new raw emotionalism begins to be felt, which will find its explosive release in the final monumental head.

The over fifty extant studies of Rodin's head of Balzac form their own remarkable society of types and moods and forms. Together they comprise a compelling serial portrait.[8] The final monumental head can be seen as a summation and an intensification of the

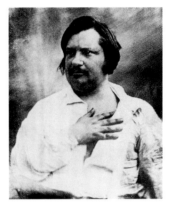

Louis-Auguste Bisson. *Balzac.* 1842. Daguerreotype

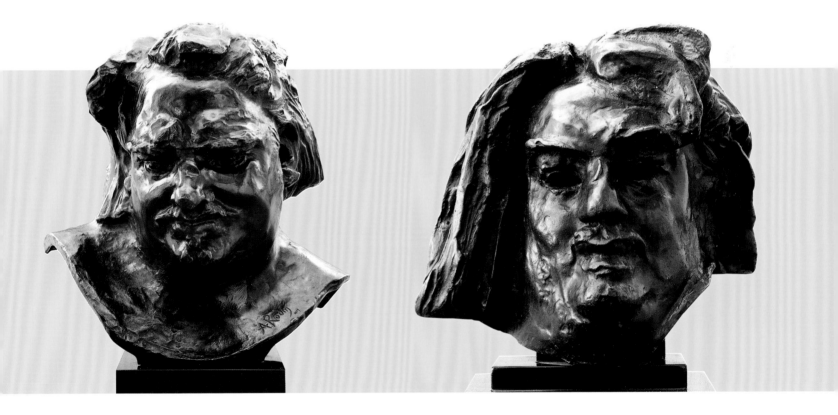

LEFT TO RIGHT: **Auguste Rodin.**
Bust. c. 1894. Bronze (cast 1971), 12⅛ x 12⅛ x 10⅛" (30.8 x 30.8 x 25.8 cm). The Museum of Modern Art, New York. Gift of The Cantor, Fitzgerald Collection
Head. 1897. Bronze, 7½ x 7½ x 6¼" (19 x 19 x 15.9 cm). The Museum of Modern Art, New York. Gift of The Cantor, Fitzgerald Collection

works that went before it. If the serial propulsion of the figure treatment ultimately moved toward concentration and revolutionary abstraction, the progression of the heads moved toward amplification and unprecedented expressionistic freedom. Together they formed a totality that ushered in a modern epoch in sculpture.

Matisse's Heads of Jeannette

Matisse, the greatest colorist of the twentieth century, avowed that he reserved his main and overarching ambitions for painting, to which his sculpture played only a secondary role. Certainly, his vast painting oeuvre overwhelms, in sheer number, the eighty-four works that constitute his entire sculptural production. Matisse stated that his sculpture served an essentially private function, forming a complement to his painting: "[I] worked in clay as a respite from painting when I had done absolutely all that I could for the moment. Which is to say that it was always for the purpose of organization. It was done to give order to my sensations."[9] Nevertheless, Matisse is responsible for some of the century's most radical and innovative sculptural achievements, foremost among which must be counted his famous series of Jeannette heads.[10]

If Matisse praised Paul Cézanne as the father or "god of painting," his relationship to Rodin was both less intense and more ambivalent or oedipal. Commentaries that have come down to us show Matisse still rankling late in life over a disappointing youthful encounter with the great master (Rodin advised the young Matisse to add detail to drawings submitted for review), and passages in Matisse's writings find fault with the uncontained, overly rhetorical, gestural, and additive qualities in Rodin's work.[11] Equally, however, Matisse's writings include citations that list Rodin among a pantheon of true and admired artistic achievers.[12] Certainly Matisse's sculpture registers the profound impact of Rodin's work. In the end, Matisse turned to the tradition that Rodin represented to absorb, challenge, and transcend it.

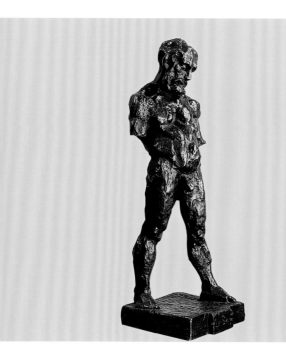

Matisse's first original sculpture is *The Serf* (1900–04). In 1900, the year it was begun, Rodin overshadowed all young artists in Paris, his reputation only enlarged by force of the recent Balzac controversy. In that year, Matisse not only visited Rodin's studio but saw Rodin's work on exhibition. *The Serf*, an armless striding figure, made after a model who was once Rodin's, shows its debt to Rodin in its stance, its abbreviated, fragmented gesture, and its emphatic modeling. It shares with certain of Rodin's single-figure works (including *Headless Naked Figure Study for Balzac*) a concern for an essential, internal dynamic structure and for a free, uninhibited handling of the medium. Matisse seized upon these attributes in Rodin's works, revealing them as latently modern. He asserts them more emphatically and, in his mature sculptures, develops them further as increasingly autonomous expressive means.

Matisse consistently eschewed the additive and rhetorical in Rodin's work, finding them inimical to his understanding of expression. His famous 1908 "Notes of a Painter" criticizes Rodin as a "great sculptor who gives us some admirable pieces, but for [whom] a composition is merely a grouping of fragments, which results in a confusion of expression."[13] At the outset of the same text, Matisse clarifies his goals: "What I am after, above all, is expression. . . . Expression, for me, does not reside in passion bursting from a human face or manifested by violent movement. The entire arrangement of my picture is expressive."[14]

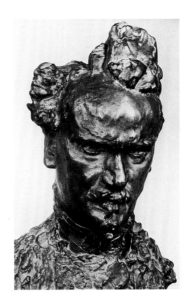

In 1910 Matisse began the extraordinary series of Jeannette heads, works that give astonishing plastic form to his articulated theories. The five heads of Jeannette were created, at uneven intervals, over a six-year period. It has been said that each work in the series is both complete and provisional.[15] Each is an independent work of art; and each is also an integral part of a series that developed organically as one completed work, spawned or inspired a successor, until the sequence reached its unpredestined end.

The earliest works in the series, *Jeannette (I)* and *Jeannette (II)*, are portraits made from the model in early 1910 (p. 72). The sitter, Jeanne Vaderin, was a young woman recovering from an illness and Matisse's neighbor in the Paris suburb of Issy-les-Moulineaux. She is also the subject of the painting *Girl with Tulips* (Hermitage Museum, St. Petersburg) and its charcoal study (p. 72). *Jeannette (I)* shares with the drawing graphically delineated, handsome features—asymmetrical eyes, strongly articulated brows, and an aquiline nose—set within a carved oval face. The relative conservativism and restraint of *Jeannette (I)* may be owing to Matisse's somewhat tentative address to full-scale portraiture in the round, a genre in which he had only once previously worked, ten years earlier. *Jeannette (II)*, modeled from a plaster cast of *Jeannette (I)*, is more animated and broadly conceived. The adaptations simplify and synthesize: the neck is surgically removed to focus attention on the head; the hair is massed, the brow and oval cheeks smoothed, and the arching nose is given new prominence, its sweep reinforced by a rising continuous line that divides to form eyebrows. *Jeannette (I)* and *Jeannette (II)* form a pair and partake somewhat in the dialectic that informs Matisse's paired, or partnered, paintings, where a particularized first version is followed by a more synthetic, second work.

With *Jeannette (III)*, completed the next year, the portrait project is radically reconceived (p. 73). No longer tied to the model, *Jeannette (III)* is—like its successors—a freely invented variation, a bold research into the expressive power of construction, volume, and form. The monolithic head is reformulated as a three-part construction of head, bust, and base—an arrangement reinforced by the division of the hair into three volumetric masses and the tripartite orchestration of the eyes and nose. The separate volumes and forms of the head, which adhere in dynamic syncopation in a frontal view, resolve, in profile, in a strikingly unified polygonal whole. Just at the moment when Matisse departs most radically from tradition, he revisits it. The pneumatic volumes of the hair in *Jeannette (III)* appear to find their source in the expressive

OPPOSITE, TOP LEFT: Auguste Rodin. *Headless Naked Figure Study for Balzac.* 1896. Bronze (cast 1970), 39 x 15¼ x 12½" (99 x 38.6 x 32 cm). The Museum of Modern Art, New York. Gift of The Cantor, Fitzgerald Collection

OPPOSITE, TOP RIGHT: Auguste Rodin. *Naked Balzac with Folded Arms.* 1892. Bronze (cast 1966), 29¾ x 12⅛ x 13⅝" (75.5 x 30.8 x 34.6 cm). The Museum of Modern Art, New York. Gift of the B. G. Cantor Art Foundation

OPPOSITE, BOTTOM: Henri Matisse. *The Serf.* 1900–04. Bronze, 37⅜ x 13⅜ x 13" (92.3 x 34.5 x 33 cm). The Museum of Modern Art, New York. Mr. and Mrs. Sam Salz Fund

ABOVE: Auguste Rodin. *Bust of Henri Rochefort.* 1894–98. Bronze, 29½ x 22¹⁄₁₆ x 13⅜" (75 x 56 x 34 cm). Musée Rodin, Paris

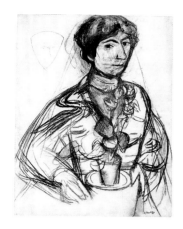

Henri Matisse. *Girl with Tulips (Jeanne Vaderin)*.
1910. Charcoal on paper, 28¼ x 23" (73 x 58.4 cm).
The Museum of Modern Art, New York. Acquired
through the Lillie P. Bliss Bequest

upswept clusters that crown Rodin's *Bust of Henri Rochefort* (1894–98), a plaster version of which Matisse had purchased eleven years before (p. 71).[16]

In *Jeannette (IV)*, made after the plaster cast of its predecessor, the assertive features of *Jeannette (III)* are enlarged and developed to an exaggerated and animated extreme. Seen in profile, the angular clusters of hair and the carved beaklike nose radiate, pinwheel-like, around the carved projecting cheek. The bust and head are narrowed in a frontal view, creating a vertical thrust that is reinforced by the upward gravitation of features. As in *Jeannette (III)*, the rising, burgeoning volumes analogize a flower on the verge of full bloom. The works recall the drawing *Girl with Tulips (Jeanne Vaderin)*, where the metaphorical link between female well-being and fertility and the energy of plant life was, most explicitly, proposed.

Jeannette (V), made as many as five years after *Jeannette (IV)*,[17] is entirely unprecedented in its plastic formal invention. It reveals the liberating influence of Cubism, and of tribal art, not only in its part-to-part organization and its abstraction but also, and more importantly, in the freedom with which Matisse approaches his motif. Taking as his starting point the plaster cast not of *Jeannette (IV)*, as one might expect, but that of the more architectonic

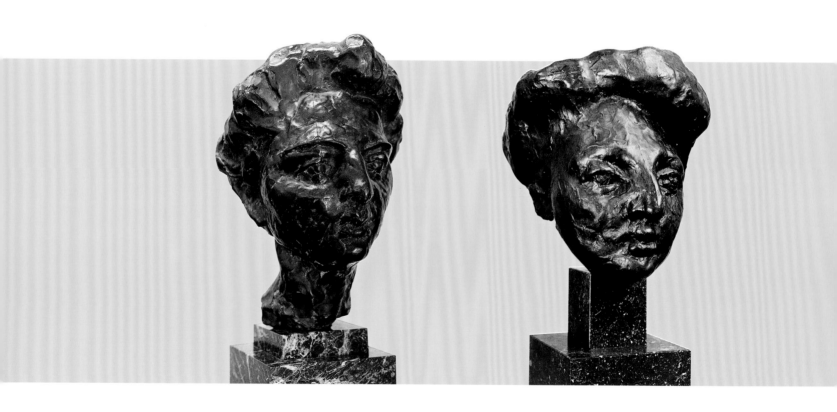

LEFT TO RIGHT: Henri Matisse.
Jeannette (I). 1910. Bronze, 13 x 9 x 10" (33 x 22.8 x 25.5 cm). The Museum of Modern Art, New York. Acquired through the Lillie P. Bliss Bequest
Jeannette (II). 1910. Bronze, 10⅜ x 8¼ x 9⅝" (26.2 x 21 x 24.5 cm). The Museum of Modern Art, New York. Gift of Sidney Janis

Jeannette (III), Matisse excises the hair and flattens the left eye to reassert the head as a single form. He then excavates its core, uncovering its irreducible parts—almost abstract masses and planes, the features in their most elemental form. The plant-woman association of the previous work is here invested with new energy and fecundity.

The Jeannette heads are distinct and autonomous works, just as they are states, or stages, in a progression. The sheer invention of the individual variations—and their coexistence as a group—focuses attention on the process of making and on the process of formation within each work.

The serial progression of these heads is, like that of the Balzac head studies, one of increasing intensification and, like that of the final Balzac monument, is one that reaches its conclusion in radical synthesis and expression. The serial momentum of the Matisses—self-willed and self-reflexive—produced some of the most innovative formal speculations in sculpture of the twentieth century. The final, culminating work, *Jeannette (V)*, is the most formally and psychologically potent in the series; it is a sculpture of unprecedented daring and concentration, less than two feet high yet monumental in its contained, expressive force.

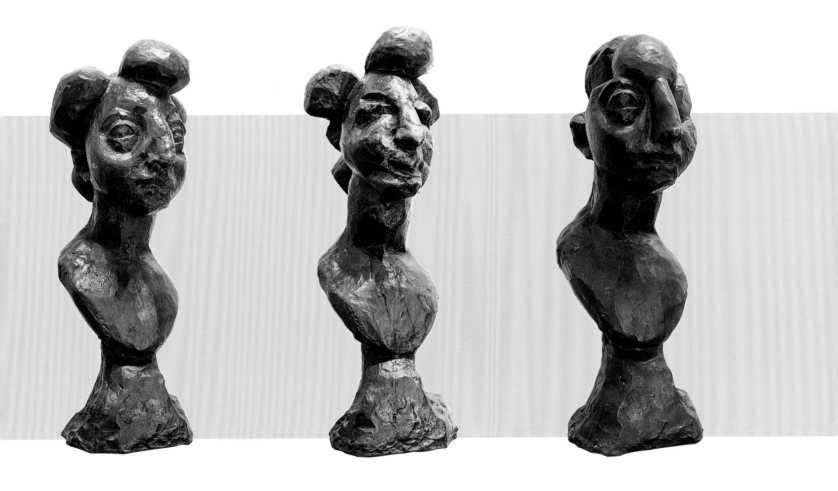

LEFT TO RIGHT: Henri Matisse.
Jeannette (III). 1910–11. Bronze, 23¾ x 10¼ x 11" (60.3 x 26 x 28 cm). The Museum of Modern Art, New York. Acquired through the Lillie P. Bliss Bequest
Jeannette (IV). 1910–11. Bronze, 24⅛ x 10¾ x 11¼" (61.3 x 27.4 x 28.7 cm). The Museum of Modern Art, New York. Acquired through the Lillie P. Bliss Bequest
Jeannette (V). 1916. Bronze, 22⅞ x 8⅜ x 10⅝" (58.1 x 21.3 x 27.1 cm). The Museum of Modern Art, New York. Acquired through the Lillie P. Bliss Bequest

Ensor

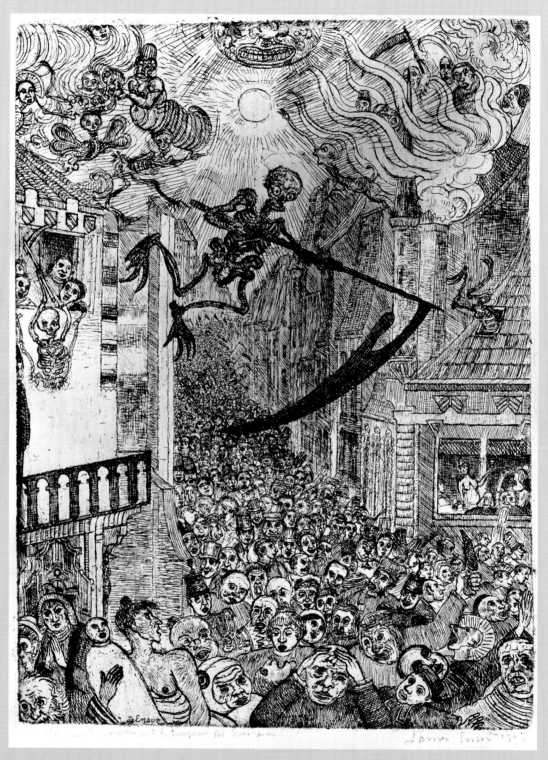

James Ensor. *Death Chasing the Flock of Mortals.* 1896. Etching and drypoint, plate: 9⁷/₁₆ x 7³/₁₆" (23.9 x 18.2 cm). The Museum of Modern Art, New York. Purchase Fund

Posada

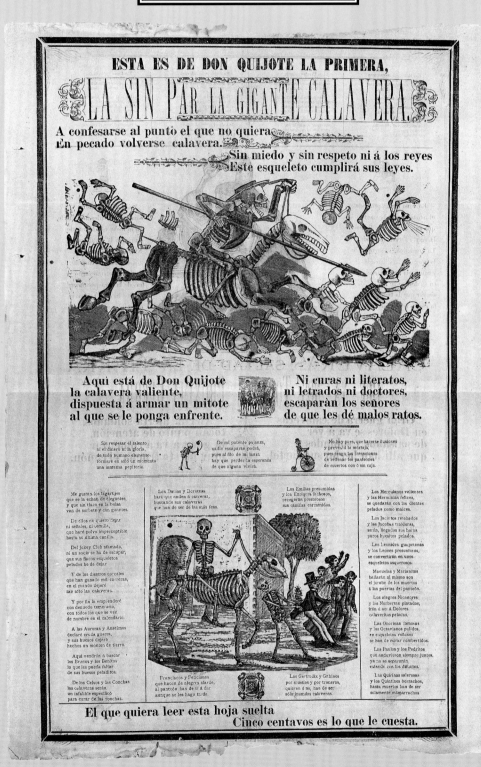

José Guadalupe Posada. *This is about Don Quixote the First, the Unequaled Giant Calavera.* c. 1895. Engraving, relief printed, and letterpress, comp.: 22¹⁄₁₆ x 13⁷⁄₁₆" (56 x 34.1 cm). Publisher: Antonio Vanegas Arroyo, Mexico City. The Museum of Modern Art, New York. Inter-American Fund

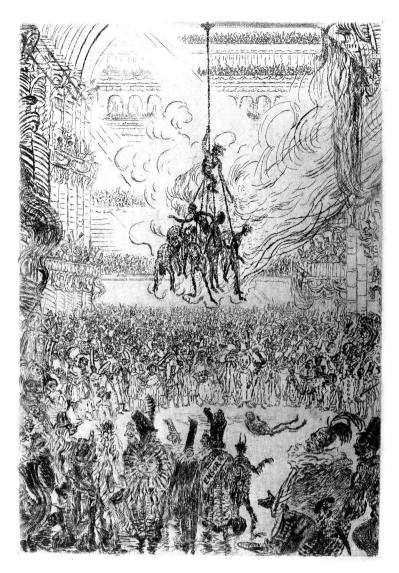

James Ensor. *Hop-Frog's Revenge.* 1898. Etching and drypoint, plate: 14¼ x 9¹³⁄₁₆" (36.8 x 24.9 cm).
The Museum of Modern Art, New York. Gift of Victor S. Riesenfeld

At the end of the nineteenth century, art was replete with symbols, allegories, and metaphors that reflected the disturbing inner moods and external realities of modern humanity in the face of encroaching industrialization. The pervasiveness of fin-de-siècle morbidity, and its often concurrent humor, are no more evident than in the work of the Belgian James Ensor and the Mexican José Guadalupe Posada—two artists working contemporaneously in different locales and formats, and for distinct audiences. Yet both combined grotesque realism and fantastic symbolism to communicate the foibles of the human condition. While the specific culture of each artist fueled their respective work, it is extraordinary to see how closely their wildly imaginative image banks—full of skeletons, demons, and masked figures—mirror each other.

Ensor was born in 1860 in Ostend, a resort city on the coast of Belgium, where he remained his entire life. Academically trained in the European tradition of the fine arts, he was influenced by the rich history of Dutch and Flemish painting. As a printmaker, Ensor worked mainly in drypoint and etching,[1] techniques that suited his interest in complex linearity and minute detail. The artist's prints were issued in small edition sizes (the largest known edition is seventeen) and thus reached a limited audience.[2]

Posada, born in 1852 in Aguascalientes, a town north of Mexico City, was apprenticed as a printmaker before settling in

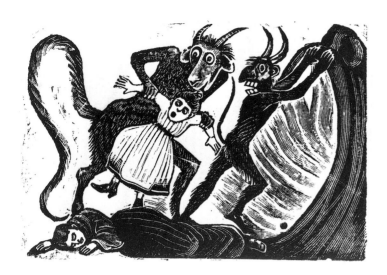

José Guadalupe Posada. *A Most Terrible Example! A Girl Slanderer Is Carried Away by the Devil!!!!!* c. 1890–1913. Engraving, relief printed, comp.: 3½ x 5½" (9 x 13.3 cm). Publisher: Antonio Vanegas Arroyo, Mexico City. The Museum of Modern Art, New York. Larry Aldrich Fund

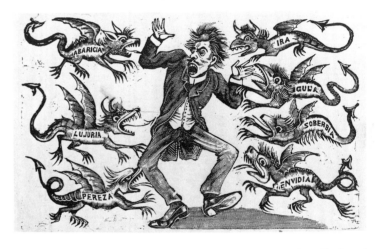

José Guadalupe Posada. *Shocking and Terrible Occurrence in the City of Silao in the First Days of the Twentieth Century: Suicide of a Greedy Rich Man!* 1900. Engraving, relief printed, comp.: 3⅝ x 6¹/₁₆" (9.3 x 15.4 cm). Publisher: Antonio Vanegas Arroyo, Mexico City. The Museum of Modern Art, New York. Larry Aldrich Fund

the capital to master engraving and etching at the workshop of Antonio Vanegas Arroyo, a renowned publisher of broadsheets. These large-format, mass-produced sheets sold very inexpensively on the street. Their large print run and the inclusion of text elements printed in raised lettertype necessitated a highly reproducible form of relief engraving,[3] which Posada easily mastered. These illustrations, with their strong graphic qualities, appealed to the literate and illiterate populations of Mexico alike.[4]

For Ensor, Ostend's local parades, religious processions, raucous Mardi Gras celebrations, and throngs of tourists at the beach inspired his crowded compositions and disquieting subject matter. So too did the carnival masks that were sold to tourists at his family's souvenir shop. The literature of the

period, particularly the macabre tales of Edgar Allan Poe, provided a further source for his imagery. Posada worked within the Mexican popular graphic tradition of journalistic satire, which included images of *calaveras*, or personified skulls and skeletons. These images captivated mass audiences and became symbols of the Mexican homeland. Posada drew his subjects from the most sensational news stories, as well as indigenous myth, folklore, and Catholicism.

Essential to both artists were the themes of death and its inevitability. Ensor's *Death Chasing the Flock of Mortals* (p. 74) combines the dread of mortality and the artist's fascination with public mayhem. Skeletal demons with scythes descend from the sky, assailing the endless parade of people trapped on

James Ensor. *The Battle of the Golden Spurs.* 1895. Etching, plate: 7¹/₁₆ x 9⁷/₁₆" (17.9 x 24 cm). The Museum of Modern Art, New York. Abby Aldrich Rockefeller Fund

a narrow city street and setting populated buildings ablaze. The message is clear: the bourgeoisie, workers, soldiers, clergy, women, and children alike cannot escape the undiscriminating specter of death.

Ensor's print bears a striking similarity in composition and theme to Posada's illustration *This is about Don Quixote the First, the Unequaled Giant Calavera* (p. 75), particularly in its central figure. This broadsheet was issued for the Day of the Dead, an annual Mexican festival traditionally celebrated in November to acknowledge mortality, commemorate the dead, and celebrate life. With this theme, Posada popularized his signature depictions of *calaveras*. Here he turns Cervantes's character of Don Quixote into a *calavera*, giving even this mythical hero and his good deeds

an ominous and absurd cast. The accompanying text contains the explicit message that the power of Don Quixote's lance can be wielded at anyone, regardless of profession or social status.

Real-life events reported in Mexican newspapers were the source for many of Posada's prints. The more astonishing the story, the greater the circulation of his broadsheets. Posada infused facts with his keen imagination, depicting how deviant behavior leads to horrific torment and punishment in hell. *A Most Terrible Example! A Girl Slanderer Is Carried Away by the Devil!!!!!* (p. 77) illustrates the fate of Cenobia, a twelve-year-old girl who delighted in slandering the people of her community. This particular incident involved Cenobia inventing an adulterous liaison, which resulted in the murders of two innocent

James Ensor. *The Entrance of Christ into Brussels.* 1898. Etching and drypoint, plate: 9¾ x 14" (24.8 x 35.5 cm). The Museum of Modern Art, New York. Abby Aldrich Rockefeller Fund

people. Posada pictures a horrified Cenobia being spirited away by demons.

Posada's *Shocking and Terrible Occurrence in the City of Silao in the First Days of the Twentieth Century: Suicide of a Greedy Rich Man!* (p. 77) is based on the story of a man who had inherited wealth at an early age, succumbed to numerous sins, and suffered devastating financial and social troubles, ultimately resolving to take his own life. Posada shows the man, in a state of near death, being attacked by evil spirits identified with the seven deadly sins: greed, lust, sloth, anger, gluttony, pride, and envy. Another of Posada's most sensationalized prints is *Very Interesting News of the Four Murders Committed by the Unfortunate Antonio Sánchez . . . Who, After the Horrible Crime, Ate the Remains*

of His Own Son (p. 80), which relates a tale of bankruptcy, domestic murder, and cannibalism. According to the story, Sánchez suffered the punishment of being shot in public; his body was destroyed, washed away by a violent storm. Instead of focusing on the act of murder itself or the fate of the criminal, here Posada stresses the act of cannibalism, heightening the drama and grotesquerie of the report.

While Ensor also based numerous works on actual events, he often chose a fictional literary subject because it appealed to his macabre imagination. His *Hop-Frog's Revenge* (p. 76), based on an 1845 Poe short story, illustrates the revenge of a dwarfed court jester called Hop-Frog against a disrespectful king and his seven ministers. Ensor pictures the final scene of the story,

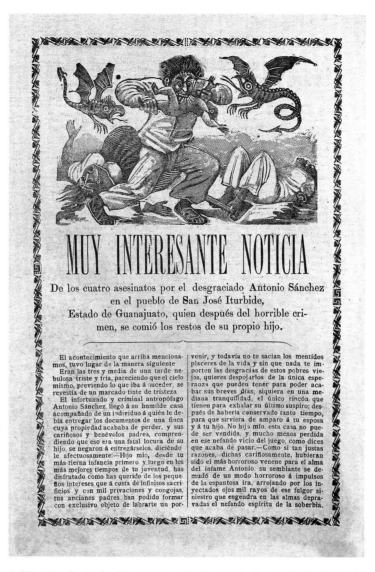

José Guadalupe Posada. *Very Interesting News of the Four Murders Committed by the Unfortunate Antonio Sánchez in the Village of San José Iturbide, in the State of Guanajuato, Who, After the Horrible Crime, Ate the Remains of His Own Son.* 1911. Engraving, relief printed, and letterpress, comp.: 9⅞ x 6⁹⁄₁₆" (25.3 x 16.7 cm). Publisher: Antonio Vanegas Arroyo, Mexico City. The Museum of Modern Art, New York. Inter-American Fund

a masquerade ball with the king and his companions costumed as orangutans, chained together, hoisted to a chandelier chain, and set ablaze. The brutal pageantry of the scene is intensified by the infinitely receding crowd of costumed guests surrounding the spectacle.

Another of Ensor's prints, *The Battle of the Golden Spurs* (p. 78), refers to a 1302 battle between France and Belgium which resulted when Flemish workers revolted against French rule. The name of the battle derives from the field being scattered with the spurs from the riding boots of the French army. Ensor's panoramic view of the battlefield is a tableau of hysteria, with soldiers engaging in a variety of barbaric and scatological acts. The print also harks back to his numerous pictures of over-

run beaches and streets in his local city of Ostend. The brutality of the scene is underscored by the contrast between the white of the paper and the scattered bodies delineated with strong black outlines, giving the scene an eerie, cartoonlike quality.

During the 1880s Ensor suffered personal problems and professional rejection, and these concerns were reflected in his work. Many were based on religious subjects, particularly the torments of Christ, which relate metaphorically to the artist's own feelings of alienation and persecution. The most dramatic example is Ensor's *The Entrance of Christ into Brussels* (p. 79), created first as a painting and then as a print, which reenacts Christ's entry into Jerusalem. Here, however, Christ is a tiny lost figure in the center of a carnivalesque parade. This print also

reflects Ensor's vision of the society of his day, specifically the strikes and mass demonstrations of the growing labor movement and socialist groups. Included are several banners which champion workers' rights, among them, "Vive la sociale" or "Long Live the Welfare State," and "Vive anseele et Jésus," referring to Edouard Anseele, a pioneer of the Flemish socialist movement who was influential at the time.

While the imagery of Ensor's and Posada's prints have striking similarities, their approaches differ in some fundamental and critical ways. Posada highlights the actions of the individual. Although he employs sophisticated shading and line work at times, his figures are simplified and often isolated, and space is flattened. The message of his prints is thus clear and

CLOCKWISE FROM UPPER LEFT:

José Guadalupe Posada. *The Man Hanged on the Street of Window Grilles, Balvanera: Horrible Suicide, Monday January 8, 1892.* 1892. Engraving, relief printed, comp.: 4⅝ x 3⅞" (11.7 x 9.8 cm). Publisher: Antonio Vanegas Arroyo, Mexico City. The Museum of Modern Art, New York. Larry Aldrich Fund

José Guadalupe Posada. *Terrible Example: A Girl in a Pact with the Devil!!!!!* c. 1890–1913. Engraving, relief printed, comp.: 3½ x 5¼" (8.9 x 13.4 cm). Publisher: Antonio Vanegas Arroyo, Mexico City. The Museum of Modern Art, New York. Larry Aldrich Fund

José Guadalupe Posada. *The Gambler* from the portfolio *Twenty-Five of José Guadalupe Posada.* Posthumously printed, 1942. Engraving, relief printed, comp.: 3¼ x 2" (8.2 x 5 cm). Publisher: La Estampa Mexicana (Taller de gráfica popular), Mexico City. Edition: 100. The Museum of Modern Art, New York. Inter-American Fund

José Guadalupe Posada. *Ballad: A Dispute between Mothers-in-law, Godmothers, and Sons-in-law.* c. 1890–1913. Engraving, relief printed, comp.: 3⅝ x 5⅜" (9.1 x 13.6 cm). Publisher: Antonio Vanegas Arroyo, Mexico City. The Museum of Modern Art, New York. Larry Aldrich Fund

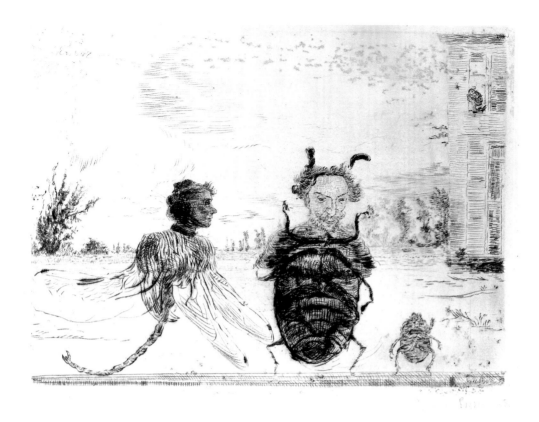

ABOVE: James Ensor. *Peculiar Insects.* 1888. Drypoint, plate: 4 ⅝ x 6¼" (11.8 x 15.9 cm). The Museum of Modern Art, New York. Abby Aldrich Rockefeller Fund

RIGHT: James Ensor. *My Portrait as a Skeleton.* 1889. Etching, plate: 4¾ x 3¹/₁₆" (11.8 x 7.8 cm). The Museum of Modern Art, New York. Abby Aldrich Rockefeller Fund

OPPOSITE: José Guadalupe Posada. *Artistic Purgatory.* 1904. Engraving, relief printed, comp.: 22¹/₁₆ x 13⅜" (56 x 34 cm). Publisher: Antonio Vanegas Arroyo, Mexico City. The Museum of Modern Art, New York. Inter-American Fund

understandable to all. The formal and symbolic power of Ensor's prints, by contrast, comes from their crowded pageantry, infinitely receding depth, and myriad of details and references. Swarming street and interior scenes amplify the violent nature of the individual's actions. Yet despite their distinct approaches, Posada and Ensor—who never met or knew each other's work—drew upon their indigenous cultures, religions, and traditions to produce similarly bizarre and apocalyptic interpretations of the modern worlds they inhabited. Both artists were influential transitional figures who passed on an iconography of fantasy and supernatural forces that came to characterize the art of the early twentieth century.

EL PURGATORIO ARTISTICO,

En el que yacen las Calaveras de los Artistas y de los Artesanos!

¡En este Purgatorio sin segundo,—Los Artistas se ven de todo el Mundo!

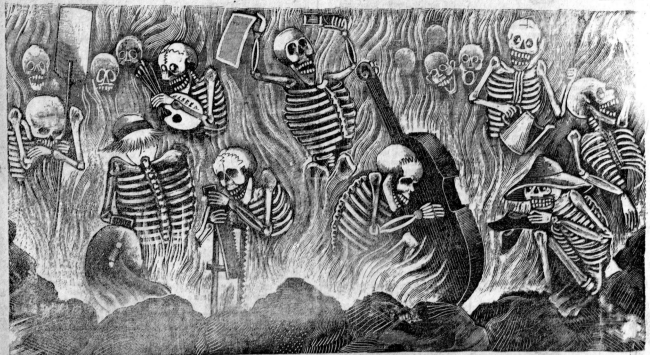

He aquí el cuadro que nos representa palpablemente lo que es el principio de la vida y lo que es su inexorable fin.—"Hoy por tí y mañana por mí."

 Cobijados están por un sudario
Artesanos y Artistas á millares.

 Y es seguro hallarás al que buscares
Por orden singular de abecedario

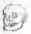

Agustinillo el Albañil

Tú fuiste un buen albañil,
Cargaste sobre tus hombros
Los adobes. los escombros
Con dificultades mil.
Pusiste el tejamanil
Con una destreza rara,
Cargaste con tu cuchara
Al pasar á la otra vida,
Y hoy tu cara es convertida
En calavera muy rara.

Barbero de Barrio

Muchos prodigios hiciste
Con el pelo y con la barba,
Por eso no se te escarba
La losa en que sucumbiste,
Algunas cortadas diste
A la gente pasajera.
Más ahora por tu tontera
Yaces dentro una mortaja,
Con tijeras y navaja
Para tusar calaveras.

Carpintero de Aflicion

Tú hiciste muchos primores,
Como fueron malas puertas
Unas torcidas ó tuertas
Y otros malos mostradores.
Pero en fin, tus valedores
Que te quisieron deveras.
Vienen todos con sus ceras
Y muy piadosos á verte,
Que estás por tu infausta suerte
Entre tantas calaveras.

Dorador Impertinente

A los hombres opulentos
Más de mil cuadros doraste
Y en todos muy bien quedaste
Y ellos también muy contentos.
Pero tuviste momentos
De tal torpeza y manera,
Que ninguno lo creyera
Pues hoy tienes en tus manos,
Los asquerosos gusanos
Royendo tu calavera.

Encuadernador de Fama

Una biblioteca entera
A un doctor encuadernaste,
Y con él tan bien quedaste
Que toda se descosió
Y tu fama por doquiera.
Con gran éxito brilló.
Todo el mundo la admiró,
Y en el libro de la muerte
Por la desdichada suerte
Tu calavera se vió.

Fustero Arrinconado

A un hombre muy caporal
Famoso fuste le hiciste,
Pues por tu suerte tuviste
Una madera inmortal.
Así no quedaste mal,
Más al dar una carrera
En su yegua pasajera.
Un golpe mortal se dió,
Por eso te acompañó
A ser cual tú calavera,

Grabador Inteligente

Tú serías buen grabador,
Pero toda tu destreza
No te libró de que fueras
A la tumba de cabeza.
Sacude allí la pereza
Y deja de ser lo que antes,
Que aburrias á los marchantes
Y ahora en tu sepulcro labra
Con buriles elegantes
En tu obsequio una palabra.

Herrero sin fuerza

A tí no te irá tan mal
Si estás en el purgatorio,
Porque es muy cierto y notorio
Que tu oficio es congenial,
En la caverna infernal,
No tendrás ningun trastorno,
Revisarás en contorno
A todos tus parroquianos,
Y así echarás con tus manos
Las calaveras al horno.

¡Calavera que no apesta— Y solo un centavo cuesta!

MARIA DEL CARMEN GONZÁLEZ

COMPOSING with THE Figure

OPPOSITE: Gary Hill. *Inasmuch as It Is Always Already Taking Place.* 1990. Sixteen-channel video/sound installation with sixteen modified monitors recessed into a wall, overall 16 x 53¾ x 68" (40.6 x 136.5 x 172.7 cm). The Museum of Modern Art, New York. Gift of Agnes Gund, Marcia Riklis, Barbara Wise, and Margot Ernst; and purchase

In Gary Hill's 1990 installation *Inasmuch as It Is Always Already Taking Place*, sixteen video monitors of various sizes, recessed in a long niche in the wall, display different parts of the human body, while soft sounds of pages being turned, hands rubbing, and murmuring can be heard. All but one of the screens show life-sized images, and Hill draws upon the viewer's willingness to see the intimate video images as real, while he simultaneously believes that the work is a fragmented, electronic human still life.[1] As extreme as Hill's decomposition and reassembly of the figure is, it is built on the revolutionary methods of composing and deconstructing the figure introduced in the early twentieth century.

By 1900 the role of the human figure in pictorial art was changing in at least three ways. First, artists were creating visual narratives that could not easily be deciphered. Second, special attention was being paid to the relationship of figure and ground: figures were camouflaged within variegated backgrounds, were dissolved within atmospheric fields, and appeared

84

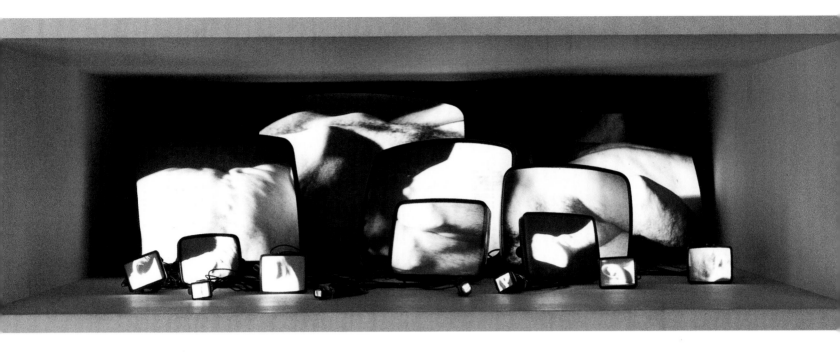

to emerge from unspecific locations. And third, artists developed diverse methods of deconstructing the figure, which became, on occasion, practically unrecognizable. In such cases, only through finding visual clues or reading the titles would the viewer realize that figures were depicted.

In Gustav Klimt's *Hope, II* (p. 86) of 1907–08, a monumental and seemingly pregnant woman stands perfectly centered in a traditional pose. Her regally patterned dress and the patch of gold hovering like a halo above her bowed head echo depictions of saints in medieval illuminated manuscripts. Yet, despite the enormity and centrality of her placement, the brilliant colors and patterns that flood the composition are more mesmerizing than the figure. A visual flurry, created by gold flecks of paint (interestingly, Klimt's father was a goldsmith), bombards the viewer, whose gaze shifts from background to figure and back again, flattening the figure's illusion of three-dimensionality. Perhaps only after further investigation of the robe's patterning may the viewer see the skull on the woman's belly and the female figures camouflaged toward the bottom of the robe.

In Paul Signac's portrait of Félix Fénéon (p. 86), unlike Klimt's painting, the figure is off to one side; in the center of the canvas is the eye of a swirling vortex, a dynamic design probably inspired by an anonymous Japanese print illustrating both geometric and organic kimono patterns. This visual disturbance detracts from the figure by pulling the viewer's gaze away from it. Indeed, Signac's lengthy title—*Opus 217. Against the Enamel of a Background Rhythmic with Beats and Angles, Tones, and Tints, Portrait of M. Félix Fénéon in 1890*—acknowledges the weight of the background. Also diverting attention is the figure's prominent gesture. He stands in profile, seeming to offer a flower to an unseen person, like an actor before a stage backdrop. In fact, this is a portrait of a celebrated art and literary critic, who later became one of Henri Matisse's dealers. Signac said of the work, "This will not be a commonplace portrait." Even before its completion, Fénéon seems to have agreed, occasionally signing letters to Signac with "Félix of the iris."[2]

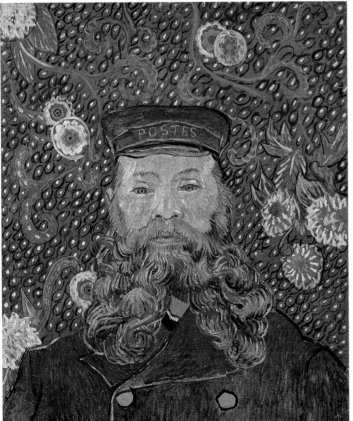

OPPOSITE, TOP: Gustav Klimt. *Hope, II*. 1907–08. Oil, gold, and platinum on canvas, 43½ x 43½" (110.5 x 110.5 cm). The Museum of Modern Art, New York. Mr. and Mrs. Ronald S. Lauder and Helen Acheson Funds, and Serge Sabarsky

OPPOSITE, BOTTOM: Paul Signac. *Opus 217. Against the Enamel of a Background Rhythmic with Beats and Angles, Tones, and Tints, Portrait of M. Félix Fénéon in 1890.* 1890. Oil on canvas, 29 x 36½" (73.7 x 92.7 cm). The Museum of Modern Art, New York. Fractional gift of Mr. and Mrs. David Rockefeller

LEFT: Vincent van Gogh. *Portrait of Joseph Roulin*. 1889. Oil on canvas, 25⅜ x 21¾" (64.5 x 55.2 cm). The Museum of Modern Art, New York. Gift of Mr. and Mrs. William A. M. Burden, gift of Mr. and Mrs. Paul Rosenberg, gift of Nelson A. Rockefeller, gift of Mr. and Mrs. Armand Bartos, The Sidney and Harriet Janis Collection, gift of Mr. and Mrs. Werner E. Josten, and Loula D. Lasker Bequest (all by exchange)

ABOVE: Henri Matisse. *Woman beside the Water*. 1905. Oil and pencil on canvas, 13⅞ x 11⅛" (35.2 x 28.3 cm). The Museum of Modern Art, New York. Purchase and partial anonymous gift

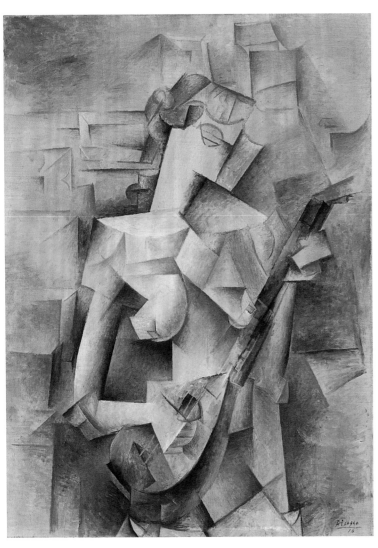

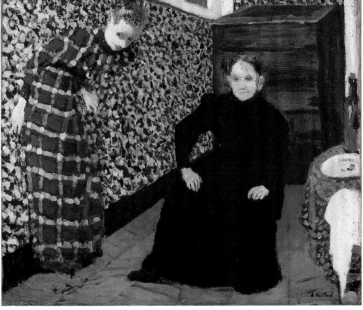

OPPOSITE, BOTTOM: Pablo Picasso. *Girl with a Mandolin* (Fanny Tellier). 1910. Oil on canvas, 39½ x 29" (100.3 x 73.7 cm). The Museum of Modern Art, New York. Nelson A. Rockefeller Bequest

OPPOSITE, TOP: Henri de Toulouse-Lautrec. *Mme Lili Grenier*. 1888. Oil on canvas, 21¾ x 18" (55.2 x 45.7 cm). The Museum of Modern Art, New York. The William S. Paley Collection

ABOVE: Henri Matisse. *Woman on a High Stool* (Germaine Raynal). 1914. Oil on canvas, 57⅞ x 37⅝" (147 x 95.6 cm). The Museum of Modern Art, New York. Gift and bequest of Florene M. Schoenborn and Samuel A. Marx

RIGHT: Édouard Vuillard. *Mother and Sister of the Artist*. c. 1893. Oil on canvas, 18¼ x 22¼" (46.4 x 56.5 cm). The Museum of Modern Art, New York. Gift of Mrs. Saidie A. May

Although titled *Bather*, Matisse's painting of 1909 simply shows a nude; whether it is female or male is uncertain. The field of brilliant, high-toned blue enveloping the body can be seen as water that the bather enters. However, the blue is set down in brushstrokes that echo the shape of the bather's body rather than describe water. Additionally, the exposed canvas and thin washes of pale blue pigment surrounding the figure's legs do not particularly resemble splashing water. The bather thus seems to be wading as much into paint as into water, and therefore into the painting itself. The figural form is flattened by the touches of blue pigment that invade the legs and arm. Thick, black outlines slip and shift across both the flesh-colored areas and the blue ground, almost like the misalignments that sometimes result during printing processes.

If *Bather* shows a figure entering a pictorial ground, Pablo Picasso's *Nude with Joined Hands* of 1906 shows a figure emerging from one. The rose-colored hue of the background radiates through her body, as if the pigment has permeated it. The woman depicted, Fernande Olivier, was then Picasso's lover, and her gesture of modesty, or of denial, and her indeterminate gaze add to the ambiguous nature of the portrait. Reminiscent of Paul Cézanne's *The Bather* of about 1885 (p. 143), the nude stands with one leg behind the other— momentarily pausing, hesitant—in an even less defined environment than that of the Cézanne painting. The overall simplicity of the female figure and the surrounding rose field, which functions like a backdrop, evokes a classical bas-relief, adding an element of idealization to the sympathetic portrait.

OPPOSITE: Henri Matisse. *Bather*. 1909. Oil on canvas, 36½ x 29⅛" (92.7 x 74 cm). The Museum of Modern Art, New York. Gift of Abby Aldrich Rockefeller

ABOVE: Pablo Picasso. *Nude with Joined Hands*. 1906. Oil on canvas, 60½ x 37⅛" (153.7 x 94.3 cm). The Museum of Modern Art, New York. The William S. Paley Collection

ABOVE: Pablo Picasso. *Three Musicians.* 1921. Oil on canvas, 6'7" x 7'3¾" (200.7 x 222.9 cm). The Museum of Modern Art, New York. Mrs. Simon Guggenheim Fund

OPPOSITE: Henri Matisse. *The Moroccans.* 1915–16. Oil on canvas, 71⅜" x 9'2" (181.3 x 279.4 cm). The Museum of Modern Art, New York. Gift of Mr. and Mrs. Samuel A. Marx

Picasso's *Three Musicians* of 1921 is a visual pun. What looks like a collage of colored sheets of paper is in fact a painting of flat, geometric forms imitating a collage. It is difficult to separate the three musicians—Pierrot at left, Harlequin at center, and the masked man at right—because their planes seem to shift and collide. Beneath the three figures and toward the left lies a dog, only partially visible. Picasso placed his musicians in a claustrophobic, shallow space that resembles a small stage. In the same year that Picasso painted this picture, he was also making stage designs for Sergei Diaghilev's Ballets Russes dance troupe. The subject of Picasso's painting is, thus, a topical one.

The subject of Matisse's *The Moroccans* of 1915–16, on the other hand, is a geographically distant memory, since the work is a compilation of his impressions of Morocco, which he had last visited two years earlier. Those recollected images are set down as three distinct areas. The black field serves both to connect and separate these episodes. In the upper left, we see a balcony with an abstracted bouquet of flowers and, behind it, a domed mosque. Below this, four yellow melons with green leaves lie on a gridded ground. To the right on the pink field, a figure wearing a turban crouches or sits with his back to the viewer. To his left, another turbaned figure is seen from above. The linear form in the top right corner of the painting may describe another figure, with bent legs beneath a draped robe. Like the black ground, the geometric treatment in this canvas marked a dramatic shift for Matisse, whose art came unusually close to Picasso's in this period.

OPPOSITE: Fernand Léger. *Three Women.* 1921. Oil on canvas, 6' ¼" x 8' 3" (183.5 x 251.5 cm). The Museum of Modern Art, New York. Mrs. Simon Guggenheim Fund

ABOVE: Pablo Picasso. *Les Demoiselles d'Avignon.* 1907. Oil on canvas, 8' x 7'8" (243.9 x 233.7 cm). The Museum of Modern Art, New York. Acquired through the Lillie P. Bliss Bequest

ABOVE: Pablo Picasso. *Card Player*. 1913–14. Oil on canvas, 42½ x 35¼" (108 x 89.5 cm). The Museum of Modern Art, New York. Acquired through the Lillie P. Bliss Bequest

OPPOSITE: Man Ray. *The Rope Dancer Accompanies Herself with Her Shadows*. 1916. Oil on canvas, 52" x 6' 1⅜" (132.1 x 186.4 cm). The Museum of Modern Art, New York. Gift of G. David Thompson

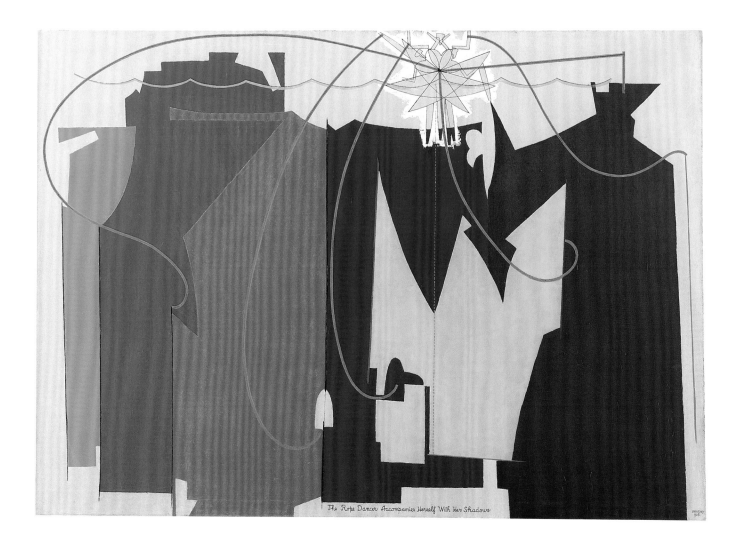

In Picasso's 1913–14 *Card Player*, the figure is less easily perceived in the composition than are the figures in *Three Musicians* (p. 92). When *Card Player* was painted, only those who were closely following Picasso's work could probably have read such an image. Even now it is difficult. But as we look at it, the yellow, upside-down-T shape is slowly transformed into a nose; to its left, the brown wave of curving lines becomes strands of hair; and, beneath the nose, there emerges a black moustache, which is turned upward at the ends. Three gray rectangles at the center of the painting fan out in the form of playing cards. Yet even as the viewer discerns the figure, Picasso's pattern of curved and straight edges confuses the understanding of figure and ground, that is, of how the card player fits into the space.

Man Ray's 1916 *The Rope Dancer Accompanies Herself with Her Shadows* uses a vocabulary similar to Picasso's in *Card Player* but to a far more radical effect. If the title were not written on the painting, there would hardly be reason to look for a figure. Man Ray made drawings of a dancer in three separate poses, enlarged them, and traced their outlines onto colored paper, thus preserving only the silhouettes or shadows of these poses. He then cut out the silhouettes and arranged them to form the flat areas of color that dominate the painting. But the rope dancer in her three original poses is there as well, at the top of the canvas where the gray ropes joining the colored areas converge.

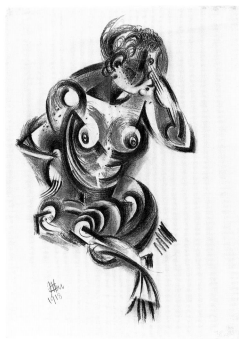

ABOVE: Umberto Boccioni. *Dynamism of a Soccer Player*. 1913. Oil on canvas,
6'4⅛" x 6'7⅛" (193.4 x 201 cm). The Museum of Modern Art, New York. The Sidney
and Harriet Janis Collection

RIGHT: Johannes Itten. *The Eavesdropper*. 1918. Colored crayon, charcoal, and pencil on
paper, 19¾ x 14¼" (50.2 x 36.2 cm). The Museum of Modern Art, New York. The Joan
and Lester Avnet Collection

PEOPLE 98

In Umberto Boccioni's *Dynamism of a Soccer Player* of 1913 and Johannes Itten's *The Eavesdropper* of 1918, figures are depicted as if dissolving. Boccioni's painting evokes speed not through the depiction of frozen movements but by staccato juxtapositions of the body's forms. For example, at the center of the composition, a soccer-ball shape encloses images of the player's thigh, bent knee, and calf, suggesting that he is moving continuously. This sensation of perpetual motion is heightened by Boccioni's technique of short, rapid-fire brushstrokes in crosshatch patterns, which seem to depict a conflation of actions. Itten, on the other hand, disembodied his figure through sharp tonal variations, contrasting the areas of light and dark created with pencil, charcoal, and colored crayon. His eavesdropper does not dematerialize in motion but rather seems to be mutating in shape.

Marcel Duchamp's 1912 *The Passage from Virgin to Bride* also describes a transitional phase. In this abstract compilation of human and machinelike forms, the figure is virtually indecipherable, reduced to abstract volumes and outlined convex and concave shapes. Duchamp's title, as always, is important. It tells us that the painting is about a transformation of social role and sexual state, and is therefore not a depiction of one or more figures but an illustration of a concept. Duchamp painted *The Passage from Virgin to Bride* after making two sketches titled *Virgin No. 1* and *Virgin No. 2* and before a painting titled *Bride (Mariée)*.

Duchamp knew Eadweard Muybridge's *Animal Locomotion*, a collection of 781 plates published in 1887, in which *Man Throwing Discus* appeared. Muybridge's work was a great inspiration for early modern artists fascinated by speed and the depiction of movement. His photographs allowed artists to see humans and animals frozen in the middle of particular actions and revealed how strange movements looked when dissected in this manner. Muybridge's work also put forth the question of how individual, isolated parts of an action might be recombined in new ways, as in the other three compositions reproduced on these two pages.

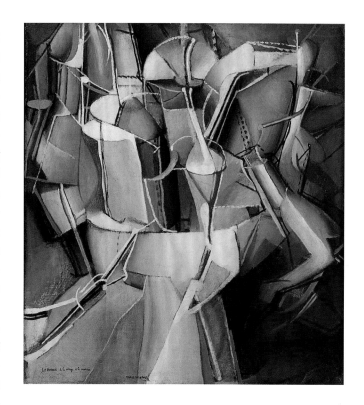

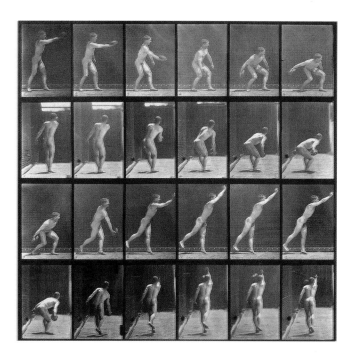

ABOVE: Marcel Duchamp. *The Passage from Virgin to Bride*. 1912. Oil on canvas, 23⅜ x 21¼" (59.4 x 54 cm). The Museum of Modern Art, New York. Purchase

BELOW: Eadweard Muybridge. *Man Throwing Discus*, plate 307 from *Animal Locomotion*. 1887. Collotype, 10 x 10⅝" (25.4 x 27 cm). The Museum of Modern Art, New York. Gift of the Philadelphia Commercial Museum

Fernand Léger. *Exit the Ballets Russes.* 1914. Oil on canvas, 53¾ x 39½" (136.5 x 100.3 cm). The Museum of Modern Art, New York. Gift of Mr. and Mrs. Peter A. Rübel (partly by exchange)

Kasimir Malevich. *Woman with Water Pails: Dynamic Arrangement.* 1912–13.
Oil on canvas, 31⅝ x 31⅝" (80.3 x 80.3 cm). The Museum of Modern Art, New York

ABOVE: Max Ernst. *The Hat Makes the Man*. 1920. Gouache, pencil, ink, and cut-and-pasted collotypes on paper, 14 x 18" (35.6 x 45.7 cm). The Museum of Modern Art, New York. Purchase

BELOW: El Lissitzky. *Announcer* from the portfolio *Figurines*. 1920–21, published 1923. Lithograph, sheet: 20¹⁵⁄₁₆ x 17⅞" (53.2 x 45.4 cm). Edition: 75. The Museum of Modern Art, New York. Purchase

The four works illustrated here show constructions of objects that suggest figural form. In Max Ernst's *The Hat Makes the Man* of 1920, no figure is represented, only stacked bowler hats. Yet in the second column of hats from the left, for example, the top two bowlers and the lines connecting them can be seen as a nodding head and neck. Below that a cylindrical form creates the trunk of the body, and underneath a bell-like shape could represent the waist through to the knees. Finally, in Ernst's title, a common saying gains a Freudian, phallic interpretation. Quite different is El Lissitzky's 1920–21 lithograph *Announcer* from his portfolio *Figurines*, an image of unrecognizable objects, machinelike forms with sharp edges and geometric angles that together form an industrial mannequin.

Giorgio de Chirico's *The Great Metaphysician* of 1917 and Vladimir Baranoff-Rossiné's *Symphony Number 1* of 1913 are earlier interpretations of the same idea, only evocative of handicraft rather than industrial processes. Once functional, sometimes still identifiable objects—depicted in the former and real in the latter—are the raw materials of figural constructions and, therefore, are transformed. De Chirico's painting shows a strange fabrication, with mannequin head and a body made of painting stretcher bars and other materials, which serves as a traditional monumental statue in a plaza. Baranoff-Rossiné even more dramatically overturned the notion of the traditional figural sculpture in his three-dimensional assemblage of unconventional materials: wood, cardboard, and crushed eggshells. The work makes use of negative space and objects of uncertain reference in its challenge to the viewer to visualize a figure while moving around the sculpture.

The works reproduced on the following two pages may make even greater demands on their audiences. The human form in Vilmos Huszar's *Composition with Female Figure* (p. 104) of 1918 could hardly be identified if it were not for the two small triangles toward the top of the composition, which can be read as eyes. The woman and guitar in a painting by Picasso of 1914 (p. 105) have been decomposed and distributed over the canvas's surface, remaining indecipherable except for the occasional evocative detail. Francis Picabia's *Conversation II* (p. 104) of about 1922 offers only four truncated bodies that seem to float in front of dark horizontal bars. Like Hill's video and sound installation, this work uses the fragmented body to create an utterly mysterious configuration set in an ambiguous space.

ABOVE: Giorgio de Chirico. *The Great Metaphysician*. 1917. Oil on canvas, 41⅛ x 27½"
(104.5 x 69.9 cm). The Museum of Modern Art, New York. The Philip L. Goodwin
Collection

RIGHT: Vladimir Baranoff-Rossiné. *Symphony Number 1*. 1913. Polychrome wood,
cardboard, and crushed eggshells, 63¼ x 28½ x 25" (160.7 x 72.4 x 63.5 cm).
The Museum of Modern Art, New York. Katia Granoff Fund

ABOVE: Francis Picabia. *Conversation II*. c. 1922. Watercolor on composition board, 17⅞ x 23⅞" (45.4 x 60.6 cm). The Museum of Modern Art, New York. Mary Sisler Bequest

RIGHT: Vilmos Huszar. *Composition with Female Figure*. 1918. Oil on canvas, 31½ x 23¾" (80 x 60.3 cm). The Museum of Modern Art, New York. The Riklis Collection of McCrory Corporation

OPPOSITE: Pablo Picasso. *Woman with a Guitar*. 1914. Oil, sand, and charcoal on canvas, 45½ x 18⅝" (115.6 x 47.3 cm). The Museum of Modern Art, New York. Gift of Mr. and Mrs. David Rockefeller

Aristide Maillol. *The River*. 1938–43. Lead (cast 1948), 53¾" x 7'6" x 66" (136.5 x 228.6 x 167.7 cm), on lead base designed by the artist, 9 ¾ x 67 x 27 ¾" (24.8 x 170.1 x 70.4 cm). The Museum of Modern Art, New York. Mrs. Simon Guggenheim Fund

JOHN ELDERFIELD

unique forms
of continuity in space

This short essay takes its title from Umberto Boccioni's sculpture of 1913 (p. 108), which sought to describe how parts of a body in movement might be imagined continuing in space beyond the body's physical envelope, stretched out by the velocity and flapping in the force of the wind. Thus Boccioni, it is often said, imagined a superman of the future.[1] Less frequently noticed is that this hero is not even four feet tall.

But, clearly, the size of a work of art is important for the creation of its composition and for the way that the completed work affects the beholder. In painting, creating the composition usually *begins* by establishing the size of the work. In sculpture, it *ends* with it: the size of the work is a creation of the composition, and is finally established only at the conclusion. The sample of sculptures illustrated to scale on these pages suggests that size is important to sculpture in one or more of the following three ways.[2]

First, size is a function of representation. That is, all other factors being equal, the closer in size a representational sculpture is to what is perceived to be the real or true size of its assumed source, the more likely it will be accepted as a faithful representation of that source. This is the logic of life-size

waxworks, and a reason why most modern sculptors avoid life size, not wanting their work to be confused with mere imitation, and wanting its real, true size to be noticed as a compositional decision that the sculptor made.

Second, size is a function of value, as evidenced by the truly superhuman size of Auguste Rodin's *Monument to Balzac* (p. 66), or the intimate, possessable size of Aristide Maillol's *Leda* (p. 111). However, the association of size and value is such a deeply embedded, traditional convention of representational art that modern sculptors will tend to be wary of relying upon it. Thus, Rodin does not merely use size but, by means of generalization, amplifies the presence afforded by size to give heroic stature to his image. Maillol heightens the sense of possessability by use of the contrasting gesture of warding off. And Boccioni avoids a literally large size for his image of a hero, achieving the effect of size with an expansively super-charged figure elevated on a pedestal.

Third, size is a function of visibility. Thus, the larger the work, the more easily it will be seen at a distance. However, the association of size and visibility is so vulnerable to the relative clarity of what is being looked at that sculptors have

long learned to substitute the new equation: size is a function of visual clarity. This is especially evident in a work like Henri Matisse's *La Serpentine* (p. 135); although relatively small—small enough to seem graspable—it is so clearly articulated that it fulfills the artist's own requirement that sculpture "must carry from a distance."[3]

Of course, we can look at a sculpture by Matisse from any distance we choose. But even when we view it from close up, we still find ourselves distanced from it because it is conceived as a visual motif, ordered and arranged and architecturally contained; that is to say, it is conceived as a sculpture to be looked at as well as a figure to be approached. The change from figurative sculptures that are mainly perceived as figures to those that are mainly perceived as sculptures occurred in the period between 1880 and 1920 and distinguishes the

sculptures illustrated on the following pages. Rodin's *St. John the Baptist Preaching* (p. 113) is mainly a figure, mainly experienced as a surrogate person, for all its utterly unnatural scale and detail. His *Three Shades* (p. 112), however, offers itself in the first place as a visual motif, a composition not only of solid figures but also of voids, namely, the negative spaces between the figures and the spaces outside the figures that are shaped by the figures' silhouettes. Thus, we will want to see it as a whole and will need sufficient distance from it to do so. The same is true for Matisse's *La Serpentine*, Vladimir Baranoff-Rossiné's *Symphony Number 1* (p. 109), Elie Nadelman's *Man in the Open Air* (p. 109), and Constantin Brancusi's *Socrates* (p. 112). And here again, it is in the clarity with which these works are compositions of solids and voids, more than by their degree of "abstraction," that they declare themselves as sculptures:

Jacob Epstein. *The Rock Drill.* 1913–14. Bronze
(cast 1962), 28 x 26" (71 x 66 cm), on wood base
12" (30.5 cm) diam. The Museum of Modern Art,
New York. Mrs. Simon Guggenheim Fund

Henri Matisse. *The Serf.* 1900–04. Bronze,
37⅜ x 13⅜ x 13" (92.3 x 34.5 x 33 cm). The
Museum of Modern Art, New York. Mr. and Mrs.
Sam Salz Fund

Umberto Boccioni. *Unique Forms of Continuity in
Space.* 1913. Bronze (cast 1931). 43⅞ x 34⅞ x
15¾" (111.2 x 88.5 x 40 cm). The Museum of
Modern Art, New York. Acquired through the Lillie
P. Bliss Bequest

Elie Nadelman. *Man in the Open Air.* c. 1915.
Bronze, 54½" (138.4 cm) high; 11¾ x 21½"
(29.9 x 54.6 cm) (at base). The Museum of
Modern Art, New York. Gift of William S. Paley
(by exchange)

Vladimir Baranoff-Rossiné. *Symphony Number 1.*
1913. Polychrome wood, cardboard, and crushed
eggshells, 63¼ x 28½ x 25" (160.7 x 72.4 x
63.5 cm). The Museum of Modern Art, New York.
Katia Granoff Fund

Wilhelm Lehmbruck. *Standing Youth.* 1913. Cast
stone, 7'8" x 33½" x 26¾" (233.7 x 85.1 x 68 cm),
including base. The Museum of Modern Art, New
York. Gift of Abby Aldrich Rockefeller

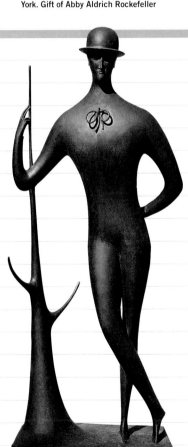

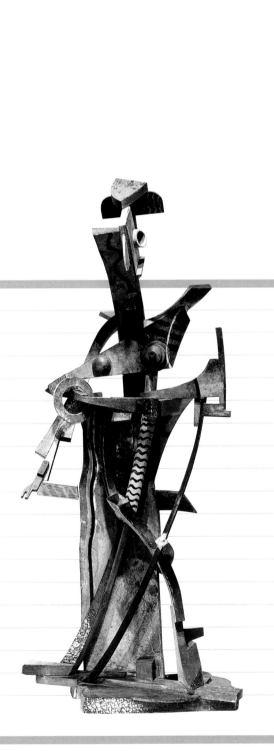

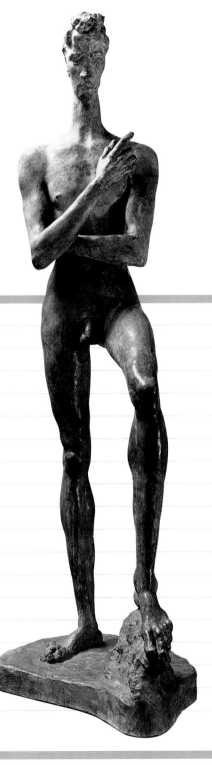

works whose coherence is a function of their internal structure rather than of their degree of figural imitation. Similarly, Jacob Epstein's *The Rock Drill* (p. 108), which represents a figure masquerading as a rock drill, or vice versa, is actually more imitative a work than Matisse's *The Serf* (p. 108), composed, in the words of the sculptor William Tucker, of "a discontinuous and arbitrary array of lumps more suggestive of vegetable life than human anatomy . . . sculpture structured not by anatomy or some imposed expressive purpose, but by the willed coherence of perception alone."[4]

By illustrating to scale the sculptures presented here, we invite attention to these and other questions relating to size, distance, and the perceptual as well as physical composition of modern sculptures. And we also invite attention to precisely what these illustrations do *not* show: if a sculpture is to be perceived as a visual motif, then every (principal) view on a sculpture must need offer the perception of a visual motif. Rather like a serial composition in painting or photography, composed of several separate images (pp. 180, 182), such a sculpture will be composed of several views, each of which comprises a separate image.

And, as in a serial composition, the sequence of views each sculpture presents may be thought of as variations on the

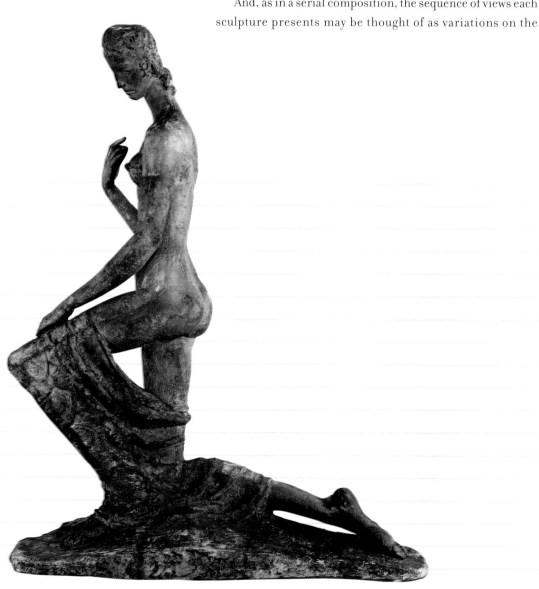

51"
48"
45"
42"
39"
36"
33"
30"
27"
24"
21"
18"
15"
12"
9"
6"
3"
0"

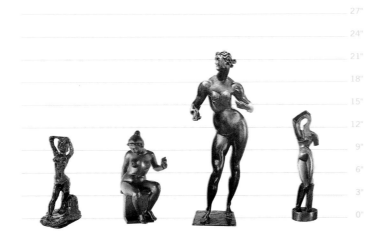

OPPOSITE:

Wilhelm Lehmbruck. *Kneeling Woman*. 1911.
Cast stone, 69½ x 56 x 27" (176.5 x 142.2 x
68.6 cm), including base. The Museum of Modern
Art, New York. Abby Aldrich Rockefeller Fund

AT LEFT:

Henri Matisse. *Standing Nude, Arms on Head.*
1906. Bronze (cast 1951), 10⅜ x 4⅛ x 4⅞"
(26.3 x 10.5 x 12.3 cm), including base. The
Museum of Modern Art, New York. Louise
Reinhardt Smith Bequest

Aristide Maillol. *Leda*. 1902. Bronze, 11⅛ x 5⅞ x
5½" (28.1 x 14.7 x 14 cm). The Museum of
Modern Art, New York. James Thrall Soby Bequest

Elie Nadelman. *Standing Female Nude*. c. 1909.
Bronze, 21¾ x 8⅝ x 7¼" (55.2 x 22 x 8.4 cm),
including base. The Museum of Modern Art, New
York. Aristide Maillol Fund

Alexander Archipenko. *Woman Combing Her Hair*.
1915. Bronze, 13¾ x 3¼ x 3⅛" (35 x 8.3 x 8
cm). The Museum of Modern Art, New York.
Acquired through the Lillie P. Bliss Bequest

BELOW, LEFT TO RIGHT:

Aristide Maillol. *The Mediterranean*. 1902–05.
Bronze (cast c. 1951–53), 41 x 45 x 29¾" (104.1
x 114.3 x 75.6 cm), including base. The Museum
of Modern Art, New York. Gift of Stephen C. Clark

Henri Matisse. *Large Seated Nude*. 1923–25.
Bronze, 31¼ x 30½ x 13¾" (79.4 x 77.5 x 34.9
cm). The Museum of Modern Art, New York. Gift of
Mr. and Mrs. Walter Hochschild (by exchange)

subject or theme of the sculpture: not merely variations on the nominal, external subject (the represented figure), but also on the *sculptural* subject, that is, how the figure has been reshaped in its representation. However, this should not be taken to mean that each variation is no more than a different view of the sculpture, a different version of the sculpture as seen first from this side and then from that. Each variation of the sculptural subject presents itself thus. We cannot see the sculptural subject except from the different views afforded by the sculpture. But whereas the sculpture as such, as an object, is coalesced by our accumulation of such views, the sculptural subject, as a visual theme, is diversified by them.

To attend to questions relating to the size, distance, and the perceptual as well as the physical composition of a sculpture allows us better to look for what Thomas Puttfarken has described as a "rewarded position" before the work of art, a place where there seems to be a fit between our viewing position and the work, a place that enables us to include our own physical orientation toward the work in the way that we imagine its subject.[5] To acknowledge that apprehension of a sculpture's subject will require several viewing positions clearly tends to the conclusion that we should look to a sculpture for several positions of reward. More than that, it will suggest that the rewards of including our own physical orientation toward a sculpture, in the ways that we imagine its diversified subject, will enroll us in a performative relationship to the sculpture in which beholder and sculpture are mutually informing. This will additionally remind us, if we need reminding, that there is no substitute for direct, temporally extended experience of any work of art.

Constantin Brancusi. *Socrates.* 1922. Oak, 50¾ x 21⅛ x 25⅛" (128.8 x 53.7 x 63.8 cm), including base (irreg.). The Museum of Modern Art, New York. Mrs. Simon Guggenheim Fund

Auguste Rodin. *The Three Shades.* 1881–86. Bronze, 38⅜ x 36⅜ x 19½" (97.3 x 92.2 x 49.5 cm). The Museum of Modern Art, New York. Mary Sisler Bequest

George Minne. *Kneeling Youth.* 1898. Original plaster, 31⅞ x 7¾ x 17¾" (80.8 x 19.8 x 45.2 cm), including base. The Museum of Modern Art, New York. Gift of Mr. and Mrs. Samuel Josefowitz

Aristide Maillol. *Summer.* 1910–11. Tinted plaster, 64 x 13¼ x 11¾" (162.5 x 33.6 x 29.8 cm), including base. The Museum of Modern Art, New York. Gift of the artist

Auguste Rodin. *St. John the Baptist Preaching.* 1878–80. Bronze, 6' 6¾" (200.1 cm) high, at base 37 x 22 ½" (94 x 57.2 cm) (irreg.). The Museum of Modern Art, New York. Mrs. Simon Guggenheim Fund

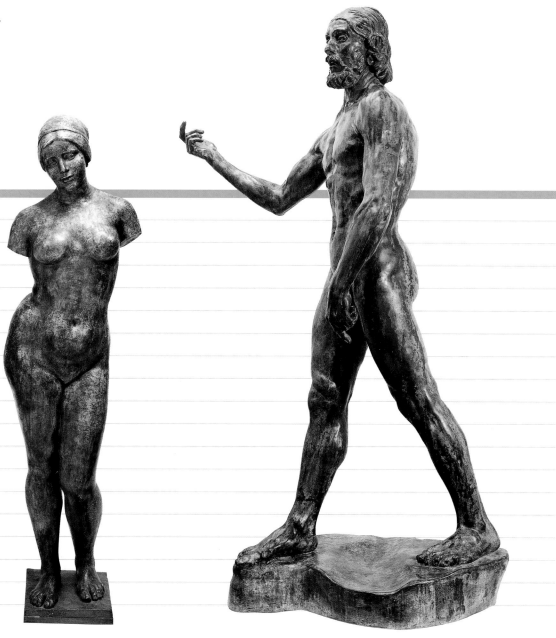

Elizabeth Levine

figure and field

The figure in a picture has both a posture and a placement—a stance that it strikes and a position in relation to the field around it. These are linked, each symbiotically shaping the other, and the visual dialogue between them suggests narratives, metaphors, and understandings.

In Jean Delville's delicate pencil-and-charcoal *Expectation* (c. 1904; opposite), a pregnant Virgin Mary seems massive, even though she is partially hidden by the doorway in which she stands—in fact *because* she stands in that doorway, for she nearly fills it. And the doorframe itself fills the picture, abutting the edges of the page. The floor, meanwhile, is a black-and-white checkerboard, a grid that both establishes the figure in the shallow private space beyond the door and marks a threshold over which she does not step. This sets her back from the viewer, apart, a figure to be honored from a distance.

Unlike Delville's Mary, the figure in Clarence White and Alfred Stieglitz's *Nude* (1907; above) has no firm frame to place her. Instead, she floats on the paper, emerging not from a regular grid but from a nebulous darkness. Although anonymous, she suggests a Venus returning from bathing, for she stands in classical *contrapposto*—one foot before the other, one knee slightly bent, the other knee taking the weight of hips and torso. Her sensuality is heightened by the shadow and light on her body.

E. J. Bellocq's image of a woman at a mirror belongs to a series of photographs of prostitutes in the old Storyville district of New Orleans. Bellocq, as the photographer Lee Friedlander remarks, seems to have allowed these women to decide for themselves "what [they] wanted to be like . . . some of them wanted to be nude and some of them wanted to look like they were going to church. He just let them act out whatever they had in mind for themselves."[1] Naked except for a pair of high-heeled black shoes, the woman in

OPPOSITE: Jean Delville. *Expectation.* c. 1904. Pencil and charcoal on paper, 39¾ x 17½" (100.8 x 44.5 cm). The Museum of Modern Art, New York. The Joan and Lester Avnet Collection

ABOVE: Clarence White and Alfred Stieglitz. *Nude.* 1907. Platinum print, 9½ x 5½" (24.1 x 14 cm). The Museum of Modern Art, New York. Purchase

Untitled (c. 1912; p. 117) turns her back to the viewer and studies herself in the mirror. Her long, uneven black hair falls loosely to the middle of her back, directing the viewer's eye down toward her lower torso; the curves of her body swell against the hard edges of an armoire, a contrast echoed in the pattern of the room's wallpaper, an organic floral sandwiched between vertical bars. Self-absorbed, the woman also, through her reflection, engages with the viewer. Her pose recalls classical mythology and the story of Narcissus, as well as other tales of morality and vanity; implicit in Bellocq's photograph, though, are not only vanity but the control and commodification of the female body, establishing a tone for the image that is provocative and contemplative at once.

Paul Gauguin's *The Moon and the Earth* (1893; p. 117) is an interpretation of a Tahitian myth. The woman standing in lush tropical forest is the goddess of the moon; she is trying unsuccessfully to persuade the male god of the earth to allow humans to be reborn after death. If Bellocq's image intimates a male viewer, in Gauguin's that viewer appears, at the upper right. Although the woman represents the moon and he the earth, he is situated above the horizon, she below it. His gaze, looking directly at the painting's viewer, suggests his control over not only the woman but the larger world. Emphasizing his power, Gauguin makes him almost twice the woman's size: dark and massive, his head and shoulders take up a full quarter of the canvas. The woman, meanwhile, is given lighter skin, and her curving form is conventionally "feminine." On her right, the profile of her body is almost a mirror image of Bellocq's New Orleans prostitute; and both painter and photographer show a woman in some way looking to an authority within the picture—although where Gauguin grants all power to the male earth-god, the prostitute turns her back on the camera, and on the implicitly male viewer, and looks to her own reflection.

Between 1901 and 1908, Pablo Picasso returned several times to the theme of the relationship between two standing women. In *Two Nudes* (1906; p. 118) the women's bodies, squat and angular, crowd the confines of the picture.[2] Reinforcing the ambiguity of the congested space, these bodies are subtly distorted, the turning of limbs, trunks, and heads around the figures' vertical axes being slightly unnatural; and although the women seem weighty and massive, their anatomies deny a complete sense of volume, pushing toward pictorial flatness. One woman's breast is drawn as an elliptical appendage, the other's left hand is a sort of protruding flipper. This latter woman, on the left, parts a curtain, inviting entry into some area beyond, which, however, is effectively blocked by her companion. And even if we were to pass through this amorphous drape, there seems to be nowhere to go—the threshold, as Margaret Werth writes, "is an ornery one: it will not let us in or out."[3] The contorted pointing gesture of the woman on the right has a number of possible connotations—perhaps she is inviting the viewer to look toward the curtain, perhaps she is fixing her hair.[4]

Henri Matisse's series of four backs, from 1908–31, are vertical slabs of bronze, each cast in low relief to shape a woman's figure from behind. Sharing the texture and color of the field around them, the women seem to melt into the surrounding atmosphere. Yet they are enormously solid and imposing. A pen-and-ink drawing of a woman in a related pose (p. 119, right)—in fact a study for the first of these sculptures—shows a more delicately curvilinear figure than in any of the bronzes, standing in a leaning *contrapposto*; along her left side, though, and particularly in the cross-hatching of the thigh, she is barely delineated from the surrounding space, as if Matisse were already experimenting

LEFT: Paul Gauguin. *The Moon and the Earth (Hina Tefatou).* 1893. Oil on burlap, 45 x 24½" (114.3 x 62.2 cm). The Museum of Modern Art, New York. Lillie P. Bliss Collection

ABOVE: E. J. Bellocq. Untitled. c. 1912. Gelatin silver printing-out-paper print by Lee Friedlander from the original negative, c. 1966–69, 9^{13}/$_{16}$ x 7^{13}/$_{16}$" (25.4 x 20.2 cm). The Museum of Modern Art, New York. Gift of Lee Friedlander

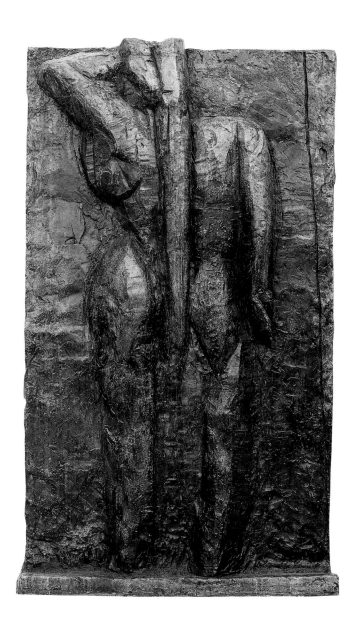

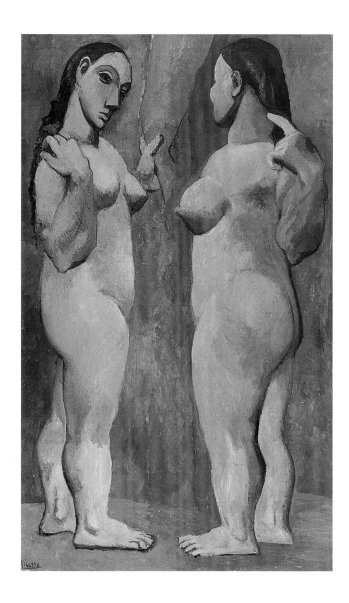

with her dissolution. Like the model in the drawing, the figure in *The Back, III* (above), completed in 1916, has a narrowing waist, curving back and buttocks, a softly rounded bent left arm, and broad yet feminine shoulders. But she stands far more upright and straight, her legs, right arm, and column of hair all strong verticals, which give her an immovable stability. The fourth and final version (opposite, left), which followed fifteen years later, is more geometric still, the figure a subtly rounded, blocklike rectangle, divided down its spine, that resonates with the architectonic form of the bronze field.

In *Large Nude* and *The Large Woodcut* (both 1906; p. 122), Matisse approaches the same figural pose in quite different ways. In both pictures—prints in two different mediums—a woman's body bisects the page diagonally. She wraps her arms around one side of her head, initiating a turning of weight that concludes in the crossing of

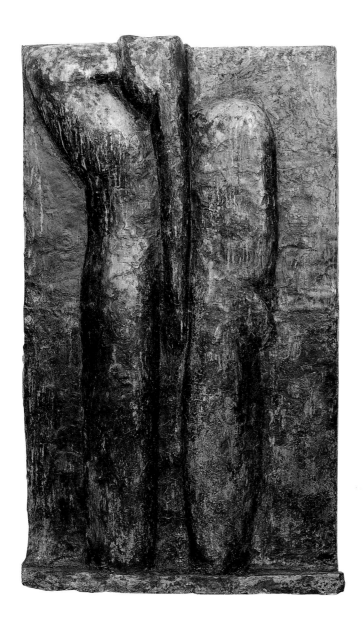

her legs. In *Large Nude*, the body is only slightly modeled; the volumes of torso and limbs derive mostly from the way they stand out against the dark shadings around them. Head and breasts become rounded geometries, and a single curve denotes the entire body from skull to folded right knee. The woman floats in an undetermined space, like a fetus in the womb. In *The Large Woodcut*, on the other hand, the body has a hard, angular linearity—in part a consequence of the graphic quality innate to the woodcut medium. (In making a woodcut, the artist carves the image into a wooden block, from which the print is made; a lithograph involves drawing on stone with a greasy crayon, allowing softer edges, more tonal variation, and more control.) The figure is distinguished from the space around it not only by its own lines but by the graphic markings with which that space is filled.

OPPOSITE, LEFT: Henri Matisse. *The Back, III.* 1916. Bronze, 6' 2½" x 44" x 6" (189.2 x 111.8 x 15.2 cm). The Museum of Modern Art, New York. Mrs. Simon Guggenheim Fund

OPPOSITE, RIGHT: Pablo Picasso. *Two Nudes.* 1906. Oil on canvas, 59⅝ x 36⅝" (151.3 x 93 cm). The Museum of Modern Art, New York. Gift of G. David Thompson in honor of Alfred H. Barr, Jr.

ABOVE, LEFT: Henri Matisse. *The Back, IV.* 1931. Bronze, 6' 2" x 44¼" x 6" (188 x 112.4 x 15.2 cm). The Museum of Modern Art, New York. Mrs. Simon Guggenheim Fund

ABOVE, RIGHT: Henri Matisse. *Standing Woman Seen from Behind* (Study for *The Back, I*). 1909. Pen and ink on paper, 10½ x 8⅝" (26.6 x 21.7 cm). The Museum of Modern Art, New York. Carol Buttenweiser Loeb Memorial Fund

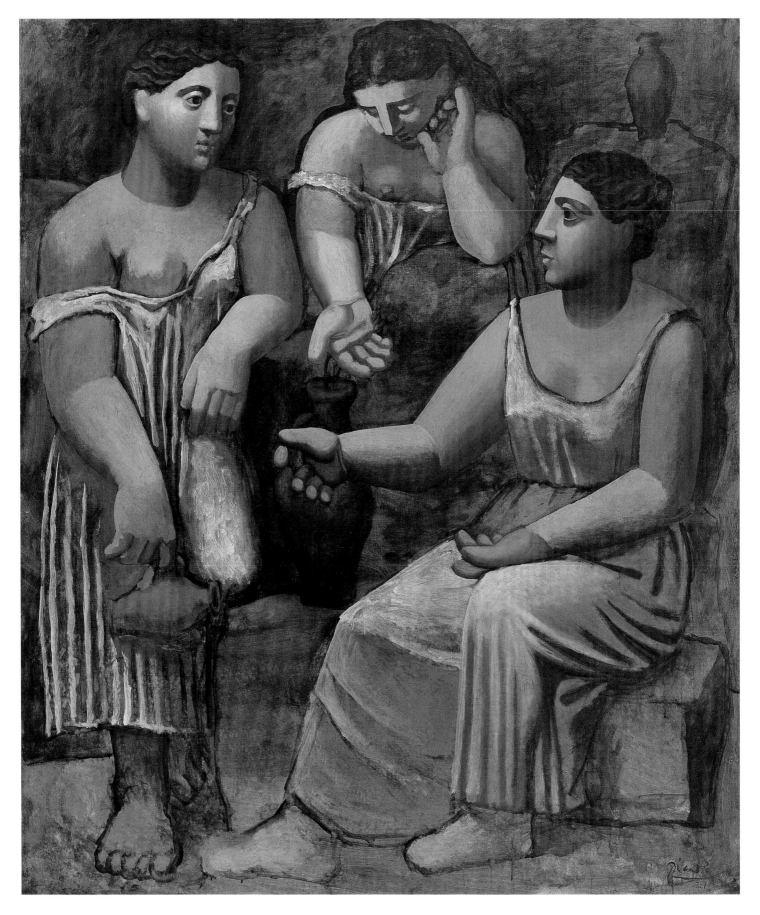

OPPOSITE: Pablo Picasso. *Three Women at the Spring*. 1921. Oil on canvas, 6'8¼" x 68½" (203.9 x 174 cm). The Museum of Modern Art, New York. Gift of Mr. and Mrs. Allan D. Emil

ABOVE: Aristide Maillol. *Desire*. 1906–08. Tinted plaster relief, 46⅞ x 45 x 4¾" (119.1 x 114.3 x 12.1 cm). The Museum of Modern Art, New York. Gift of the artist

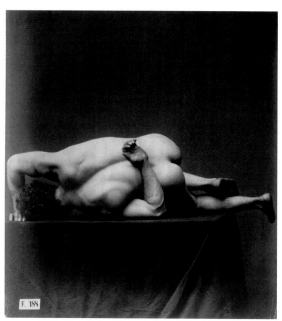

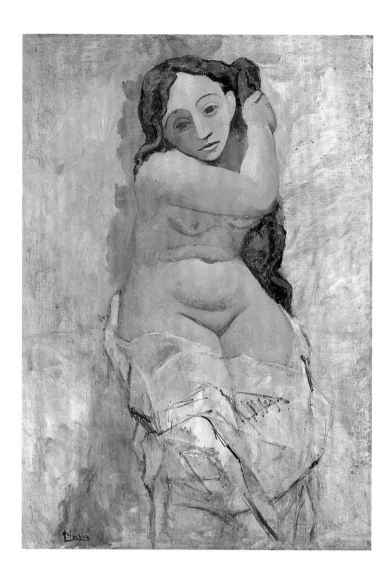

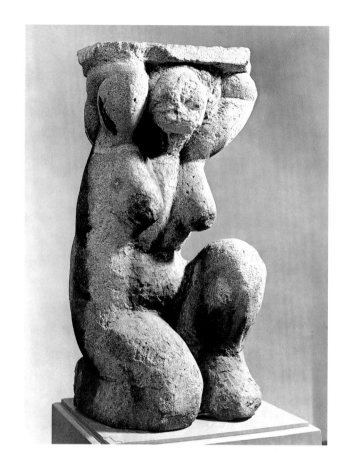

ABOVE, LEFT: Pablo Picasso. *Woman Plaiting Her Hair.* 1906. Oil on canvas, 50 x 35¾" (127 x 90.8 cm). The Museum of Modern Art, New York. Florene May Schoenborn Bequest

ABOVE, RIGHT: Amedeo Modigliani. *Caryatid.* c. 1914. Limestone, 36¼" (92.1 cm) high, at base 16⅜ x 16⅞" (41.6 x 42.9 cm). The Museum of Modern Art, New York. Mrs. Simon Guggenheim Fund

Amedeo Modigliani's *Caryatid* (1914; p. 123) is an image that makes pictorial use of each corner and edge of the sheet. A caryatid is an architectural element, usually a female figure, which carries weight as a column or pillar does; and Modigliani's figure braces its hands against the top of the page, as though trying to keep open the picture space by supporting its top. The head, too, bends downward and sideways, as if to avoid being crushed by this unseen weight. Like Matisse in *Large Nude,* Modigliani simplifies the body and its features into ovals and ellipses, examining the relation between figure and field instead of suggesting the physical attributes of any particular individual. A limestone sculpture from around the same time (above, right) is another caryatid; here the weight rests on the woman's shoulders rather than on her upturned hands, but otherwise the forms of the torso are similar. Abstracting the human figure, Modigliani distills it into a sequence of full and rounded shapes.

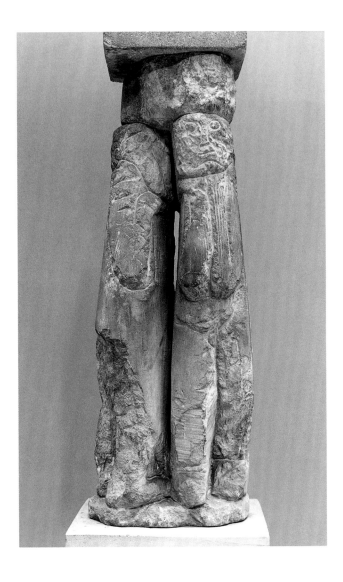

In *Double Caryatid* (c. 1908; above, left), Constantin Brancusi addressed the same architectural element, then made the reference literal by incorporating the work as part of the base for his marble *Magic Bird* (1910–12). The pair of limestone figures stands on a limestone block; their heads support another block of limestone, on which rests the sculpture itself. These torsos are far closer to the cylindrical form of the pillar than is Modigliani's kneeling figure, and their features, instead of being shaped out of swells and hollows in the stone, are a roughly incised linear design. Like Picasso in, for example, the masklike faces of *Two Nudes*, *Three Women at the Spring* (1921; p. 120), and *Woman Plaiting Her Hair* (1906; opposite), Brancusi asserts the qualities of ancient or "primitive" art. He also renders his caryatids not as voluptuous females but as forms barely distinguished from the stone of which they are made; instead of emerging from their limestone ground, they are unified with it.

LEFT: Constantin Brancusi. *Double Caryatid*. c. 1908. Limestone, 29⅝" (75.2 cm) high. The Museum of Modern Art, New York. Katherine S. Dreier Bequest

RIGHT: Constantin Brancusi. Study for *The First Step*. 1913. Crayon on paper, 32⅜ x 15" (82.1 x 38 cm). The Museum of Modern Art, New York. Benjamin Scharps and David Scharps Fund

HAMLET.

ACTORS

Dancers

BATHERS

Hamlet and Harlequin, like saints in historical paintings, identify themselves by their attributes, or personal emblems, the skull and the diamond-patterned costume respectively. But the characters portrayed by actors also, of course, make themselves known by their words and by expressive gestures that support and sometimes substitute for words. Hence, the association of acting and the art of figural representation, traditionally an art of silent, frozen theater that told stories by illustrating significant gestures and actions stopped at typically expressive moments. The Beggarstaffs' poster represents both a word and an action (holding a very significant prop) to make its subject doubly clear. Ironically, then, it has none of the famous indecision of its subject— just as Pablo Picasso's painting has none of the lighthearted, comedic associations of its subject, being severe and slightly sinister, as well as obscure. The theatrical association of the Picasso is, in fact, as much in its composition from planes like stage flats as in the patterned costume, which resembles geometric camouflage patterning that had just been introduced in World War I. And, although of a posterlike flatness and clarity of shape, the painting has to be scrutinized for its figural references, for example, for the fingers made from tiny black or white lines. Thus, the figure seems hidden in the composition. This is not so much a composition *of* a figure as a composition made *from* a figure. But so, in its own way, is the Beggarstaffs' poster. The works illustrated on the following pages similarly may be thought of as compositions made both *of* and *from* actors, dancers, bathers, and similar figures, for whom posing or performing is integral to what they do. Such figures, which compose themselves, have always lent themselves to be composed.

OPPOSITE, LEFT: The Beggarstaffs (William Nicholson and James Pryde). *Hamlet.* 1894. Stencil, 67⅜ x 28⅞" (171.1 x 73.3 cm). The Museum of Modern Art, New York. Gift of The Lauder Foundation, Leonard and Evelyn Lauder Fund, Jack Banning, and by exchange

OPPOSITE, RIGHT: Pablo Picasso. *Harlequin.* 1915. Oil on canvas, 6'¼" x 41⅜" (183.5 x 105.1 cm). The Museum of Modern Art, New York. Acquired through the Lillie P. Bliss Bequest

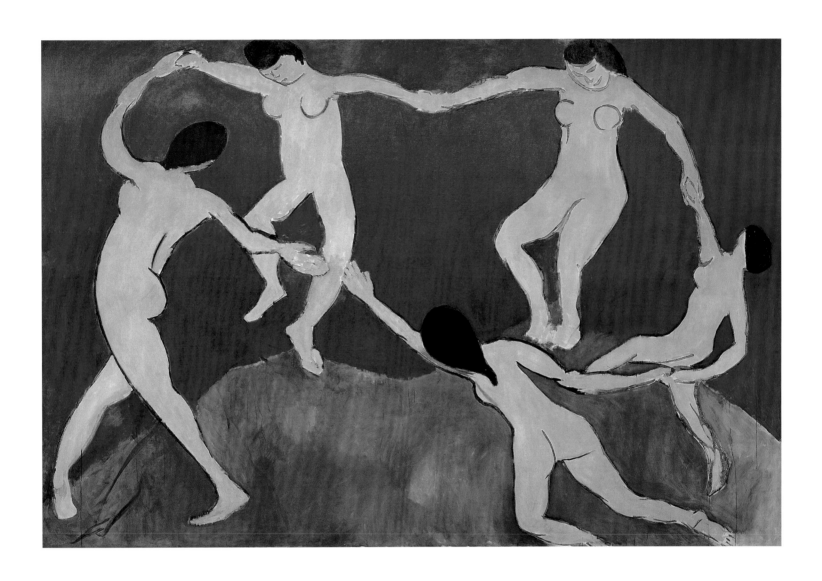

OPPOSITE: Auguste Rodin. *The Three Shades.*
1881–86. Bronze, 38⅜ x 36⅜ x 19½"
(97.3 x 92.2 x 49.5 cm). The Museum of
Modern Art, New York. Mary Sisler Bequest

ABOVE: Henri Matisse. *Dance* (First Version). 1909.
Oil on canvas, 8'6½" x 12'9½" (259.7 x 390.1
cm). The Museum of Modern Art, New York. Gift of
Nelson A. Rockefeller in honor of Alfred H. Barr, Jr.

ABOVE: Clarence White. *The Hillside.* c. 1898.
Platinum print, 7¹¹⁄₁₆ x 6¼" (19.6 x 15.9 cm).
The Museum of Modern Art, New York. Gift of
Mr. and Mrs. Clarence H. White, Jr.

RIGHT: Marcel Duchamp. *Two Nudes.* 1910.
Oil on canvas, 38⅞ x 31⅞" (98.9 x 81.8 cm).
The Museum of Modern Art, New York. Mary Sisler
Bequest

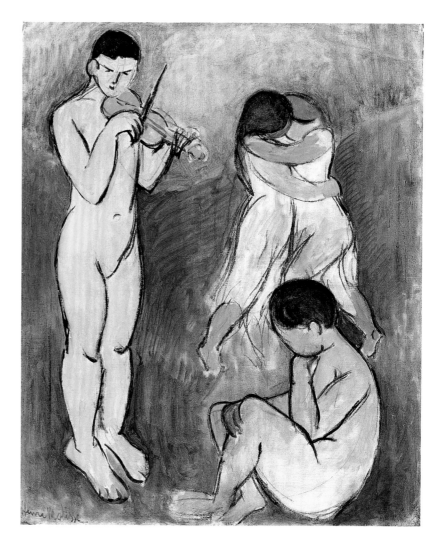

LEFT: Aristide Maillol. *Two Women.* 1900. Terracotta, 7⅜ x 5¼ x 2⅜" (18.7 x 13.2 x 6.1 cm). The Museum of Modern Art, New York. The William S. Paley Collection

ABOVE: Henri Matisse. *Music* (sketch). 1907. Oil and charcoal on canvas, 29 x 24" (73.4 x 60.8 cm). The Museum of Modern Art, New York. Gift of A. Conger Goodyear in honor of Alfred H. Barr, Jr.

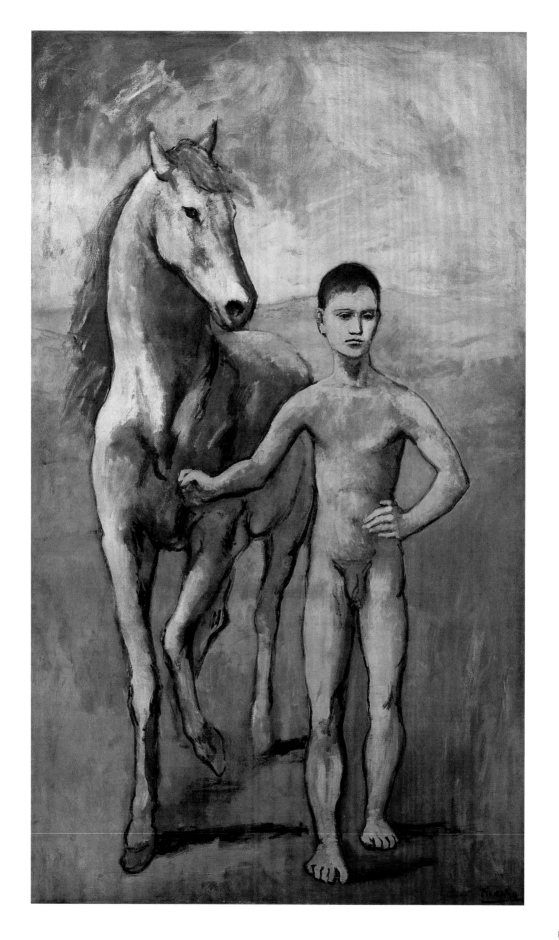

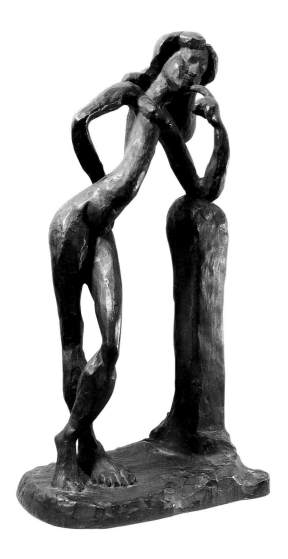

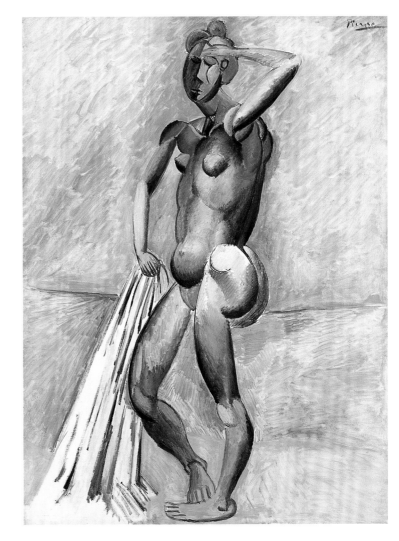

OPPOSITE: Pablo Picasso. *Boy Leading a Horse.*
1905–06. Oil on canvas, 7'2⁷⁄₈" x 51⅛"
(220.6 x 131.2 cm). The Museum of Modern
Art, New York. The William S. Paley Collection

ABOVE, LEFT: Henri Matisse. *La Serpentine.* 1909.
Bronze, 22¼ x 11 x 7½" (56.5 x 28 x 19 cm),
including base. The Museum of Modern Art,
New York. Gift of Abby Aldrich Rockefeller

ABOVE, RIGHT: Pablo Picasso. *Bather.* 1908–09.
Oil on canvas, 51⅛ x 38⅛" (129.8 x 96.8 cm).
The Museum of Modern Art, New York.
Louise Reinhardt Smith Bequest

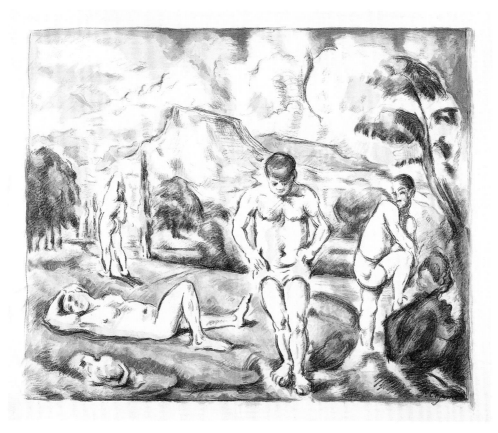

Paul Cézanne. *The Bathers, Large Plate.* 1896–97. Lithograph, comp.: 16¾ x 20¹¹⁄₁₆" (42.6 x 52.5 cm). Publisher: Ambroise Vollard, Paris. Printer: Auguste Clot, Paris. The Museum of Modern Art, New York. Lillie P. Bliss Collection

Bathers are ubiquitous in early modern art. The subject was treated by both prominent and obscure artists, by the avant-garde and the conservative, and to an extraordinarily diverse effect. Thus, the works illustrated on the following pages range from the starkly monumental, by André Derain (p. 137), to the whimsically decorative, by Félix Vallotton (p. 140), and from the conventionally mythological, by Aristide Maillol (p. 141), to the surprisingly topographical, by Edward Hopper (p. 141). Bathers usually meant female Bathers, of course, and the reasons for the popularity of this subject include the following.

First, it was an excuse for representing female nudes. Second, it was an excuse for a prurient interest in female nudes. Third, bathing had become popular not only as a therapeutic treatment, but also for pleasure. Consequently, bathing (and representations of Bathers) came to accrue both illicit sexual associations and, therefore, women's servitude, and the exercise of bodily liberation and, therefore, of women's rights. But bathing continued to serve (and bathers to symbolize) an increasing interest in cleanliness and hygiene in a culture where bathrooms were still very rare. Fourth, Bathers, however

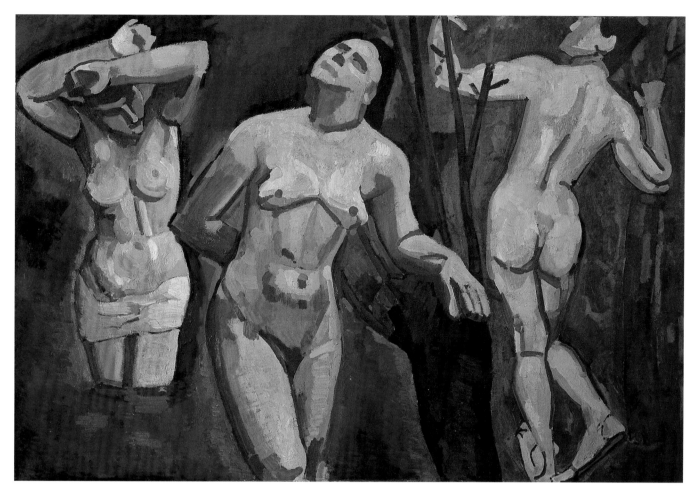

André Derain. *Bathers*. 1907. Oil on canvas, 52" x 6'4¾" (132.1 x 195 cm). The Museum of Modern Art, New York. William S. Paley and Abby Aldrich Rockefeller Funds

modernized or generalized, afforded a way of extending familiar themes in earlier classical or biblical paintings, or in so-called Orientalist images of usually North African women in often seductive poses. Therefore, they found a market in a period of increasingly specialized artistic production. Fifth, Bathers satisfied the wish for more conservative imagery in an artistic *rappel à l'ordre*, or call for traditional order, that had emerged in the 1880s and persisted into the early twentieth century to shape the subjects of even the most formally radical paintings. Sixth, Bathers afforded the possible combination not only of conservative subject and radical means, but also of narrative subject and means so radical as to make an engaging puzzle of the story. Seventh, Bathers allowed the combination of traditional subject and modern setting, and of traditionally noble subject and frolicking about in the water.

Examples that substantiate many of these explanations for the popularity of Bathers as subjects may be found on the following pages, and a more detailed account of two compositions of single bathers, made over a century apart, may be found on pages 144–45.

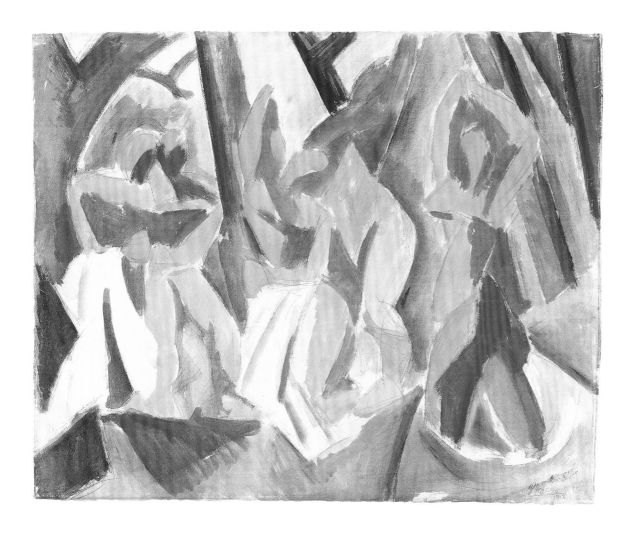

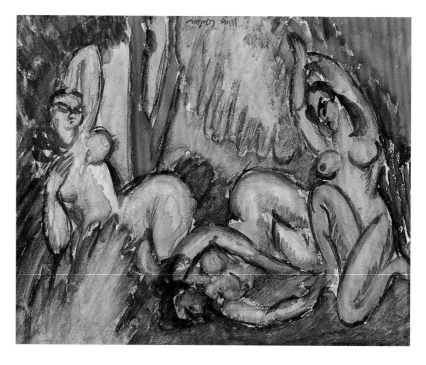

ABOVE: Pablo Picasso. *Bathers in a Forest.* 1908.
Gouache, watercolor, and pencil on paper, 18¾ x
23⅛" (47.5 x 58.7 cm). The Museum of Modern Art,
New York. Hillman Periodicals Fund

RIGHT: Max Weber. *Three Bathers.* 1909.
Gouache on paper, 7¼ x 8⅞" (18.6 x 22.7 cm).
The Museum of Modern Art, New York. The Joan
and Lester Avnet Collection

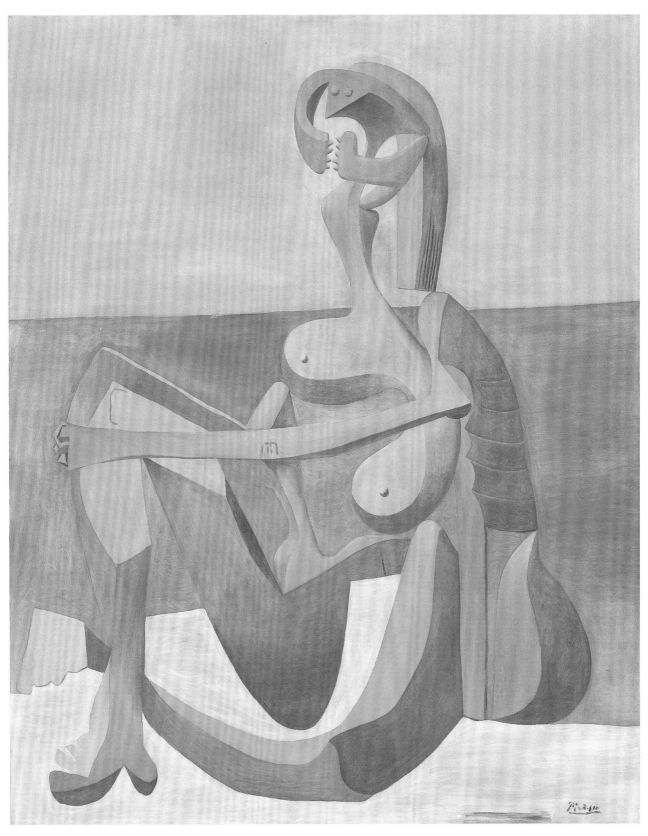

Pablo Picasso. *Seated Bather.* 1930. Oil on
canvas, 64¼ x 51" (163.2 x 129.5 cm).
The Museum of Modern Art, New York.
Mrs. Simon Guggenheim Fund

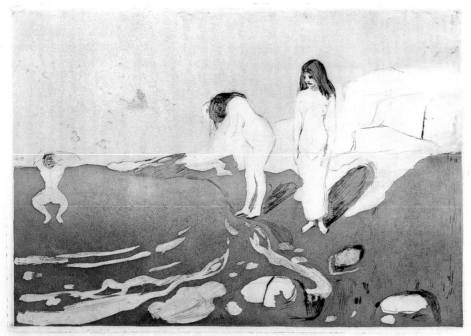

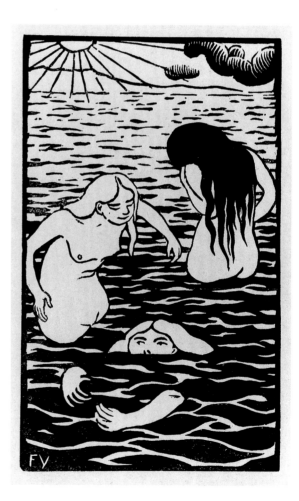

ABOVE: Edvard Munch. *Girls Bathing*. 1895.
Drypoint and etching, plate: 8¾ x 12¾" (22.2 x
32.3 cm). Edition: approx. 100. The Museum of
Modern Art, New York. Purchase

RIGHT: Félix Vallotton. *Three Bathers*. 1894.
Woodcut, comp.: 7³⁄₁₆ x 4⅜" (18.2 x 11.2 cm).
Publisher: Revue blanche, Paris. Edition: approx.
2,000. The Museum of Modern Art, New York.
Gift of Heinz Berggruen

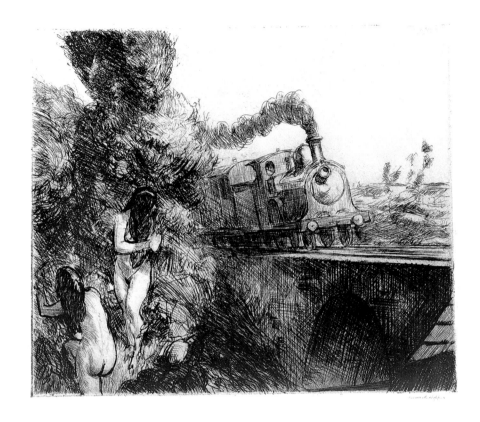

ABOVE: Edward Hopper. *Train and Bathers.*
1920. Etching, plate: 8¼ x 9⅞" (21 x 25 cm).
The Museum of Modern Art, New York. Gift of
Abby Aldrich Rockefeller

LEFT: Aristide Maillol. *Two Nude Bathers Under a
Tree at the Water's Edge.* 1895. Lithograph,
comp.: 10 x 12¹⁄₁₆" (25.4 x 30.6 cm). Edition:
100. The Museum of Modern Art, New York.
Given anonymously

Rineke Dijkstra. *Odessa, Ukraine. 4 August 1993*. 1993. Chromogenic color print, 46⅜ x 37" (117.8 x 94 cm). The Museum of Modern Art, New York. Gift of Agnes Gund

Paul Cézanne. *The Bather.* c. 1885. Oil on canvas, 50 x 38⅛" (127 x 96.8 cm). The Museum of Modern Art, New York. Lillie P. Bliss Collection

Artist unknown. *Standing Model*. c. 1860–80.
Photograph, 5½ x 3½" (14 x 8.9 cm). The Museum
of Modern Art, New York. Gift of Curt Valentin

Académies were originally academic exercises, representations of a posed nude or almost nude model. Then the term became applied to virtually any such representation that was not obviously pornographic or ethnographic, such as this ordinary, anonymous, later-nineteenth-century photograph of a standing model (at left).[1]

Although made from life in the studio, *académies* were frequently posed in imitation of figures in admired historical works of art, and their dual affiliation is often evident. Thus, the pose of this model joins a famous stance from classical Greek sculpture—neither walking nor standing but simply establishing a point of balance[2]—with a casual, relaxed arrangement of hands above hips, a conflation of the antique and the atelier. The result is at once monumental and matter-of-fact, both timeless and quotidian. Or, rather, the matter-of-fact and the quotidian seem as if overlaid upon, and, therefore, as if in the process of effacing, the monumental and timeless. The bodily image, frozen in its pose, appears also to be frozen in the process of a temporal transformation, as a once nobly expressive pose has become routine for a bored model in a cold studio. In consequence, the figure accrues a certain melancholy aspect—and an associated erotic aspect, for the pose has been deprived of meaning except with respect to its display of the body. The ancient pose raises the expectation of a great narrative composition; the present reality substitutes a nearly naked body—but that, too, is unreachable. We learn twice of the association of absence and desire in an image of what is doubly distant and unattainable.

Yet, this particular image has achieved an eerie topicality, for it so resembles a famous Bather by Paul Cézanne (pp. 136, 143) that we cannot but see it except through the artist's eyes. It is as if Cézanne is being imitated by his ancestor, as if time flows backward, allowing the modern artist to achieve priority over his past.[3]

Bathing, interestingly, is the subject of the very first image that we have of the youthful Cézanne,[4] and memories of his early, idyllic bathing expeditions stayed with him to the end of his life. In this sense, time does flow backward in his celebrated Bather compositions. For Cézanne, the Bather did not only mean the expected female Bather, but also the male Bather, a subject that carried more than a note of self-identification.

Cézanne's *The Bather* of about 1885 (p. 143) shows a young man whose image is thought specifically to derive from the aforementioned photograph.[5] Comparison with the photograph reinforces the antique-cum-atelier quality of the figural image and, therefore, the effect of it having been pasted onto the landscape, then both landscape and figure painted over indiscriminately in flat, hatched brushstrokes, using the same colors for each. The salmon-cream color of the beach, the emerald green of the grass, the denim blue of the sky, and the accents of cobalt blue, ocher, and gray-black that enliven the landscape and the water all compose, to a greater or lesser degree, the surface of the figure. And this figure of paint offers itself to us as a surface, just as the landscape of paint offers itself to us as painted on the surface of a backdrop close-up behind the figure. Both figure and landscape are horizontally banded surfaces, moreover, which cause one's eyes to move alternatively right to left and left to right while scanning up and down the tall painting. The effect is a bit like reading a text.[6]

It is interesting, then, that a principal awkwardness of detail that Cézanne took from the photograph is in the treatment of the arms and hands. In the photograph, the distorted foreshortening of the arms pushes the bleached, flattened torso forward of them,

while the fingers of the hands hold that thin plane rather like holding a large sheet of paper—which the figure itself (impossibly) is reading, and is holding out to us to read, too. Cézanne seized on this perceptual ambiguity. In his early, 1866 painting of his father reading the newspaper *L'Événement (The Event)*, we sense that the artist is offering us something momentous for our eyes to read. But if this picture is to be thought a projection of the artist onto the image of his youth,[7] then its reprise, and therefore replacement, of his father's image is bound to be significant.

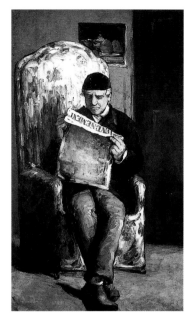

Paul Cézanne. *Portrait of Louis-Auguste Cézanne Reading "L'Événement."* 1866. Oil on canvas, 6'6¾" x 47¼" (200 x 120 cm). National Gallery of Art, Washington, D.C. Collection Mr. and Mrs. Paul Mellon

Dijkstra's *Odessa, Ukraine. 4 August 1993* is, like Cézanne's *The Bather*, a highly formalized, large modern work (p.142). But whereas *The Bather* shows what may be interpreted as a symbol, Dijkstra's photograph shows an individual—one who seems so forcefully awkward and vulnerable, as well as shamelessly sexual, very different indeed from the timeless solemnity of the Cézanne painting.

Yet, when Rineke Dijkstra photographed this anonymous youth, she produced an image not unconnected to something very basic to the sources, at least, of Cézanne's painting—the traditions of the *académie* and the Bather. Her photograph also raises the question: What can and will be projected by the beholder onto the image of a posed, nearly naked youth, both by the first beholder, the artist, and by subsequent beholders? Both the *académie* and the Bather are artistic inventions, traditional artistic subjects that present figures posed purely for the purpose of being viewed.[8] This being so, the poses of such figures cannot be said to be internally motivated, that is, cannot be said to be the result of any intention on the part of these figures. The intention, rather, is on the part of the artist who set the poses of these figures, which is why their poses often seem artificial, whether or not they are posed in imitation of earlier works of art. Yet, it is natural to attribute intention to the pose of a figure. So, a figure posed with no apparent internal intention except for the purpose of being viewed will seem to some viewers to have the intention only of exhibitionism. And the more apparently realistic the medium, the more apparently exhibitionist a figure posed purely for the purpose of being viewed can seem. Therefore, Dijkstra's photograph will eventually raise the disturbing possibility that the youth is there for self-exhibition, on display, and may be thought to be defiant as well as vulnerable, self-assured as well as awkward, knowingly erotic and willingly made into an object by being available to be viewed.

What, then, happened at Odessa in the Ukraine, on August 4, 1993? One of the few things that we can say for sure is that a photograph was taken there, and then a photograph that records the taking of a photograph. We are accustomed to think of a painting by Cézanne as offering the record of the process of painting. Is Dijkstra doing something similar to Cézanne after all? But this photograph that records the taking of a photograph also records the posing for a photograph, a performance of the subject of the photograph as well as of the photographer. In a popular seaside resort in the former Soviet Union, not long after its collapse, a Dutch photographer persuaded a youth to be photographed alone on the beach, and a photograph was made in which the defiance and vulnerability possibly of a new era but certainly both of adolescence and of posing for a photograph are recorded. That, at least, seems the most plausible account. Yet, this beautifully awkward moment is recorded in a description without a time or a place, in an uncommunicative solitude that provokes the anxiety, and the pleasure, of not quite knowing for certain what is happening, which maintain the entrancement before the work.

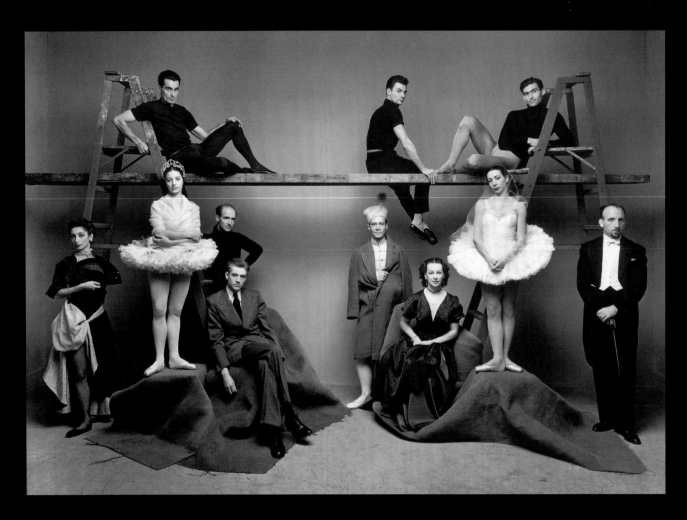

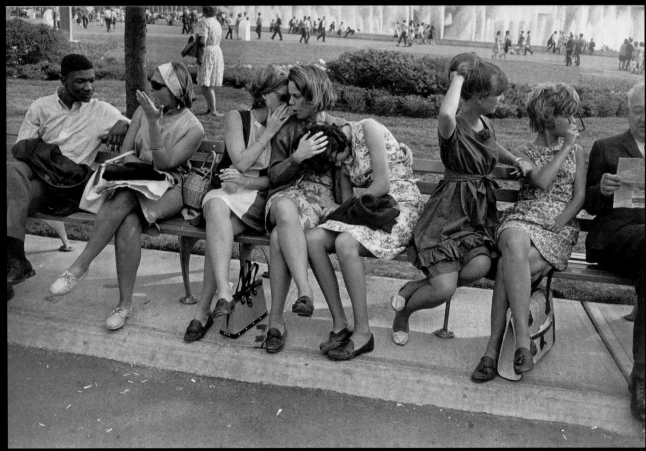

M. Darsie Alexander

POSED to UNPOSED:
encounters with the camera

Throughout the history of photography, posed subjects have comprised an essential category of human imagery. Posing occurs for many reasons: to commemorate a personal milestone, clarify a group affiliation, advertise a product, or dramatize a narrative. It is a means of controlling an image through specific choices related to props, setting, body language, facial expression, and arrangement of subjects. As such, it is based on an agreement, however tacit, between two or more parties.

In the early years of the medium, posing was a necessary function of having one's picture taken. The daguerreotype process, widely in use by the 1840s, required a large box camera that contained a copper plate covered with silver iodide, which reacted chemically upon exposure to light. After developing, the result was a unique, laterally reversed image on the polished metal, giving rise to the expression "mirror with a memory." Unfortunately, the success of the daguerreotype depended on sitters remaining absolutely still for periods of several minutes; often their heads were held in place by metal brackets. Photographers and subjects worked collaboratively to find positions that would be most flattering under these difficult circumstances, sometimes referring to guides and handbooks for advice.

Though the daguerreotype process was gradually replaced in the 1850s by glass negatives yielding paper positives, the technical improvement did not render picture making any easier. The wet-plate system, which was in use through the 1870s, involved a great deal of preparation and follow-through: a photographer had to photosensitize the plate and expose and develop it on-site. This laborious procedure was undertaken with heavy and awkward equipment, which greatly stifled the quest for spontaneity. If people were to be described with any degree of detail and accuracy, photographs had to be posed.

The first posed pictures were portraits of families and individuals. Having photographs made was a means to permanently memorialize loved ones, as evidenced in a picture from the 1850s by American George N. Barnard of four children seated against a satin backdrop (p. 148). Though it is difficult to imagine from a modern-day perspective, the idea that one's countenance could be forever recorded on a reflective surface was both a comfort and a revelation. For the first time, people could see exact transcriptions of the faces of friends and relatives in image form. Daguerreotypes were viewed as precious not only in their jewel-like appearance but as objects of deep personal significance.

OPPOSITE, TOP: Irving Penn. *The Ballet Theater, New York.* 1947. Gelatin silver print, 13¾ x 19⅜" (34.9 x 49.2 cm). The Museum of Modern Art, New York. Gift of Condé Nast Publications

OPPOSITE, BOTTOM: Garry Winogrand. *World's Fair, New York City.* 1964. Gelatin silver print, 8⅝ x 12⅞" (21.9 x 32.7 cm). The Museum of Modern Art, New York. Gift of N. Carol Lipis

The integration of photography into the rituals of family life has inspired many forms of posing, be it for a spur-of-the-moment snapshot at a graduation or a formal wedding portrait. In 1930 Martín Chambi was hired to document the marriage of Don Julio Gadea. Chambi was known throughout the elite of Cuzco for his sensitive approach to portraiture, which is illustrated by his photograph of the Gadea wedding party. Chambi posed his subjects within a domestic environment to create the effect of a procession that has been temporarily halted. Bride and groom emerge from the darkness to stand in a strong and enveloping light, as friends and family wait inside the threshold of an entryway in the background. Among the most striking features of this composition is its somber mood; virtually no one smiles. The mysterious ambiance, accentuated by contrasts of light and shadow, is unlike modern-day conventions of wedding portraiture, which idealize moments of utmost happiness and familial harmony.

The commemoration of social or professional affiliations is the function of many posed photographs. James Van Der Zee, a popular studio photographer in Harlem, opened his doors in 1917 to a clientele of predominantly middle- and upper-middle-class New York residents. Inspired by fashion, film, and magazines, Van Der Zee realized the power of the pose to create an image of status and economic privilege. For *Unity Athletic*

ABOVE: **George N. Barnard. Untitled. 1850s. Hand-tinted daguerreotype, 4¼ x 5½"** (10.8 x 14 cm). The Museum of Modern Art, New York. Gift of Mrs. Armand P. Bartos

BELOW: **Martín Chambi. *Gadea Wedding.* 1930. Gelatin silver print, 9⁷/₁₆ x 12⁷/₈"** (24 x 32.7 cm). The Museum of Modern Art, New York. Gift of the Vera Louise Fraser Estate

OPPOSITE: **James Van Der Zee. *Unity Athletic and Social Club, Inc.* 1926. Gelatin silver print, 7¾ x 9¹⁵/₁₆"** (19.7 x 25.2 cm). The Museum of Modern Art, New York. Samuel J. Wagstaff, Jr. Fund

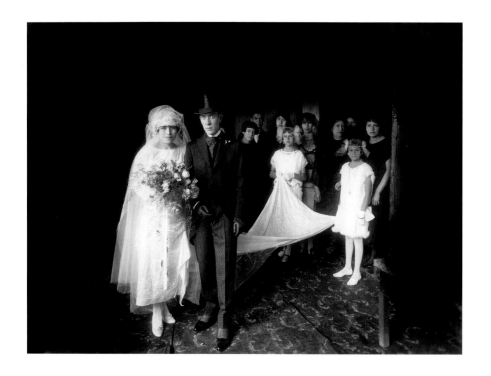

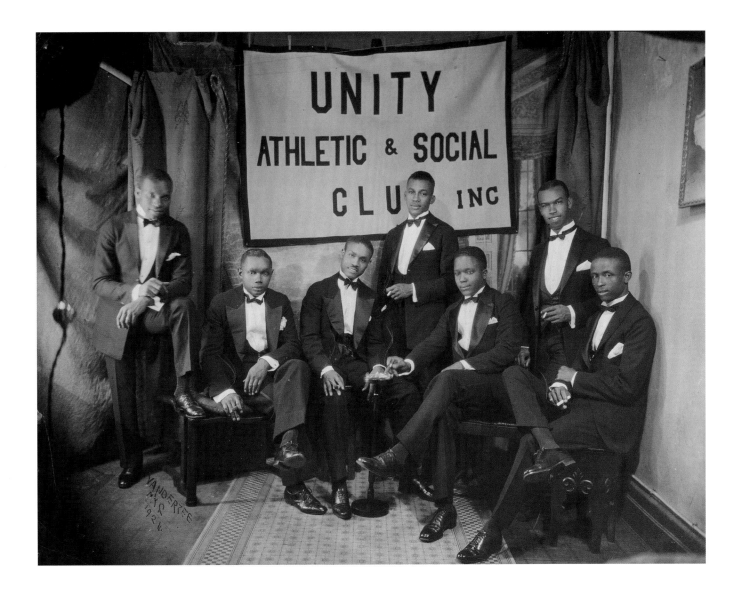

and Social Club, Inc., of 1926, every detail was carefully plotted to support the sought-after effect: the choice of apparel, the configuration of the subjects, and their individual postures and gestures. The men, in matching black tuxedos, were arranged to convey an attitude of relaxed elegance, with legs crossed and cigars or cigarettes casually balanced in their fingers. A studio lamp, visible along the left edge of the picture, casts a dramatic light on the sitters, adding to the artifice of glamour affected in this image.

Photographers who document social conditions have also manipulated poses, even when this compromises the supposed "truthfulness" of an image. Dorothea Lange worked for the Farm Security Administration, a division of the United States Department of Agriculture, which undertook an extensive campaign to photograph the hardships of rural life in Depression-era America. Focusing on the plight of migrant laborers, Lange created images that would broaden awareness and stimulate aid to rural workers. In two photographs from 1937 of the same group of unemployed tenant farmers (p. 150), Lange experimented with the potential of different poses to illustrate the strength of hardworking men yet also suggest their misfortune. In one photograph, the figures stand against the backdrop of a rustic house, confronting the camera with their collective gaze. In a second composition, the crouching figures look in slightly different directions, each seemingly lost in his own thoughts. Taken a full thirty minutes after the first picture, this photograph raises provocative questions: did the subjects adjust their stance on their own, or was the rearrangement something Lange contrived in order to create another, perhaps more psychologically compelling, portrait? A comparison of the two works also

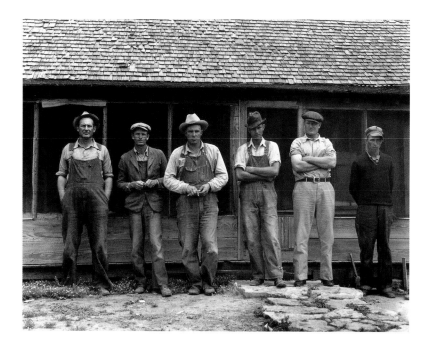

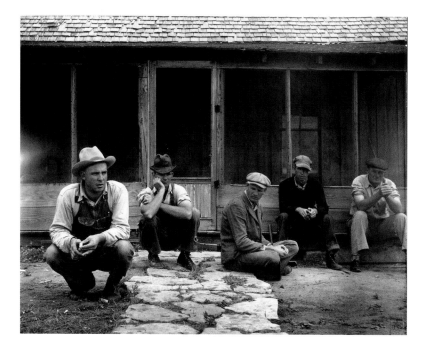

reveals that Lange cropped the second image to eliminate a figure. She might have felt that paring down the composition would intensify its effect. Yet when Lange reprinted the image in the 1960s, she restored the farmer to his original place among the group.

Working decades earlier, both Peter Henry Emerson and Frances Benjamin Johnston employed rigorous methods to pose their subjects in narrative photographs that illustrate the lives and labors of specific regional and ethnic groups. Emerson, a physician by training, documented the rural populations of England's East Anglia in consciously artistic compositions derived from the styles of nineteenth-century Realist painters such as Jean-François Millet. Emerson's photographs depict men and women working the land—tilling soil, picking berries, and reaping the harvest. Though based on the actuality of the subjects' daily existence, his images draw upon themes of heroism and dignity through the use of symbolic poses. For example, *The Barley Harvest, Suffolk* (p. 152), published in 1888, represents human fatigue and stoic determination through carefully chosen gestures. A seated man is about to quench his thirst, while another sharpens his scythe for further toil. Like Emerson, Johnston was interested in "active" poses that would suggest her subjects' virtuous qualities. Johnston, who photographed America's coal miners as well as its aristocrats, embarked upon a commissioned project for The Hampton Institute, a school dedicated to the proper education and vocational training of African and Native Americans. In 168 pictures made in 1899 and 1900 (p. 153), well-dressed, well-mannered students are arranged in tableaulike configurations to represent a balanced life of study, work, and relaxation.

Photographs that demonstrate a more casual encounter between subject and visual recorder began to appear in the late nineteenth century. In 1888 George Eastman of Rochester, New York, marketed a camera that was small, hand-held, and easy to use, permitting pictures to be taken under a wide variety of conditions. With its rapid-advance mechanism, the 35mm Leica, which became available to the public in 1925,

ABOVE: Dorothea Lange. *Six Tenant Farmers without Farms, Hardeman County, Texas.* 1937. Gelatin silver print, 12⅞ x 15½" (32.7 x 39.4 cm). The Museum of Modern Art, New York. Purchase

BELOW: Dorothea Lange. *A Half-Hour Later, Hardeman County, Texas.* 1937. Gelatin silver print, 10³⁄₁₆ x 13½" (25.9 x 34.3 cm). The Museum of Modern Art, New York. Purchase

OPPOSITE: Arthur Mole and John D. Thomas. *The Human U.S. Shield: 30,000 Officers and Men. Camp Custer, Battle Creek, Michigan.* 1918. Gelatin silver print, 12¾ x 10⁵⁄₁₆" (32.4 x 26.2 cm). The Museum of Modern Art, New York. Gift of Ronald A. Kurtz

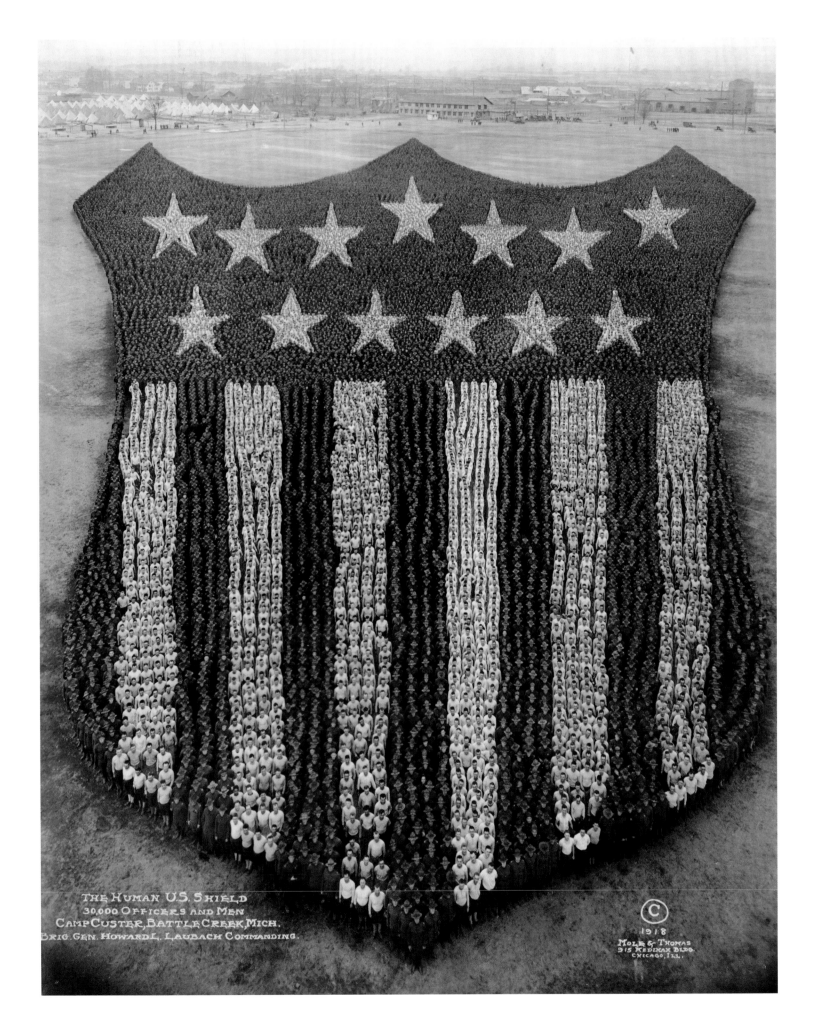

THE HUMAN U.S. SHIELD
30,000 OFFICERS AND MEN
CAMP CUSTER, BATTLE CREEK, MICH.
BRIG. GEN. HOWARD L. LAUBACH COMMANDING.

© 1918
MOLE & THOMAS
915 MEDINAH BLDG
CHICAGO, ILL.

improved the efficiency of the hand-held camera and allowed photographers to shoot successive frames very quickly. It was also extremely compact, which engendered greater freedom in the picture-taking process. Photographers began to approach their subjects from an unlimited range of positions, using their mobility to capture the flow of everyday life.

As a consequence of these technological changes, which enabled subjects and photographers to respond instantaneously to one another, a new form of posing emerged. To "strike a pose" a subject freezes in a theatrical attitude directed at the camera. In a photograph by Helen Levitt from around 1940 (p. 154), for example, two boys make exaggerated gestures that evoke the dramatic poses of great actors or orators. Although people respond in many ways to being photographed, subjects who act or mug for the camera adopt outward personae that reveal little of themselves to scrutiny.

At the same time, by striking poses they may manifest sides of their personalities that are not readily apparent in the course of everyday life. Thus for one person a pose might serve as a protective strategy or smoke screen, and for another disclose personality traits that are normally concealed.

In *Alicante, Spain* of 1933 (p. 154) by Henri Cartier-Bresson, three people respond to the photographer's assertive presence by configuring themselves into a bizarrely twisting arrangement that is both graceful and disturbing. As they turn to look into the lens of his 35mm camera, they lean into one another, hands and bodies forming a circular flow of contact. To the left, a woman raises a blunt knife to her companion's neck in a pseudo-menacing gesture. Like other photographs by Cartier-Bresson, this one is full of ambiguities: who are these subjects, and what are they attempting to convey by their actions? Inspired by Surrealism's attention to uncanny occurrences

and odd juxtapositions, Cartier-Bresson extrapolated fragments of the visual world through cropping, framing, and foreshortening to create enigmatic compositions stripped of all spatial and narrative context.

The features of hand-held cameras have had radical implications for the creation of unposed photographs, which record the subtle and unexpected effects of life in motion. With lighter and smaller equipment, photographers can document human activity surreptitiously, acting like spies and voyeurs. During the 1890s, for example, Arnold Genthe wandered the streets of San Francisco's Chinatown with a small Zeiss camera hidden beneath his jacket, a strategy that allowed him to observe a wide range of unmediated everyday phenomena from the position of inconspicuous bystander (p. 157).

The work of Jacques-Henri Lartigue embodies the qualities of immediacy and chance that characterize unposed

OPPOSITE: **Peter Henry Emerson.** *The Barley Harvest, Suffolk,* from *Pictures of East Anglian Life.* 1888. Photogravure, 9⅜ x 9½" (23.8 x 24.1 cm). The Museum of Modern Art, New York. Purchase

ABOVE: **Frances Benjamin Johnston.** *Geography. Studying the Seasons.* 1899–1900. From *The Hampton Album.* Platinum print, 7½ x 9⁹⁄₁₆" (19.1 x 24.3 cm). The Museum of Modern Art, New York. Gift of Lincoln Kirstein

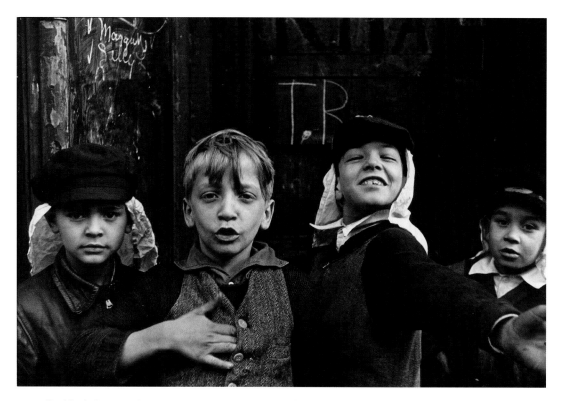

ABOVE: Henri Cartier-Bresson. *Alicante, Spain.* 1933. Gelatin silver print, 10¼ x 15³⁄₁₆" (26 x 38.5 cm). The Museum of Modern Art, New York. Gift of the photographer

BELOW: Helen Levitt. *New York.* c. 1940. Gelatin silver print, 8¹⁵⁄₁₆ x 13¼" (22.7 x 33.7 cm). The Museum of Modern Art, New York. Gift of the photographer

OPPOSITE, TOP: Joel Meyerowitz. *Paris.* 1967. Gelatin silver print, 9¹⁄₁₆ x 13½" (23 x 34.3 cm). The Museum of Modern Art, New York. Purchase

OPPOSITE, BOTTOM: Weegee (Arthur Fellig). Untitled. 1942. Gelatin silver print, 10⁵⁄₁₆ x 13³⁄₁₆" (26.2 x 33.5 cm). The Museum of Modern Art, New York. The Family of Man Fund

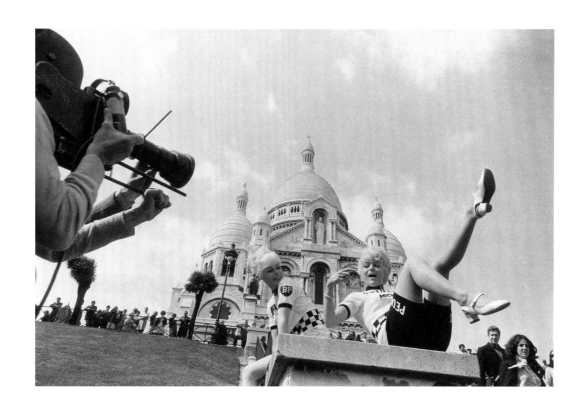

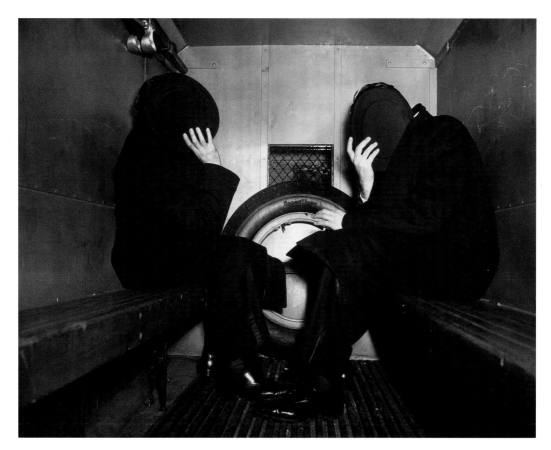

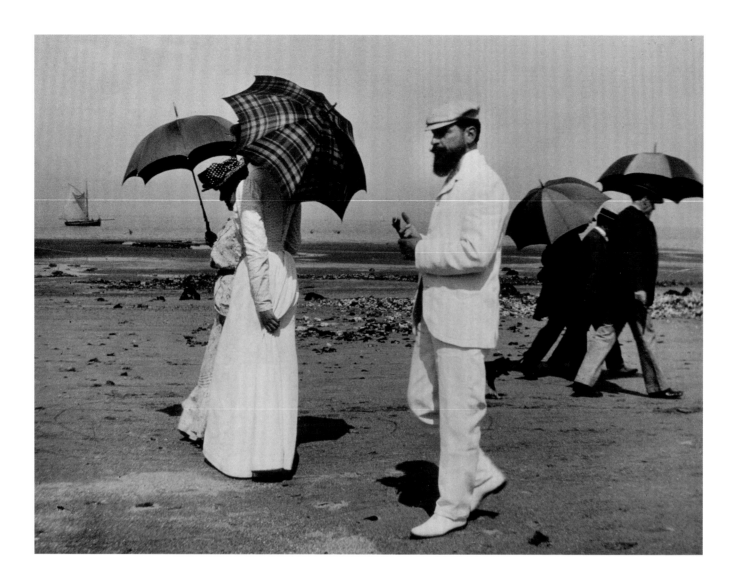

photographs. When he began to photograph as a young boy, it was because he wanted to document the action of his life: bicycle races, jumping contests, speeding cars. Drawn to movement of any variety, Lartigue was always ready to record its many permutations with his Block-Notes camera. Taken in 1908 when he was a teenager, a picture showing an afternoon stroll becomes a record of flux in *The Beach at Villerville*. In the foreground, a man absentmindedly clasps his hands as a woman turns to view a boat on the horizon. Further back, three men in black recede as they exit the frame of the image. This picture captures a sense of passing, not only of people but of time. It is as if everything is about to shift: bodies, gestures, light. A fragment of life, this picture could never be reenacted.

The work of Americans Tod Papageorge and Garry Winogrand is the product of an intense observation of the world and an acute ability to respond instantaneously to its unpredictable, humorous, and tragic manifestations. In the 1978 *Alice in Wonderland* (p. 159) by Papageorge, the sight of a figure (whose gender is unclear) perched on a bronze sculpture that commemorates a storybook heroine is evidence of the odd and momentary occurrences of life in the city. The strange scale of the people in relation to the sculpture, the mingling of animate and inanimate body parts, and the playful surrounding activity mimic the peculiar events of Lewis Carroll's tea party. In the foreground, a little boy kneels amid

ABOVE: Jacques-Henri Lartigue. *The Beach at Villerville*. 1908. Gelatin silver print, 10½ x 13¾" (26.7 x 35 cm). The Museum of Modern Art, New York. Purchase

OPPOSITE, TOP: Manuel Alvarez Bravo. *Conversation near the Statue*. 1933. Gelatin silver print, 7 x 8¾" (17.8 x 22.2 cm). The Museum of Modern Art, New York. Mr. and Mrs. Clark Winter Fund

OPPOSITE, BOTTOM: Arnold Genthe. *Street of Gamblers* (Chinatown, San Francisco). 1896 or later. Gelatin silver print, 9¾ x 11⅞" (24.8 x 30.2 cm). The Museum of Modern Art, New York. Gift of Albert M. Bender

a display of mysteriously placed objects—including a hat, tin pot, and rubber mask—lost in his own imaginary tale. Winogrand viewed public space as a kind of theater comprising many small dramas. In *World's Fair, New York City* of 1964 (p. 146), a park bench becomes a stage where secrets are shared, conversations sparked, and curious looks advanced. In addition to the physical description the work provides—the pattern of legs, the leans and whispers—it also alludes to broader human relationships and suggests the coexistence of two parallel worlds: the specific and intimate reality of the women clustered on the park bench and the anonymous presence of the crowds visible in the distance.

Overtly posed compositions contrast sharply with the complex and subtle language of the body when caught unawares. In posed works, gesture, facial expression, and comportment are encoded to relay specific meanings and messages. However, when subjects are pictured outside the controlled environment of a studio or a set-up environment,

ABOVE: Thomas Roma. Untitled, from the series *Come Sunday*. 1991–94. Gelatin silver print, 9¼ x 12⅝" (23.5 x 32.1 cm). The Museum of Modern Art, New York. Christie Calder Salomon Fund

BELOW: Henry Wessel. Untitled. 1977. Gelatin silver print, 9⅞ x 14¹⁵⁄₁₆" (25.1 x 38 cm). The Museum of Modern Art, New York. Joseph G. Mayer Fund

OPPOSITE: Tod Papageorge. *Alice in Wonderland*. 1978. Gelatin silver print, 18⅝ x 12¼" (47.3 x 31.1 cm). The Museum of Modern Art, New York. Gift of Robert L. Smith

their body language is often determined by the unforeseen conditions of the moment. The subjects' reactions to these conditions may be immediately recognizable; in an image from the 1991–94 series *Come Sunday* (p. 158) by Thomas Roma, for example, a parishioner stands with his eyes closed and his arms raised, a posture that quickly registers as a sign of surrender and devotion to God. However, body language is not always so easily read. The 35mm camera can stop movement at any juncture, be it climactic or incomplete. Cartier-Bresson often photographed transitional scenes in which gesture was linked to unfolding and often indeterminate action. Though body language is no less important in influencing the interpretation of his pictures, its effect can be to further a sense of ambiguity.

The photographs of Chris Killip and Sheron Rupp communicate the uninhibited attitudes of people intensely absorbed in their activities. In Killip's 1988 photograph (p. 161) of slam dancers at a club in Newcastle, England, chaotic movement consumes a couple of skinheads and provides the basis for a powerful figural composition defined by the bold lines of human anatomy. Likewise, the configuration of bodies in Rupp's work is determined by the subjects' concentrated activity. While on vacation at a campsite in Bayside, Ontario, in 1995, Rupp was captivated by the striking physical likenesses within a family and asked to photograph them. In exchange for their compliance, she took several Polaroids of the group. The photograph illustrated here (p. 161) revolves around the act of looking: as the adults assemble to study the Polaroid pictures of themselves, a boy admires his truck and a little girl assiduously puts false nails on her fingertips. Though the entire group is fully aware of Rupp, only one of them, a boy in the foreground, acknowledges her presence by staring directly into the lens of the camera. As such, he provides a point of contact and entrance for the viewer.

In recent years, the associations of unposed (quick, fleeting, surreptitious) and posed (controlled, preconceived, agreed upon) have merged in photographs that have the casualness of snapshots but were in fact carefully planned. Pictures of friends and family by Tina Barney (p. 163) seem to stem from of-the-moment encounters, as if Barney had happened upon her subjects and photographed them with a simple click

OPPOSITE, TOP: Sheron Rupp. *Untitled (Bayside, Ontario, Canada)*. 1995. Chromogenic color print, 25⅞ x 32" (65.7 x 81.3 cm). The Museum of Modern Art, New York. E. T. Harmax Foundation Fund

OPPOSITE, BOTTOM: Chris Killip. Untitled. 1988. Gelatin silver print, 15 x 18½" (38.1 x 47 cm). The Museum of Modern Art, New York. The Family of Man Fund

of the shutter. Her process, however, involves a large view camera and sophisticated lighting equipment, the use of which requires considerable labor and forethought. To create her pictures, Barney begins by taking note of her surroundings—what people are doing, how their bodies are interacting, and the quality of light, form, and color. When she has identified a scene, she positions her camera and then often directs her subjects to hold still, repeat an action, or move in a certain way. Barney's strategy of observation and intervention is one that many photographers employ to varying degrees. Rupp's bathers, for example, would not have gathered as they did if the artist had not provided the incentive to do so. Thus, distinguishing between posed and unposed in photographs is complicated by the subtle effects of staging that are incorporated into seemingly impromptu compositions.

The different methods a photographer can employ—posing one's subjects versus responding instantaneously to a rapid influx of visual stimuli—appear to result from antithetical strategies of artistic control. Highly posed photographs—such as works by Van Der Zee—reveal a deliberate contrivance in the way subjects hold particular postures and in the careful arrangement of the overall environment. Unposed photographs, by contrast, are comparatively spontaneous, derived from the chance occurrences of life. Under these circumstances, a picture is composed by manipulating specific photographic devices: isolating subjects from a particular perspective, stopping action at a precise moment, or distorting and exaggerating details through selective focus. But as Barney has shown, the strategies that differentiate posed from unposed very often overlap, eliciting further consideration of both categories. At what point does a photographer's intervention transform a "natural occurrence" into a posed scene? When does observation give way to manipulation? How much posing underlies even the most casual-looking pictures? Sometimes a photograph provides enough visual evidence to suggest answers to these questions, but often the subtle human interactions that underlie an image's construction are known only to the scene's participants.

LEFT: Larry Fink. *Hungarian Debutante Ball, New York City.* 1978. Gelatin silver print, 14¾ x 15⅟₁₆" (37.5 x 38.3 cm). The Museum of Modern Art, New York. Acquired with matching funds from the Frank Strick Foundation and the National Endowment for the Arts

OPPOSITE: Tina Barney. *Sunday New York Times.* 1982. Chromogenic color print (Ektacolor), 47½ x 60⅞" (120.7 x 154.6 cm). The Museum of Modern Art, New York. Anonymous gift

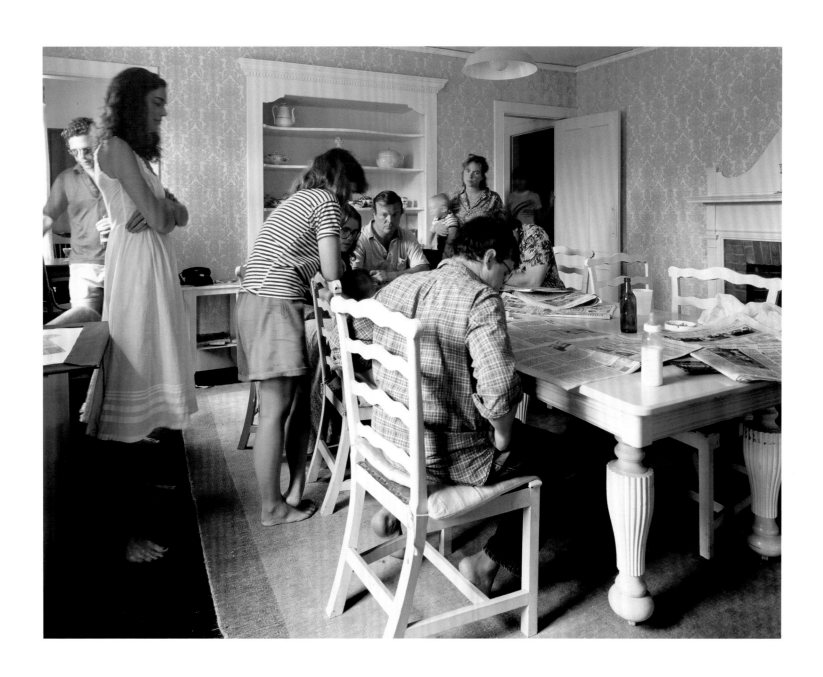

PLACES

Maria Fernanda Cardoso
Cementerio–Vertical Garden

Maria Fernanda Cardoso's subject is nature. *Cementerio–Vertical Garden* is a single wall with pencil line drawings and plastic flowers. It has been excerpted from a room-sized installation, which was originally created in 1992, and expanded in length. As in all of her work, nature is decontextualized and thus transformed in a way that is inspired by Minimalist art of the 1960s and 1970s, only with more evocative, symbolic connotations.

Clusters of artificial white flowers jut out some one and a half to two feet, in an apparently random arrangement, from a wall approximately 12 feet high and 112 feet long at The Museum of Modern Art. Seemingly growing from the architecture, the flowers are affixed into holes drilled into the wall. Before they are attached, the wall looks as if it is riddled by machine-gun fire, the artist has said. On closer inspection, we see that the wall is marked with subtle pencil drawings of arches, two by two feet in size and spaced about five inches apart. These drawings refer to a necropolis, or city for the dead, with mausoleums tightly packed together and niches along some of the walls with vases for freshly cut or plastic flowers. These cemeteries are traditional to Latin American and Southern European countries; there are many in the artist's native Colombia, where she was born in 1963. In fact, the artist had a studio near Bogotá's Cementerio Central, which became infamous in the 1950s as the site where the bodies of victims of urban violence were laid out for identification. Such violence was continuing when Cardoso created the original installation. She, nevertheless, has described the Cementerio Central as "a peaceful place to visit, with whitewashed walls, mausoleums, crypts, and cast-bronze, marble, and sandstone plaques."[1]

She describes her *Cementerio–Vertical Garden* as "preserved, frozen in life forever, in a particular moment of existence." Whether or not one is aware of her cultural context, there will be the sense of a garden that never decays, where nature is perfect and idealized. And there will surely be the shock of its artificiality—surprising even in a museum setting—and the shock of its verticality, as well as the pleasure of what Cardoso hopes is "the experience of extreme beauty, the unashamedly beautiful—white, beautiful, and pure."

—MARIA DEL CARMEN GONZÁLEZ

Maria Fernanda Cardoso. *Cementerio–Vertical Garden.* 1992. Artificial flowers and pencil on wall, dimensions variable; 11' 7" high, 112' wide (353.1 cm high, 3,413.8 cm wide) in current installation. Collection the artist

PREVIOUS TWO PAGES AND OPPOSITE: Details of the work on view at the Museo de Arte Moderno Sofía Imber, Caracas, Venezuela, 1992

Piet Mondrian. *Pier and Ocean 5*. 1915. Charcoal and white gouache on buff paper,
34⅝ x 44" (87.9 x 111.8 cm). The Museum of Modern Art, New York.
Mrs. Simon Guggenheim Fund

Mary Chan

Maria del Carmen González

Modern Places
the country and the city

Piet Mondrian said that *Pier and Ocean 5* of 1915 was inspired by the experience of walking at night on the beach at Domburg, on the North Sea coast of The Netherlands, and seeing the stars reflected in the water.[1] This picture, therefore, forms an unlikely counterpart to Vincent van Gogh's famous view of a Provençal town, his *Starry Night* of 1889 (p. 203). In the twenty-six years between the two paintings, much had changed. Van Gogh's painting offers a highly emotional account of the natural world in swirling, organic patterns of paint. Mondrian's work, by contrast, reduces the ocean's waves and reflections into a pattern of vertical and horizontal lines, and the pier is tilted up to the vertical, as if the viewer were looking down on the scene. Even without knowing that Mondrian made the work after leaving Paris for a visit to his native Holland, where he was trapped by the outbreak of World War I, we would understand that this geometric version of nature is informed by the urban experience. It is, in fact, informed not only by his artistic experiences of the city itself—Mondrian had depicted the facades of churches and other buildings—but also by the Cubism of Pablo Picasso and Georges Braque, a style formed in the city and devoted to the urban environment. Mondrian's *Pier and Ocean 5* may, therefore, be thought to show the country as seen through city eyes and a city vocabulary. Alternatively, it may be thought to show a city viewpoint and a city language stretched by a vision of nature unavailable to people living in cities.

With respect to depictions of places, the forty-year period covered by Modern*Starts*, 1880–1920, divides roughly into two. The first twenty years are dominated by pictures of the country; the second twenty years by depictions of the city. There are many exceptions to this generalization, of course, but, by and large, images of the country gave way to images of the city as modern art found its characteristic means of expression. This is not to say, however, that the early images of the country are only "about" the country; like Mondrian's *Pier and Ocean 5*, they carried from city to country their forms of expression and, thus, some of their meanings. Conversely, when the city became the principal subject of modern art, the forms and the meanings of its representations were affected by the vocabularies of expression that they inherited from the rural past.

Portrayals of nature have historically been interpreted as correctives to the spiritual degradation and materialistic concerns of urban life. European landscape painting, in particular, has consistently been informed by a reaction against the growth of cities and the subsequent encroachment of civilization. This antiurban sentiment became especially strong during the industrial revolution of the nineteenth century, as increasing

171

numbers of rural workers left home to seek employment in factories, thereby irradicably altering the economy of, and patterns of living in, the countryside. From 1851 to 1856, the population of Paris rose by 305,000—a number equal to one half of the births for all of France over the previous decade—as a direct result of the rampant depopulation of the countryside.[2] European writers and artists alike addressed this social phenomenon, among them, Charles Dickens, whose novels reflect the flux between the polarized entities of city and country. While the Victorian mind-set viewed the burgeoning industrial centers as indicators of moral decay and cultural demise, it simultaneously came to uphold the country as a bucolic place of untainted purity. The country/city dichotomy—organic versus inorganic, natural versus unnatural—was more easily expressed in literary narrative than in visual arts. Nevertheless, in pictorial representations of rural subject matter, the invariable idealization of the country reflects attitudes toward the city as well.

Escape from the modern world, whether to actual geographic sites, imaginary realms, or the domestic sphere, was a major theme in the visual arts of the late-nineteenth to early-twentieth centuries. The literal retreat to the countryside is explored in the essays "Changing Visions: French Landscape, 1880–1920" and "Landscape as Retreat: Gauguin to Nolde." Focusing on French and Northern European innovations in modern landscape painting and printmaking, these essays trace the evolution of new methods of recording the pastoral idyll, including the avant-garde breakthroughs of Fauvism and Cubism as well as the modernist embrace of the woodcut technique.

Images of landscape, just as the actual land itself, have been shaped by cultural conditions and perceptions and by the persistence of the myth of arcadia, such that the represented landscape may be read as a man-made invention. For example, in seventeenth-century Dutch paintings of the countryside, human beings are ever present, whether toiling or partaking of the pleasures of the landscape. During the Renaissance, though pagan elements still persisted in arcadian imagery, the Greek arcadia was also reimagined in terms of a rational, ordered society made apparent in the tranquillity of animals and man, harmoniously coexisting among woodlands and fields. The dominance of the Barbizon School in French landscape painting of the mid-nineteenth century coincided with the increase of tourism to the countryside, a phenomenon resulting from the popularity of the first hiking trails cleared in the

Fontainebleau forest, which were designed to offer the most pleasurable views of the landscape, and the railway, which made travel readily accessible to a wider population.[3] Paintings of specific sites were meant to conjure the artist's experience before nature, an experience that could be repeated by the viewer. By the time the Impressionists arrived at the same locations the Barbizon painters had visited, the objective recording of consequential human intrusion upon the landscape was a given.

The French landscape artists represented by works in the Museum's collection painted at recognizable sites, either on the outskirts of Paris, in those suburban areas mediating between city and country, or at fashionable seaside resorts. In certain cases, such as Henri Matisse in Morocco or Paul Gauguin in Tahiti, the escape to more distant lands reflects the impact of European colonization in the attraction to the so-called exotic and primitive as an antidote to Western civilization. Industrial growth occurred more swiftly and abruptly in Germany than in France. The artists of *Die Brücke* (The Bridge) group were most extreme in their renunciation of the deleterious effects of city life, proclaiming a collective return-to-nature movement. However, their images of nudes in the landscape were not based on site-specific observations, but rather on recollections made back in their studios. Whether the appeal of the natural was a matter of bourgeois recreation or a glorification of its healing powers, the resulting landscape pictures tell a compelling story of how the country as a scenic motif was used as a vehicle for formal innovation and inspiration, as a place to withdraw from harsher realities, and as a setting upon which artists projected their preconceived notions.

At the same time, these pictures were intended for an audience who shared the artists' anxiety and pessimism concerning their place within the urban environment. A profound longing for the preindustrial past on the part of a cultivated segment of society led to the revival of the pastoral genre. Images by artists such as André Derain and Matisse, inspired by the allegorical compositions of Pierre Puvis de Chavannes, posited a disparity between the depicted paradisiacal relationship of figures to nature and the viewers' own alienation within their environment. During a period marked by social conflict in much of Western Europe—in France partly due to the political scandal of the Dreyfus Affair, which even pitted artist against artist—the public at large experienced feelings of malaise and apprehension. Symbolism, with its emphasis upon the subjective, reflects the ensuing avoidance of contemporary reality in the arts. Referring to the Symbolist poets and artists, the critic Gustave Kahn wrote in 1886: "As to subject matter we are tired of the quotidian, the near at hand, and the compulsorily contemporaneous."[4] Though not a prescribed movement, Symbolism became an international aesthetic language that held sway for the last two decades of the nineteenth century. No longer imitative, art was seen as the projection of the individual's perceptions and feelings through exaggerated or nonrepresentational color, line, and form. Filtered through the imagination and emotions, nature presented an alternative to the struggle of people in an increasingly hostile society.[5]

The paintings reproduced on pp. 174–75 exemplify two currents in the Symbolist landscape. Gauguin left the metropolis of Paris to join the artistic community of Pont-Aven in Brittany in both 1886 and 1888. Although his painting *Washerwomen* was made in Arles during a two-month visit with van Gogh in 1888, the composition draws from his recent memories of the women of Brittany, as evidenced by their native dress. The canvas treats the familiar theme of the female figure in relationship to the land. With identically curved backs, the women bend over the shore of the Roubine du Roi—one of the canals surrounding Arles—seeming to meld into the landscape. Beginning in the mid-nineteenth century, most notably in the paintings of Jean-François Millet, the theme of the rural worker, removed from the corrupt present, enjoyed great popularity as a timeless symbol of both preindustrial life and the nobility of labor. Additionally, the peasant genre allowed for the perpetuation of the allegorical themes of past art. A woman nursing her baby, for example, could be interpreted as the Virgin and child. Gauguin went so far as to juxtapose the pious Breton women with their religious apparitions in several paintings.

Pont-Aven had flourished as an artists' colony for more than twenty years by the time Gauguin arrived there. Motivated by an antimachine and anticivilization sentiment, artists settled in the region, searching for rapport with what they perceived to be a primitive, peasant culture. Thus, prior to Tahiti, Brittany offered Gauguin the hope of locating the "savage" element that would not only correlate to but inspire his artistic expression. Of course, in escaping Paris, Gauguin ignored the modernization overtaking Brittany, which can be attributed to the economic and agricultural resurgence that in turn led to the growth of tourism and the popularization of the peasant culture itself. Believing in the mythical construct that

an unsophisticated culture was closer to nature than his own, Gauguin developed a formal vocabulary based on unmodulated color and thick, black outlines that he felt corresponded to the simplicity and "primitiveness" of his subjects.[6]

In contrast to Gauguin's quest for arcadia, Edvard Munch's works offer no alternative to urban despair. The setting for *The Storm* of 1893 can be identified as Åsgårdstrand, the Norwegian town where the artist maintained a summer home. The atmosphere of this landscape is purely psychological. For Munch, the countryside, rather than representing an outlet for escape, only mirrored the angst and tension caused by inhabiting the modern world. Indeed, this haunting landscape of the imagination may be read as a combination of country and city because of the presence of nature along with the buildings in the background. In other works by Munch with overtly urban settings, the city seems to be an instrument of sickness and death. In *The Storm*, the glowing windows of the middle house morbidly resemble yellow eyes, lending the building itself a psychological presence. Meanwhile, the faceless figures of the women, their hands held to their heads, are ghostly apparitions that may represent both uneasiness and eroticism. Like Gauguin, Munch associated the feminine with nature, but his correlations of figures to natural settings communicate an intensely personal anxiety as well as a broader public disenchantment. In this sense, Munch followed the Northern Romantic tradition of transcribing characteristics of living beings on the landscape and, through such physiognomic connotations, portraying abstract states of emotion.

Other artists approached the notion of the primal landscape through a stylistic abstraction of nature or a straightforward rendering of topographical motifs. Examples of both practices by early-modern and contemporary artists appear in the essay "Seasons and Moments." Whereas the interpretations of the four seasons by Vasily Kandinsky and Cy Twombly (pp. 184–85, 188) are abstract depictions of moments unfolding in nature, the photographs of Eugène Atget and Robert Adams (pp. 180, 182) document specific sites over a period of time. Interestingly, Kandinsky's panels, com-

missioned to be installed within the circular foyer of a New York City apartment, reflect the strong influence upon the artist of Russian peasant culture. The encompassing environment of intense colors they create simulates the effect of the brightly colored artworks and objects decorating the interiors of peasant homes.[7] Bridging the two extremes of abstraction and accurate rendering is Claude Monet's *Water Lilies* (pp. 186–87), a late work that revisits the artist's interest in the natural effects of light and water, within his private garden retreat.

Finally, another type of imagined landscape is set forth in the essay "The American Place: Landscape in the Early Western," which discusses the realization of the countryside on the movie set. Thus, an actual geographical place, as well as a not-too-distant past, is reconstructed in an artificial environment for an escapist medium. In creating another set of myths, this time of the American taming of unexplored terrain, the Western film is not so far removed from the centuries-old envisioning of the countryside as a place free from the impurities of the modern city, a place where virtue always wins.

OPPOSITE: Paul Gauguin. *Washerwomen*. 1888. Oil on burlap, 29⅞ x 36¼" (75.9 x 92.1 cm). The Museum of Modern Art, New York. The William S. Paley Collection

ABOVE: Edvard Munch. *The Storm*. 1893. Oil on canvas, 36⅛ x 51½" (91.8 x 130.8 cm). The Museum of Modern Art, New York. Gift of Mr. and Mrs. H. Irgens Larsen and acquired through the Lillie P. Bliss and Abby Aldrich Rockefeller Funds

Lewis Hine. *Child in Carolina Cotton Mill.* 1908. Gelatin silver print, 7⁹⁄₁₆ x 9½" (19.2 x 24.1 cm). The Museum of Modern Art, New York. Purchase

The fifty-year period before World War I, which would tear Europe apart between 1914 and 1918, saw the greatest economic growth in history, a huge industrial expansion and technological revolution that shaped the urbanized, industrialized, and mechanized life of the "modern" century.[8] Inevitably, art was changed. As the young Italian Futurist painters declared in 1910: "Living art draws its life from the surrounding environment. Our forebears drew their aesthetic inspiration from a religious atmosphere which fed their souls; in the same way we must breathe in the tangible miracles of contemporary life. . . . How can we remain insensible to the frenetic life of our great cities?"[9]

Industrialization meant, of course, an enormous growth in urban populations at the expense of the countryside. But it also meant the introduction of industry into the countryside, which transformed it in ways like that recorded in Lewis Hine's photograph *Child in Carolina Cotton Mill* of 1908. Hired by the National Child Labor Committee of the United States in November 1908, Hine visited textile mills in North Carolina and Virginia in order to document child-labor practices and conditions. The young girl in this photograph appears engulfed by the seemingly endless mass of machinery that recedes in perspective beside her. While this is an early example of how perspective can seem alienating in modern art (Giorgio de Chirico's work is a later example), Hine thought of himself as a documentalist and social reformer, rather than as a modern artist. It took vernacular photographers like him to show what the modern world actually looked like, which is the subject of the essay "Rise of the Modern World." It is one of the ironies of this period that the world was changing more swiftly than ever before, but the styles of artistic expression—except in photography and, to a lesser extent, in film—seemed ill-fitted to describe its visual properties.

As representations of the country could not but reflect the urban background of the artists who created them, so representations of the city reflected the preexisting language used to depict the natural environment. Thus, while a landscape by Georges-Pierre Seurat, for example, can be thought to reflect in its technique the factory environment of repetitive production processes, a painting like Ernst Ludwig Kirchner's *Street, Dresden* of 1908 can be seen as a transposition of organic forms to the modern city, albeit in lurid, seemingly artificial colors. In fact, metaphors of nature, notably the anthill and the ocean, had commonly been used in the nineteenth century to describe the busy crowds of cities.[10] Kirchner's painting, how-

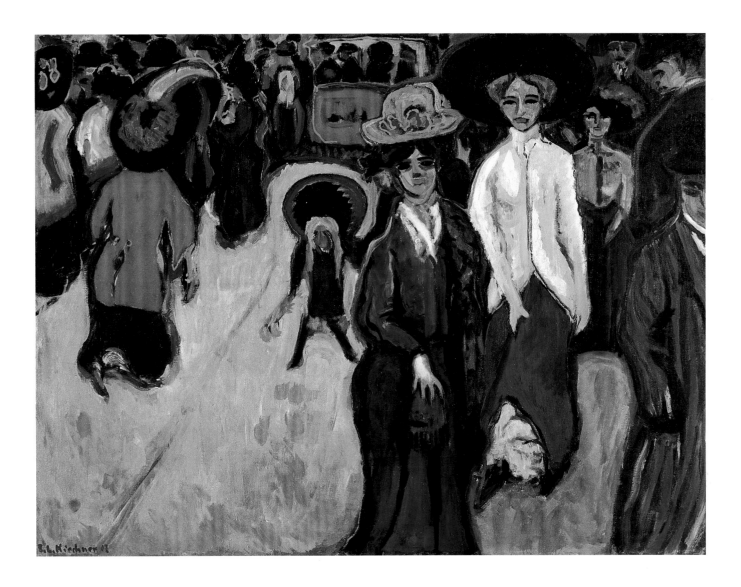

Ernst Ludwig Kirchner. *Street, Dresden.* 1908, dated 1907. Oil on canvas, 59¼" x 6'6⅞" (150.5 x 200.3 cm). The Museum of Modern Art, New York. Purchase

ever, uses organic forms without conveying a sense of movement; each anxious-looking figure can be perceived as isolated, engaged with neither its neighbors nor the viewer. His work looks back to the art of Munch, and conveys a similar sense of alienation in the urban environment, fright at the city's congestion, and withdrawal into the self. The literary critic Malcolm Bradbury has observed: "Much modern art has taken its stance from, gained its perspectives out of, a certain kind of distance, an exiled posture—a distance from local origins, class allegiances, the specific obligations and duties of those with an assigned role in a cohesive culture."[11] The artist's stance then mirrors that of the city dweller isolated from his or her roots; to represent the city dweller is, in a sense, to create a self-portrait.

A very different transposition of the organic to the urban is found in Umberto Boccioni's *The City Rises* of 1910 (p. 178). Exploding from the center of the struggling mass of the painting is an enormous red horse with a blue yoke, which seems more like a winged horse than a creature of labor. This modern, Futurist composition is thus dominated by an ancient

Umberto Boccioni. *The City Rises.* 1910. Oil on canvas, 6'6½" x 9'10½" (199.4 x 301 cm). The Museum of Modern Art, New York. Mrs. Simon Guggenheim Fund

symbol. Around it, men and additional horses struggle, a steam engine spews white clouds of smoke, skyscrapers are erected. All are swept together in a big organic swirl that is reminiscent of Art Nouveau. The vocabulary of that style, though evocative of the natural world, was clearly understood to announce a "new art" that was modern, urban, and cosmopolitan. For the Futurist painter Boccioni and the Art Nouveau designer Hector Guimard, energetic, swirling, "vitalist" forms connoted the modern experience. (See the essay "Hector Guimard and the Art Nouveau Interior.") Even if the Art Nouveau interior comprised an image of the country brought into the city, it was very far from rural. As Paul Signac, one of the first occupants of Guimard's Castel Béranger, wrote to the art critic Félix Fénéon: "Do you know that in the house we are going to have our nest—'Eccentric House' for the passersby but gay, practical, and bright for the tenants—there is even a telephone!"[12]

But still the question remained: how was the urban experience to be recorded, other than photographically, in a way that seemed appropriate to it? Were there specifically "urban" techniques to be utilized? In the latter part of the nineteenth century, the Impressionists had found the techniques of naturalism entirely adequate for representations of the city, but of the city as a place of "informal and spontaneous sociability," of picnics and boating trips that were effectively "urban idylls," as Meyer Schapiro observed.[13] It took Cubism to show how the city as a place of fragmentation, dislocation, and dissonance could be represented. This city, however, was not the "real" one of the vernacular photographers, the materially dominated environment of slums, science, and shop windows, but the "unreal" city of fantasy and strange juxtapositions.[14]

The transition from "real" to "unreal" is suggested in the essay "The Conquest of the Air," which describes how depictions of flying machines and images of the world recorded from the air can be seen to form part of a narrative that leads to the abstract painting of Kasimir Malevich. But, for Malevich, the unreal place "represented" in his abstractions was not the city but limitless space. The quintessential technique of modern

urban representation is, surely, collage, which most closely parallels what T. S. Eliot called *"le mélange adultère du tout"* (the adulterous mixture of everything) in the modern, unreal city.[15] Collage is included in the essay "Unreal City," as well as in parts of the Things section of this book. However, "Unreal City" addresses not only technique but mood. It suggests that the Cubist-influenced paintings of Paris made by Matisse, de Chirico, and others in the period around World War I might be looked at together for what they reveal of the urban experience. These paintings show a very uneasy city, virtually emptied of human presence and harshly shaped by the patterns of geometry. Paris, at that time, had a population of three million people. It had gained its physical form during Baron Georges Haussmann's public-works program begun in 1852, which swept away the confused, "organic" crush of the old city and replaced it with an architectural homogeneity that was geometric, formal, and severe. These traits and their consequences are what we see in the paintings in "Unreal City." But we also see early modernism's principal city at the time of the war, an upheaval that, to a greater extent than any previous war had, employed modern, mechanical means as the agent of nature's destruction.

In the 1880–1920 period of Modern*Starts*, the representation of the city in artworks may be thought to begin with the expression of alienation due to the perceived antagonism of nature and society (in Paris, caused in part by the disruptions wrought by "Haussmannization"), and to end with the expression of alienation resulting from the perceived destruction of nature by society. The mood of the 1920s would be one of putting all this in the past and creating a brave, new, modern world. Yet the art of the period of Modern*Starts* certainly cannot be thought of as antagonistic to urban life, only as struggling to find an appropriate way to interpret it artistically. For in the second half of the period, cities truly were restored as vital subjects of art after the nervousness and escapism of the first half of this period. Modern art may have begun in fear and disparagement of modernity, but it grew into an identification with it, which meant an identification with the city as well. Thus, the characteristics of the modern city, its cosmopolitanism and its internationalism, its mixture of cultures, languages, and styles, its repetitive and dislocated organization, its license and its tolerance, its chaos and its contingency, its frictions and its change, all became ingredients and metaphors of the modern. This set the pattern not only for art of the 1920s but also for much that has followed.

JOHN ELDERFIELD

| *Seasons* | *and* | *Moments* |

. . . to him [Claude Monet], from the beginning, nature had always appeared mysterious, infinite, and unpredictable as well as visible and lawful. He was concerned with "unknown" as well as apparent realities. [1]

So wrote William Seitz in a 1960 publication on Monet that accompanied an exhibition at The Museum of Modern Art that would hardly have been scheduled except for the Monet vogue that had begun in the late 1940s in validation of Abstract Expressionist painting, like Jackson Pollock's, and that grew through the 1950s alongside the development of abstract-representational painting, like Helen Frankenthaler's and Joan Mitchell's.[2] For Seitz, though, the apparent abstraction and immense symbolic power of Monet's late works, like his *Water Lilies* of about 1920 (pp. 186–87), are not to be thought the result of the artist having altered the record of perceived reality in order to create an abstracted or symbolic version of what he saw. Rather, Monet should be thought to have painted, in his later as well as his earlier years, an unaltered record of a perceived reality that he found to be so intrinsically mysterious that the sheer record could not help but demonstrate this. Therefore, what look like stylistic liberties taken with the appearance of nature are, in fact, liberties that nature itself takes with its own appearance, which the artist must seek out, and record, to reveal nature's intrinsic mysteries. Nature will thus reveal itself not through an imagination of whatever hidden mysteries it may contain but, rather, through observation of its intriguing visible particulars, over seasons as well as at moments.

When Seitz wrote of Monet's concern "with 'unknown' as well as apparent realities," he was echoing what Leo Steinberg had written in 1956 on the occasion of The Museum of Modern Art's recent acquisition of a *Water Lilies* painting: "For all his fabled and acknowledged realism, Monet now looks in nature for those fractions in which—torn from all mental moorings—the appearance becomes apparition."[3]

OPPOSITE, CLOCKWISE FROM UPPER LEFT: Eugène Atget. *Parc de Saint-Cloud, arbre.* 1919–21. *Parc de Saint-Cloud.* 1919–21. *Saint-Cloud, hêtre.* 1919–21. *Saint-Cloud.* 1924. *Saint-Cloud.* 1924. *Saint-Cloud.* 1924. Albumen silver prints, each approx. 9½ x 7" (24 x 18 cm). The Museum of Modern Art, New York. Abbott-Levy Collection. Partial gift of Shirley C. Burden

181

Robert Adams. *Southwest from the South Jetty, Clatsop County, Oregon.* 1990. Gelatin silver prints, each 14⁷⁄₁₆ x 18⅛" (36.7 x 46 cm). The Museum of Modern Art, New York. John Parkinson III Fund, Robert and Joyce Menschel Fund and Samuel J. Wagstaff, Jr. Fund

Bill Viola. *Hatsu Yume (First Dream)*. 1981. Videotape. Color, stereo sound, 56 minutes.
The Museum of Modern Art, New York. Gift of Catherine Meacham Durgin

These words, like Seitz's, could serve to valorize abstract-representational paintings of the 1950s. Read from a present prospect, however, they can also serve to aid understanding of earlier and later forms of abstract-representational painting, from Vasily Kandinsky's so-called *Four Seasons* paintings of 1914 (pp. 184–85)—originally conceived in an environmental installation that parallels that of some of Monet's *Water Lilies*[4]—to Cy Twombly's *The Four Seasons* paintings of 1993–94 (p. 188).[5] Both sets of paintings urge the beholder not to try to be more specific than the paintings themselves but, rather, to consider them "in relation to the mystery that surrounds them, not as a problem to be cleared up but as the very condition in which they appear at all."[6] The same message equally applies to Joan Miró's *The Birth of the World* (p. 189), painted in 1925 and, therefore, almost contemporaneously with the *Water Lilies*. The impress of the horizontal stretcher bar across the center of the canvas emerges from its very fabric to conjure up zones of earth and sky without specifying their description.[7] And the watery fall of paint down the surface evokes a primal flood at the first moment of nature while testifying to whatsoever in the world refuses to be reduced to one single explanation.

Yet, Seitz's and Steinberg's accounts of Monet engage not only abstract-representational paintings of whatever period, but also those works of art that choose "fractions" of nature in order carefully to record their visible particulars, in the belief that nature will thus open to reveal its mysteries. Here, the "naturalism" of Monet's *Water Lilies* finds a measure of common ground with the contemporaneous photographs of a single beech tree taken by Eugène Atget on at least three separate occasions in the years 1919 to 1924 (p. 180),[8] which, in turn, are associable with the recent, serial photographs of the Columbia River meeting the Pacific Ocean made by Robert Adams in 1990 (p. 182).[9]

Atget's beeches, like Monet's earlier paintings of poplars, carry a projection of human posture in their mode of topographical portraiture, only to oppose the appearance with the apparition that spreads, as if by self-propagation, to compose the pictorial shape.[10] Adams's photographs of the ocean partake of Monet's ambition "to produce an illusion of an endless whole, a wave without horizon, without shore."[11] Yet, the effect that they provide of an unbounded watery illusion also, surprisingly, retains its specificity of climatic and tidal detail in a way that causes one to look not only with a sense of discovery, as happens with

Monet and Atget, but also actually in search of information. The same is true, albeit in different terms, of the 1981 video, *Hatsu Yume (First Dream)*, by Bill Viola (p. 183) that hypnotically records precise details of a Japanese landscape in a temporally extended continuum that produces "an illusion of an endless whole," in this case of scenes experienced as if in a dream "from a mysterious, detached, third [person] point of view."[12]

Each photograph by Atget may be thought of as one work in a series—therefore, like a painting in a series by Monet—although we do not, in fact, know whether the photographer himself intended to compose a series of works. In contrast, though, the photographs by Adams and the video by Viola both constitute, in their separate ways, a series in one work, and may therefore be thought to be akin to the *Water Lilies* by Monet, which offers multiple views of nature on a surface that resembles a cinematic

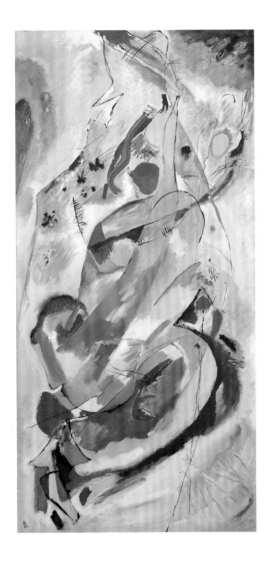

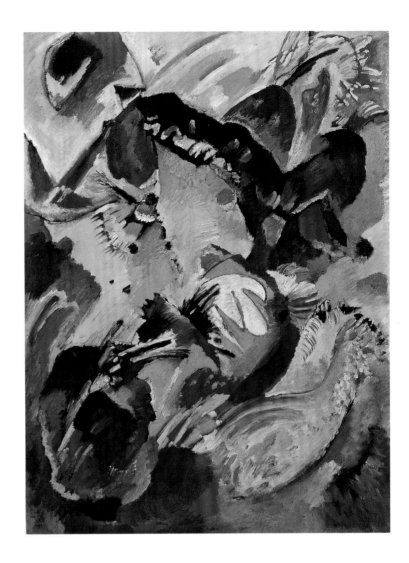

panorama. But for all the differences between these representa-
tions—and they are many—they all proceed on the assumption
that the mysteries of nature are accessible to observation, albeit
of its fractions torn from their moorings, rather than are hidden
and have to be imagined. Paradoxical though it may seem, their
subjects remain mysterious precisely because they are visible,
not concealed.

A useful insight into all of these works is offered by the example
of Wallace Stevens's "variation" poems, in which each principal
metaphor is a different variation or restatement of the theme
(the internal subject) of the work—a theme that in its nominal
aspect is external to the work, borrowed from reality, but in its
more essential poetic aspect is internal to the work, subsisting
in its imaginative structure of verbal materials.[13] The internal

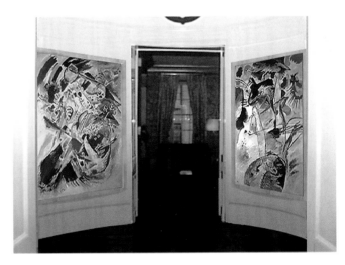

**Kandinsky's panels for Edwin R. Campbell as installed in the vestibule of his apartment.
Reconstruction**

theme cannot simply be described by specific reference to reality, for it is the product of imagination in confrontation with reality. That is to say, neither does the internal theme surrender to reality nor does it retreat from reality into a merely imaginary world. Thus, the actual imagery in Stevens's poems (and in the works under consideration here) can be thought of as variations that the artist's imagination makes on the theme of reality, variations that are also on the internal pictorial theme of the work.

In Stevens's interpretation, what ultimately is at issue here concerns the modernist imagination, and what distinguishes a modern from a pre-modern conception of the external world. A pre-modern conception, founded on theological belief, saw external reality as creation, and the artist as someone who analogized God's creation by uncovering the true, hidden reality behind the external reality of "things as they are." This is unacceptable to a skeptical modernist like Stevens because it means that imagination—God's infinite imagination that has created external reality—replaces external reality as the ultimate subject the artist's imagination confronts. And since, for a skeptical modernist, theological belief is a fiction we have made up for ourselves, it finally means that the artist's imagination is simply confronting itself, which makes his work merely a narcissistic reflection of his own imagination, encountering no resistance from anything external. If the poetic subject is to be the product of the imagination in confrontation with reality, the artist cannot believe in any hidden reality, for such a reality is unreal, merely the mirror of the imagination itself. The poetic subject, however open and revealed to us, is

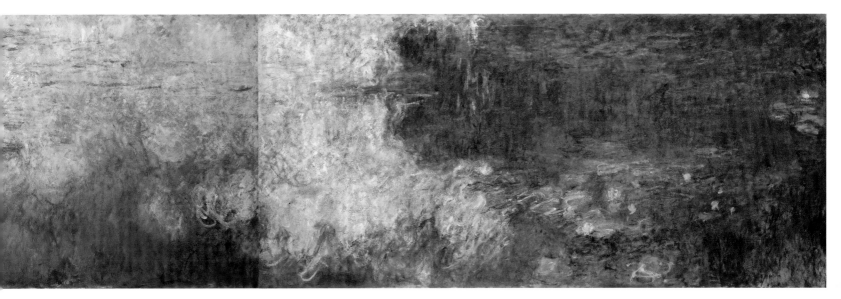

Claude Monet. *Water Lilies.* c. 1920. Oil on canvas, triptych, each section 6'6" x 14' (200 x 425 cm). The Museum of Modern Art, New York. Mrs. Simon Guggenheim Fund

therefore never a single thing because reality is not an imaginary, single thing but is always a phenomenal, changing thing: not the supreme fiction of a preexistent creator, but something that only existed when it was reimagined by the artist, whose works of art would each comprise a supreme fiction.

"The arrangement contains the desire of / The artist," is how Stevens put it. "But one confides in what has no / Concealed creator." Thus, the artist will want to draw our attention to the mysteries of the unconcealed—in the illuminating fractions of nature glimpsed in its seasons and at its moments. Doing so, the artist "walks easily / The unpainted shore, accepts the world / As anything but sculpture."[14] Rather, as seasons and moments of a nature that the artist will desire to arrange in order the better to understand.

OPPOSITE, CLOCKWISE FROM UPPER LEFT: Cy Twombly. *The Four Seasons: Spring, Summer, Autumn,* and *Winter. Spring, Autumn, and Winter:* 1993–94. *Summer:* 1994. Synthetic polymer paint, oil, pencil, and crayon on canvas; *Spring:* 10'3⅛" x 6'2⅞" (312.5 x 190 cm); *Summer:* 10'3¾" x 6'7⅛" (314.5 x 201 cm); *Autumn:* 10'3½" x 6'2¾" (313.7 x 189.9 cm); *Winter:* 10'3¼" x 6'2⅞" (313 x 190.1 cm). The Museum of Modern Art, New York. Gift of the artist

ABOVE: Joan Miró. *The Birth of the World.* 1925. Oil on canvas, 8'2¾" x 6'6¾" (250.8 x 200 cm). The Museum of Modern Art, New York. Acquired through an anonymous fund, the Mr. and Mrs. Joseph Slifka and Armand G. Erpf Funds, and by gift of the artist

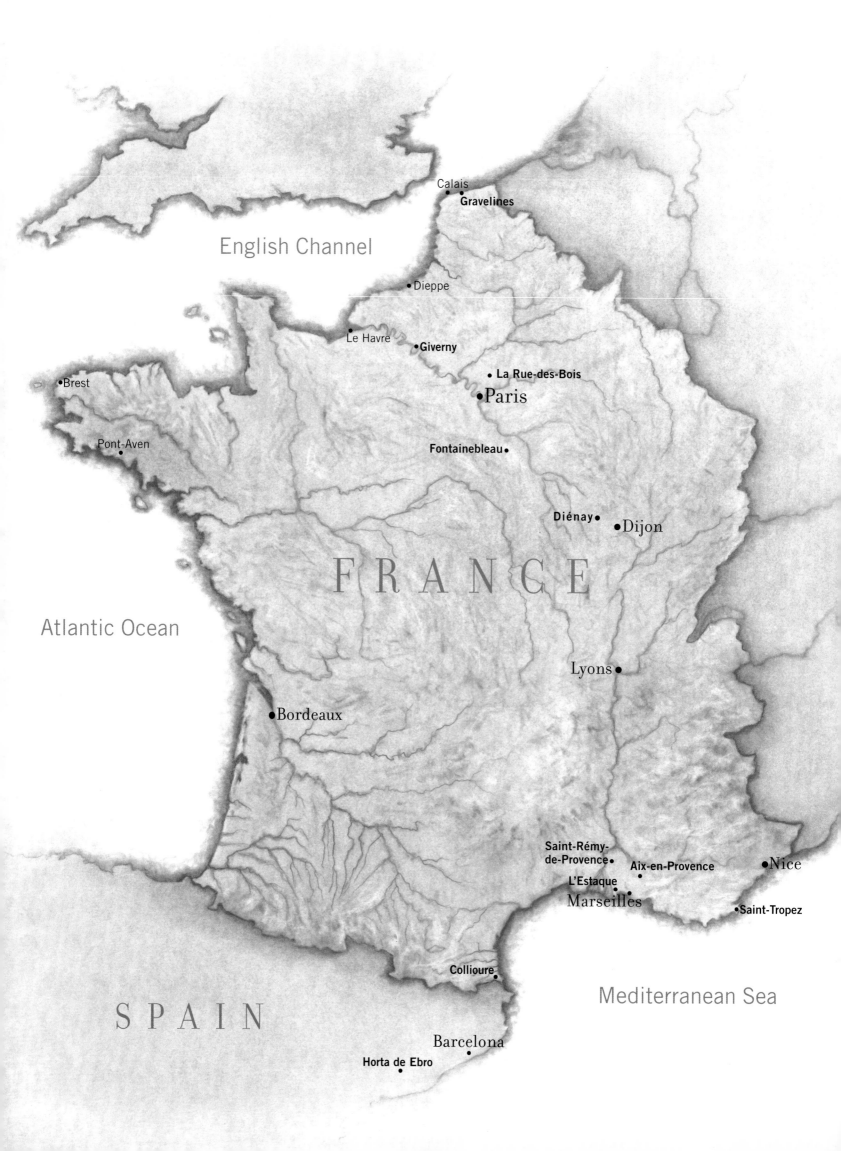

English Channel

Calais
Gravelines

•Dieppe

Le Havre
Giverny

Brest•

•**La Rue-des-Bois**

•Paris

Pont-Aven
•

Fontainebleau•

Diénay•
•Dijon

F R A N C E

Atlantic Ocean

Lyons•

•Bordeaux

Saint-Rémy-
de-Provence•
Aix-en-Provence
•Nice

L'Estaque•
Marseilles
•Saint-Tropez

•Collioure

Mediterranean Sea

S P A I N

Barcelona

Horta de Ebro

MAGDALENA DABROWSKI

CHANGING VISIONS
French Landscape, 1880–1920

Landscape painting flourished in France during the four decades between 1880 and 1920; far-reaching changes were taking place in the perception of nature, and artists registered them immediately.[1]

An important factor in the evolution of landscape painting was the new ease of travel, by train and later by car. Stimulating urban artists and making nature available to them, travel also decisively influenced both artists' and audiences' perception of landscape, and changed the vision of what landscape is. Landscape as painting, landscape as place: the issue became crucial. Landscape art grew increasingly site-specific, responding in different ways to the local; the assumption grew that the viewers of a painting might recognize the scene it showed. Landscape art also reflected evolving social attitudes: "land" was becoming "countryside," a place of retreat and recreation, and a balance to industrialization and urbanization. As the network of railroads expanded throughout France, making "countryside" more and more accessible to an ever broader segment of urban society, train travel itself generated a changed perception of landscape, framing it as a rapid succession of images that allowed a more immediate experience of its diversity and heightened its interest as spectacle.[2]

The painting of the period should nevertheless be seen in relation to the classical French landscape tradition established in the seventeenth century, with the Arcadian scenes of Nicolas Poussin (p. 192) and with Claude Lorrain's poetic visions of the Roman Campagna[3]—a tradition codified in 1800 by the painter Pierre-Henri de Valenciennes, in a treatise that placed depictions of nature alongside history scenes and portraiture among the "noble" types of painting.[4] Another antecedent was the seventeenth-century Dutch model (p. 193, top), more informal and less idealized than the work of

OPPOSITE: **Map of France**

ABOVE: **France, Spain, and northern Morocco**

191

Nicolas Poussin. *Landscape with the Body of Phocion Carried Out of Athens.* 1648. Oil on canvas, 44⅞ x 68⅞" (114 x 175 cm). National Museum of Wales, Cardiff. On loan from the Earl of Plymouth

Poussin or Claude; this aesthetic current had entered the French tradition with artists of the 1830s through around 1860, the so-called Barbizon School (p. 193, bottom), who took a realistic approach to geographical sites, conveying their beauty through a more accurate rendering of their topography.[5] Late-nineteenth- and early-twentieth-century French landscape art, then, reflected the polarity between a southern and a northern tradition: on the one hand, the classical, Italianate landscapes of Poussin and Claude; on the other, the alternative paradigm of the Dutch and later the Barbizon.

An artist closely identified with landscape painting during the last third of the nineteenth century was Claude Monet, whose name became practically synonymous with Impressionism. Early in his career, profiting from the example of the Barbizon School, Monet tried to develop his own original idiom based primarily on color.[6] His central concern became the problem of creating color relationships on the canvas that would reflect the visual sensations he had experienced in observation of nature. Monet relied on a somewhat exaggerated intensity of color and contrast, and on a variegated structure of brushstrokes, both clear in his late canvas *Agapanthus* (c. 1918–25; p. 195). It was through the technical dexterity of his manipulation of color, in passages sometimes tight, sometimes loose, that he tried to convey a feeling of nature. Monet's work reflected an entirely altered way of looking at landscape.

In 1883 Monet moved into a house in Giverny, on the Seine northwest of Paris, where he would live until his death. Most of his subsequent canvases depict the landscape of the region, many of them recording his own garden (pp. 186–87, 194). The tapestrylike surfaces of these later works seem almost abstract, especially when compared with photographs of their sites. Color, in diverse intensities and hues, seems to lie on the skin of the canvas, forming a web of varied brushstrokes and eliminating compositional depth. These shimmering images create what is often referred to as a "decorative landscape"; the site is a reference point, but is transformed and conditioned by light, color, and Monet's own vision.

While Monet created near-weightless views of the fields and shores of Normandy, Paul Cézanne was developing his own ways of describing landscape, in sites around both Paris and his native town of Aix-en-Provence. Among these was the forest of Fontainebleau, some twenty-five miles southeast of Paris. Fontainebleau had attracted artists through much of the nineteenth century. The Barbizon generation of the 1830s considered it an oasis of unspoiled nature, a retreat from the disorienting modernity of

the city; some thirty years later, in the early 1860s, Monet was visiting and working in the forest; and Cézanne was there some thirty years after that, in the 1890s (p. 196). Photographs of the places Cézanne saw, both here (p. 196) and in Aix (pp. 200, 201),[7] suggest that he found many details of composition, structure, and color within the scenes themselves, independently of the style in which he would render them. These details served as a scaffolding on which he would impose the qualities of his painting: the rhythmic brushwork, the diverse textures, the variations in the values of local hues (with their balance of warmer and cooler), the slight modifications of angle of view.

Jacob van Ruisdael. *The Great Forest*. n.d. Oil on canvas, 54⅞ x 70⅞" (139.5 x 180 cm). Kunsthistorisches Museum, Vienna

The works that resulted both adhered to the original site and transformed it into an almost abstract composite of harmonious colors. Using what would become known as his "constructive stroke"—groupings of parallel brushstrokes, their function descriptive rather than ornamental—Cézanne created weighty, solid-looking forms that are nevertheless built up of multiple discontinuities: instead of rendering the precise natural form, he would apply patterns of brushstrokes from which the eye would infer it. The method entailed a rejection of the perspectival conventions followed by painters since the Renaissance, yet Cézanne felt he was working in the tradition of Poussin—although he also purportedly claimed that he wanted to "redo Poussin after nature."[8] He wanted, that is, to convey the timelessness suggested by Poussin's idyllic landscapes, yet simultaneously to render the specific qualities of the place and moment in which he himself was working. Building up form out of touches of color, Cézanne focuses the viewer's attention on the substance of the picture—on the relation between the illusion of place and the means by which that illusion is created. Implicit in his work is a notion of *passage*—of one plane opening into another—that would be developed in the early twentieth century by Pablo Picasso and Georges Braque. Their innovations are apparent in Picasso's 1908 *Landscape* (p. 197), executed at the village of La Rue-des-Bois, northeast of Paris.

Théodore Rousseau. *Oak Trees in the Forest of Fontainebleau*. n.d. Oil on canvas, 36³/₁₆ x 46⁷/₁₆" (92 x 118 cm). Collection Claude Aubry, Paris

A landscape explored by many painters of the period was the Normandy shore and the coast along the English Channel. The coming of the railways had made the region a fashionable resort area for Parisians, and from Normandy to the Belgian border, harbors, misty sea atmospheres, and picturesque shorelines became subjects for artists. Georges Seurat was among those who addressed the raw yet serene beauty of this scenery. Monet, in views of the same region, depicted nature as sublime to the point where it is almost threatening, large and untamable; Seurat, in canvases such as *The Channel at Gravelines, Evening* (1890; p. 198), suggested something more austere in this broad coastal plane, finding a quality of deep stillness in its flat sand and quiet sky. The sense of emotional distance is reinforced by the careful technique, a "pointillist" method, controlled and rational, using small dots of complementary colors. Compared to photographs of Gravelines and its port (p. 198), Seurat's painting is strikingly empty of human activity; defined by a subtle planar geometry, the scene is simultaneously static and expectant.

A different approach to landscape appears in the monotypes made by Edgar Degas on a journey to Diénay, near Dijon, in 1890 (p. 199). The formal structures of these works—in which large, blank expanses denote different terrains (fields, meadows, woods)—approach abstraction, yet retain a sense of immediate responsiveness to a particular place. Actually, though, these landscapes were executed from memory, without the benefit of sketches done on the spot, after the artist alit from the carriage that had taken him from Paris to Diénay.[9] They should be seen as souvenirs of sites perceived in

English Channel

Le Havre •Rouen
Honfleur
 •Vétheuil

motion rather than as the results of contemplative execution outdoors, *en plein air* (the practice of many artists from the Barbizon School on, even if they often finished the work later in the studio). In fact these works break from the traditional relationship between artist and subject, in that they deliberately set out to convey imagery perceived "en route." The products of fleeting experience, fragmentary scenes caught by a moving observer, they respond to the nineteenth century's new fluency of travel and are predictive of the camera snapshots taken by tourists in our own time. They are, however, exceptionally apt in capturing the essential structure of the scene—the masses and volumes of fields, bushes, and trees, all documented in a later photograph (p. 199).

The South of France contributed greatly to the evolution of landscape art. Beginning in the 1880s, Cézanne created remarkable views of Provence landmarks such as the Château Noir (p. 200) and Mont Sainte-Victoire (p. 201). Photographs of these sites (pp. 200, 201) indicate his adherence to the characteristics of the motif, even while his inventive treatment of the surface departs from any conventional notion of naturalistic rendering.

Mont Sainte-Victoire in particular is among Cézanne's best-known motifs—one he painted often, in watercolor as well as oil, viewing the mountain from different angles and emphasizing its structure through rhythmic, almost architectonic pictorial constructions. The compositional balance of these works, their refined color relationships, and the frequent use of the whiteness of the underlying paper or canvas to provide luminosity give the motif monumentality and expressiveness. The brushwork and color combinations suggest an almost abstract structure, yet at the same time provide quite precise topographical information. Each of Cézanne's renderings of this imposing rock formation is framed in its own language of marks, its own system of color. Mont Sainte-Victoire is the icon of Cézanne's late period.

To the northwest of Aix lies the village of Saint-Rémy-de-Provence, where Vincent van Gogh stayed for a time in the asylum of Saint-Paul-de-Mausole. Confined there by his own volition in 1889, he painted the surrounding countryside, with its olive groves, vineyards, and cypress trees. The heavy impasto

Monet's waterlily pond, Giverny, 1924

Monet's waterlily pond, Giverny, 1989

OPPOSITE: Claude Monet. *Agapanthus.* c. 1918–25. Oil on canvas, 6' 6" x 70¼" (198.2 x 178.4 cm). The Museum of Modern Art, New York. Gift of Sylvia Slifka in memory of Joseph Slifka

Text on the map:

Paris

Barbizon

Georges Balagny. *Scotch Fir, Path, Rocks.* 1877. Albumen silver print, 11¾ x 10¼" (29.8 x 25.9 cm). Département des Estampes et de la Photographie, Bibliothèque Nationale de France, Paris

Paul Cézanne. *Pines and Rocks (Fontainebleau?).* 1896–99. Oil on canvas, 32 x 25¾" (81.3 x 65.4 cm). The Museum of Modern Art, New York. Lillie P. Bliss Collection

of his Saint-Rémy works conveys the lushness of nature and imparts the area's spectacular colors and light. Van Gogh's energetic brushstrokes and particular palette—the blue-violet shadows, the dark green cypresses, the intensely blue sky with its touches of golden yellow—appear at their most striking and hauntingly tense in *The Starry Night* (1889; p. 203). While Cézanne for the most part adhered to the motif he described, van Gogh's image combines actual landmarks with invented ones: the village lies below the mountains where the artist has situated it (p. 202), yet his church steeple is entirely made up, rising in distant parallel to the soaring cypress in the left foreground. (A number of writers have likened this addition to the churches of van Gogh's native Holland.) And the

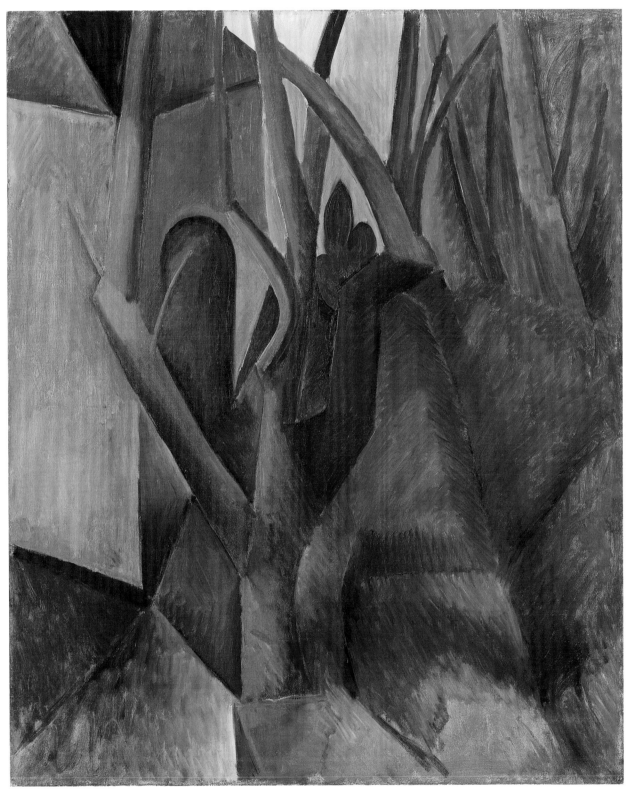

Pablo Picasso. *Landscape.* 1908. Oil on canvas, 39⅝ x 32" (100.8 x 81.3 cm). The Museum of Modern Art, New York. Gift of Mr. and Mrs. David Rockefeller

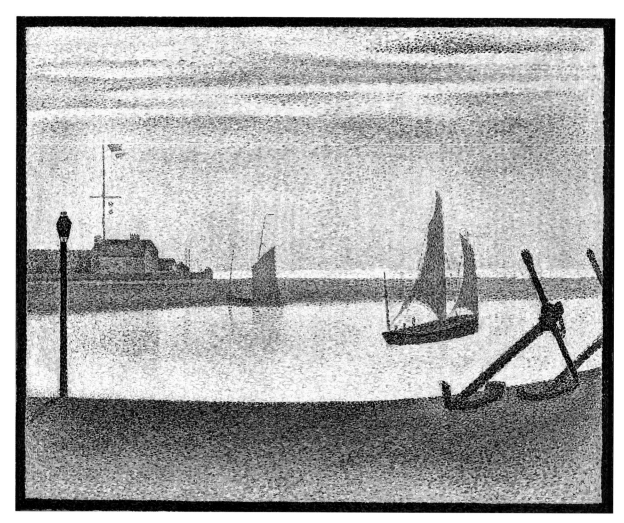

Georges-Pierre Seurat. *The Channel at Gravelines, Evening.* 1890. Oil on canvas, 25¾ x 32¼ " (65.4 x 81.9 cm). The Museum of Modern Art, New York. Gift of Mr. and Mrs. William A. M. Burden

"Gravelines—Panorama du Grand-Fort-Philippe." n.d. Postcard

swirling sky, with its bright yellow moon and stars, is almost decorative, yet has the sweeping quality of a fantasy or dream.

Artists also found inspiring sites on the Côte d'Azur. In 1893 Paul Signac bought a house in Saint-Tropez, then a quiet fishing village (p. 204). Over the years he would often invite his friends to visit, as Matisse did in the summer of 1904, painting light-suffused works executed in small, dotlike brushstrokes of pure color. The dazzling coloration of the landscape, the beauty of the Mediterranean coast, and especially the spectacular light of the Riviera prompted Matisse to return regularly to the South of France, and in 1917 he finally settled there, exploring land and shore in his paintings.

Another Midi village that shaped a distinct vision of landscape was L'Estaque, a place of lush vegetation, impressive rock formations, and spectacular views of the

Chaumont •

Dijon •

Besançon

Hilaire-Germain-Edgar Degas. *Green Landscape.* c. 1890. Monotype, plate: 11⅞ x 15¹¹⁄₁₆" (30.1 x 39.9 cm).
The Museum of Modern Art, New York. Louise Reinhardt Smith Bequest

Hilaire-Germain-Edgar Degas. *A Wooded Landscape.* c. 1890. Monotype, plate: 11⅞ x 15¹³⁄₁₆" (30.1 x 40.2 cm).
The Museum of Modern Art, New York. Louise Reinhardt Smith Bequest

A landscape in the Côte d'Or. n.d.

Paul Cézanne. *Château Noir*. 1904–06. Oil on canvas, 29 x 36¾" (73.6 x 93.2 cm). The Museum of Modern Art, New York. Gift of Mrs. David M. Levy

Château Noir, Aix-en-Provence, c. 1935. John Rewald Library
Collection, Archives of the National Gallery of Art, Washington, D.C.

Mediterranean.[10] L'Estaque also possessed a light that only brightened the natural luminosity of its countryside. Cézanne first visited the area in 1864, then often returned in the 1870s and early 1880s. After 1885, the village and its harbor grew increasingly built up and also became a tourist center, but still held a fascination for many artists. André Derain spent the summer there in 1906, executing brightly colored canvases such as *Bridge over the Riou* (p. 206), which confirmed his reputation as one of the group christened the Fauves—or "wild beasts"—because their palette was thought outrageously lurid.

Besides bringing out the intensity of the local color, the brilliant light of L'Estaque emphasized the underlying bones of the scenery—the vertical trees, the horizontal masses of mountains, rocks, and architecture. This quality infused Derain's previously loose, mosaiclike idiom with a stronger structure: the shapes in *Bridge over the Riou* are more

LEFT: Mont Sainte-Victoire, Aix-en-Provence, c. 1935. John Rewald Library Collection, Archives of the National Gallery of Art, Washington, D.C.

BELOW: Paul Cézanne. *Mont Sainte-Victoire.* 1902–06. Watercolor and pencil on paper, 16¾ x 21⅜" (42.5 x 54.2 cm). The Museum of Modern Art, New York. Fractional gift of Mr. and Mrs. David Rockefeller (the donors retaining a life interest in the remainder)

robust than in his earlier Fauve work, and deploy larger areas of flat, saturated, unmodulated color, reminiscent of the work of Paul Gauguin. The landscape of L'Estaque helped Derain to synthesize his interest in *matière*, that is, in paint and surface texture, and in dazzling combinations of color.

Two years later, however, in the summer of 1908, the same area inspired a much more compact and coloristically sober composition, Braque's *Road near L'Estaque* (p. 207). At L'Estaque in 1906–07, Braque had worked in his own Fauve idiom, using an exuberantly heightened palette and producing paintings that were solidly structured but curvilinear, their strong outlines creating undulating patterns. Now, in *Road near L'Estaque*, he explored new options. Looking back to Cézanne, he emphasized the structure of the site, but his forms are more geometrical than Cézanne's. He limited color to the triad of ochers, blues, and greens, and covered the canvas with a feathery brushwork, an almost uniformly dense surface pattern. This angular structure and restricted color make *Road near L'Estaque* proto-Cubist.

Although some powerful Fauve painting was done in L'Estaque, the real birthplace of Fauvism was Collioure, a seaside village in the eastern Pyrenees, near the Spanish border.[11] There during the summer of 1905 were produced such radical canvases as Matisse's *Landscape at Collioure* (p. 205). Shocking at the time, Fauvism was based on the use of bright primary colors applied in small brick-shaped marks, creating a mosaiclike surface. Between the brushstrokes, raw, unpainted patches of canvas showed as visible whites or beiges, heightening the paintings' chromatic intensity.

Fauvism enacted a reconciliation between tradition and innovation in landscape painting, combining the classical tradition—the Arcadian vision inherited from Poussin—with the more closely observed mode derived from the Barbizon, a mode, however, that as we have seen, with Impressionism and Cézanne, had developed into an analytic exploration of how to represent what was observed. Paintings such as *Landscape at Collioure* present a nonspecific, idyllic, Arcadian landscape, yet the viewer can read the painting both as an illusion of depth (despite the lack of traditional perspective) and as a surface structured by color and arabesque pattern.

Saint-Rémy-de-Provence from the air, with the Saint-Paul-de-Mausole asylum in the foreground, c. 1940s. Postcard

Vincent van Gogh. *The Starry Night*. 1889. Oil on canvas, 29 x 36¼" (73.7 x 92.1 cm). The Museum of Modern Art, New York. Acquired through the Lillie P. Bliss Bequest

OPPOSITE: Paul Signac. *The Buoy (Saint-Tropez Harbor)*. 1894. Lithograph, comp: 15¹³⁄₁₆ x 12¹³⁄₁₆" (40.2 x 32.5 cm). Publisher: Gustave Pellet, Paris. Printer: August Clot, Paris. The Museum of Modern Art, New York. Abby Aldrich Rockefeller Fund

ABOVE: Henri Matisse. *Landscape at Collioure*. 1905. Oil on canvas, 15¼ x 18⅜" (38.8 x 46.6 cm). The Museum of Modern Art, New York. Gift and Bequest of Mrs. Bertram Smith

ABOVE: André Derain. *Bridge over the Riou.* 1906. Oil on canvas, 32½ x 40" (82.5 x 101.6 cm). The Museum of Modern Art, New York. The William S. Paley Collection
BELOW: August Macke. *Children Carrying Water, L'Estaque.* 1914. Photograph, 3⁵⁄₁₆ x 3⁵⁄₁₆" (8 x 8 cm). Westfälische Provinzial und Feuersozietät, Münster

The part that Collioure played in the development of Fauvism was performed for Cubism by the Catalan village of Horta de Ebro (also known as Horta de San Juan). Here Picasso spent the summer of 1909, intending, he said, to paint landscapes better than those Braque had done the year before at L'Estaque.[12] In their structure and composition, works such as *The Reservoir, Horta de Ebro* (p. 208) represent the early phase of Analytical Cubism. Picasso was fascinated by Horta, and took many photographs there. Comparison of *The Reservoir, Horta de Ebro* with one of these photographs (p. 208) shows how closely the painting followed its source, while also massing volumes in "cubified" shapes that give the work its structure. Using a notion of *passage* derived from Cézanne, Picasso created a surface that could be read as flat and continuous, even while it also communicated the volume and solidity of architecture. It is worth noting, however, that although the forms of his works

Georges Braque. *Road near L'Estaque*. 1908. Oil on canvas, 23¾ x 19¾" (60.3 x 50.2 cm). The Museum of Modern Art, New York. Given anonymously (by exchange)

Daniel-Henry Kahnweiler. *View of L'Estaque*. 1910. Photograph. Kahnweiler-Leiris Archives, Paris

in Horta de Ebro reflect his understanding of the late, faceted forms of Cézanne, they do not reflect light in the same way. In fact Picasso renders nature as a kind of architecture.

Still another approach to landscape appears in works that Matisse painted in Morocco, which had fallen under French influence in the early nineteenth century and in 1912 became a French protectorate. Matisse visited Morocco that year, and his stay there helped him, he said, to "make contact with nature again, better than did the application of a lively but somewhat limiting theory, Fauvism."[13] What Morocco offered Matisse was a luxuriant nature, a sensuosity, a different appreciation of color, light, and space, and elements of the oriental and the exotic in which he had already become interested. The gardens in particular, with their lushness and color, became for him a kind of Arcadia— places of solitude, contemplation, and retreat.

Pablo Picasso. *Roofs at Horta de Ebro*. 1909. Photograph. Picasso Archives, Paris

Pablo Picasso. *The Reservoir, Horta de Ebro*. 1909. Oil on canvas, 24⅛ x 20⅛" (61.5 x 51.1 cm). The Museum of Modern Art, New York. Fractional gift of Mr. and Mrs. David Rockefeller

Under the influence of Moroccan light, Matisse began to reexamine a device he had already used in his decorative compositions of 1906–10: the use of large expanses of color, flat and without visual detail. Areas like these reappear in *Periwinkles/Moroccan Garden* (p. 209), yet the work's thin layers of pinks, its light and dark greens, and its touches of ocher almost palpably convey the exotic quality of a North African garden. Closing one phase of Matisse's work and marking the start of another, the painting imparts a personal vision of landscape, abstract (in its compositional arrangement) yet specific (in its palette and atmosphere). It was through inventions like these that landscape painting was assured its important position within the development of modern art.

SPAIN
Gibraltar
Mediterranean
Sea
Tétouan

Henri Matisse. *Periwinkles/Moroccan Garden*. 1912. Oil, pencil, and charcoal on canvas, 46 x 32¼" (116.8 x 82.5 cm). The Museum of Modern Art, New York. Gift of Florene M. Schoenborn

Landscape as Retreat
Gauguin to Nolde

Paul Gauguin journeyed to Brittany, the Caribbean, and finally the South Seas to replenish his creativity in unfamiliar, exotic settings. Like many artists of the late nineteenth and early twentieth centuries, he disparaged the rapid modernization then occurring in Western society—a development that intensified the dichotomy between city and country, culture and nature, that would characterize much of the modern period. Yet his art, like that of many others of the time, reveals a murky ambivalence to these dichotomies. Gauguin's images manifest a hybrid of opposing influences—pagan and Christian, primitive and Western—that cannot be fully understood without also considering the rampant European colonization of these supposedly arcadian locales and his own immersion in the avant-garde art of his time.

In 1889 Gauguin made his first set of prints as a way to reprise his travels. He hoped these prints, *10 Zincographies* (lithographs made by drawing with a wax crayon or liquid wash on zinc rather than on stone), would promote his work to a wider audience. In *Pastoral in Martinique*, the curving outline of the women's forms echoes the shape of the tree and branch, conveying a sense of languorous movement and idyllic charm. This print also evidences Gauguin's precocious talents and intuitive inventiveness with lithography, the most draftsmanlike of the print mediums. He sensitively experimented with the textural effects created by liquid washes of ink on metal, most evident in the stippled grays of the hilly background at left. The massive tree anchors the print, but its dark, hovering leaves add an unsettling, ominous presence to this otherwise tranquil pastoral, suggesting nature's independence from and uncontrollable power over human existence.

When he returned to Paris in 1893 after his first excursion to Tahiti, Gauguin made his second set of prints, this time in the hopes of explicating his exotic motifs to a skeptical Parisian audience. He planned the series, titled *Noa Noa*, as illustrations for a book (never published as such) about his South Seas sojourn and chose the popular woodcut medium in

OPPOSITE: Paul Gauguin. *Nave Nave Fenua (Fragrant Isle)* from the series *Noa Noa*. 1893–94. Woodcut and stencil, comp.: 13¹⁵⁄₁₆ x 8¹⁄₁₆" (35.5 x 20.4 cm). Printer: Louis Roy. Edition: 25–30. The Museum of Modern Art, New York. Gift of Abby Aldrich Rockefeller

ABOVE: Paul Gauguin. *Pastoral in Martinique*. 1889, published 1894. Zincograph, comp.: 7⅜ x 8¾" (18.7 x 22.3 cm). Publisher: Ambroise Vollard, Paris. Printer: probably Auguste Clot. Second edition: approx. 50. The Museum of Modern Art, New York. Lillie P. Bliss Collection

part because of its compatibility with printing type. The medium's coarse textures and irregular line also appealed to Gauguin as a new expressive tool for his imagery of this remote locale.

The woodcut was experiencing a revival among artists in France in the 1890s; its primitive craftsmanship and medieval religious origins attracted many artists. Gauguin wrote, "It is precisely because the woodcut goes back to the primitive era of printmaking that it is interesting."[1] Japanese woodcuts had also flooded Paris by the 1880s, after trade with Japan had been reestablished in the mid-nineteenth century. These colorful prints were widely admired and collected by artists, including Gauguin, for their flattened, unmodeled forms, decorative outlines, and abstract sensibility. Gauguin borrowed the early Japanese woodcut technique for the ten *Noa Noa* images. *Nave Nave Fenua* (p. 210) is composed of a variety of patterned lines, from the curving forms of the exotic backdrop foliage to the parallel strokes defining the shore of the brook. Using the coarse woodcutting methods and tools of his wood relief sculptures, Gauguin infused his woodcuts with even greater expressive force—scooping out large areas with a chisel and cutting thin lines with a sharp knife.[2] The contrast between the delicate lines and broad chiseled channels imparts graphic and sculptural effects simultaneously. In addition, Gauguin adopted unconventional inking and printing methods, sometimes deliberately printing blocks off-register to convey a mystical, ethereal feeling in these nocturnal scenes.

In *Nave Nave Fenua*, as in the Martinique image, a woman, here naked, stands in a luxuriant landscape.[3] But the landscape is not an observed one. The foreground peacock flowers and central winged lizard are imaginary. And the image of the Tahitian goddess is equally manufactured, based not on a local inhabitant but on a photograph of a Buddhist temple carving.[4] The undulating foliage dominates her, and the menacing lizard assumes center stage. Gauguin's amalgam of images depicts a troubled paradise and seems to allude to Tahiti's own disturbing situation at the time. A French colony since 1881, Tahiti had been pictured as a mythical paradise in numerous travel journals and tourist literature, but by the time of Gauguin's visit had been widely exploited by colonial interests and was considered one of the most degraded islands in the South Seas.[5]

Edvard Munch lived in Paris between 1895–96 and was undoubtedly aware of Gauguin's *Noa Noa* series.[6] Munch's work reflected the older artist's generalized approach to form and symbolic use of color as well as the rough cutting and bold flatness specific to these woodcuts. By the 1890s, the landscape had become a recurrent theme for Munch. But even prior to this period he had used images of his local Norwegian landscape as a vehicle for his psychological statements, eliminating traditional spatial configurations and abstracting the elements of nature into symbols of intense mood: "Nature is not something that can be seen by the eye alone—it lies also within the soul, in pictures seen by the inner eye."[7]

In 1889 Munch began spending his summers in the small coastal town of Åsgårdstrand on the Oslo fjord, and most of his paintings of the 1890s were created there. Its rocky coastline, tall pine forests, and lingering twilight appear over and over in his emotive images of anxiety, loneliness, and melancholy. The woodcut *Women on the Shore*, possibly inspired by Gauguin's *Auti Te Pape* from *Noa Noa*, depicts two women in different stages of life with a typically austere and fatalistic overtone. Munch portrays one figure as young, white, virginal, and upright, and the other as shrouded, black, stooped, and deathlike. On the same shoreline in *Evening (Melancholy: On the Beach)* a forlorn figure broods in the foreground.

ABOVE: Paul Gauguin. *Auti Te Pape (Women at the River)* from the series *Noa Noa*. 1893–94. Woodcut and stencil, comp.: 8 1/16 x 14" (20.5 x 35.5 cm). Printer: Louis Roy. Edition: 25–30. The Museum of Modern Art, New York. Gift of Abby Aldrich Rockefeller

OPPOSITE, TOP: Edvard Munch. *Women on the Shore*. 1898. Woodcut, comp.: 17 15/16 x 20 1/4" (45.5 x 51.5 cm). Edition: approx. 50. The Museum of Modern Art, New York. Purchase

OPPOSITE, BOTTOM: Edvard Munch. *Evening (Melancholy: On the Beach)*. 1896. Woodcut, comp.: 16 15/16 x 20 15/16" (43 x 53.3 cm). Edition: approx. 50. The Museum of Modern Art, New York. Abby Aldrich Rockefeller Fund

In both images Munch brilliantly intensifies the works' meanings through his innovative woodcut technique. By cutting his woodblocks into jigsaw-puzzle pieces, he accentuates the conceptual "parts" and "wholes" of his images. In *Women on the Shore* (p. 213), for example, Munch cut his block of wood into three pieces, one for the water, one for the beach, and one for the two women. Uniting his visions of youth and old age in one block, he emphasizes the inevitability of death and strengthens our impression of the women as states of the same figure. Similarly, separating the sea from the land on different blocks heightens the emotional impact of the limitlessness of nature. In *Evening (Melancholy: On the Beach)* (p. 213) his abrupt juxtaposition of foreground and background enhances the distance between the monumental despondent figure and the trysting couple in the distance and underscores his recurrent theme of the isolated human condition. Following Gauguin's model, Munch also distinctly exploited the grain of the wood, enlivening the curving red lines of the sky.

Munch lived in Berlin intermittently from the mid-1890s until 1908. The expressive power of his work as well as his unique fusion of materials and content exerted a profound influence on a revolutionary group of young German artists known as *Die Brücke* (The Bridge), which included Ernst Ludwig Kirchner, Erich Heckel, Max Pechstein, and Karl Schmidt-Rottluff.[8] Based in Dresden, these artists aimed to create a vital and life-affirming community to counter the dehumanizing effect of the particularly rapid industrialization occurring in Germany during this period. The *Brücke* group formed in 1905 among a backlash of "back to nature" groups critical of the cities' increasingly commercial values. Artist colonies developed in search of a "primordial" unity with nature, and nudist groups appeared extolling their capacity for a freer communion

OPPOSITE, TOP: Erich Heckel. *On the Grass.* 1912. Lithograph, comp.: 13⅛ x 17⅛" (33.3 x 43.5 cm). The Museum of Modern Art, New York. Abby Aldrich Rockefeller Fund (by exchange)

OPPOSITE, BOTTOM: Max Pechstein. *Hunting Game* from the journal *Der Sturm.* 1911, published 1912. Woodcut, comp.: 8⅞ x 10³⁄₁₆" (22.6 x 25.9 cm). Publisher: *Der Sturm,* Berlin. Edition: 100. The Museum of Modern Art, New York. Purchase

BELOW: Ernst Ludwig Kirchner. *Bathers Throwing Reeds* from the portfolio *E L Kirchner (Die Brücke V).* 1909, published 1910. Woodcut, comp.: 7⅞ x 11½" (20 x 29.2 cm). Publisher: Brücke Kunstlergruppe, Dresden. Edition: approx. 68. The Museum of Modern Art, New York. Riva Castleman Endowment Fund, the Philip and Lynn Straus Foundation Fund, Frances R. Keech Fund, and by exchange, Nina and Gordon Bunshaft Bequest, Gift of James Thrall Soby, Anonymous, J. B. Neumann, Victor S. Riesenfeld, Lillie P. Bliss Collection, and Abby Aldrich Rockefeller Fund

ABOVE: Ernst Ludwig Kirchner. *Trees on a Mountain Slope*. 1920. Woodcut with collage, comp.: 15³⁄₁₆ x 22³⁄₈" (38.6 x 56.9 cm). The Museum of Modern Art, New York. Gift of Samuel A. Berger

OPPOSITE, TOP: Ernst Ludwig Kirchner. *Winter Moonlight*. 1919. Woodcut, comp.: 12¹⁄₁₆ x 11⁵⁄₈" (30.7 x 29.5 cm). The Museum of Modern Art, New York. Purchase

OPPOSITE, BOTTOM: Erich Heckel. *Snowfall* from the portfolio *Eleven Woodcuts 1912–1919, Erich Heckel*. 1914, published 1921. Woodcut, comp.: 17¹⁄₈ x 11½" (43.4 x 29.3 cm). Publisher: J. B. Neumann, Berlin. Edition: 40. The Museum of Modern Art, New York. Purchase

with the environment. The radical philosophy of Friedrich Nietzsche, which advocated artists' need for freedom from the constraints of civilized society, was widely read among artists and intellectuals, including the young artists in Dresden. They even took their group name, *Die Brücke*, from Nietzsche's prologue in *Thus Spoke Zarathustra*, in which the bridge is a metaphor for man's journey from the immersion in culture to a state of freedom and "overcoming."

The *Brücke* group proclaimed their synthesis of art and life to be a radical alternative to industrialized society. Influenced by rebellious, anti-urban attitudes, they also believed that nature could replenish the spirit and help restore meaning to life.[9] They began taking frequent communal excursions to the country with their models, traveling to the Moritzburg lakes outside Dresden, as well as to seaside areas along the Baltic and North Seas to swim, sunbathe, and sketch in the nude. (Gauguin's Tahitian retreat was well known among the group, and his *Noa Noa* journal had been published in a German periodical in 1908.) In Heckel's *On the Grass* (p. 214) and Kirchner's *Bathers Throwing Reeds* (p. 215), the figures seem at one with the natural environment and take striking, unprompted, and unconventional poses. Kirchner's sexually aroused male among a trio of playfully posed females also reflects *Die Brücke*'s newfound spontaneity and freedom from societal mores. In Heckel's lithograph the fleshy sensual nudes curve along the undulating lines of the landscape, accentuating the sense of harmony and materiality with the earth. A similar effect occurs in Pechstein's *Hunting Game* (p. 214), as body contours echo the landscape

rhythms. The tree branches bend in tandem with the legs of the females at right, and the orange and black earth extends the figures' seated poses, merging humanity and landscape.

These country visits served as inspirations for numerous paintings and prints. But the works themselves were not done from nature but rather after sketches and studies done in nature. The final images were synthetic characterizations of mood distilled in memory, rather than the faithful representation of a particular landscape. Kirchner first sketched *Bathers Throwing Reeds* on a postcard to Heckel in 1909 from the Moritzburg lakes, and typical of the *Brücke* artists' working method, he only completed the woodcut back in the Dresden studio later the following winter. Moreover, Pechstein's woodcut hunting scene, transformed into a vision of a lost, exotic arcadia, was actually derived from a Benin bronze relief the artist saw in a local ethnological museum.[10] Their works evidence a cultivated spontaneity and passion revealing a peculiar mixture of intellect and intuition.

In 1911 the *Brücke* group moved from Dresden to Berlin, which had become a leading center for new art. By this point, the artists' styles began to evolve more and more in their own directions, and the group finally dissolved in 1913. In Heckel's work nature began to dominate the figure. Vertical formats and brittle angularity became typical, mirroring the Cubist and Futurist work he had recently seen in Germany. *Snowfall* (at right) exemplifies the simplified silhouettes, crystalline forms, and strong graphic sensibility characteristic of his work of this period. The moon anchors the composition against the turbulent diagonals of a stormy sky, a reflection of Heckel's unsettled state following the

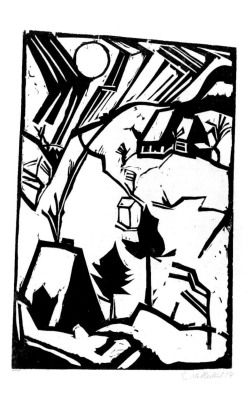

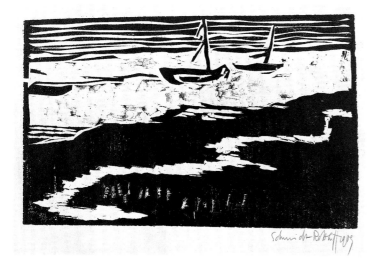

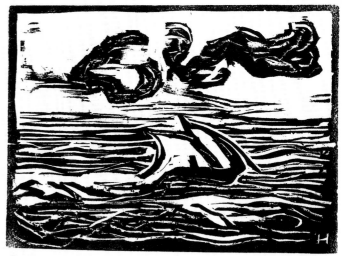

breakup of *Die Brücke* and the onset of World War I.[11] The woodcut's splintery, jagged forms contribute to the image's psychological tension.

After the war, Kirchner made a permanent retreat, moving in 1917 to Davos, Switzerland, and then to a more remote house in the mountains. His work from this point on focused on the majestic sweep of nature, devoid of human intervention. In *Winter Moonlight* (p.217) he captured the limitless grandeur and overpowering stillness of the Alps in early morning before the moonset. And yet a certain demonic or apocalyptic mood pervades the dramatically colored print. Kirchner describes the image as a response to the urban violence occurring in Berlin during the Weimar uprisings of the day: "People are half-mad there. Amidst machine-gun fire and invasions they are partying and dancing. . . . There was such a wonderful moonset early this morning: the yellow moon on small pink clouds and the mountains a pure deep blue, totally magnificent. . . . How eternally happy I am for all that to be here, and to receive only the last splashes of the waves of outside life through the mail."[12]

More than any other *Brücke* artist, Schmidt-Rottluff firmly believed in nature's ability to heal the ills of industrialization, and his work is the clearest example of a pure retreat to a rural setting. He and Heckel were school friends and had spent summers together during the early *Brücke* years in the North Sea village of Dangast. Like Heckel's *Sailboat*, which dates from one of these summers, Schmidt-Rottluff's *The Sound* illustrates an astute playfulness with the woodcut's crude surface. By rolling generous amounts of ink onto the woodblock and pressing heavily on the paper, he achieved dense blacks and left stray areas flecked with ink to represent the effects of light on the water.

Emil Nolde joined the *Brücke* group briefly in 1906. In 1914 he traveled to the South Seas and, inspired by those lush surroundings, returned with a renewed interest in nature and its cyclical rhythms. Water, and the sea in particular, were important themes for Nolde and his late lithographs are among the most moving and atmospheric expressions of this lifelong fascination. A looming sky and long horizon line emphasize the flat, misty North Sea marshland in his distilled depictions of a barren landscape. But *Windmill on the Shore* (opposite) is not only an eloquent vision of nature, but also a reflection of the artist's strongly held views against industrial encroachment on a natural landscape, specifically

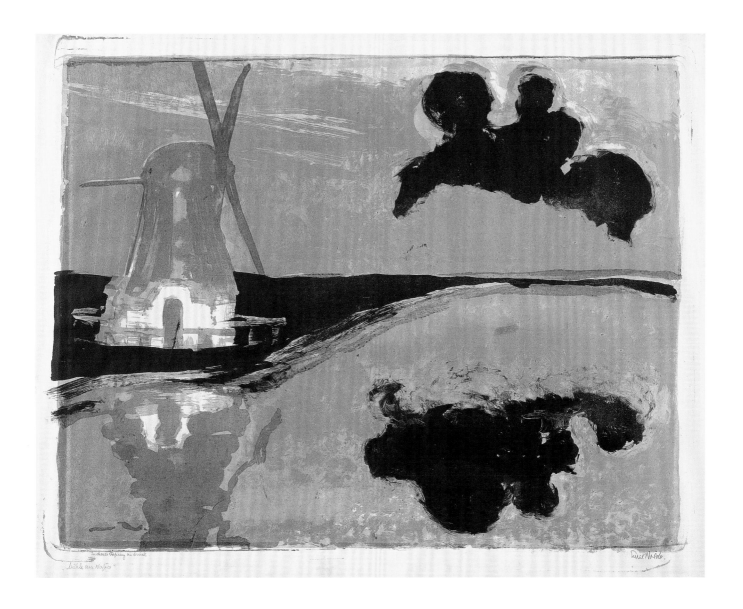

Emil Nolde. *Windmill on the Shore.* 1926. Lithograph, comp.: 23¹¹⁄₁₆ x 31¼" (60.1 x 79.4 cm). Edition: Unique impression of this state. The Museum of Modern Art, New York. James Thrall Soby Fund

a drainage project undertaken by the Danish government to prevent flooding, create more arable land, and modernize their agricultural production. (As a practical measure, the artist even designed an alternative drainage system.) Nolde's melancholy, romantic image reflects his desire to protect the natural beauty of this serene countryside against the "progress" of this modernization: "And where are the mills, the bridges, the sluices, the canals, the boats? . . . Replaced by toll houses, pumping stations and obstructing dikes. . . . The most unusual, perhaps the most beautiful region in the sacred German empire has been divided, torn up and lost—the work of engineers and men foreign to the country."[13]

When the *Brücke* artists moved their studios to Berlin, their focus shifted from nature's harmony to the discordant rhythms of the cosmopolitan city. In dynamic visions of an anti-utopia, many of these artists, as well as those of the next generation of Expressionists, such as Otto Dix and George Grosz, composed literal and allegorical depictions of cabarets and crowds, violence and prostitution. With notable exceptions, the pastoral calm of the early *Brücke* years could no longer compete with the frenzied energy of the modern metropolis.

PETER REED

HECTOR GUIMARD
and the Art Nouveau Interior

Hector Guimard's Castel Béranger—the sensational Parisian apartment building in which no detail escaped his Art Nouveau artistry—was celebrated upon its completion with an exhibition at the Salon du Figaro (p. 225). There, at a press conference, the architect related a story about the impact his new wallpaper designs had upon an unsuspecting visitor: "One man visiting Castel Béranger (I regret it was not a lady as I prefer feminine taste) suddenly went pale; the house-keeper, a good woman, immediately offered to fetch him a glass of water and kindly inquired if he was sick. . . . 'In fact I do not feel very well . . . this paper . . . I don't know why, it has a funny effect on me.'"[1] The restless curvilinear patterns of the colorful wallpapers were an astonishing, if not dizzying, background for interiors completely furnished by Guimard, who described himself as an *Architecte d'Art*, and who ambitiously and consciously set out to modernize French design.

Guimard was one of the most original designers of the style known in France as Art Nouveau. This modern, fin-de-siècle movement seemed to owe nothing to historical convention and precedent. It was neither exclusively an interior phenomenon nor solely French, but, especially in the private realm, designers unleashed their imaginations to create often fantastic, exuberantly curved, organic forms. Nature provided the inspiration for the biomorphic abstractions of Guimard and other Art Nouveau designers; its richly varied outward appearances as well as

Hector Guimard. *Le Castel Béranger.* Wallpaper (bedroom), detail. 1898. Pochoir, 17 x 12½" (43 x 32 cm). The Museum of Modern Art, New York. Gift of Lillian Nassau

221

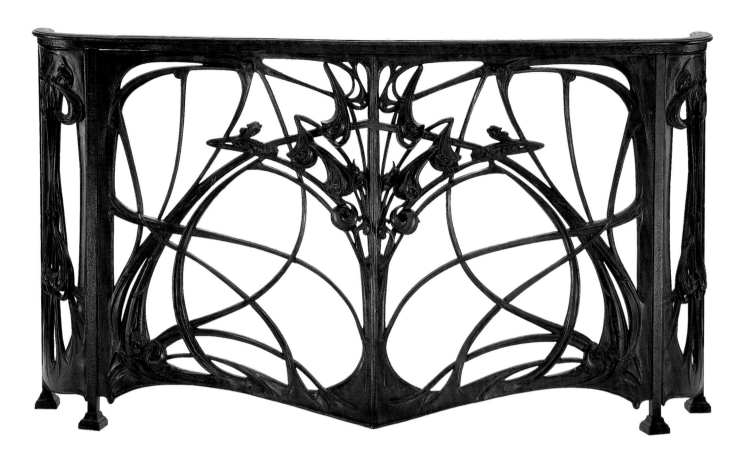

ABOVE: Hector Guimard. Balcony Railing. 1905–07. Cast iron, 40¼ x 64 x 11½" (101.9 x 162.5 x 29.3 cm). The Museum of Modern Art, New York. Phyllis B. Lambert Fund

BELOW: Hector Guimard. Entrance Gate to Paris Subway *(Métropolitain)* Station. c. 1900. Painted cast iron, glazed lava, and glass, 13'11" x 17'10" x 2'8" (424 x 544 x 81 cm). The Museum of Modern Art, New York. Gift of Régie Autonome des Transports Parisiens

OPPOSITE, TOP: Hector Guimard. Side Table. c. 1904–07. Pear wood, 29⅞ x 20½ x 17⅞" (79.9 x 52.1 x 45.6 cm). The Museum of Modern Art, New York. Gift of Mme. Hector Guimard

OPPOSITE, BOTTOM: Hector Guimard. Settee. 1897. Carved mahogany and tooled leather, 36½ x 67½ x 21" (92.7 x 171.4 x 53.3 cm). The Museum of Modern Art, New York. Greta Daniel Design Fund

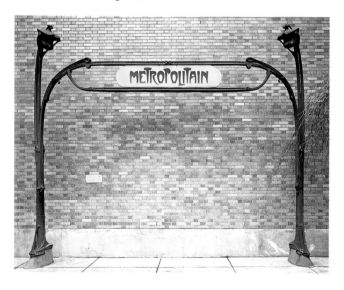

its underlying structures presented an inexhaustable source for designs that sought to express the underlying movements of forms and the creative processes in nature, rather than outward shapes alone. Art Nouveau was a perfect antidote to revival styles, such as the Empire and Gothic so prevalent in nineteenth-century eclecticism, as well as to the ordered and rational forms of the engineer. Guimard explained his aesthetic intentions and inspiration in nearly cosmic terms: "When I design a piece of furniture or sculpt it, I reflect upon the spectacle the universe provides. Beauty appears to us in perpetual variety. No parallelism or symmetry: forms are engendered from movements which are never alike. . . . These dominant lines which describe space, sometimes supple and sinuous arabesques, sometimes flourishes as vivid as the firing of a thunderbolt, these lines have a value of feeling and expression more eloquent than the vertical, horizontal and regular lines continually used until now in architecture. . . . Let us be inspired by these general laws. Let us bend before . . . the examples of the great architect of the universe."[2]

It is significant that Guimard described the act of design as sculpting. Cast iron, wood, and other materials were molded and shaped in a manner that makes us fully aware of the artist's

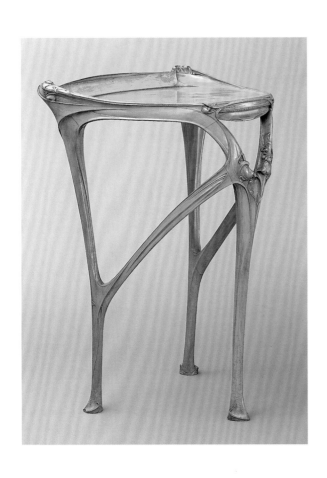

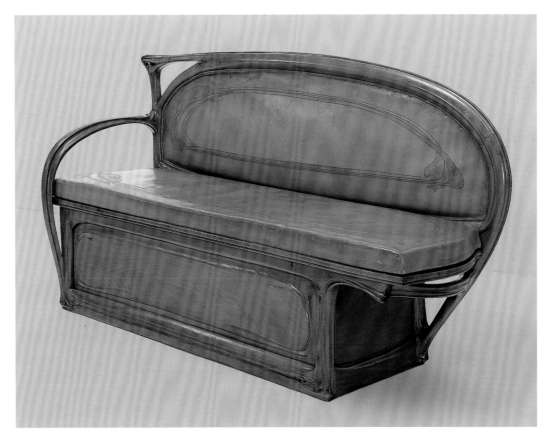

expressive hand. The flowing arabesques of a cast-iron balcony railing form a lacy protective network, delineated like a pen-and-ink drawing (p. 222). The looming dendriform structures of the famous *Métropolitain* subway gate, with its enormous illuminated blossoms, are fantastic elements that seem all the more alien in their urban context (p. 222). In Guimard's carved wood furniture, including his own desk (p. 229), the legs and arms suggest femurs and other skeletal forms, and the overall contours swell like a well-fed body. All these works assert an organic and highly individualized vision. The "lines of feeling" (to borrow a phrase from Guimard's Belgian contemporary, architect and designer Henry van de Velde) projected by the artist into the object celebrate a modern sensibility that was predicated on the expressive power of the artist to communicate through empathic means.[3] In this sense, Art Nouveau can be considered a retreat to a private psychological realm of sensations best suited to the highly aestheticized interior. Doorknobs, carpet rods, picture frames, vases, wallpaper, and typography (pp. 220, 225, 226) all share a formal vocabulary that eschews the right angle and treads carefully between symmetry and asymmetry.

There are few extant environments by Guimard, but a portfolio of photographic prints documenting the Castel Béranger provides a glimpse into this refined and dreamy world in which he designed every detail, down to the carpet rods. The stair hall is a brilliant example of the allover quality of the ornament that spreads so effortlessly from wall to floor to carpet to banister (p. 226). An artist's atelier in the garret contains a variety of decorative objects, including Henri de Toulouse-Lautrec's poster for the popular cabaret *Divan Japonais*, silhouetting the dancer Jane Avril (p. 227). The poster is a reminder not only of the immense popularity of contemporary lithographs, which were avidly collected, but also of the vogue for things Japanese that had a pervasive influence in late-nineteenth-century art and design—for example, in Guimard's wallpaper motifs (pp. 220, 226).

Guimard's stated preference for feminine taste is not surprising. With a preponderance of swelling curvatures, the formal qualities of Art Nouveau are decidedly feminine in character. Imagery of the femme fatale, with erotic flowing locks of wispy hair, also permeates fin-de-siècle art. Perhaps no woman personified this better than Loïe Fuller, the American dancer in Paris, who, with her swirling veil, performed Dionysian spectacles such as "The Butterfly," "The Orchid," "The Fire," and "The Lily," illuminated by colored lights (pp. 44, 228).

OPPOSITE, TOP: Hector Guimard. Double Picture Frame. c. 1909. Gilded bronze, 9⅝ x 14½ x 9" (24.5 x 36.8 x 22.9 cm). The Museum of Modern Art, New York. Gift of Mme. Hector Guimard

OPPOSITE, BOTTOM: Hector Guimard. Vase. c. 1898. Bronze, 10½ x 7" (25.5 x 18 cm) diam. The Museum of Modern Art, New York. Joseph H. Heil Bequest and exchange

BELOW: Hector Guimard. *Exposition Salon du Figaro, Le Castel Béranger.* 1899. Lithograph, 35 x 49¼" (88.9 x 125.1 cm). The Museum of Modern Art, New York. Gift of Lillian Nassau

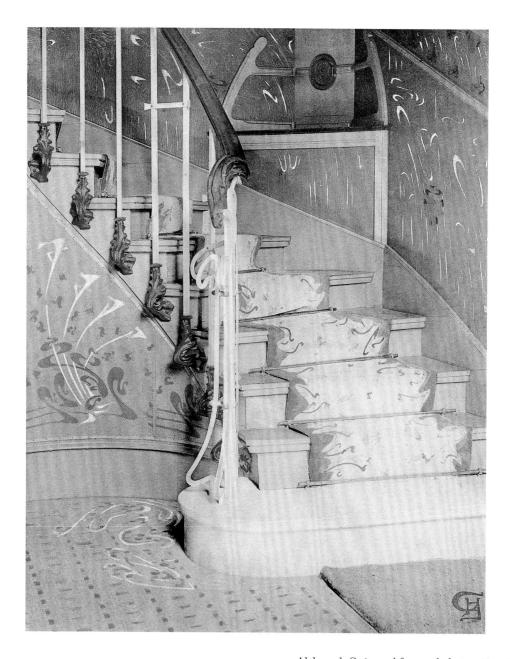

Although Guimard favored abstraction in his work, other Art Nouveau designers, particularly those associated with the prolific furniture and glass workshops in Nancy, often employed greater realism. In a lamp by Louis Majorelle, the soft glow from the globe in the form of a lotus blossom illuminates frogs on lily pads surrounding the supporting base (p. 228). The glass globe (with acid-etched veining) is especially strange; it seems less like a flower than some underwater organism, such as the amoeba and jellyfish that fascinated the contemporary German biologist Ernst Haeckel. His landmark monograph of 1899, *Kunstformen der Natur*, is illustrated with lower forms of life, and he had hopes that his research would influence designers.

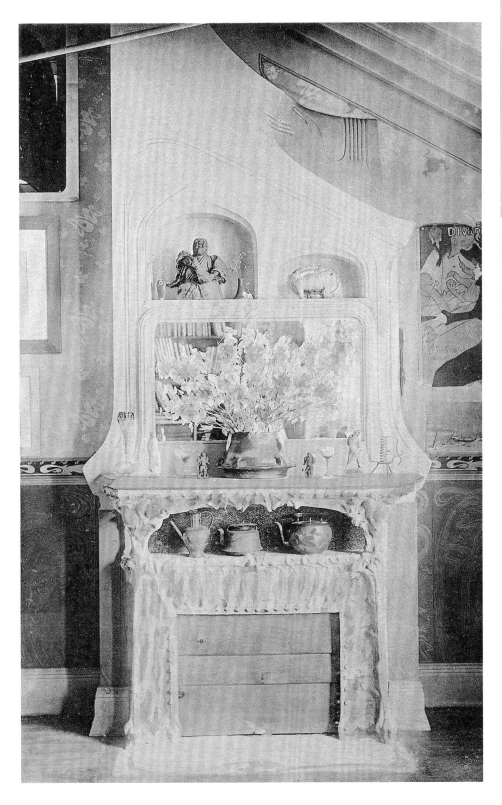

OPPOSITE: Hector Guimard. *Le Castel Béranger.* Staircase, detail. 1898. Collotype and pochoir, 17 x 12½" (43 x 32 cm). The Museum of Modern Art, New York. Gift of Lillian Nassau

LEFT: Hector Guimard. *Le Castel Béranger.* Artist's studio, detail. 1898. Collotype and pochoir, 17 x 12½" (43 x 32 cm). The Museum of Modern Art, New York. Gift of Lillian Nassau

ABOVE: Henri de Toulouse-Lautrec. *Divan Japonais.* 1893. Lithograph, 31⅞ x 24½" (80.5 x 62 cm). The Museum of Modern Art, New York. Abby Aldrich Rockefeller Fund

Daum Frères, a company that produced glass for Majorelle's lamps, ran a premier glassworks in Nancy. Not all their work depicted animal and plant life. In a series of long-necked vases, a style they called *Berluze*, the attenuated vessels are hand painted in vibrant color combinations (such as pink and green, red and yellow) applied in a loose impressionistic manner (p. 228).

In many respects, Art Nouveau was an international phenomenon. The cross fertilization was particularly rich owing to the universal exhibitions and the famous commercial shops such as Siegfried Bing's L'Art Nouveau in Paris and Arthur Liberty's successful enterprises in London and Paris. One of the most innovative designers employed by Liberty was the British artist Archibald Knox, who avoided the natural imagery so prevalent in France. His Jewel Box is a superb example of an idiosyncratic ornamentation derived from the interlacing of medieval Celtic motifs, which, regardless of its sources, shares a feeling of growth and freedom with Guimard's designs (p. 228).

Art Nouveau was an immensely popular movement, but short-lived; it became unfashionable by the end of the first decade of the twentieth century. Nevertheless, Guimard and others had effectively modernized design in formal terms as well as expressive content. As a retreat from quotidian urban realities, the rarified Art Nouveau environment also responded to a sense of interiority—the exploration of psychological states and emotions—shared by contemporary artists.[4]

OPPOSITE, TOP LEFT: Louis Majorelle and Daum Frères. Table Lamp. c. 1900. Bronze, gilt and patinated, and acid-etched glass, 27¼ x 10½" (69.3 x 26.7 cm). The Museum of Modern Art, New York. Joseph H. Heil Bequest and exchange

OPPOSITE, TOP RIGHT: Archibald Knox. Jewel Box. c. 1900. Silver, mother-of-pearl, turquoise, and enamel, 3⅞ x 11¼ x 6" (7.3 x 28.5 x 15.2 cm). The Museum of Modern Art, New York. Gift of the family of Mrs. John D. Rockefeller, Jr.

OPPOSITE, BOTTOM LEFT: Daum Frères. Vases. c. 1910. Painted blown glass, left to right: 6 x 2" (15.2 x 5 cm) diam., 6 x 2" (15.2 x 5 cm) diam., 15¼ x 3½" (38.8 x 8.8 cm) diam., 8 x 3½" (20.3 x 8.8 cm) diam., 6¼ x 2⅛" (16 x 5.4 cm) diam., 6 x 2" (15.2 x 5 cm) diam., 6⅝ x 1¾" (17 x 4.5 cm) diam. The Museum of Modern Art, New York. Joseph H. Heil Bequest and Phyllis B. Lambert Fund

OPPOSITE, BOTTOM RIGHT: François-Raoul Larche. *Loïe Fuller, The Dancer*. c. 1900. Bronze, 18⅛ x 10⅛ x 9⅛" (45.7 x 25.5 x 23.1 cm). The Museum of Modern Art, New York. Gift of Anthony Russo

ABOVE: Hector Guimard. Desk. c. 1899 (remodeled after 1909). Olive wood with ash panels, 28¾" x 8' x 47¾" (73 x 256.5 x 121.3 cm). The Museum of Modern Art, New York. Gift of Mme. Hector Guimard

651 BLUFF ON CAYUGA LAKE. L. V. R. R.

Susan Kismaric

RISE OF THE MODERN WORLD

With the invention of photography, in 1839, the industrial age had the perfect ally with which to forge a modern world. Rapidly accelerating change induced a constantly shifting panorama for the camera to record, and the camera in turn, through its great sweep of subjects, fired the imaginations and the ambitions of inventors, scientists, engineers, builders, doctors, explorers, social reformers, journalists, historians, and not least artists. Fact oriented, photography was attuned to the industrial period, even as its technology today extends into media embedded in our own time: film, video, and computer-imaging techniques unimaginable a century ago. Back then, however, the simple photographic image itself was still revolutionary.

The complementary relationship between modernity and photography extended beyond the documentation of advances in science, technology, and industry. From the moment it was invented, photography offered a new pictorial language. The medium's factual accuracy, its ability to stop time and action and to open up previously unimagined perspectives, were radical contributions to the evolution of visual representation. From telescope pictures of the moon to X rays of the human body, photographs described in detail what earlier could only be imagined. They communicated, educated, incited economic ambition, served as propaganda and advertising, aided memory, and inspired.

The industrial culture of invention moved with unbridled speed and intensity. A startling array of changes occurred within a compressed time span. In 1844, five years after the invention of photography, Samuel Morse's telegraph was used for the first time, between Baltimore and Washington, D.C. In 1846 Elias Howe patented the sewing machine; in 1864 Louis Pasteur devised the pasteurization process; in 1866 Alfred Nobel produced dynamite. The Brooklyn Bridge opened in 1872. The Remington gunsmith firm began making typewriters in 1873, Alexander Graham Bell invented the telephone in 1876, and

OPPOSITE: William Rau. *Bluff on Cayuga Lake, L.V.R.R.* 1895. Albumen silver print from glass negative, 20½ x 17⅜" (52.1 x 44.1 cm). The Museum of Modern Art, New York. Lois and Bruce Zenkel Fund

in 1877 Thomas Edison played back the first phonograph recording—of himself shouting "Mary had a little lamb." Three years later he and J. W. Swan independently invented the first electric lights. The Wright brothers flew at Kitty Hawk in 1903, and Henry Ford produced his Model T in 1908; the car revolutionized the automotive industry, and Ford also revolutionized industrial production itself through the creation of the factory assembly line. By 1917 he had produced his millionth car.

With the application of the steam engine to commercial transportation after 1829, the railroad became integral to the expanding industrial economies, and trains became powerful symbols of the new dynamism. They were crucial in the westward expansion of the United States, as railroad companies won vast public lands in order to lay tracks to new territories. (A transcontinental railroad was completed in 1869.) Photographers such as Andrew Russell, Frank Jay Haynes, and Timothy O'Sullivan documented the construction of these railroads during the 1860s, often working for the U.S. government or for the railroad companies themselves. By the time of William Rau's photograph *Bluff on Cayuga Lake, L.V.R.R.* (1895; p. 230), pioneering effort had given way to settled dailiness: this train rounding a corner in a tamed but verdant landscape may be taking tourists to visit relatives or to stay at resort hotels. The photograph was probably intended as an advertisement for the Lehigh Valley Railroad, for which Rau was the official photographer.

After the railroads had bridged America's coasts came the conquest of the western wilderness, through farming, hunting, logging, and the growth of towns and cities. These projects also were fodder for photographers, for example Darius Kinsey, who documented Washington State loggers for over fifty years beginning in 1890, his means of transport first a horse and buggy, later the train, and later still a Ford Model T. He would often have to hike into the woods a good dozen miles or so carrying his eleven-by-twenty-two-inch camera, tripod, and heavy glass plates—a weight of some 100 pounds. Kinsey made a successful business out of selling the loggers portraits of themselves at work. Intended to be kept as mementos or sent to relatives and friends, his photographs also constitute a detailed record of the men and methods of the forestry industry of the period. In *Cedar* (1916; p. 234), victorious loggers perch on a mammoth felled tree like Lilliputians in *Gulliver's Travels*, dramatizing their own situation in the western landscape.

Unparalleled in its ability to describe events and objects vividly and accurately, photography had innumerable practical applications. Companies used it to document new inventions, factories, and machinery, governments to chart the progress of the construction and civic-improvement projects that were contributing their share to the upheaval and transformation of the physical landscape. In 1863 Adolphe Terris photographed the site for a new thoroughfare in Marseilles (p. 235). France's conquest of Algeria in 1830, and the digging of the Suez Canal in 1859–69, had brought tremendous expansion to the city, the most important French port on the Mediterranean. In Terris's photograph, torn hillsides frame a baroque cathedral whose cross centers the picture; amid tumbled rock and earth, the world is changing before our eyes.

The accomplishments of engineers like Terris's road builders during this era included everything from suspension bridges, railway tunnels, aqueducts, and dams through the laying of cable across the Atlantic. All of these were photographed, as was the construction of the Eiffel Tower, a spectacular feat on the part of the noted French engineer Alexandre-Gustave Eiffel. Designed for the Paris Exposition of 1889, a showplace celebrating the

nation's commitment to industry, the tower has come to symbolize French progressive thinking at the end of the century. H. Blancard's photographs (pp. 236–37) track the progress of its construction over a period of about a year.

The early photographers' exercise of their imaginations had been encumbered by their equipment. To make an image, the photographer had to coat a glass plate with light-sensitive collodion emulsion, a process requiring complete darkness and careful temperature control; the plate had to dry; and once exposed, it had to be developed immediately. Photographers, then, were forced to carry a virtual darkroom wherever they worked. Within these tiresome physical constraints, they nevertheless managed to explore an astonishing variety of subjects and to travel widely, daring foreign territories and inhospitable conditions, from the deserts of North Africa to the peaks of the French Alps. Camera and photographer were in any case liberated from the wet-plate system in the early 1880s, with the introduction of dry-plate negatives, which photographers could make themselves or could even purchase commercially. When Robert Falcon Scott set out on his ill-fated expedition of 1911–13 to the South Pole, he took with him a photographer, Herbert G. Ponting, who used a dry-plate glass negative to record, for example, Mr. E. W. Nelson using a device to analyze water (p. 249).

In 1888 the American inventor George Eastman marketed his first box camera with roll film, the Kodak. It sold for twenty-five dollars. The film was already loaded; after the purchaser had taken 100 pictures, the camera was returned to the factory, where the film was removed for processing and was replaced with a new roll. Then the camera was returned to its owner. With the invention of the Kodak, men and women in all walks of life, working out of an ever increasing array of professional and personal motivations, could easily make photographs, further opening up the medium to new image-makers uninhibited by the restraints of pictorial convention or the exacting standards of the professional photographer. This dramatically widened photographers' potential subject matter, and also their own numbers: within fifty years after the medium's invention, the camera had moved from the hands of the few to the many.

Photographs themselves were broadcast still more widely. The reciprocity between technical advances in photography and the pace of the modern age is demonstrated nowhere more clearly than in the halftone process, invented in the 1880s to make images easily reproducible. By the late 1890s, photographic images were regularly disseminated to huge numbers of people, gaining incalculably in power in the process. A new audience materialized for photography—the broad population beyond the confines of the photo salon or the art gallery. The need on the part of newspapers, magazines, and picture weeklies for an unending supply of images not only broadened the subject matter of photography but generated a variety of far-reaching enterprises to deal with its production and reproduction, including the photo agencies that today enlist photographers to make pictures on assignment. After it became possible to transmit photographs by wire, in the mid-1920s, they were distributed almost instantaneously around the world. Like a second language, photography entered the lexicon of daily life.

If the benefits of the industrial revolution were invention, technology, new forms of architecture, and so on, their negative counterparts included the living conditions of the urban poor. The cities of Europe and the United States grew enormously during the nineteenth century, their factories attracting huge labor pools. In America, this population

Darius Kinsey. *Cedar.* 1916. Gelatin silver print,
10¹⁄₁₆ x 13⁷⁄₁₆" (25.5 x 34 cm). The Museum of
Modern Art, New York. Courtesy of Jesse E. Ebert

explosion occurred through migration not only from the countryside to the city, as in Europe, but from the old world to the new; and the tenement neighborhoods in which the new arrivals were forced to take residence were often deprived, unsafe, and squalid. In response, by the late nineteenth century a new kind of photographer had arisen, one who would use the medium in the service of social or cultural goals. Jacob Riis and Lewis Hine, for example, were amateur image-makers in the sense that neither of them took up photography as a first calling—Hine was a social worker, Riis a journalist, and both men were committed reformers—but they understood how to apply photography to a goal, using it to provide graphic and persuasive description of the conditions they sought to redress (pp. 238–39). Through images such as those in Riis's book *How the Other Half Lives*, published in 1890, photography played an essential role in the social reforms necessitated by the industrial age.

The police departments that attempted to bring order to the new urban conditions also found practical applications for photography; by the 1880s, French gendarmes routinely documented crime scenes (p. 240), while American police departments amassed "rogues'

Adolphe Terris. *Marseilles.* 1863. Albumen silver
print from a glass negative, 13¹¹⁄₁₆ x 15¾" (34.8 x
40 cm). The Museum of Modern Art, New York.
Samuel J. Wagstaff, Jr., Fund

galleries" of mug shots (p. 241). A more elegiac response to social change appears in the
work of Eugène Atget, who photographed the streets, parks, and architecture of Paris and
its environs for over thirty years, amassing an extraordinary visual catalogue of French
culture. Atget was interested in the preservationist role of photographs as visual records.
He reacted to the changes growing out of the industrial revolution by rarely recognizing
them; in his five to six thousand photographs, the Eiffel Tower appears only twice, and in
the background. Even so, industrialization makes its appearance in his images: the Paris
storefronts he photographed display mass-produced goods—machine-woven fabrics, for
example, or ready-made clothing, or even prefabricated furniture (pp. 242–43).

Working outside the aegis of art, the new photographer created a new kind of picture.
The use of photography in science was inevitable. What had been too distant or too fast to
see could now be visually captured; what had once been invisible could be fixed and studied.

Among the most influential advances were those of Eadweard Muybridge, an English-
man working in the United States, and of Étienne-Jules Marey, a French physiologist. In

the late nineteenth century, both men applied photography, with its ability to stop time in quick successive exposures, to the analysis of movement (p. 244). This became possible when emulsion speed—the speed with which the chemical emulsion in the film negative reacts to light—became fast enough and the camera mechanism sophisticated enough to record moving objects with reasonable precision. In 1882 Muybridge began his eleven-volume work *Animal Locomotion*, a thorough record of the human body walking, wrestling, running, jumping, rowing, and dancing, and of birds and other animals in motion. Muybridge used groups of ten or twelve cameras whose shutters were released mechanically as the subject passed the lens. The results of his work—19,347 individual photographs, in 781 multi-image plates—deeply affected artists and scientists of the time, and remain the most exhaustive pictorial analysis of the subject ever made. A list of some of the subscribers to *Animal Locomotion* (organized by profession, and published as an appendix to *The Human Figure in Motion*, 1901, a selection from the earlier book) includes scientists—biologists, physiologists, anatomists; artists—painters and sculptors, as well as writers on art; and also military men. Among those listed are Louis Comfort Tiffany, Augustus Saint-Gaudens, and John Ruskin.

Unlike Muybridge, Marey used a single camera, which, however, recorded multiple exposures. A Marey photograph contains a continuous stream of successive images, and delineates movement in finer increments than do Muybridge's. Marey invented what he called a "photographic gun," which took a series of exposures on a single plate. Behind the lens of this device was a revolving disc on which twelve exposures could be made in rapid

OPPOSITE: H. Blancard. Untitled (construction of the Eiffel Tower). February 1888. Platinum print, 6⅛ x 8¹¹⁄₁₆" (15.5 x 22 cm). The Museum of Modern Art, New York. Purchase

ABOVE AND RIGHT: H. Blancard. Untitled (construction of the Eiffel Tower). June 1888. Platinum print, 8¹³⁄₁₆ x 6⁵⁄₁₆" (22.3 x 16 cm). The Museum of Modern Art, New York. Purchase

H. Blancard. Untitled (construction of the Eiffel Tower). August 1888. Platinum print, 8¹³⁄₁₆ x 6⅛" (22.3 x 15.5 cm). The Museum of Modern Art, New York. Purchase

H. Blancard. Untitled (construction of the Eiffel Tower). April 28, 1889. Platinum print, 8¹⁵⁄₁₆ x 6⅛" (22.7 x 15.5 cm). The Museum of Modern Art, New York. Purchase

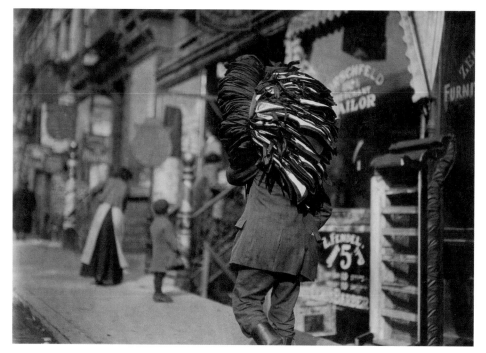

Jacob Riis. *Flashlight Photograph of One of Four Pedlars Who Slept in Cellar of 11 Ludlow Street, Rear.* c. 1890. Gelatin silver print, 5 x 7" (12.7 x 17.7 cm). The Museum of Modern Art, New York. Courtesy of The Museum of the City of New York

Lewis Hine. *New York City.* 1912. Gelatin silver print, 4¾ x 6¾" (12 x 17.1 cm). The Museum of Modern Art, New York. Stephen R. Currier Memorial Fund

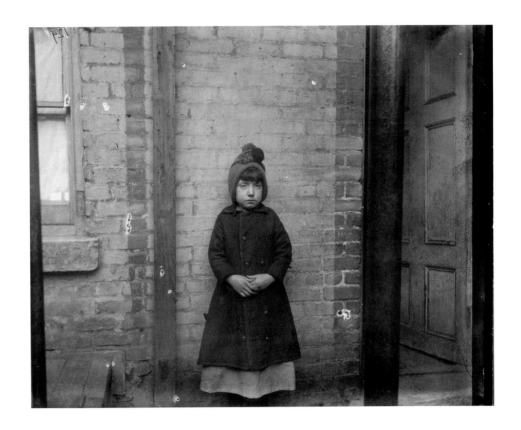

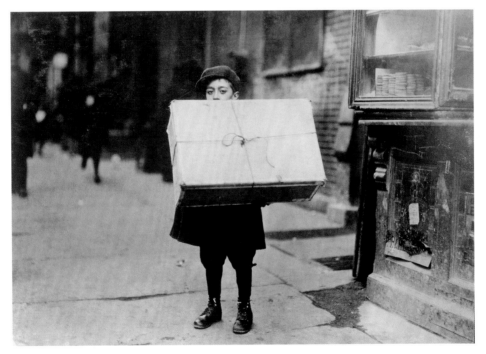

Jacob Riis. *"I Scrubs"—Katie Who Keeps House in West Forty-Ninth Street.* c. 1890. Gelatin silver print, 4 x 5" (10.2 x 12.7 cm). The Museum of Modern Art, New York. Courtesy of The Museum of the City of New York

Lewis Hine. *New York City.* 1912. Gelatin silver print, 4⁹⁄₁₆ x 6½" (11.6 x 16.5 cm). The Museum of Modern Art, New York. Stephen R. Currier Memorial Fund

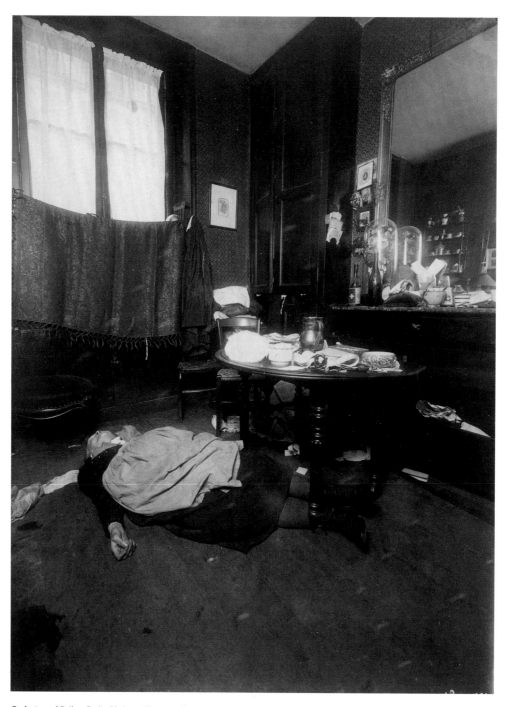

Prefecture of Police, Paris. *Madame Simon as She Was Found after the Crime, April '95,* 1895. Albumen silver print from a glass negative, 9³⁄₁₆ x 6¹³⁄₁₆" (23.3 x 17.3 cm). The Museum of Modern Art, New York. David H. McAlpin Fund

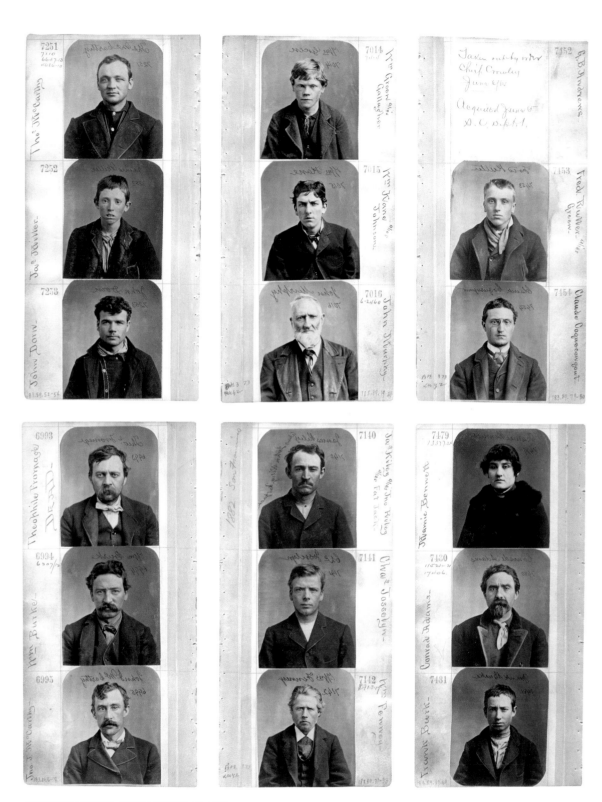

Photographer unknown. Untitled (portraits from mug
shot album). 1870s–80s. Albumen silver prints, each
2¹⁵⁄₁₆ x 2⁹⁄₁₆" (7.5 x 6.5 cm). The Museum of Modern Art,
New York. Purchase

Eugène Atget. *Avenue des Gobelins.* 1925.
Albumen silver print, 9⁵⁄₁₆ x 7" (23.6 x 17.8
cm). The Museum of Modern Art, New York.
Abbott-Levy Collection. Partial Gift of Shirley
C. Burden

Eugène Atget. *Coiffeur, avenue de L'Observatoire.*
1926. Albumen silver print, 8¹¹⁄₁₆ x 6¾" (22 x 17
cm). The Museum of Modern Art, New York. Abbott-
Levy Collection. Partial Gift of Shirley C. Burden

succession. Marey called this kind of photography "chronophotography"—the photography of time. The reverberations of the work of Marey and Muybridge would be felt throughout the twentieth century in both science and art. They can be seen in the work of artists as different as Francis Bacon, who sometimes used Muybridge's pictures as models in producing his figures, and Sol LeWitt, whose use of seriality is related to Muybridge's grid systems. Nearer to the photographers' own time, their most obvious influence appears in the work of the Futurists, whose images described the change, transition, transformation, and movement of daily life—the modern flux.

After 1900, as film got faster and cameras ever smaller and more manageable, the role of the amateur took on new importance. The French photographer Jacques-Henri Lartigue began work just after the turn of the century, and began using a hand-held Kodak Brownie at the age of eleven. As a teenager, Lartigue photographed the pleasurable pursuits and antics of his prosperous family, which included several engineers and inventors (p. 245). The family members vacationed, drove the first fast automobiles, attempted flight, and generally indulged themselves in the cutting-edge technologies of the day.

Eugène Atget. *Coiffeur, boulevard de Strasbourg.*
1912. Albumen silver print, 8¹³⁄₁₆ x 6⅞" (22.3 x
17.5 cm). The Museum of Modern Art, New York.
Abbott-Levy Collection. Partial Gift of Shirley C.
Burden

Eugène Atget. *Avenue des Gobelins.* 1927. Albumen
silver print, 8⅞ x 6¹³⁄₁₆" (22.5 x 17.3 cm). The
Museum of Modern Art, New York. Abbott-Levy Col-
lection. Partial Gift of Shirley C. Burden

Within what amounts to a family album, Lartigue's pictures are together a masterpiece of
the serendipitous. Their spontaneity, their exploitation of accidents of juxtaposition to
create coherent meanings, would provide a foundation for the work of many photogra-
phers of the 1920s and 1930s. With the invention of even faster film and the 35mm camera,
whose film could be advanced automatically, an artistic aesthetic emerged of transforming
the banal events of everyday life into art.

 Photography was applied in medicine early on. Among the first physicians to photo-
graph their patients systematically were psychiatrists, including the French doctor
Guillaume-Benjamin-Amand Duchenne (known as Duchenne de Boulogne), who, in the
1860s, took up the camera to document his analyses of human facial expression. By at-
taching current-bearing electrodes to his subjects' facial muscles, Duchenne de Boulogne
hoped to generate different expressions, proving that their origin was physiological, and
demonstrating bodily process as a kind of universal, objective causal system. Scientific in
approach as Duchenne was, his image of "fright" has a morbid poetic intensity (p. 248).
Photography would eventually become a more everyday, standard medical tool for

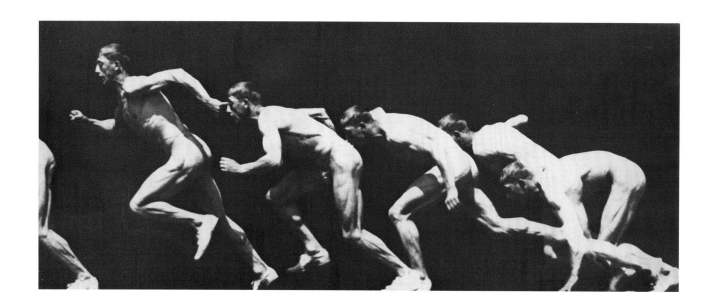

Étienne-Jules Marey or Georges Demenÿ. Untitled.
c. 1890–1900. Gelatin silver print, 6¹⁄₁₆ x 14⅝"
(15.4 x 37.2 cm). The Museum of Modern Art,
New York. Gift of Paul F. Walter

Eadweard Muybridge. *Studies of Foreshorten-
ing.* 1878–79. Albumen silver print from
wet-collodion glass negative, 5½ x 9" (14 x
23.1 cm). The Museum of Modern Art, New
York. The Family of Man Fund

Jacques-Henri Lartigue. *Paris, avenue de Acacias.*
1912. Gelatin silver print, 11¾ x 15½" (29.8 x
39.4 cm). The Museum of Modern Art, New York.
Gift of the photographer

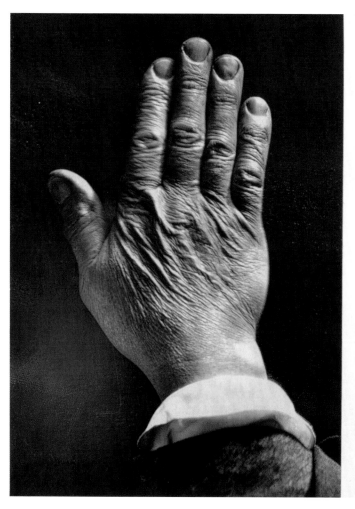

James Nasmyth (and James Carpenter). *Back of Hand and Wrinkled Apple to Illustrate the Origin of Certain Mountain Ranges Resulting from Shrinking of the Interior*, plate 11 from *The Moon: Considered as a Planet, a World, and a Satellite*. London: John Murray, 1874. Page: 11 x 8¼" (27.9 x 21 cm). The Museum of Modern Art, New York

mapping and documenting the body, as in an anatomical cross-section of a human brain, from about 1915 (p. 247). More clinical and cool, less theatrical, than Duchenne's work, these later images nevertheless tell their own stories: an X ray of a human leg from 1917, by an unknown photographer (p. 247), reveals a bullet at the lower left.

The invention of manned flight fulfilled centuries of dreams, and the coming of the airplane offered photographers dramatic new perspectives on the earth (p. 250). (Even before the Wright brothers, Félix Nadar had shot photographs from the sky, working from a balloon in 1858.) Nor did Earth itself exhaust the camera's curiosity: as early as the 1850s, photographers were combining the technologies of photography and the telescope to capture the heavens. Images like those of the Frenchmen Loewy and Puiseux made sights previously seen only by astronomers, such as the surface of the moon, available to everyday vision (p. 251). The camera could also be used metaphorically, to chart an argument: in the 1870s, James Nasmyth used photographs of skin—of the body, of fruit—to advance a geological theory about the moon (see above).

Photographer unknown (German). *Map of the Brain. Cross-section I. Frontal section*, plate 13 from an album published by the Psychiatric Clinic of Breslar. c. 1915. 7⁵/₁₆ x 5⁹/₁₆" (18.5 x 14 cm). The Museum of Modern Art, New York. Christie Calder Salomon Fund

Photographer unknown. X ray. 1917. Gelatin silver print, 15¾ x 11¾" (40 x 29.8 cm). The Museum of Modern Art, New York. Gift of Paul F. Walter

Photography supercharged the experiment and change of the industrial age. Photographic images both recorded and inspired technological achievement—inspired it *by* recording it. There were certainly many photographers during this period who made self-conscious works of art, some conforming to the traditional pictorial conventions of painting, others eventually more adventurous; and among these men and women were great photographers such as Alfred Stieglitz, Edward Steichen, and Gertrude Käsebier. But in actuality it was the photographs made without artistic intention that would prove the most inventive and influential. It was through images of the countless machines and inventions of the industrial revolution, and of the social and physical changes they precipitated, that photography demonstrated itself as modernity's great partner, nurturing the complicitous relationship between itself and the world and forever changing our future.

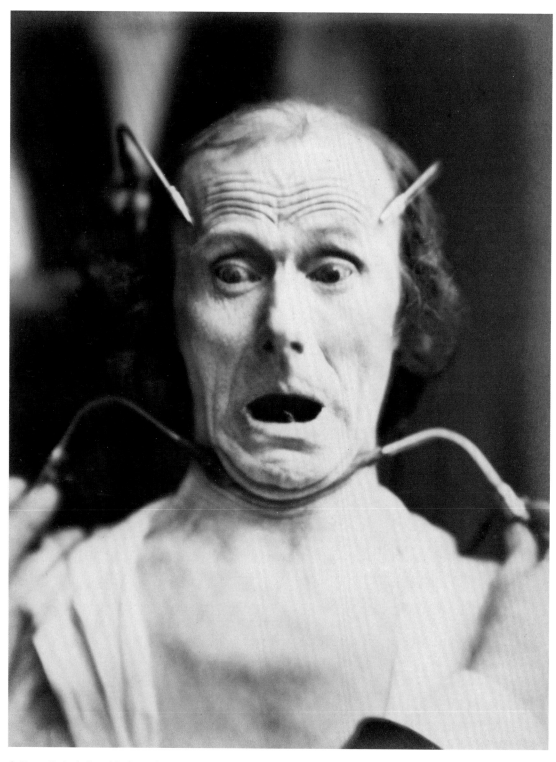

Guillaume-Benjamin-Amand Duchenne de
Boulogne. *Fright* from *Mécanisme de la phys-
ionomie humaine.* 1862. Albumen silver print
from wet-collodion glass negative, 4¾ x 3¹¹⁄₁₆"
(12.1 x 9.4 cm). The Museum of Modern Art,
New York. Gift of Paul F. Walter

Herbert G. Ponting. *Mr. E. W. Nelson.* 1911.
Gelatin silver print, 17¹³⁄₁₆ x 13³⁄₁₆" (45.3 x 33.5
cm). The Museum of Modern Art, New York. The
Family of Man Fund

Photographer unknown (British?). *London Terminal Aerodrome, Croydon.* 1921–22. Gelatin silver print, 14¹¹/₁₆ x 18¹⁵/₁₆" (37.4 x 48.1 cm). The Museum of Modern Art, New York. Gift of Paul F. Walter

Photographer unknown. Untitled (aerial reconnaissance photograph, Lavannes, World War I). 1917. Gelatin silver print, 6½ x 8⅞" (16.5 x 22.5 cm). The Museum of Modern Art, New York. Gift of Edward Steichen

Loewy and Puiseux. *The Moon (Boussingault, Vlacq, Maurolcus)*. 1899. Photogravure, 22½ x 18¼" (57.3 x 46.4 cm). The Museum of Modern Art, New York. Purchase

Mary Chan

The Conquest of the Air

In 1908 Wilbur Wright executed a record-breaking fifty-six-mile flight originating in Le Mans, France, the birthplace of the painter Roger de La Fresnaye. The following year, the French aviator Louis Blériot completed the first flight across the English Channel. La Fresnaye's 1913 painting *The Conquest of the Air* (p. 254) references the pioneering advances being realized in aviation, most obviously through its title, but also more obliquely: through the balloon floating in the upper-left portion of the sky, the French flag asserting the nation's role in the history of aviation, and perhaps even the sailboat symbolizing another type of propulsion through the air. However, it is the two male figures seated across from one another—who seem to hover above the Cubist, fractured landscape—that dominate the picture. These two are often identified as La Fresnaye and his brother, Henri, the director of a prominent aircraft manufacturer. Kenneth Silver has convincingly argued that the curious absence of an airplane itself in the painting downplays the American contribution to aviation. Instead, La Fresnaye emphasized French accomplishment via the balloon; two French brothers, Joseph and Étienne Montgolfier, had invented the first hot-air balloon in 1783.[1]

The sheer excitement generated by the notion of flight in the early twentieth century is vividly captured in a photograph of 1909 by Jacques-Henri Lartigue (p. 255). Lartigue was only sixteen when he used a rapid-lens camera to create this image of his brother, Maurice, attempting to take off in the glider he had designed. Lartigue shared Maurice's enthusiasm: "Above all there was a new magic adventure of which I dreamt at night and of which I fancied and talked: flying. Nowadays we find flying quite ordinary. But for me and for the young people of my time it was something fantastic, miraculous."[2]

Russian artist Kasimir Malevich maintained that aesthetic innovations were stimulated by, although not a direct result of, the technological progress of a rapidly changing world. A

James Wallace Black. Untitled (Providence, Rhode Island seen from a balloon). 1860. Albumen silver print, 10 x 7¾" (25.4 x 19.7 cm). The Museum of Modern Art, New York. Gift of Warner Communications, Inc.

pedagogical chart examining "the environment of painterly sensations,"[3] one of twenty-two illustrations of Malevich's theories for lectures he gave in Poland and Germany in 1927, is an explanation of three avant-garde movements: Cubism, Futurism, and his own Suprematism (p. 256). Reproductions of representative artworks are juxtaposed with both newspaper clippings and photographs meant to aid in their classification. Above the word Kubismus are a violin, word fragments, and a still life on a table. Above Futurismus are leaping athletes, a speeding train, machinery, and a row of zeppelins. During the 1920s, the zeppelin was being touted as the future of air travel. An advertising portfolio with fifteen images (p. 256) exalted the Graf zeppelin's spacious cabins, dining room, and fully equipped kitchen. The accompanying text promoted the zeppelin as a vehicle not only for passengers but one that could be used for scientific and surveying purposes as well as for transporting mail and freight. As early as 1913, Malevich conjectured that zeppelins would someday contain large cities and artists' studios.[4]

Above the word Suprematismus in the chart, the abstract compositions of Malevich's own lithographs are compared to the bold perspectives of aerial photography. Beginning with the first aerial photographs taken by the French photographer Nadar from hot-air balloons in the 1850s, the history of flight was intertwined with that of photographic techniques and equipment. The cracked emulsion of the first photograph taken from a balloon in the United States (p. 252) demonstrates the difficulties of developing images while aloft. After evolving as a tool for mapping from balloons, with the advent of the airplane aerial photography became indispensable for reconnaissance during World War I. Royal Air Force pilots were taught terms to distinguish different types of landscape: "Cubist country" signified configurations of fields bounded by roads, while "Futurist country" denoted more disordered, uninterrupted patterns.[5] The ability to see the world anew with the aid of photography also influenced the radical vantage points appearing in other mediums.

OPPOSITE: Roger de La Fresnaye. *The Conquest of the Air.* 1913. Oil on canvas, 7'8⅞" x 6'5" (235.9 x 195.6 cm). The Museum of Modern Art, New York. Mrs. Simon Guggenheim Fund

LEFT: Jacques-Henri Lartigue. *Glider Constructed by Maurice Lartigue, Château de Rouzat.* 1909. Gelatin silver print, 11¾ x 15½" (29.8 x 39.4 cm). The Museum of Modern Art, New York. Gift of the photographer

KUBISMUS FUTURISMUS SUPREMATISMUS

Thus, it is not surprising that Malevich saw correlations between flight and his ideals for a nonobjective art. His 1915 *Suprematist Composition: Airplane Flying* (above) resembles an aerial view, while it simultaneously uses the insistent diagonals of rectangular shapes in a horizonless space to suggest the dynamism of flight.[6] Calling such pictures "aerial Suprematism," Malevich perceived flight's liberation of people from the earthly realm as analogous to his conception of Suprematism's freedom from the material and its representation of spiritual absolutes. In aerial photography's abstract shapes and lines, he recognized the unadulterated simplicity and purity that he strove for in his art. Malevich wrote in 1924: "Our epoch is the dynamic epoch, the epoch of speed; one talks less and less of arts, more and more of dynamics, technology, as if the artistic beginning exists no more, as if we have already travelled far away from the time and place where art was endowed with enormous significance. . . . Suprematism cannot establish its structure upon the basis of the artistic beginning; it has chosen the dynamic basis for its constructions that are called dynamoplanes from the word plane, aeroplane."[7]

OPPOSITE, TOP: Photographer unknown. *Just Before Completion from L Z 127, Graf Zeppelin.* 1926. Gelatin silver print, 6¼ x 8⅝" (15.9 x 21.9 cm). The Museum of Modern Art, New York. Gift of the grandchildren of Daniel E. Cahill

OPPOSITE, BOTTOM: Kasimir Malevich. *Analytical Chart.* c. 1925. Cut-and-pasted photomechanical reproductions, printed papers, pencil on paper and transparent paper, gelatin silver prints, wood, and pen and ink on paper, 25 x 32½" (63.5 x 82.6 cm). The Museum of Modern Art, New York

ABOVE: Kasimir Malevich. *Suprematist Composition: Airplane Flying.* 1915. Oil on canvas, 22⅞ x 19" (58.1 x 48.3 cm). The Museum of Modern Art, New York. Purchase

SARAH GANZ

UNREALCITY

He would see discolored, old, cracking, dingy walls, with mysterious windows and rusty iron balconies of great antiquity—sights that set him dreaming dreams of medieval French love and wickedness and crime, bygone mysteries of Paris.

George de Maurier, *Trilby*, 1894[1]

The art created in Paris around the time of World War I is characterized by instability and visual disorientation.[2] To create such depictions the participants clearly saw themselves living in a period of profound uncertainty, a sentiment that was confirmed by the war. The Great War rendered the world unreal: the French landscape was torn asunder by relentless trench warfare, a population was uprooted, and the once familiar was rendered unrecognizable. A disorientation of the visible that had been fostered in the previous decade accompanied this physical rupture; an incredulity in what the eye perceived prompted a loss of confidence in the veracity of visual perception. The war's incessant destruction obliterated the visual markers by which the world had formerly been defined and brought the modes by which it had been represented artistically into question. The eroding hierarchies and social instability invigorated an embattled artistic avant-garde. Although the postwar period saw the rise of an anti-urban discourse that idealized the land and agrarian preindustrial life, the wartime era was witness to representations expressed in and through the urban context, embodying the visual rupture and crisis in confidence of the period.

During this period, Paris sustained vastly different artistic projects in close physical proximity. The location of studios belonging to prominent artists indicates that painters separated stylistically by the canon of art history were in fact working in the same vicinity, if not in the same building. From the first part of the century Marcel Duchamp, Juan Gris, Pablo Picasso, and Gino Severini held studios in Montmartre, a district in the north of Paris that had long attracted artists because of its inexpensive accommodations and elevated distance from the bustling cosmopolitan center. Particularly significant was the Bateau-Lavoir (Laundry Barge), a locus of creative talent which included the studios of André Derain, Gris, Amedeo Modigliani, and Picasso. Montparnasse, in the south of Paris, had also been a nexus of studios since the mid-nineteenth century. Between 1904 and 1914 Giorgio de Chirico, Gris, Fernand Léger, Piet Mondrian, Picasso, and Severini worked in the Montparnasse area within blocks of one another. La Ruche (The Beehive), a twelve-sided building located at 2, Passage Dantzig, was home to the studios of Alexander Archipenko, Marc Chagall, Robert Delaunay, Jean-Paul Laurens, Léger, Jacques Lipchitz, and Chaim Soutine.[3] Rather than sustaining

OPPOSITE: Giorgio de Chirico. *The Evil Genius of a King* (detail). 1914–15. Oil on canvas, 24 x 19¾" (61 x 50.2 cm). The Museum of Modern Art, New York. Purchase

259

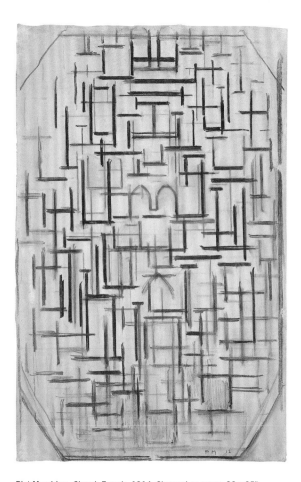

Piet Mondrian. *Church Facade*. 1914. Charcoal on paper, 39 x 25"
(99 x 63.4 cm). The Museum of Modern Art, New York. The Joan and
Lester Avnet Collection

Henri Matisse. *View of Notre Dame*. 1914. Oil on canvas, 58 x 37⅛" (147.3 x 94.3 cm). The Museum of
Modern Art, New York. Acquired through the Lillie P. Bliss Bequest and the Henry Ittleson, A. Conger Goodyear,
Mr. and Mrs. Robert Sinclair Funds, and the Anna Erickson Levene Bequest given in memory of her husband,
Dr. Phoebus Aaron Theodor Levene

Giorgio de Chirico. *Gare Montparnasse (The Melancholy of Departure)*. 1914. Oil on canvas, 55⅛" x 6' ⅝" (140 x 184.5 cm). The Museum of Modern Art, New York. Gift of James Thrall Soby

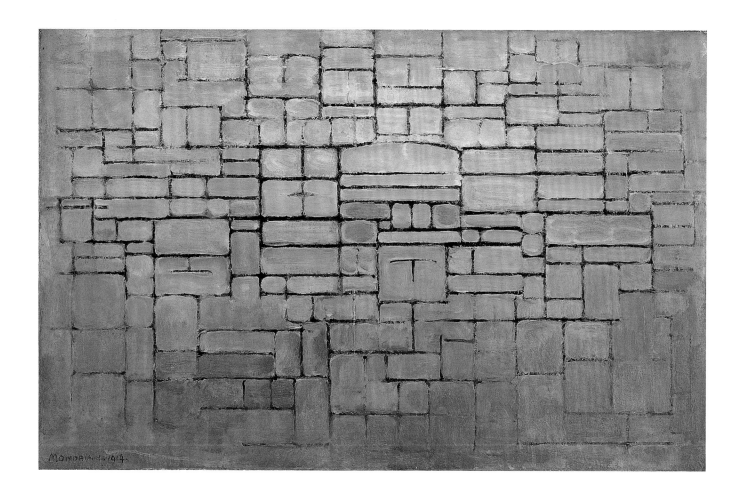

Piet Mondrian. *Composition V.* 1914. Oil on canvas, 21⅝ x 33⅝" (54.8 x 85.3 cm). The Museum of Modern Art, New York. The Sidney and Harriet Janis Collection

the avant-garde myth of isolated work and seclusion of the artist, the compact simultaneity of artistic production in Paris suggests that collaboration was an essential component of innovation.

The level of artistic convergence is further evidenced when considering the concurrent abstract projects of 1914 by Mondrian, Henri Matisse, de Chirico, and Duchamp (pp. 260–63). Although extremely varied in technique and intent, all of these images refer ultimately to the architecture and structure of the metropolis. Matisse's *View of Notre Dame* (p. 260) is one of a series of meditations on the view outside his studio window at 19, Quai Saint-Michel. Strong black lines on a glowing blue surface economically inscribe the window, street, cathedral, and recession of space, suppressing the over-wrought Gothic detail of the church. In *Church Facade* (p. 260), amid the opposition of vertical and horizontal strokes which function to dissolve figure-ground relationships, Mondrian

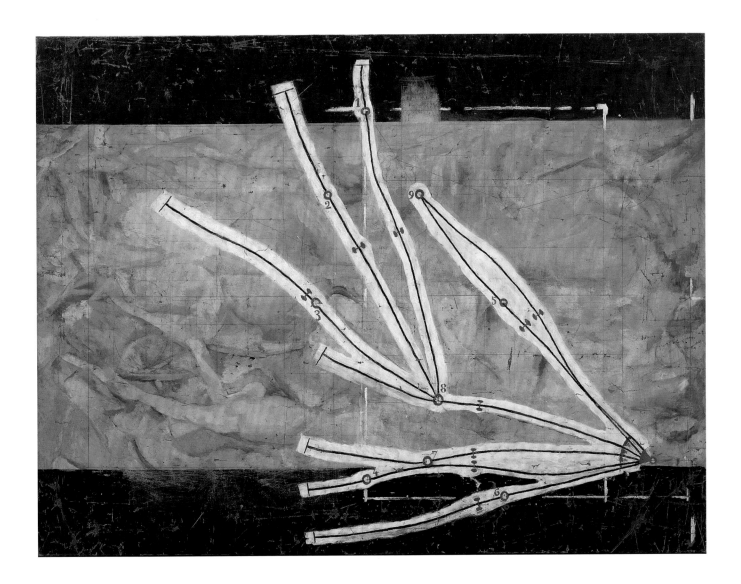

Marcel Duchamp. *Network of Stoppages.* 1914. Oil and pencil on canvas, 58⅝" x 6'5⅝" (148.9 x 197.7 cm). The Museum of Modern Art, New York. Abby Aldrich Rockefeller Fund and gift of Mrs. William Sisler

retains a sense of the Gothic tracing which hovers within the gridded surface. *Composition V* (opposite) was executed in Mondrian's studio at 26, Rue du Départ, a new building across the street from Gare Montparnasse, while de Chirico's *Gare Montparnasse* (p. 261) was created almost simultaneously in his own studio nearby on Rue Campagne-Première. In the latter picture the city's abandoned transportation hub of arrival and departure is cloaked in an atmosphere of melancholy with shadowed passages and an eerily elongated street. Duchamp's *Network of Stoppages* appears to map subterranean navigation of the metropolis. This project, and his earlier *3 Standard Stoppages* (1913–14), were intended to create "a new image of the unit of length."[4] By destabilizing pictorial meanings, these works, which were inspired by the immediate urban environment, describe a world ungrounded and unintelligible.

SITES OF CONVERGENCE

For artists working in an urban environment in the early twentieth century, being modern required coming to terms artistically with the convergence of tradition and innovation. Artists engaged with the city by contemplating its structure, technology, and social constructs. The metropolis presented numerous boundaries—physical, social, and psychological markers—that shaped urban experience. Representations of doors, windows, and throughways suggest the opportunity which the city presumably afforded its inhabitants to penetrate its boundaries while also intimating the ultimate denial of passage.

The window is a fundamental trope both in the subject matter of painting and the poetics of painting's practice. Leon Battista Alberti's Renaissance ideal of the painted image was based on a frame that could offer access to the depicted world, as he described: "On the surface on which I am going to paint, I draw a rectangle of whatever size I want which I regard as an open window through which the subject to be painted is seen."[5] The construction of linear perspective, which permits the illusion of recessive space, orders the world according to the privileged eye of the spectator and, with its pretense to reality, invites the viewer in. This legible mapping of space, which relies on a confidence in the eye as the "noblest of senses," has been repeatedly reformulated and indeed discredited since the eighteenth century.

The visual disorientation that took place around the beginning of the war challenged the hegemony of vision and prompted a return to perspective with the sole purpose of subverting its strategies of organization. By collapsing the mechanisms with which space is illusionistically represented, the grid of perspective gives way to another grid, that of the image surface itself.[6] The window of perspectival space that once framed and provided access to the external world is replaced by a tenuous and vacillating screen, a picture surface that no longer effaces its presence but mediates the viewer's experience. Rather than delivering the world in its entirety, the image presents an ambiguously cropped fragment of the whole. This replacement of transparent window with an opaque surface is a critique of traditional modes of representation, perhaps a result of the destruction of order posed by the war.

The "mysterious windows and rusty iron balconies" described by George de Maurier lace Eugène Atget's turn-of-the-century photographs of Paris. The facades of shops and bistros advertise what may be purchased within, while the glass-paned doors simultaneously offer admittance and reflect the street behind. In a color lithograph of 1899 by Pierre Bonnard (p. 266), the window of his studio meshes with the picture plane and frames a view out onto houses in a facing courtyard. Édouard Vuillard's blurred pattern of wallpaper, furniture, and figure in *The Window* of 1893 (p. 266) suggests the intimacy of a nineteenth-century interior, here accentuated by the curtained window, which seals off the glowing light beyond from the privacy of the room. In these examples the frame of the canvas or photograph parallels the window frame. Through the device of windows, schematized and compressed spaces maintain a clear distinction between interior and exterior, intimate and public.

Conversely, Delaunay's *Windows* of 1912 (p. 267), with its vacillating planes and fractured forms, subverts the idea of the window as a transparent screen between interior and exterior, offering an image in which inside and outside exist simultaneously. By integrating several vantage points of the view from his studio of the Eiffel Tower, Delaunay creates a window that is no longer a dependable demarcation of public and private, distant and proximate; it cannot withstand the conflation of these polarities in the modern world. In *The Enigma of a Day* (p. 270) and *The Evil Genius of a King* (pp. 258, 272), of 1914 and 1914–15, respectively, de Chirico restores Renaissance perspective only to obscure and exaggerate its illusionist strategies, emphasizing the uncanny desolation of abandoned buildings and city squares. In *The Blue Window* (p. 271) and *Piano Lesson* (p. 273),

OPPOSITE, TOP: Eugène Atget. *Au Bon Puits, rue Michel-le-Compte, 36.* 1901. Albumen silver print, 8⅝ x 7" (21.9 x 17.8 cm). The Museum of Modern Art, New York. Abbott-Levy Collection. Partial gift of Shirley C. Burden

OPPOSITE, BOTTOM: Eugène Atget. *Au Petit Dunkerque, 3 quai Conti.* 1900. Albumen silver print, 8½ x 6⅞" (21.6 x 17.5 cm). The Museum of Modern Art, New York. Abbott-Levy Collection. Partial gift of Shirley C. Burden

ABOVE: Eugène Atget. *A la Grappe d'Or, 4 place d'Aligre.* 1911. Albumen silver print, 8⁹⁄₁₆ x 6⅞" (21.7 x 17.4 cm). The Museum of Modern Art, New York. Abbott-Levy Collection. Partial gift of Shirley C. Burden

LEFT: Eugène Atget. *Cabaret, 62 Rue de l'Hotel de Ville.* 1902. Albumen silver print, 8⁹⁄₁₆ x 7" (21.8 x 17.8 cm). The Museum of Modern Art, New York. Abbott-Levy Collection. Partial gift of Shirley C. Burden

LEFT: Pierre Bonnard. *House in a Courtyard* from the portfolio *Some Scenes of Parisian Life.* 1899. Lithograph, 13⅝ x 10¼" (34.7 x 26 cm). Publisher: Ambroise Vollard, Paris. Edition: 100. The Museum of Modern Art, New York. Larry Aldrich Fund (by exchange)

BELOW: Édouard Vuillard. *The Window.* 1893. Oil on canvas, 14⅞ x 17⅞" (37.8 x 45.5 cm). The Museum of Modern Art, New York. The William S. Paley Collection

OPPOSITE: Robert Delaunay. *Windows.* 1912. Encaustic on canvas, 31½ x 27⅝" (79.9 x 70 cm). The Museum of Modern Art, New York. The Sidney and Harriet Janis Collection

Matisse rejects perspective outright, collapsing the relationship between figure and ground and schematically demarcating space. Again, the interpenetration of interior and exterior is realized through the motif of the window, as Matisse later expressed: "Space is one unity from the horizon right to the interior of my workroom.... the wall with the window does not create two different worlds."[7] The points of reference that had served to register the viewer's distance from and relationship to the object of vision are disrupted. And although these images do not literally illustrate contemporary events, they integrate the challenges to security and structure presented by the wartime period.

Edith Wharton's 1915 description of the wartorn French countryside seems to parallel the transformation in painting from a legible arrangement of space to a destabilized conflation of interior and exterior, near and far: "Every window-pane is smashed, nearly every building unroofed, and some house fronts are sliced clear off, with the different stories exposed, as if for the stage-setting of a farce."[8] Abstracted from partially demolished buildings in the vicinity of Montparnasse, Mondrian's *Color Planes in Oval* registers crumbled facades and fragmented walls, perhaps as seen from his studio window at 26, Rue du Départ. Executed on glass, Duchamp's *To Be Looked At* resembles a shattered window after the fact. Its framed transparency continually alters the image, capturing chance and a site of chance destruction due to the later breaking of the glass.

ABOVE: **Marcel Duchamp.** *To Be Looked At (From the Other Side of the Glass) with One Eye, Close To, for Almost an Hour.* 1918. Oil paint, silver leaf, lead wire, and magnifying lens on glass (cracked), 19½ x 15⅝" (49.5 x 39.7 cm), mounted between two panes of glass in a standing metal frame, on painted wood base, overall height, 22" (55.8 cm). The Museum of Modern Art, New York. Katherine S. Dreier Bequest

OPPOSITE: **Piet Mondrian.** *Color Planes in Oval.* 1913–14. Oil on canvas, 42⅜ x 31" (107.6 x 78.8 cm). The Museum of Modern Art, New York. Purchase

OPPOSITE: Giorgio de Chirico. *The Enigma of a Day*. 1914. Oil on canvas, 6'¼" x 55" (185.5 x 139.7 cm). The Museum of Modern Art, New York. James Thrall Soby Bequest

ABOVE: Henri Matisse. *The Blue Window*. 1913. Oil on canvas, 51½ x 35⅝" (130.8 x 90.5 cm). The Museum of Modern Art, New York. Abby Aldrich Rockefeller Fund

Giorgio de Chirico. *The Evil Genius of a King.* 1914–15. Oil on canvas, 24 x 19¾"
(61 x 50.2 cm). The Museum of Modern Art, New York. Purchase

Henri Matisse. *Piano Lesson*. 1916. Oil on canvas, 8' ½" x 6' 11¾" (245.1 x 212.7 cm).
The Museum of Modern Art, New York. Mrs. Simon Guggenheim Fund

Giorgio de Chirico. *Playthings of the Prince*. 1915. Oil on canvas, 21⅞ x 10¼"
(55.4 x 25.9 cm). The Museum of Modern Art, New York. Gift of Pierre Matisse
in memory of Patricia Kane Matisse

THINGS UNCANNY

The idea of the interior as a space in which personal identity
and emotional experience were forged was compromised by
destruction during World War I that literally exposed interiors
to view. There was, in this shift, a measure of the uncanny, a
shocking disturbance in the ordered existence of the world
and distance from the known. The uncanny posits the familiar
as strange, the near as obscured, and is laced with nostalgia
for the security of preexisting order. Theodor Adorno related
the uncanny to art: "Estrangement from the world is a moment
of art . . . the most extreme shocks and gestures of estrangement
emanating from modern art . . . are closer to us than most art
which merely seems close because of its historical reification."[9]
What can be more uncanny than an abstract still life, in its
manipulation of a traditional artistic trope, in its destabilization
of recognizable domestic and quotidian objects?

Still lifes, particularly in the seventeenth-century Dutch
tradition, were accumulations of objects assembled for their
beauty, rarity, exoticism, and allusion to prosperity, as well
as the opportunity they afforded artists to demonstrate their
mastery of mimesis. "What can be the justification of such an
assemblage if not to lubricate man's gaze amid his domain,
to facilitate his daily business among objects whose riddle is
dissolved and which are no longer anything but easy surfaces?"[10]
asks Roland Barthes, who describes the still life as a collection
of desired objects. So when these items are rendered not as
exercises in realism but as abstract compositions, what they
signify is unclear. The abstract still life eschews the comfort of
the ordinary objects of daily life. Rather than the familiarity
of the domestic, we are presented instead with the distinctly
"unhomely." Meaning becomes increasingly elusive as the space
between the object and its representation widens; the absence
of information renders the object's presence unexpected
and distanced.

In *Variation on a Still Life by de Heem* (p. 277), Matisse grafts
his Cubist meditations onto an archetypal still life via the 1893
copy he made of that work in the Louvre as a student.
Conflating illusionism and abstraction, the legible objects and
their Old Master source coexist with the bold fractured space
that supports and surrounds them. Gris, on whose example
Matisse drew, begins to obscure the distinction between object

Fernand Léger. *Propellers.* 1918. Oil on canvas, 31⅞ x 25¾"
(80.9 x 65.4 cm). The Museum of Modern Art, New York.
Katherine S. Dreier Bequest

and context in *The Sideboard* (p. 276), as the bottles and surface on which they are arranged intermingle. Léger's *Propellers* suggests an up-close investigation of the interstices of a mechanical apparatus in which surfaces and interiors are ever in flux, approaching then receding from our gaze. A similar disorientation is produced in de Chirico's *Playthings of the Prince* but through opposite means. Deep space is suggested by plummeting orthogonals, yet the narrow view offered by the picture plane and the rocketlike object that looms in its foreground fails to define scale and leaves our relationship to the image ambiguous. The 1913 collages of Picasso and Braque (pp. 276, 278) employ quotidian or café objects to collapse the distinction between figure and ground and even reverse their relationship. The superimposition of shapes or pieces of paper suggests a progression of near and far that is immediately

undermined by their patterned, printed, or drawn surfaces, which signify objects that extend beyond the boundary of their support.

It may be argued that allusions to the interior and quotidian stand as the antithesis to modernity and suggest a retreat from the historical moment in pursuit of a space that existed independently of politics and war. However, such an escape reiterates and even accentuates the manner in which the climatic events of the teens affected artistic production. If the interior no longer gave shape to privacy and self-definition, and a still life ceased to offer up delectable objects for consumption, then their obscured and fragmented representations embody a sense of tension and transition. The once familiar is rendered uncanny, demanding the construction of a new language to articulate an unreal world.

Georges Braque. *Guitar*. 1913–14. Gesso, pasted papers, charcoal, pencil, and gouache on canvas, 39¼ x 25⅝" (99.7 x 65.1 cm). The Museum of Modern Art, New York. Acquired through the Lillie P. Bliss Bequest

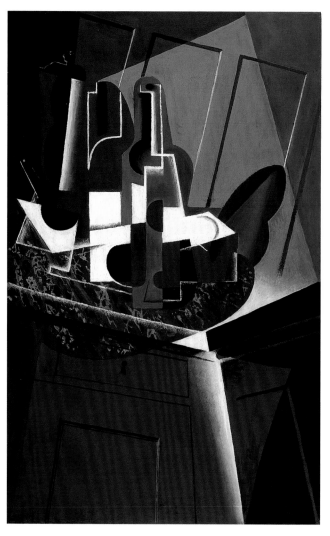

Juan Gris. *The Sideboard*. 1917. Oil on plywood, 45⅞ x 28¾" (116.2 x 73.1 cm). The Museum of Modern Art, New York. Nelson A. Rockefeller Bequest

Henri Matisse. *Variation on a Still Life by de Heem.* 1915. Oil on canvas, 71¼" x 7'3"
(180.9 x 220.8 cm). The Museum of Modern Art, New York. Gift and bequest of Florene M.
Schoenborn and Samuel A. Marx

Henri Matisse. *Goldfish and Palette*. 1914. Oil on canvas, 57 ¾ x 44 ¼" (146.5 x 112.4 cm).
The Museum of Modern Art, New York. Gift of Florene M. Schoenborn and Samuel A. Marx

Pablo Picasso. *Guitar*. 1913. Cut-and-pasted papers, charcoal, ink, and
chalk on blue paper mounted on ragboard, 26 ⅛ x 19 ½" (66.4 x 49.6 cm).
The Museum of Modern Art, New York. Nelson A. Rockefeller Bequest

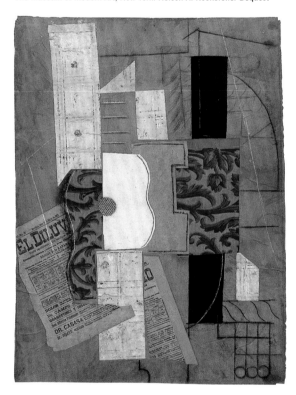

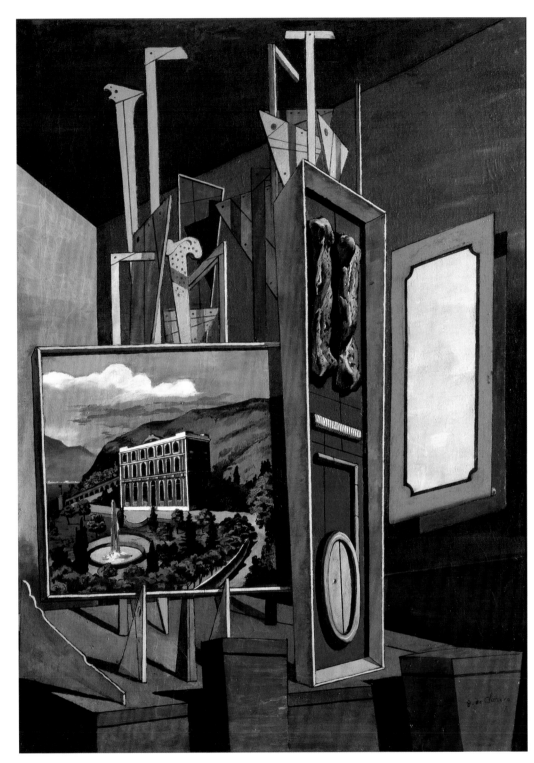

Giorgio de Chirico. *Great Metaphysical Interior*. 1917. Oil on canvas, 37 ¾ x 27 ¾"
(95.9 x 70.5 cm). The Museum of Modern Art, New York. Gift of James Thrall Soby

MARY LEA BANDY

THE AMERICAN PLACE
Landscape in the Early Western

This mesa plain had an appearance of great antiquity, and of incompleteness; as if, with all the materials for world-making assembled, the Creator had desisted, gone away and left everything on the point of being brought together, on the eve of being arranged into mountain, plain, plateau. The country was still waiting to be made into a landscape.

Willa Cather, *Death Comes for the Archbishop*[1]

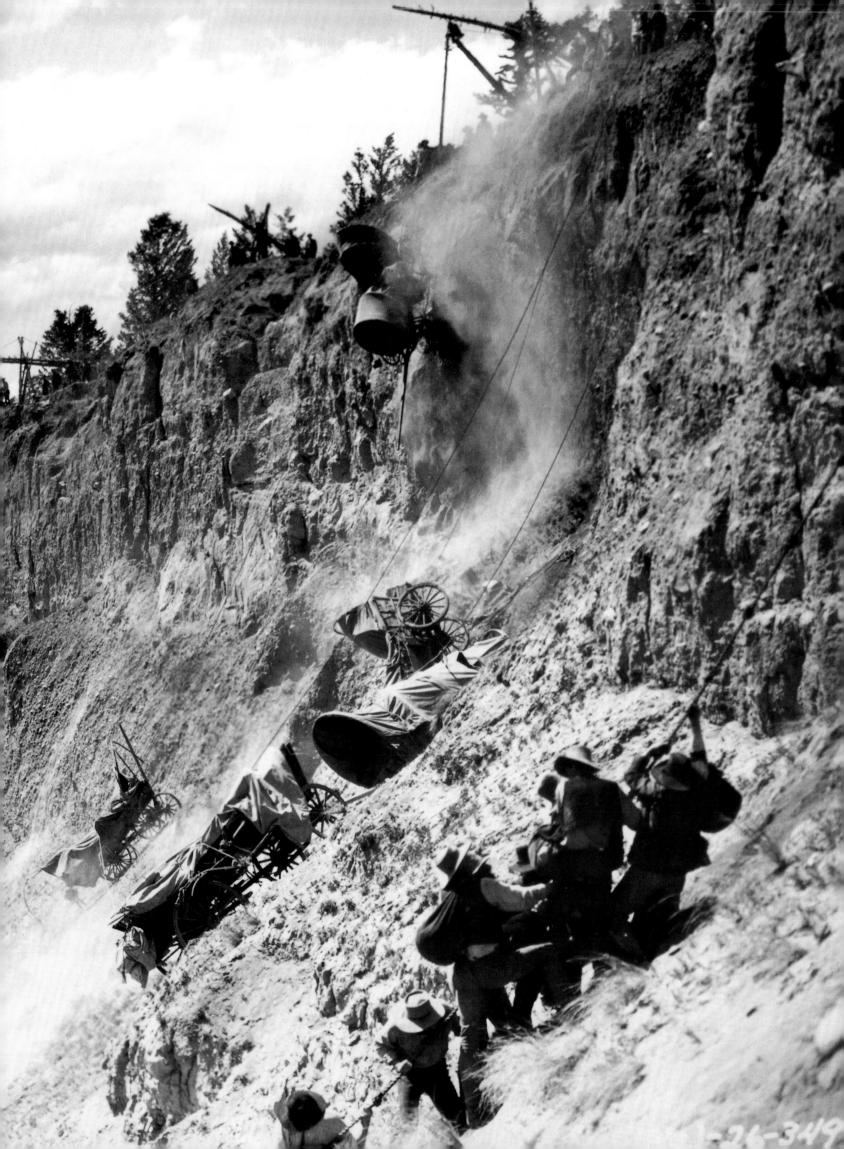

PREVIOUS PAGES: Raoul Walsh. *The Big Trail.* 1930. 35mm, black and white, sound, 122 minutes. The Museum of Modern Art, New York. Preserved with funding from Martin Scorsese, the Celeste Bartos Film Preservation Fund, and the National Endowment for the Arts

ABOVE: Edwin S. Porter. *The Great Train Robbery.* 1903. 35mm, black and white with color tinting, silent, 11 minutes. The Museum of Modern Art, New York. Preserved with funding from the Celeste Bartos Film Preservation Fund and the National Endowment for the Arts

In film, the Western genre depicts the transition of the unexplored country into landscape— an imagined landscape assembled from shots of actual locations and studio settings to represent another place in another time. A selected terrain mimics the topography conceived in the scenario, and the cameraman and editor adjust light, angle, and pace to create a landscape intense in desire—a place sacred and profane. The uncontrollable forces of weather and shifts of time in the turning of the earth—sunrise, high noon, and sunset— enforce the Western's defining characteristics of passage or stasis, fear and aloneness. A moral universe, at once exotic and familiar, reveals itself in steep canyons and across rivers, over mountains and through deserts, as the journey through one or another moment of the American past takes hold. For the Western is inseparable from America's history; accordingly, it is beset by contradictions and often vain attempts at realism. The Western does not age, or so the critic André Bazin believed, which may be because it has been a supple reflector of political and psychological perceptions from Theodore Roosevelt's era to the space age.[2] As we ought to know by now, even the past is unpredictable.

To its explorers, its first geologists, photographers, and painters, the American West was a wilderness, rich in monuments and awesome in scale. To its settlers it offered a landscape, a "vast unit of human occupation, indeed a jurisdiction," befitting the historian Simon Schama's trace of the term *landskip*, which appeared in colloquial English not long after Columbus reached the New World and revealed, to the acquisitive and highly competitive European empires of the sixteenth century, new lands to be taken.[3] Spurred on by the Lewis and Clark Expedition of 1804–06, a journey through the Louisiana Purchase territory acquired from France, which doubled the size of the United States, nineteenth-century European and American white people delved deep into the sparsely populated wilderness that constituted the trans-Mississippi West. A concept of Manifest Destiny was articulated, to justify the goal to "overspread the continent allotted by Providence for the free development of our multiplying millions."[4] Colluding in expansionism were frontier enterprise and governmental legislation authorizing the division of territories and acreage for approved speculators and emigrants, all of which necessitated the relocation of native peoples to ever more western areas. In the 1870s and 1880s, the U. S. Army corralled the last of the native warriors into desert "reservations" out of the path of "progressive" society, and by 1893 the historian Frederick Jackson Turner declared the frontier closed.[5]

The fading of the frontier coincided with the first motion pictures; one became subject for the other. The transformation of wilderness into occupied landscape, the progressive evolution of a new civilization of settlers, constituted the thematic underpinning of the Western. Adventurousness and mythmaking paralleled success in melodrama and comedy. Earlier, dime novels and Buffalo Bill Cody's Wild West spectacles provided patterns of action narrative and types of frontier characters. In 1888 the future president, Roosevelt, published his exploits as a Dakota cowboy in *Ranch Life and the Hunting Trail,* illustrated by his friend Frederic Remington. In 1902 the popularity of the Western surged with a novel about a lonesome cowboy, *The Virginian,* by another friend, Owen Wister, and this was followed in 1903 by Edwin S. Porter's film *The Great Train Robbery.* Shot at Thomas Alva Edison's New York studio and in New Jersey along the Lackawanna Railway, the eleven-minute film created an illusion of reality. A violent robbery takes place aboard a seemingly moving train, made by intercutting studio shots with matte shots of the passing landscape and exteriors of the moving train, and later the escape and chase of the robbers. The shot of a

gunman firing directly at the audience, the bright colors tinting the puffs of gunsmoke and the strongbox's explosion added to the film's broad appeal. New York and New Jersey also represented the West of D. W. Griffith's first Biograph Company Westerns, before the company spent four winters in southern California in 1910–13. Griffith's final Biograph Western, *The Battle at Elderbush Gulch*, which paired Mae Marsh and Lillian Gish in an unsettled West, climaxed in an attack by Indians and a rescue by the U.S. Cavalry. Griffith's use of parallel action created terrific suspense, as did the high-angle shots of Indians surrounding the cabin and the arrival of troops. The setting could be anywhere; the country is a moral and physical wilderness not unlike that presented in the novels of James Fenimore Cooper and Nathaniel Hawthorne nearly a century earlier.

In feature-length Westerns of the 1910s, the transformation theme gathered narrative force with the dominance of the lonely cowboy turned gunfighter, who shuttles between evil and good as he contemplates the responsibilities of saintliness. The newly established success of Hollywood's star system nurtured favored performers in familiar roles of emotional power and physical prowess, and Harry Carey, William S. Hart, and Douglas Fairbanks created memorable Westerners. A trio of their films shot on locations in California in 1917 and 1918 reveals, in related ways, contradictions inherent in romanticized yet longingly naturalistic portrayals of the struggle for control of water, land, or railroad rights. Carey starred for a youthful John Ford in *Straight Shooting* in 1917, as a gun for hire whose loyalty shifts from the murderous ranchers to the farmers before he persuades his

D. W. Griffith. *The Battle at Elderbush Gulch.*
1913. 35mm, black and white, silent, 25 minutes
(approx.). The Museum of Modern Art, New York

John Ford. *Straight Shooting*. 1917. 35mm,
black and white, silent, 55 minutes (approx.).
The Museum of Modern Art, New York

William S. Hart. *Selfish Yates*. 1918. 35mm,
black and white, silent, 45 minutes (approx.).
The Museum of Modern Art, New York. Acquired
from the artist. *Production shot, with Hart and
cinematographer Joseph August*

John Emerson. *Wild and Woolly.* 1917. 35mm,
black and white, silent, 60 minutes (approx.).
The Museum of Modern Art, New York. Acquired
from the artist. *Douglas Fairbanks*

James Cruze. *The Covered Wagon.* 1923. 35mm, black and white, silent, 96 minutes. The Museum of Modern Art, New York. Acquired from Paramount Pictures

outlaw pals, residing in Devil's Valley beyond the slit in the rocks known as Beale's Cut, to ride to the rescue (p. 284). Little sky appears above the high horizon; hills and rock walls fill the screen, as Ford contains the action in the depth of the landscape, compressing movement within the frame. We gaze through space into the landscape, which is not a flat plane; the scenes are tight and concentrated yet intimate and accessible, revealing the strength of Ford's visual sensibility for location shooting, which he rediscovered triumphantly in 1938–39 in the Monument Valley locations of *Stagecoach*.

Hart's good-badman persona dominated Westerns such as *Selfish Yates* (1918), in which he created an occupied terrain of rough townscape, here the main street of Thirsty Center, Arizona (p. 284). If Carey presaged John Wayne in physique and personality, with shadings of ambivalent motives, Hart's avenger looks forward to Clint Eastwood's Westerner, tall, laconic, and unforgiving, capable of hard riding across miles of a stern, treeless horizon to bring the wicked community to its knees.

"I'd like the West better if it was in the East," says Chico Marx in *Go West* of 1940. In *Wild and Woolly* (1917), so keen to go West is Fairbanks, heir of a New York railroad tycoon, that he turns the bedroom of the family mansion into an outpost with tepee, campfire, and cactus, where he lassos the butler and rides the staircase (p. 285). His character, the enthusiastic, naive all-American youth, a romantic eager for adventure and success, takes his notions of the West from dime novels. Anita Loos's scenario and intertitles cleverly mock his foolishness while satirizing the Western itself. Dreams are made only to be punctured when our hero is sent to Bitter Creek (actually Burbank) to run a railroad line through town, where he encounters real adventures of crooked men and an attack by Indians. He may favor the wide-open spaces over urban claustrophobia, but he does not quite shed his

urbanity. The comedy suggests that the West lacks culture and class; at the film's end, Fairbanks and his bride descend the grand staircase of their own opulent mansion, whose doors open to a vista, inviting our hero to mount his steed and dash straight away into his newly acquired landscape. Like the wealthy Roosevelt, Fairbanks believed in the West as a source of natural virtue, a site of conversion from the corruption of modern society to a morally charged manhood—but not without that society's comforts.

Again, the Western offers contradictions. Carey and Hart, as romantic gunfighters who may ride off alone into the landscape, pose as naturalistic or realistic characters who suffer and survive, and devolve into myth. Fairbanks, unabashedly capitalistic in achieving success and a happy home with his girl, is ever optimistic and confident, yet as restless at the end of his dream as at its beginning. His hero cannot distinguish his dreams from the reality of the landscape he occupies, so he must make the landscape part of his dream. The comic hero emerges as the less mythic and more modern character, and brilliantly endures.

The frontier's reach to the Pacific Ocean gained speed from overland wagon trains, gold rushes, and land grants, as well as from the successful linking of the telegraph and railroad. All were prime subjects of Western epics, which popularized, with sincerity and some historical accuracy, the expansion of the white man's culture and economy, and showed some regret for the vilification of the Indian. James Cruze's *The Covered Wagon* of 1923 ambitiously reconstructed the experience of a great migration of pioneers from the Missouri River to the Oregon territory in 1848, shooting on locations in Utah and Nevada (p. 286). An intertitle gives the Indian's point of view regarding the white man's plow: "With him he brings this monster weapon that will bury the buffalo, uproot the forest and level the mountain."

Landscape shapes and threatens the character of the hero in *The Gold Rush* (1925) and the heroine in *The Wind* (1928), starring the preeminent actors of film's silent era, respectively, Charlie Chaplin and Lillian Gish. Hilarious as are Chaplin's encounters with snowstorms and rocky precipices in Alaska (shot in Nevada and in the studio), and tragic as are Gish's attempts to resist the brutal Texas wind (on location in California's Mojave Desert near Bakersfield), each thrillingly evades destruction by the elements. The happy endings are false, however, for each should have wandered off alone into the wilderness. Chaplin had been inspired by stereoscopic views of Chilkoot Pass in the gold rush of 1898, showing a long line of prospectors trekking up the mountain, and by the tragedy of the Donner pioneers snowbound in the Sierra Nevadas, who roasted their moccasins and each other to survive. Directed by Victor Seastrom, *The Wind* is a powerfully charged story in which the evil forces of nature, resistant to the white man's invasion, seek to obliterate light, air, and water, bringing an unending drought upon the settlers and ranchers to drive them away. But the wind is equally sexually charged, pushing Gish to madness as it seeks to obsess her, like an Olympian god intent on seduction and punishment.

If *The Wind* masterfully brought to a close the silent Western of the 1920s, *The Big Trail* daringly launched, in 1930, an epic Western photographed on location for wide screen and sound (pp. 280–81). Director Raoul Walsh and his cameramen utilized Twentieth Century-Fox's new 70mm Grandeur process to hold, steadily and boldly, a series of broad panoramas, such as cliffs near the Sierra Nevadas that challenged the pioneers in the film's most thrilling sequence. The narrative of this ambitious undertaking follows a wagon train from the Missouri River to the Oregon territory in the 1840s. Walsh took cast and crew on locations for months. He noted: "We had plenty of

footage of the wagon train fording rivers and toiling through rugged canyon country and crawling over the mountains in the supposedly westward trek. These were intended as portrayals of the hardships encountered by earlier travelers, as well as a sharp contrast to the easier travel across the level plains. But I needed a clincher, something to bring home to viewers how the pioneers actually put their lives on the line during such migration. . . . The opportunity I had been waiting for came when a transverse cleft stopped progress. The cut was deep and precipitous and there was a white curl of water in the bottom. . . . I wanted to cross that canyon . . . ropes were the answer. . . . The first wagon over the edge was lowered slowly to the canyon floor. I had one camera down there and the other shooting from above. We sent a couple of slung horses after the wagon, and both cameras recorded pilgrims going down a free-hanging rope hand over hand. . . . The last wagon to go down gave the sequence more reality than I had bargained for. About halfway in its swaying descent, a knot must have slipped. The wagon hung lopsided just long enough to heighten the suspense. Then it went crashing to the canyon floor to make a pile of wreckage in the white water. I held my breath until I was sure that both cameras had caught the action. Now I had my clincher."[6]

The Big Trail's production was as burdened as were its fictional pioneers. The film was shot in two versions, in wide-screen Grandeur and in standard 35mm; the complexities of hauling cumbersome equipment, filming in sound with microphones hidden among barrels and wagons, and moving hundreds of cast, crew, and animals

Victor Seastrom. *The Wind*. 1928. 35mm, black and white, silent, 73 minutes (approx). The Museum of Modern Art, New York. Acquired from MGM. *Lillian Gish*

substantially increased costs. Walsh cast John Wayne in his first starring role, a scout who leads the wagon train as he seeks frontier justice for the men who killed his best friend, establishing a character he would portray most meaningfully in later Westerns directed by Ford and Howard Hawks. When *The Big Trail* opened in November 1930, the nation had endured a great financial collapse; few theaters could afford the projection equipment required for Grandeur prints. The naturalism of the locations and the unglamorous wagon camps, the almost documentary look at the rigors of pioneering, little appealed to a public worried about the current failure of the American dream. Audiences spurned the familiar national myth of a heroic Westerner, who triumphs over the harshness of the wilderness through integrity, determination, and courage, and Wayne was relegated to lesser or B-Westerns for the next nine years until Ford cast him as the Ringo Kid in *Stagecoach*.

Walsh was a master storyteller, with an unmannered visual style and pacing that gave his Westerns a seamlessness and deceptively easy beauty; he knew as well as any artist where to place river, mountain, and sky. What distinguished his vision of a country waiting to be made into a landscape was his grasp of scale, depth, and light. The camera looked at and across wagons and terrain. There would not be as sweeping and visually engaging a Western epic derived from an actual event until *Red River*, Hawks's production, in 1946–48, depicting the first cattle drive from Texas to Kansas, in which Wayne and the mythic Westerner, following his youthful adventures in *The Big Trail* and *Stagecoach*, become forever joined.

Charles Chaplin. *The Gold Rush.* 1925. 35mm, black and white, silent, 85 minutes (approx.). The Museum of Modern Art, New York. *Production shot, with Chaplin*

THINGS

Michael Craig-Martin
Objects, Ready or Not

"To take something as a picture," Michael Craig-Martin says, describing his own intention, "is to allow the presence of the pictured to overwhelm the presence of the picture."[1] The objects he pictures on walls overwhelm by the surprise of their intrinsic appearance—of their unexpectedness in size, color, contour, and silhouette—but also by their sudden appearance in familiar settings that are now hardly recognizable, artificially colored tracts of space without scale, across which the objects are scattered, each in its own, individual perspective world. "Objects form our only common language," the artist has said.[2] He makes the common language seem uncommonly strange.

Since the late 1970s Craig-Martin has been compiling a pictorial dictionary of man-made, usually domestic objects, which he draws upon, and adds to, whenever he makes one of his paintings of objects, many of which he makes on walls.[3] With only a single exception, he creates only one picture of each type of object for his dictionary; so the same pipe, the same camera, the same lamp, and so on, will appear in his paintings. Thus, each of these objects seems like a mass-produced object that differs from others of the same model only according to where it is placed. Each object, moreover, will be a typical object, the very essential object of its type. It will not be a merely generic object, though, for there will be a sufficiency of detail to individualize it, but not so much detail as to make it seem unique; and any object that does not resemble itself—for example, a portable telephone that resembles a portable computer—cannot be considered. The only type of object that needs to have more than one picture in the dictionary (a lot of pictures, in fact) is the chair. Self-evidently, there is not one single typical chair—no one chair that typifies the chair—in the same way that there is one typical grand piano, stepladder, flashlight, urinal, umbrella, file cabinet, can with paintbrushes in it, revolver, etc.

Some of these objects, however, do not seem to belong only to the external object world, but also to the object world of the museum; others seem to belong only to the object world of the museum, and not to the external object world at all. The artist's own notes on this particular installation, quoted on the opposite page, make a point of the different classes of objects to be found within the museum, and specifically within The Museum of Modern Art.

—JOHN ELDERFIELD

PREVIOUS TWO PAGES AND OPPOSITE:
Michael Craig-Martin. Studies for *Objects, Ready or Not*. 1999. Computer-generated images for a wall painting. Installed at The Museum of Modern Art, New York. Acrylic, housepaint, and tape on wall, total dimensions of installation: 11'5" high, 442'4" wide (347.9 cm high, 13,482.3 cm wide). Collection the artist

Urinal and bicycle [wheel]: object as readymade
Back of canvas: painting as object
Rietveld chair: art/design object
Thonet chair and anglepoise lamp: classic design objects
Camera: maker of image objects (photographs)
Magritte pipe and Johns paintbrushes: later objects in art
 —Michael Craig-Martin, 1999

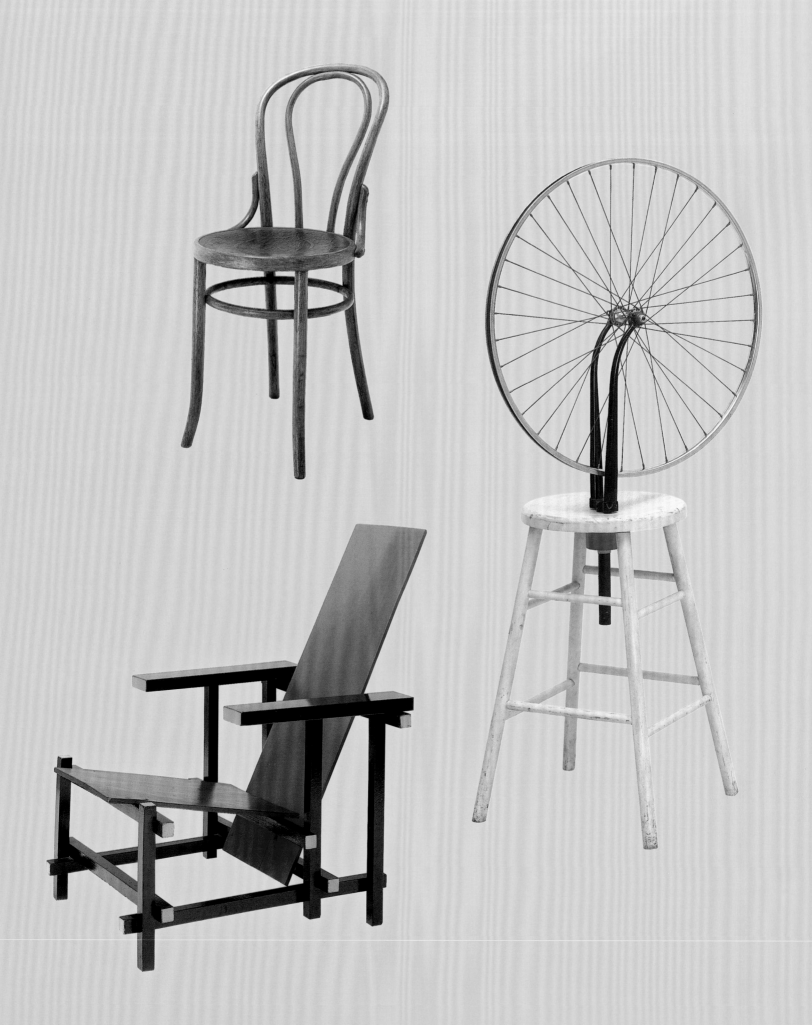

PETER REED

Common and Uncommon THINgs

Michael Craig-Martin has spoken of how the "things," the objects, that surround us "constitute the world we have made for ourselves and form our only common language."[1] But very easily these everyday things come to seem strange. "If you look for example at the chairs around this table, each is individual, but if they were moved around, the fact is you and I would have no way of knowing which is which."[2] The quality of simultaneous identity and difference, of knowing and not knowing how an object fits into the common language world of objects is heightened in the kinds of objects that are found in museums, and, in part, because they are found in museums.

The ubiquitous bentwood side chair designed and manufactured by the Gebrüder Thonet is a virtually anonymous design that has remained in production since 1876. It was created for an international market and a growing bourgeois consumer society, but without a specific interior in mind and with no overwhelming aesthetic or moral aim other than to be inexpensive, by taking advantage of industrial processes in its manufacture,

and to be easily transportable. The side chair, also known as the café chair, is an icon of bohemianism: from paintings by Henri de Toulouse-Lautrec to Federico Fellini's film *8½*, the chair is part of the mise-en-scène. The commonness of the Thonet chair makes its presence easily overlooked, becoming effectively "invisible" as design. Yet when it is introduced into the museum context it appears virtually a "found object."

Gerrit Rietveld's Red Blue Chair, by contrast, bears little resemblance to a functional chair; instead, it has achieved the status of a design object. The spatial implications of its rectilinear structure, the clear articulation of its separate parts, and the purity of its primary colors are formal, aesthetic concerns having little to do with utility. The first version of the chair was unpainted; later versions were painted in red and blue. These colors brought Rietveld's work more directly in line with the de Stijl movement, but Rietveld apparently did not ascribe any absolute value to these colors. The aim of the abstract nonobjective work of the de Stijl movement was to liberate art

OPPOSITE, CLOCKWISE FROM UPPER LEFT:
Gebrüder Thonet. Side Chair. c. 1876. Manufactured after 1918. Bentwood and stamped seat, 35¾ x 16¾ x 17" (90.8 x 42.5 x 43 cm). The Museum of Modern Art, New York. Anonymous gift

Marcel Duchamp. *Bicycle Wheel*. 1951. Third version, after lost original of 1913. Assemblage: Metal wheel, 25½" (63.8 cm) diam., mounted on painted wood stool, 23¾" (60.2 cm) high; overall, 50½ x 25½ x 16⅝" (128.3 x 63.8 x 42 cm). The Museum of Modern Art, New York. The Sidney and Harriet Janis Collection

Gerrit Rietveld. Red Blue Chair. 1923. Painted wood, 34⅛ x 26 x 33" (86.7 x 66 x 83.8 cm). The Museum of Modern Art, New York. Gift of Philip Johnson

from its function of representing the real world and to search for a new harmonic reality in postwar society. For all the supposed "rationality" and purity of the Red Blue Chair, it has a mysterious presence, in part because it seems to be a sculpture of a chair rather than an actual chair. Because it is removed from the ordinary, the chair takes on a "metaphysical" aspect.

In fact, Rietveld's chair designs have been compared to paintings by the metaphysical painter Giorgio de Chirico (pp. 261, 270, 272, 274, 279), whose imaginary and disorienting spaces, populated with strangely juxtaposed real objects, evoke other dreamlike worlds. Rietveld's contemporary, Theo van Doesburg, writing for the publication *De Stijl* in 1920, compared a Rietveld armchair to a painting of an imaginary urban scene by de Chirico. To emphasize the effect, the poetic text was laid out typographically in a Dadaist fashion:

Difference and correspondence.
Difference in intention, in expression, in means.
Correspondence in metaphysical feeling and mathematical indication of spaces.
In both: spaces bounded by spaces.
Penetration by space.
Mystique of space.[3]

Both the painting and the chair transcend their status as objects and suggest some unknowable realm, the abstract chair perhaps more grounded in reality than the familiar things, surreally juxtaposed, in de Chirico's paintings.

Marcel Duchamp's readymade, *Bicycle Wheel* (p. 296), combines some aspects of both the Thonet and Rietveld chairs. Its component parts are even more invisible as design than the café chair; its mysterious presence is reminiscent of the Red Blue Chair. Duchamp created the work by placing an industrially manufactured bicycle wheel without its rubber tire on the seat of a common, painted wood stool. The wheel was set above the seat, rather than below it, as in an actual bicycle; its placement thus evokes associations of a clock, a sundial, or some mysterious machine. Duchamp declared his *Bicycle Wheel* a work of art and placed it in a gallery, thus establishing its legitimacy as a work of art by its context. But the perception of all objects are colored by their context. One expects to see multiple Thonet chairs; seeing only one isolated in a museum can be disquieting. Conversely, it would seem strange to see a cluster of Red Blue Chairs.

The importance of the object, both real and depicted, in early modernism is the subject of this section, which is titled Things. The following pages illustrate the extraordinary diversity and the connections between three-dimensional objects (including sculpture, design, and architectural fragments) and two-dimensional representations of objects (paintings, prints, drawings, and photographs). The emphasis on the object as an object in its own right is a significant characteristic of early modernism. The sculptor William Tucker perceived this phenomenon when he wrote: "If one word captures the aspirations of modernism from about 1870 until the Second World War, it is surely object. Firstly in poetry and painting, then in sculpture, music and architecture, the word came to denote an ideal condition of self-contained, self-generating apartness of the work of art, with its own rules, its own order, its own materials, independent of its maker, of its audience and of the world in general."[4]

In the period 1880 to 1920, emphasis on the object led to a number of important, innovative modern "starts." The symbolic and allegorical underpinnings associated with traditional still-life painting and figurative sculpture were now discarded, and in design the imitation of historical styles was consciously avoided. This did not deny art its metaphorical power, however; the organic imagery of Art Nouveau is a particularly cogent example.

The genre of still life became increasingly important in this period, perhaps even rivaling its acclaimed status in seventeenth-century Dutch art.[5] Its apparent neutrality of subject matter made it an appropriate vehicle for formalization. This is not to say that still lifes are of strictly formal interest, but beginning with Paul Cézanne, still life concerned itself with the relationship of the proximate objects presented on a horizontal plane—the reality of what is available to touch—to the visual reality of the painting's verticality, thus posing challenges to perspectival traditions demonstrated by figure-ground relationships. The images in the essay "Tables and Objects" illustrate the relationship between the flat, vertical picture plane and the objects presented on a tabletop.

The traditional still life of the *objet-tableau* was further transformed by the Cubists and by the invention of collage, which introduced real objects such as fragments of wallpaper and newspaper into painting, thus asserting the object character of the work alongside its depictive character. The Cubist collage is both an object itself and a representation of objects. Related to this was the development of the object-poem or

Giorgio de Chirico. *The Song of Love*. 1914. Oil on canvas, 28¾ x 23⅜" (73 x 59.1 cm). The Museum of Modern Art, New York. Nelson A. Rockefeller Bequest

Piet Mondrian. *Composition C*. 1920. Oil on canvas, 23¾ x 24" (60.3 x 61 cm).
The Museum of Modern Art, New York. Acquired through the Lillie P. Bliss Bequest

concrete poetry whereby poems are shaped to resemble objects. Guillaume Apollinaire's concrete poetry gave typography a sensory role in that words are arranged in expressive compositions evocative of the subject matter itself. The liberation of typography in this manner characterizes Filippo Tommaso Marinetti's imaginative publications, such as the visually dynamic "In the Evening, Lying on Her Bed, She Reread the Letter from her Artilleryman at the Front" (p. 330, bottom left). The relationships between images of things and words are further explored in the essay "Objects / Words."

The self-contained apartness Tucker ascribed to early modern art characterizes transformations of the traditional still-life genre. A photograph of four bowls by Paul Strand, titled *Abstraction*, is a still-life composition that intentionally interprets the object as a purified abstract shape. These ordinary domestic objects are investigated for their visual qualities and as such are completely divested of symbolic or iconographic meanings. In a tightly framed composition the bowls are carefully arranged in an overlapping fashion so that the geometry of the modulated black-and-white tones of the photograph create a rhythm of curved lines and surfaces for entirely aesthetic ends. The composition is pleasing precisely because it transcends the things depicted, causing one to contemplate and see beyond the bowls themselves.

Abstract painters also displayed an awareness of the objectlike quality of their work, and the relationship between abstraction and the planar dimension of the wall reached a critical juncture for painters such as Piet Mondrian. In his drawing of a church facade, the wall is distilled into a network of horizontal and vertical lines (p. 260). The art historian Robert Welsh observed: "While it remains unsettled to what extent Mondrian's principles of design derived from architecture, a penchant for painting architectural motifs was manifested from early in his career. The prevalence of church and Parisian building themes in the late and post-cubist years testifies to the sympathy he had for the concept of painting as a form of mural decoration."[6] Mondrian's later works dispensed with the architectural subject in favor of complete abstraction. In *Composition C*, a nearly square, nondirectional painting, Mondrian created a nonhierarchical whole, and the planes of color and their division by dark lines eliminate any sense of depth. Significantly, Mondrian worked on a flat horizontal plane of proximity before lifting the painting up to the visual (vertical) plane.[7]

Paul Strand. *Abstraction*. 1915. Photogravure, 8¹⁵⁄₁₆ x 6⁹⁄₁₆" (22.8 x 16.6 cm). The Museum of Modern Art, New York. Anonymous gift

Another kind of abstraction seen in this period is the condensed, purified, reductive object, which appeared in architecture and design objects earlier than in sculpture. In an effort to reform design aesthetics, the clean lines of the elongated Claret Pitcher of about 1880 by Christopher Dresser, inspired in part by Japanese design, was a refreshing antidote to the heavily ornamented Victorian designs of the same period (p. 302). A number of later design objects share a similar sense of purification, such as the steel vase with gridded perforations by Josef Hoffmann (p. 340). The sculptures of Constantin Brancusi are perhaps the most notable examples of the condensed purified object in the early twentieth century. His *Endless Column*, a hand-carved oak column in the form of rhomboids, is an isolated object with a definable presence (p. 303). Paradoxically, its "apartness" has a cosmic architectural quality if one imagines the column's infinite extension, implied by its title, separating heaven and earth. The half-rhomboids at either end reinforce the sense of incompleteness. Significantly, the source for this work may have been a hand-carved sculptural base for another work by Brancusi. It was a radical decision to consider the base a sculpture in its own right. Brancusi further blurred the distinctions of traditional genres by claiming that "True architecture is Sculpture."[8]

Another radical change in sculpture during this period was the shift from modeling or carving to constructing from disparate parts. The innovative process of combining things to make a work of art and of constructing an object rather than modeling it grew out of Cubist-derived sculpture. Picasso's *Guitar* was the first constructed sculpture, and his *Glass of Absinth*, which includes an actual utensil, are relevant examples (pp. 310, 342). Kurt Schwitters's assemblages of discarded materials expanded the vocabulary further (p. 332). The shift from modeling to constructing bears an obvious relationship to the

Christopher Dresser. Claret Pitcher. c. 1880. Glass, silver, and ebony, 16⅝ x 9¹⁵⁄₁₆ x 4" (42.2 x 25.2 x 10.2 cm). The Museum of Modern Art, New York. Gift of Mrs. John D. Rockefeller III

creation of design objects, many of which are assembled from parts. The essay titled "Objects as Subjects" presents poignant juxtapositions of objectlike sculpture and design objects.

The isolated object, freed from any contextual associations, made its appearance in the art of the early modern period. Lucian Bernhard's so-called object posters (*Sachplakat*) present ordinary commercial objects for what they are: cigarettes, spark plug, light bulb, and a woman's shoe (pp. 326–27). Simple and clear, these isolated images are treated in almost a trompe l'oeil fashion but with all sense of narrative removed to stress their unambiguousness. Paul Outerbridge's photograph of a Saltine box (p. 348) has a similar frankness, but its initial clarity disappears upon further contemplation, not unlike the bowls in Strand's photograph. Yet both Bernhard's posters and Outerbridge's photograph are powerful and mysterious because they are isolated from any context. This isolation reinforces the links between a world of purity and geometry and the world of metaphysical painting and surrealism—precisely the qualities van Doesburg's poem makes clear.

The following pages illustrate some of the diverse characteristics of modern design objects, among which the chair has a special status. A chair's anthropomorphic aspects make it a fertile "subject" for the designer. It is difficult to conceive of any "typical" chair, as one can conceive of a "typical" umbrella or cup and saucer. Thus they are the subject of perpetual redesign, and, as they proliferate, the "type" expands. The essay "Ten Chairs" presents a selection of early modern wood chairs that illustrate a wide variety of forms, from the organic suppleness of bentwood to the simplified planes of Frank Lloyd Wright's side chair (p. 304).

Among sculptures of objects, the guitar held a privileged status, thanks to the Cubists' embrace of this form. Yet, one would not know what a guitar looks like from any Cubist work. Like the proliferation of different chair designs, images of guitars seem to move away from the accepted type. These depictions of guitars are, in fact, a form of modern "resistance" to established generic types. Just as the modernists created against the resistance of the still life, the landscape, and figure painting, so they created against the resistance of the typical "chair," "guitar," or any number of design objects such as "vase" or "lamp." Designers have taken various approaches, such as overelaborating or underelaborating—in other words, providing more or less detail than is necessary for the object type. Variations on the type tend to fall into two principal

Constantin Brancusi. *Endless Column.* 1918. Oak, 6'8" x 9⅞" x 9⅝" (203.2 x 25.1 x 24.5 cm). The Museum of Modern Art, New York. Gift of Mary Sisler

categories: the organic and the geometric—and, in some instances, such as the ornament of Louis Sullivan, a combination of the two. For Sullivan, one was an aspect of the other, the complex growing from the simple (p. 335). But more often the organic presented a retreat from the geometric purity which increasingly became associated with industrial production and the removal of the tactile qualities and irregularities associated with hand production.

One way of thinking about the "common language" of objects is how they organize themselves in terms of gravity. All objects are subject to gravity and therefore tend to relate to the horizontal: on the ground, on a table, on a wall, or hung from the ceiling. The horizontal implies a proximate, tactile plane. Alternatively, a vertical wall surface implies a more distant, visual plane. Such realizations helped form the organizing principle of some of the essays that follow. (The evolution of this strategy is described further on pp. 27–30.) One thing is clear: objects are necessarily thought of not only purely and apart, but also in the context of place, whether expected or unexpected. The images that follow demonstrate the diversity of objects, real and depicted, made in the 1880 to 1920 period and collected by The Museum of Modern Art.

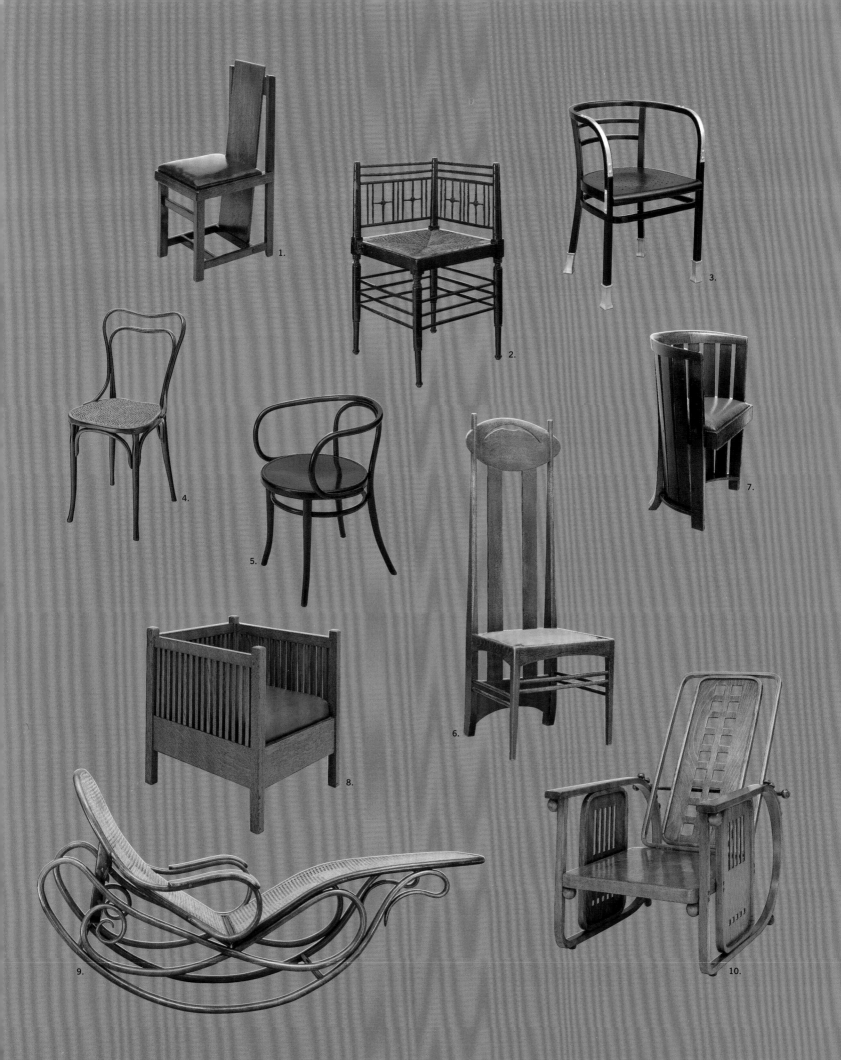

TEN Chairs

PETER REED

1. Frank Lloyd Wright. Side Chair. 1904. Oak and leather, 35¾ x 15 x 18⅝" (90.8 x 38.1 x 47.3 cm). The Museum of Modern Art, New York. Gift of the designer

2. Ford Madox Brown. Sussex Corner Chair. c. 1865. Ebonized oak and rush, 27⅞ x 16½ x 16½" (69.8 x 41.3 x 41.3 cm). The Museum of Modern Art, New York. Gift of Robert and Joyce Menschel

3. Otto Wagner. Armchair. 1902. Stained, bent beechwood with aluminum fittings, 30⅞ x 22¼ x 20¼" (78.5 x 56.5 x 51.5 cm). The Museum of Modern Art, New York. Estée and Joseph Lauder Design Fund

4. Adolf Loos. Side Chair. c. 1898. Steam-bent beechwood and cane, 34 x 17⁷⁄₁₆ x 20⁷⁄₁₆" (86.4 x 44.3 x 52 cm). The Museum of Modern Art, New York. Estée and Joseph Lauder Design Fund

5. Gebrüder Thonet. Armchair. c. 1904. Steam-bent beechwood, 28⅜ x 20⅞ x 21¹⁵⁄₁₆" (74.5 x 52.7 x 55.7 cm) The Museum of Modern Art, New York. Philip Johnson Fund

6. Charles Rennie Mackintosh. Side Chair. 1897. Oak and silk upholstery, 54 x 19⅜ x 18" (137.1 x 49.2 x 45.7 cm). The Museum of Modern Art, New York. Gift of the Glasgow School of Art

7. Charles Rennie Mackintosh. Armchair. 1907. Oak and leather, 30¼ x 22½ x 14¼" (76.9 x 57.1 x 36.2 cm). The Museum of Modern Art, New York. Gift of the Glasgow School of Art

8. Gustav Stickley. Armchair. c. 1907. Oak and leather, 29 x 26 x 27⅝" (73.6 x 66 x 70.2 cm). The Museum of Modern Art, New York. Gift of John C. Waddell

9. Gebrüder Thonet. Rocking Chaise with Adjustable Back. c. 1880. Beechwood and cane, 30½ x 27½ x 68½" (77.5 x 70 x 174 cm). The Museum of Modern Art, New York. Phyllis B. Lambert Fund and gift of the Four Seasons

10. Josef Hoffmann. Sitzmaschine Chair with Adjustable Back. c. 1905. Bent beechwood and sycamore panels, 43½ x 28¼ x 32" (110.5 x 71.7 x 81.3 cm). Mfr.: J. & J. Kohn, Austria. The Museum of Modern Art, New York. Gift of Jo Carole and Ronald S. Lauder

The chair is an object of perpetual reinvention. The diverse range of aesthetic expression in chair design is astonishing yet unsurprising. To ask why we need another chair is tantamount to asking why we need another book, another painting, or another building. There is no perfect chair, just as there is neither a perfect work of art nor a perfect human being. It seems as if there are as many types of chairs as there are people; and an assemblage of chairs underscores the different personalities that can be attributed to these ubiquitous pieces of furniture. Perhaps, because of a chair's anthropomorphic character (reinforced by the language used to describe its parts — legs, arms, seat, and back) and because of its sculptural and architectural character, the chair invites contemplation as an object situated comfortably between people and places. Of course, chairs serve varying functions (such as work, dining, leisure, and ritual), but as objects of artistic attention they are also often infused with moral, social, economic, and technological agendas.[1]

With the elimination of much applied decoration and elaborate upholstery, the early modern chair achieved a kind of sculptural presence unto itself, without relying on references to anything else, for example, heraldic emblems associated with royalty and carvings of flora and fauna. It was usually designed with mass production in mind, and wood was the favored material: inexpensive, flexible, and pleasant to touch. Given the extraordinary presence that chairs command in our environments, it is not surprising that modern designers, most of whom considered architectural spaces and their contents as total works of art, explored a vast range of forms.

Although he aimed for a "style-less style" (by eschewing references to the past), Charles Rennie Mackintosh's high-backed chair, designed for the Luncheon Room of Miss Cranston's famous tea rooms in Glasgow, is suggestive of many things (p. 304 and left). The linear tapering slats of the chair's back support an oval halolike headrest curiously perforated with an abstracted bird in flight. The anthropomorphic references of the headpiece are even more evident when the chairs are grouped around a table defining a zone of conversation.

Frank Lloyd Wright's Side Chair, an important precursor to Gerrit Rietveld's Red Blue Chair, demonstrates a startling simplification of parts emphasizing the horizontal and vertical planes of the seat and back (p. 304 and below). Allowing the canted backrest to span from the rear stretcher below the seat to above the crest rail (at shoulder height) gives a great spatial sense and planar dimension. The deliberate avoidance of curved forms is indicative of the principles Wright espoused in his seminal talk of 1901, "The Art and Craft of the Machine," insomuch as he believed machines (such as the band saw) were best suited to the repetition of simple linear motions. Inspired

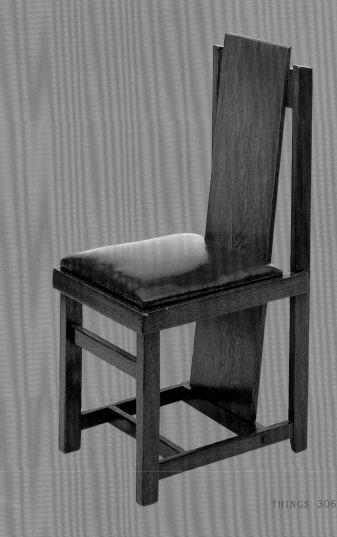

ABOVE: Charles Rennie Mackintosh. Side Chair. 1897. Oak and silk upholstery, 54 x 19⅜ x 18" (137.1 x 49.2 x 45.7 cm). The Museum of Modern Art, New York. Gift of the Glasgow School of Art

RIGHT: Frank Lloyd Wright. Side Chair. 1904. Oak and leather, 35¾ x 15 x 18⅝" (90.8 x 38.1 x 47.3 cm). The Museum of Modern Art, New York. Gift of the designer

OPPOSITE, TOP: Josef Hoffmann. Sitzmaschine Chair with Adjustable Back. c. 1905. Bent beechwood and sycamore panels, 43½ x 28¼ x 32" (110.5 x 71.7 x 81.3 cm). Mfr.: J. & J. Kohn, Austria. The Museum of Modern Art, New York. Gift of Jo Carole and Ronald S. Lauder

OPPOSITE, BOTTOM: Gebrüder Thonet. Rocking Chaise with Adjustable Back. c. 1880. Beechwood and cane, 30½ x 27½ x 68½" (77.5 x 70 x 174 cm). The Museum of Modern Art, New York. Phyllis B. Lambert Fund and gift of the Four Seasons

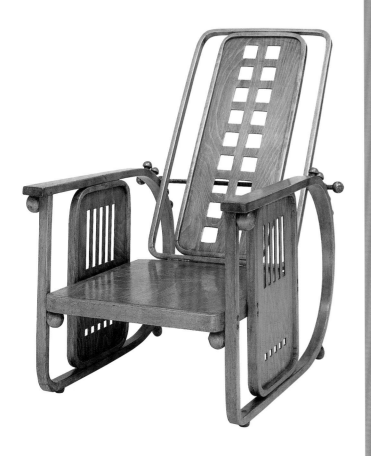

by the British Arts and Crafts movement, Wright also advocated reform especially in the design of the American home for which he believed the machine could be an ally: "Now let us learn from the Machine. It teaches us that the beauty of wood lies first in its qualities as wood . . . that all wood carving is apt to be a forcing of the material, an insult to its finer possibilities as a material having in itself intrinsically artistic properties, of which its beautiful markings is one, its texture another, its color a third."[2]

The rational production and clear structural expression Wright advocated was also shared by Josef Hoffmann, a founding member of the Vienna Secession and the Wiener Werkstätte craft studio. His adjustable-back chair, the *Sitzmaschine* (machine for sitting), originally designed for the Purkersdorf Sanatorium in Vienna, is constructed of an interplay of curved bentwood elements and flat rectilinear planes, demonstrating his preferred geometric form language (p. 304 and left).

No less rational in its production, but different in expression, is the Thonet brothers' bentwood rocker (p. 304 and below). Bentwood technology, perfected in the nineteenth century by Austrian furniture manufacturers such as Gebrüder Thonet and J. & J. Kohn, provided designers with the opportunity of manipulating wood rods into an infinite variety of curvilinear shapes. Bentwood was made by steaming beechwood, bending the supple rods, and placing them in molds to dry. The exuberant flowing calligraphy of the Rocking Chaise, best seen in profile, appears to be a continuous piece of wood (but is in fact two pieces spliced together). The sinuous frame and cane seat achieve an extraordinary effect of lightness and transparency.

NINE GUITARS

The guitar was a popular subject for avant-garde artists at the beginning of the twentieth century. In the early modernist art of the Cubists, the guitar, commonly found in the café and the artist's studio, bespoke a bohemian life. For Pablo Picasso and Juan Gris, the instrument evoked the Spanish culture of their homeland, where the guitar is thought to have originated. In addition to communicating place, the Spanish flamenco and classical guitar were both extremely popular in the late-nineteenth and early-twentieth centuries.

Stringed instruments also belong to the fine-art tradition of still life and genre painting, where they frequently have amorous connotations. Picasso's guitars are no exception. He acknowledged that the curvaceous form of the guitar was associated with the female body, an idea then current in art and literary circles.

In the language of Cubism, the guitar provided a potent and playful subject for visual punning: how much of its fragmented form could represent the whole instrument? A curved silhouette becomes shorthand for the body of the guitar. A circle and parallel lines can read as sound hole and strings. Ironically, the part of the guitar that is a void often becomes the most solid and recognizable part.

ABOVE: Pablo Picasso. *Guitar*. 1912–13. Construction of sheet metal and wire, 30½ x 13¾ x 7⅝" (77.5 x 35 x 19.3 cm). The Museum of Modern Art, New York. Gift of the artist

BELOW: Pablo Picasso. *Guitar*. 1913. Cut-and-pasted papers, charcoal, ink, and chalk on blue paper, mounted on ragboard, 26⅛ x 19½" (66.4 x 49.6 cm). The Museum of Modern Art, New York. Nelson A. Rockefeller Bequest

Picasso's *Guitar* of 1912–13 (p. 308 and left) opened the door to a century of rich sculptural experimentation. Neither modeled nor carved, as Western sculpture had been since antiquity, it is revolutionary in form and technique: constructed of sharply cut sheet-metal planes that suggest, instead of define, volume and reveal, rather than enclose, mass. The body of the guitar is peeled away in fragments, rendering it transparent. The sound hole, strings, and curvilinear pieces provide visual clues for the viewer, who ultimately must rely on previous knowledge of what a guitar looks like to make sense of the sculpture.

In *Guitar*, a collage of 1913, Picasso introduced wallpaper, a mass-produced object, in an attempt to disrupt traditional methods of representing the observable world and to insert a material deemed unacceptable in art (p. 308 and below). Visual and verbal puns abound. Floral wallpaper cut in the shape of a guitar reappears in rectilinear form, perhaps to indicate a table or wall, and has the visual effect of flattening the space. A rectilinear swath of box-patterned wallpaper, in this context, stands for the guitar's neck and fretwork, while a circle of newsprint represents the sound hole. Picasso includes the front page of the Barcelona newspaper *El Diluvio*, which is truncated to read "Diluv," a sly pun on the Musée du Louvre in Paris, where modern art was not exhibited. The front page also contains an advertisement for an oculist, a possible reference to disparaging critics who joked that the disintegrating objects of Cubism were the result of poor vision.

The architect and painter Le Corbusier preferred the solid representation of things to the Cubist fracturing of form. Le Corbusier was a cofounder of Purism, a style that sought to "purify" Cubism. With painter Amédée Ozenfant, Le Corbusier outlined his beliefs in postwar order and purity in their publications: *Après le Cubisme* (the manifesto of 1918) and the avant-garde journal *L'Esprit Nouveau* (1918–25).

In *Still Life* (1920), Le Corbusier borrows the objects of a Cubist picture and stabilizes them through the use of carefully composed horizontals and verticals, simple geometry, and rhyming shapes (pp. 308, 311). In contrast to the fractured form and confused space of the Cubists, Le Corbusier uses shading to lend solidity to the objects and sets them in a recognizable architectural space, suggested by the floor and doorway in the upper left. Yet Le Corbusier, like Picasso, plays with issues of seeing: we look at and down upon the stack of plates, which forms the guitar's sound hole.

Working with Purist and Cubist ideas, Uruguayan-born Joaquín Torres-García, who was raised in Spain, believed abstraction should be rational and rooted in the real world. *Guitarra* (1924) is a small, frontal relief constructed of roughly hewn pieces of wood that jaggedly fit together like a puzzle (p. 308 and left). Similar to Picasso's forms, Torres-García's simple planar shapes suggest, rather than replicate, the instrument. Two cut-away half circles imply a sound hole, while two red strips indicate the strings of the guitar. The toylike size, rudimentary forms, and unrefined finish give this sculpture a playfulness that is similar to the wood blocks for children that he made at the same time. *Guitarra*, in both subject and whimsy, is probably a homage to Spain, his second homeland, and to his compatriot Picasso.

ABOVE: Le Corbusier (Charles-Édouard Jeanneret). *Still Life*. 1920. Oil on canvas, 31⅞ x 39¼" (80.9 x 99.7 cm). The Museum of Modern Art, New York. Van Gogh Purchase Fund

LEFT: Joaquín Torres-García. *Guitarra*. 1924. Painted wood relief, 12½ x 4 x 3⅛" (37.7 x 10 x 7.7 cm). The Museum of Modern Art, New York. Abby Aldrich Rockefeller Fund

Tables and OBJECTS

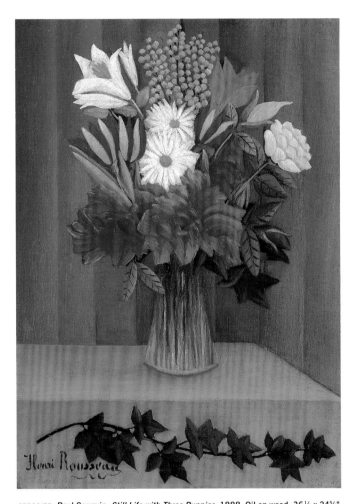

OPPOSITE: Paul Gauguin. *Still Life with Three Puppies.* 1888. Oil on wood, 36⅛ x 24⅝"
(91.8 x 62.5 cm). The Museum of Modern Art, New York. Mrs. Simon Guggenheim Fund

ABOVE: Henri Rousseau. *Flowers in a Vase.* 1901–02. Oil on canvas, 18¼ x 13"
(46.4 x 33 cm). The Museum of Modern Art, New York. The William S. Paley Collection

Objects, being subject to gravity, are usually found on horizontal planes; large objects sit on the plane of the floor, and smaller ones on that of the table. The table is the principal site and part of the subject of still-life painting. Since paintings are vertical planes, the relationship between the horizontal plane of the table and the vertical plane of the painting is also an integral part of the subject of still life. This is especially true during the modern period, when artists tipped the painted tabletop up to meet the vertical picture plane.

Paul Gauguin's *Still Life with Three Puppies* and Henri Rousseau's *Flowers in a Vase* were painted only thirteen years apart, in 1888 and 1901–02, respectively, but they represent extremes of spatial treatment in still life. The nonhierarchical arrangement of objects in Gauguin's painting adds to the disorientation produced by the tabletop's having been lifted almost to the vertical. Moreover, the table is only truly identifiable from the curve of its edge at the bottom of the painting. Rousseau's work is a straightforward depiction of a vase of flowers set centered on a table for us to look at. It is modern in its crisp, geometric clarity. Gauguin's table, on the other hand, defies gravity, both lifting up the objects on it for us to look at and bringing them closer to our touch.

ABOVE: Paul Cézanne. *Milk Can and Apples.* 1879–80. Oil on canvas, 19¾ x 24" (50.2 x 61 cm). The Museum of Modern Art, New York. The William S. Paley Collection

OPPOSITE: Paul Cézanne. *Still Life with Fruit Dish.* 1879–80. Oil on canvas, 18¼ x 21½" (46.4 x 54.6 cm). The Museum of Modern Art, New York. Fractional gift of Mr. and Mrs. David Rockefeller

Commenting on the work of Paul Cézanne, the art historian Meyer Schapiro wrote that still life "consists of objects that, whether artificial or natural, are subordinate to man as elements of use, manipulation and enjoyment; these objects are smaller than ourselves, within arm's reach, and owe their presence and place to a human action, a purpose. They convey man's sense of his power over things in making or utilizing them; they are instruments as well as products of his skills, his thoughts and appetites. . . . They appeal to all the senses and especially to touch and taste."[1]

If we do imagine ourselves reaching to the fruit on the table of Cézanne's *Still Life with Fruit Dish*, the painting itself stands in the way. It is like an opaque wall—made of small, densely troweled brushstrokes—divided horizontally near the center. The objects seem as much embedded in the surface of the painting as set in an illusionistic space. Indeed, space seems to open up only above the central horizontal line, which marks the far edge of the table; the wallpaper resembles sky. Below the division, everything is compacted within the tipped-up tabletop, a surface whose solid, densely packed objects lure us, but whose heaviness of paint distances us by compromising

the illusion. Still life began with classical Roman pictures of objects whose semblance to real things was intended to fool the eye. Cézanne's still life similarly invites touch only to disappoint it, encouraging looking instead. The seemingly vertical table in works like this one set the pattern for many modern still lifes, among them Giorgio Morandi's *Still Life* (p. 322). Although this is also a canvas divided into horizontal bands, it is more austere and abstract than Cézanne's work. Not rounded fruit but elongated, man-made objects, Morandi's forms are laid out against the vertical plane of the table in a horizontal row, arranged a bit like figures standing along a wall.

ABOVE: Paul Cézanne. *Still Life with Apples*. 1895–98. Oil on canvas, 27 x 36½"
(68.6 x 92.7 cm). The Museum of Modern Art, New York. Lillie P. Bliss Collection

OPPOSITE: Paul Cézanne. *Still Life with Ginger Jar, Sugar Bowl, and Oranges*. 1902–06.
Oil on canvas, 23⅞ x 28⅞" (60.6 x 73.3 cm). The Museum of Modern Art, New York.
Lillie P. Bliss Collection

In Cézanne's later still lifes, such as the works on these two
pages, the objects are more openly dispersed than in his earlier
ones. He sometimes left areas of canvas unpainted to breathe
air into the compositions. Some are very opulent, including
Still Life with Ginger Jar, Sugar Bowl, and Oranges, which offers
the viewer its rich delights by tipping its objects up toward the
vertical. We can, illogically, look down into the bowl of fruit at
the center. Paul Klee's *Still Life with Four Apples* (p. 318) further
developed that idea. The simplicity of this painting's compo-
sition—four circles in a circle in a rectangle—would become
standard in modern art.

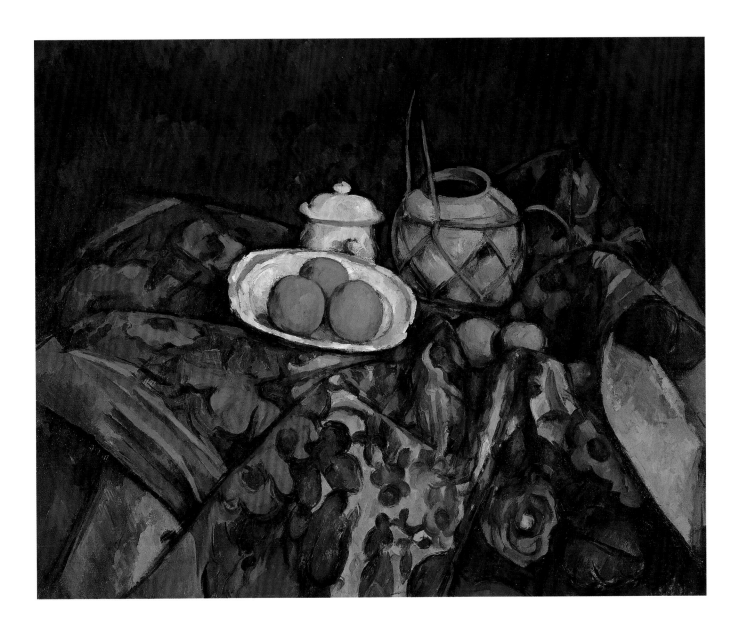

Within their newfound simplicity, the works on the following pages demonstrate various ways artists have treated objects in relationship to tables. In paintings by Matisse (p. 319) and Joan Miró (p. 320), the tables and objects are flat shapes parallel to the surface of the painting. In works by Pablo Picasso (p. 321) and Georges Braque (p. 323), the shapes of the paintings themselves mimic the shapes of tabletops. The edge of a represented table is blurred in a painting by Édouard Manet (p. 324). It disappears entirely in a work by Matisse (p. 325), so that the objects float in an uncertain space. Matisse's painting is, unexpectedly, divided vertically, with

the objects overlapping the division; what may look at first like the edge of the table could be the edge of a tablecloth. In Lucian Bernhard's lithograph (p. 325), a solid ground presumably connotes both horizontal and vertical planes, with the cigarettes on a horizontal surface and the word MANOLI on a vertical wall. Precisely where the division is we cannot tell. Three actual tables—by Edward William Godwin (p. 318), Charles Rennie Mackintosh (p. 322), and Gerrit Rietveld (p. 323)—are illustrated as well for the clarity and simplicity of their design and for the similarities in their vocabulary to the tables of the still lifes.

ABOVE: Paul Klee. *Still Life with Four Apples*. 1909. Oil and wax on paper mounted on composition board, 13½ x 11⅛" (34.3 x 28.3 cm). The Museum of Modern Art, New York. Gift of Mr. and Mrs. Peter A. Rübel

RIGHT: Edward William Godwin. Table. c. 1875. Wood and brass, 28¾ x 40 x 40" (73 x 101.6 x 101.6 cm). The Museum of Modern Art, New York. Gift of Paul F. Walter

OPPOSITE: Henri Matisse. *The Rose Marble Table*. 1917. Oil on canvas, 57½ x 38¼" (146 x 97.2 cm). The Museum of Modern Art, New York. Mrs. Simon Guggenheim Fund

ABOVE: Joan Miró. *Table with Glove*. 1921. Oil
on canvas, 46 x 35¼" (116.8 x 89.5 cm).
The Museum of Modern Art, New York. Gift of
Armand G. Erpf

OPPOSITE: Pablo Picasso. *The Architect's Table*.
1912. Oil on canvas, 28⅜ x 23½" (72.7 x
59.7 cm). The Museum of Modern Art, New York.
The William S. Paley Collection

RIGHT: Giorgio Morandi. *Still Life.* 1916. Oil on canvas, 32½ x 22⅝" (82.6 x 57.5 cm). The Museum of Modern Art, New York. Acquired through the Lillie P. Bliss Bequest

BELOW: Charles Rennie Mackintosh. Tea Table. 1904. Ebonized wood, 24⅛ x 19¾ x 36¾" (61.3 x 50.2 x 93.3 cm). The Museum of Modern Art, New York. Guimard Fund

OPPOSITE, TOP: Georges Braque. *Soda.* 1912. Oil on canvas, diam. 14¼" (36.2 cm). The Museum of Modern Art, New York. Acquired through the Lillie P. Bliss Bequest

OPPOSITE, BOTTOM: Gerrit Rietveld. Side Table. 1923, manufactured 1983. Painted wood, 23⅜ x 20⅜ x 19¾" (60 x 51.8 x 50.2 cm). The Museum of Modern Art, New York. Gift of Manfred Ludewig

ABOVE: Édouard Manet. *Two Roses on a Tablecloth*. 1882–83. Oil on canvas, 7⅝ x 9½" (19.4 x 24.1 cm). The Museum of Modern Art, New York. The William S. Paley Collection

BELOW: Henri Matisse. *Fruits on a Morrocan Plate*. 1914–15. Monotype, comp.: 2¼ x 6⅛" (5.7 x 15.6 cm). The Museum of Modern Art, New York. Abby Aldrich Rockefeller Fund

OPPOSITE, TOP: Lucian Bernhard. *Manoli*. 1910. Lithograph, 28 x 37¼" (71.1 x 94.6 cm). The Museum of Modern Art, New York. Don Page Fund

OPPOSITE, BOTTOM: Henri Matisse. *Gourds*. 1915–16. Oil on canvas, 25⅝ x 31⅞" (65.1 x 81 cm). The Museum of Modern Art, New York. Mrs. Simon Guggenheim Fund

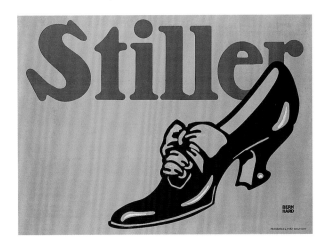

OBJECTS *words*

A basic childhood experience is learning to recognize and name objects,[1] that is, to match a word (a verbal signifier) to an object (the thing signified). The later experience of doing this when dealing with a visual work of art that contains pictures of objects (visual signifiers) is more complicated. For we will want to match these visual signifiers with verbal signifiers (the pictures of objects with the words for objects) as well as with the actual (but absent) things signified. But matters become even more complicated in a period when a work of art itself is thought to be an object. And, if a work of art that both represents objects and that itself is thought to be an object is a tangled-enough proposition, then a work that, additionally, represents words that represent objects is bound to be a puzzle—and is often meant to be.

Words, of course, have usually been kept outside the space of pictures, as titles or commentaries, in the belief that the verbal and the visual are separate, opposing realms.[2] And words have always been thought to be more instantaneous, enduring signifiers than visual images, given the obvious contingencies of visual representation. In the case of Lucian Bernhard's posters, word and image are juxtaposed—only, the word (the verbal signifier) does not refer to the object in the way that the image (the visual signifier) does. The word, unlike the image, does not "name" the object. Rather, it gives a brand name, which, if repeated often enough, is hoped will attach to the object, replacing the (absent) original given name. For this strategy to work requires that the image be somewhat like a word itself: its goal is to call up the object as if by its original name, so that the new name, written just behind it, may be introduced as the old name's replacement. This means that the image must be stripped of whatever visual qualities might delay the eye in reaching that goal, present qualities being subordinated to future advantages. In advertising, in Norman Bryson's account, "the image is less important *in praesentia* than it is as anticipated memory: the moment of its impact may be intense, but only so that the visual impression can go on resonating within the mind after it has ceased to contemplate the actual image."[3]

OPPOSITE, TOP: Lucian Bernhard. *Bosch*. 1914. Lithograph, 17⅞ x 25¼" (45.5 x 64.1 cm). The Museum of Modern Art, New York. Gift of The Lauder Foundation, Leonard and Evelyn Lauder Fund

OPPOSITE, BOTTOM: Lucian Bernhard. *Osram AZO*. c. 1910. Lithograph, 27⅝ x 37⅜" (70.2 x 94.9 cm). The Museum of Modern Art, New York. Department Purchase Fund

ABOVE: Lucian Bernhard. *Stiller*. 1908. Lithograph, 27⅛ x 37½" (68.9 x 95.2 cm). The Museum of Modern Art, New York. Gift of The Lauder Foundation, Leonard and Evelyn Lauder Fund

Also in the service of rapid consumption is the fiction that the thing signified is *exterior* to the image, that is, it has not been conjured up in the shaping of the image (although obviously it has) but somehow preexists the work and has entered it from "outside." Again, this is to treat the visual signifier like a verbal signifier, which does preexist how it is used and does not have to be invented in its use, as a visual signifier does. This disguising of how the making of the work produces the signification gives what we call "realism" to an image. Thus, we will be inclined to call the images in Bernhard's posters "realistic," and disinclined to do so for those in Pablo Picasso's and Georges Braque's prints.[4]

The verbal images in these prints (pp. 328–29) come, in the main, from a similar pool of brand names, advertising slogans, and labeled objects of commodity culture as the one to which Bernhard contributed. Yet, they—and their accompanying visual images—are as obscure as his are clear, and in the service of a consumption as slow as his is rapid. They use the apparatus of mass culture at the service of an artistic élite accustomed to a puzzling and a contemplative art.[5] Thus, for example, many people could, presumably, have perceived that "Vie Marc" on the bottle in the Picasso print might refer to a brandy called "L'eau de vieux Marc" and that an ace of hearts on a playing card could well be a symbol of love, but only if they understood that they were being asked to puzzle it out. However, only a very small circle of people would have known that Picasso had a new love in his life ("vie"), Éva Gouel, who was also known as Marcelle ("Marc") Humbert; nor would it probably have occurred to them (without knowing of Picasso's fondness for puns) that one of the meanings of "marc" is a residuum or essence, which seems appropriate for an art of such visual and verbal condensation.[6]

Picasso and Braque's dealer at this period, Daniel-Henry Kahnweiler, argued that fundamental "to the comprehension of Cubism and of what, for me, is truly modern art [is] the fact that *painting is a form of writing . . .* that creates signs."[7] One of the consequences of this was to liberate typographic design, for perhaps writing could now become a form of painting, one that disposes words and word fragments as the painter disposes visual (and now verbal) signs. Filippo Tommaso Marinetti's book of "words-in-freedom" does just that. In one plate

Pablo Picasso. *Still Life with Bottle of Marc.* 1911, printed 1912. Drypoint, plate: 19 11/16 x 12" (50 x 30.5 cm). Publisher: Édition Henry Kahnweiler, Paris. Edition: 100. The Museum of Modern Art, New York. Acquired through the Lillie P. Bliss Bequest

(p. 330, bottom left), we are asked to image that a woman described by a visual signifier, the silhouette at the bottom of the sheet, is reading everything else that is on the sheet, which itself signifies a letter from the Front. The letter and this sheet that signifies it tell of the war through verbal signifiers that describe sometimes words and sometimes sounds that elide into visual signifiers of things exploding and crashing around.

The other Marinetti plate, and the works illustrated by Theo van Doesburg and Kurt Schwitters and by Fernand Léger (pp. 330–31), are less complicated. They minimize anything specifically imitative (therefore, both visual signifiers and onomatopoeia) and make abstract visual compositions of verbal signifiers, relying on how word fragments and neologisms will be read visually to the extent that their verbal significance is occluded. And all throw in a few purely abstract, nonsignifying shapes to remind us that, in the form of the typography as well as in the words it composes, the connection between signifier and signified is always arbitrary.

ABOVE, LEFT: Georges Braque. *Fox.* 1911, published 1912. Drypoint, plate: 21⁹/₁₆ x 14¹⁵/₁₆" (54.8 x 38 cm). Publisher: Édition Henry Kahnweiler, Paris. Edition: 100. The Museum of Modern Art, New York. Gift of Abby Aldrich Rockefeller

ABOVE, RIGHT: Georges Braque. *Job.* 1911, published 1912. Drypoint, plate: 5⅞ x 7⅞" (14.3 x 20 cm). Publisher: Édition Henry Kahnweiler, Paris. Edition: 100. The Museum of Modern Art, New York. Gift of Victor S. Riesenfeld

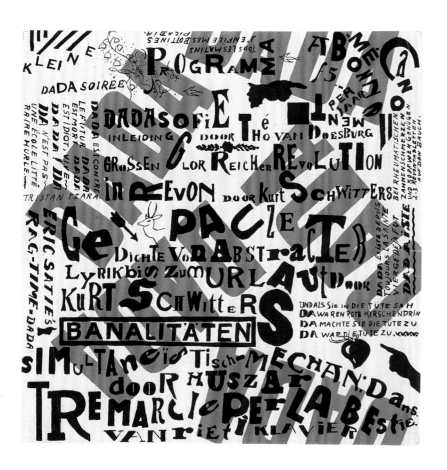

LEFT: Theo van Doesburg and Kurt Schwitters. *Kleine DADA Soirée.* 1922. Lithograph, 11¹⁵⁄₁₆ x 11¾" (30.3 x 29.9 cm). The Museum of Modern Art, New York. Gift of Philip Johnson, Jan Tschichold Collection

BELOW, LEFT: Filippo Tommaso Marinetti. Plate for *"Les Mots en Liberté Futuristes."* 1919. Letterpress, 13⅜ x 9¼" (34 x 23.2 cm). The Museum of Modern Art, New York. Gift of Philip Johnson

BELOW, RIGHT: Filippo Tommaso Marinetti. Plate for *"Les Mots en Liberté Futuristes."* 1919. Letterpress, 13⅜ x 9¼" (34 x 23.2 cm). The Museum of Modern Art, New York. Gift of Philip Johnson

OPPOSITE: Fernand Léger. Illustration for *La Fin du monde, filmée par l'ange N.D.* by Blaise Cendrars. 1919. Pochoir in color, with line-block reproductions of ink drawings. Page: 12⅜ x 9¹³⁄₁₆" (31.5 x 25 cm). Paris, Éditions de la Sirène. Edition: 1,225. The Museum of Modern Art, New York. The Louis E. Stern Collection

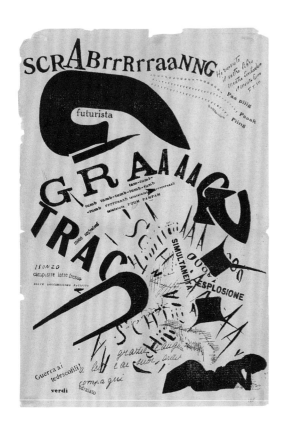

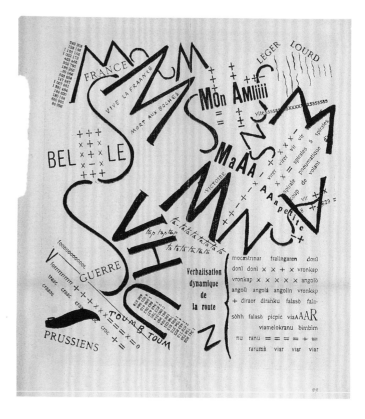

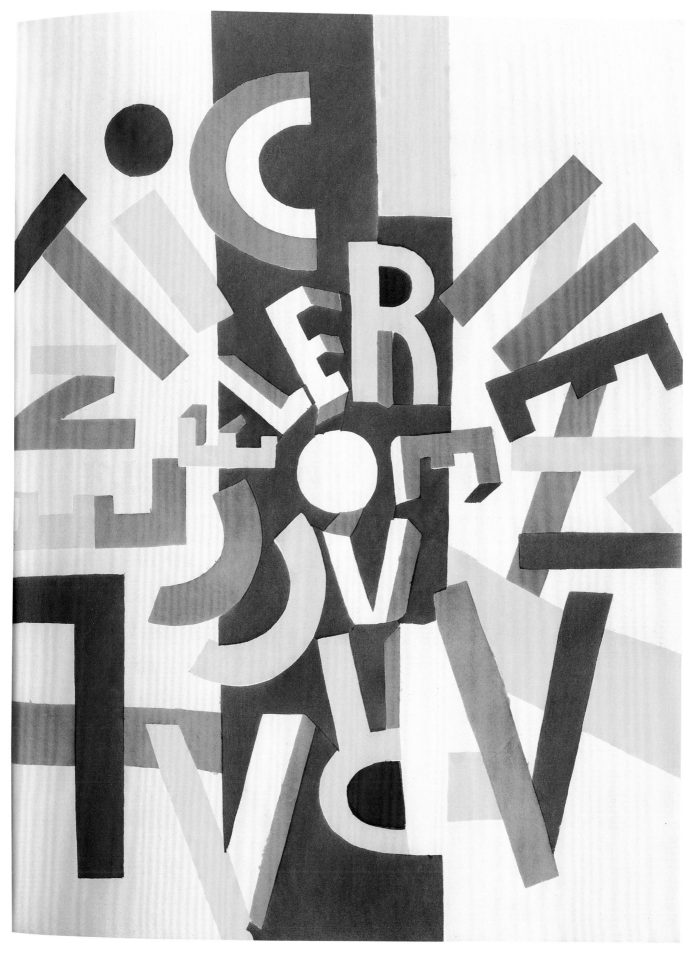

PETER REED

Objects,
Walls,
Screens

OPPOSITE: Kurt Schwitters. *Revolving*. 1919. Relief construction of wood, metal, cord, cardboard, wool, wire, leather, and oil on canvas, 48⅜ x 35" (122.7 x 88.7 cm). The Museum of Modern Art, New York. Advisory Committee Fund

ABOVE: Joan Miró. *The Carbide Lamp*. 1922–23. Oil on canvas, 15 x 18" (38.1 x 45.7 cm). The Museum of Modern Art, New York. Purchase

Kurt Schwitters's relief assemblage of discarded materials, *Revolving* (opposite), is an appropriate segue from the preceding images of "concrete poetry," which included the Dada poster Schwitters designed with Theo van Doesburg (p. 330, top). The expressive power of his visual poetic experiments coincided with his revolutionary pictures of fragments of stuff laid on a painted canvas. Like collage, unconventional materials were now put on an equal footing with paint; as in his poetry, which juxtaposed words in new contexts for expressive effect, so was Schwitters equally liberated in his manipulation of materials, colors, and forms. Both a painting and a construction, *Revolving* suggests the inner workings of a machine with turning gears. The precision of the circles and diagonal connecting rods (made of metal, cord, wire, and leather) serves no apparent purpose. It is not an optimistic piece, but is infused with the melancholy of making a new world (and new art forms) from the remains of German culture following the Great War. Schwitters explained that "everything had broken down . . . new things had to be made from fragments." The revolving circles, the detritus of some machine, takes on more universal meanings with its implications of worlds revolving in space.[1]

OPPOSITE: Piet Mondrian. *Church Facade.* 1914. Charcoal on paper, 39 x 25" (99 x 63.4 cm). The Museum of Modern Art, New York. The Joan and Lester Avnet Collection

ABOVE: Louis Henry Sullivan. Spandrel from Gage Building, Chicago, detail. 1898–99. Painted cast iron, 50" x 6' 2⅞" x 4" (127 x 190.2 x 10.1 cm). The Museum of Modern Art, New York. Gift of Dubin & Dubin, Architects, Chicago

BELOW: William Henry Fox Talbot. *Lace.* 1845. Salted paper print (photogram), 6½ x 8¾" (16.5 x 22.3 cm). The Museum of Modern Art, New York. Gift of Dr. Stefan Stein

Frank Lloyd Wright. Clerestory Window from Avery Coonley Playhouse, Riverside, Ill. 1912. Color and clear glass, leaded, 18⁵/₁₆ x 34³/₁₆" (46.5 x 86.9 cm). The Museum of Modern Art, New York. Joseph H. Heil Fund

Despite the atmospheric qualities of Schwitters's painterly canvas, we are also aware of the assemblage as relief. Objects are literally nailed onto the picture, reinforcing its "thinglike" status as a relief painting that hangs on the wall. When abstraction approaches a condition of flatness by the suspension of illusionistic depth, the result is an emphasis on the vertical plane and hence a wall or screenlike quality. Joan Miró's *The Carbide Lamp* (p. 333) could have comfortably appeared in the preceding section, which illustrates tables and objects, and concludes with objects placed on monochromatic backgrounds. Similarly, the lamp is placed in an ambiguous space. Perhaps the colored ground is a table, but without the convention of illusionistic depth, the flatness of the picture plane is reinforced.

The frontality implied in a flat or upturned picture plane renders a picture analogous to that of a facade. Piet Mondrian's *Church Facade* is an abstract drawing of opposed horizontal and vertical lines and dashes that form a lively rhythmic network (pp. 260, 334). It is, in fact, derived from the brick facade of the village church at Domburg, the Netherlands. The outline of arched windows in the center of the composition, corresponding to the central tower of the church, is barely discernible. The drawing approaches complete abstraction.

Buildings designed by the American architect Louis Henry Sullivan are clothed in a profusion of lacy ornament that gives the underlying structure an expressive voice. The cast-iron balustrade, which originally concealed a structural beam of a commercial building, suggests the vitality of his new organic architecture (p. 335). A dense curvilinear foliation is interwoven with a still-visible armature of rectilinear geometry, the metaphorical seed which gave life to the flourish of tendrils. The architect's task, Sullivan claimed, was to "impart to the passive materials a subjective or spiritual human quality which shall make them live." Sullivan described his intentions in particularly expressive terms and claimed that "the architect is one kind of poet, and his work one form of poetry."[2]

The play between opacity and transparency, between wall, window, and screen is fundamental to architectural facades, and representations of them. They are objects to look at and to look through. Frank Lloyd Wright's stained-glass window was part of a continuous band of clerestory windows around the playroom of a kindergarten. Each window in the series was composed of lively combinations of simple geometric motifs in bright primary colors. The windows were inspired by the sight of a parade, and display shapes abstracted from

Theo van Doesburg. *Café Aubette, Strasbourg.* Color scheme for ceiling and short walls of ballroom, preliminary version. 1927. Ink and gouache on paper, 10¾ x 24¾" (27.3 x 62.8 cm). The Museum of Modern Art, New York. Gift of Lily Auchincloss, Celeste Bartos, and Marshall Cogan

balloons, confetti, and even an American flag. The arranging of shapes into patterns in the window relates to the formal strategies Wright adopted in his architecture. His belief in the universality of fundamental geometric forms was as much a response to rational methods of modern machine production as an intuitive understanding that abstract forms carried shared spiritual values. Geometric forms had played a role in Wright's own childhood education through a German system of educational toys, the Froebel blocks, which he later credited as a major influence on his ideas about architecture.

Geometric abstraction became a valid language for representing a new utopian order in the aftermath of World War I; this is reflected in van Doesburg's design for the Café Aubette. The walls and ceiling are painted in rectangles of primary colors arranged in a diagonal fashion. Van Doesburg was a founder of the de Stijl movement and, influenced by the ideas of Mondrian, believed that the underlying essence and universality of the visible world could only be achieved through a logical process of reduction to a system of squares, rectangles, lines, and primary colors.

The transformation of a wall into screens or protective grilles by means of perforations and voids situates the works illustrated here by Antoni Gaudí and Eileen Gray between architecture and sculpture. In Gaudí's hands, strips of wrought iron were transformed into flowing, ribbonlike undulations to form a protective grille on the ground story of a Barcelona apartment building, which he designed in an equally organic fashion (p. 338). The fluid appearance of the screen evokes images of fishing nets commonly seen on the Mediterranean. Gray's screen is a Cubist-inspired design of rectangular wood panels stacked together like building blocks (p. 339). They are hinged and can pivot in a zigzag pattern, resulting in a sculptural composition of solid and void. The panels are finished in shiny black lacquer, inspired by Japanese decorative arts, and appropriate to the sophisticated Parisian interior for which they were designed.

ABOVE: Antoni Gaudí. Grille from the Casa Milá, Barcelona. 1905–07. Wrought iron,
65¾ x 72½ x 19⅝" (167 x 184 x 50 cm). The Museum of Modern Art, New York.
Gift of Mr. H. H. Hecht in honor of George B. Hess and Alice Hess Lowenthal

OPPOSITE: Eileen Gray. Screen. 1922. Lacquered wood and metal rods, 6'2½" x
53½" x ¾" (189.2 x 135.9 x 2 cm). The Museum of Modern Art, New York.
Hector Guimard Fund

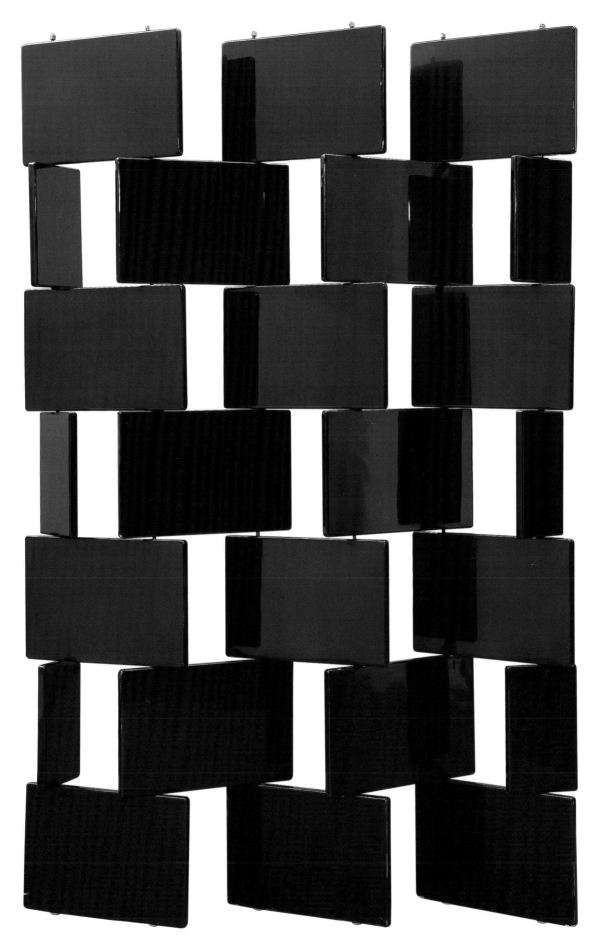

Objects
AS SUBJECTS

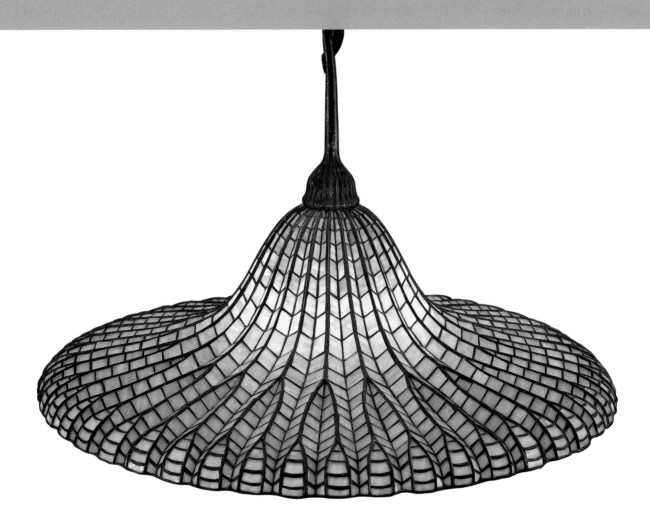

For the designer of an object, the object is the subject of the design insofar as the design is a reimagination of the subject—a subject called a vase, for example—say, in a more organic or a more geometric form. For sculptors, by contrast, the sculptural object has rarely been thought of precisely as the subject of the work. The subject is usually thought of as something else—a figure, say—and the design of the sculptural object as a reimagination of that.

Traditionally, sculptures of actual objects were rare, being only made to depict such things as the attributes of gods or saints and the trophies of war. A Cubist sculpture of a guitar altered all this (see p. 310), and thus utterly complicated the object world of twentieth-century art. It meant that sculptors of actual objects found themselves in the same position as designers of actual objects: the object had become subject. But, additionally, the sculptural object could now be thought of as a subject whether or not it depicted an object, which led to extremely objectlike sculptures that do not depict actual objects, being abstract, but still resemble actual objects, albeit previously unseen objects of uncertain use. This, in turn, led to the appreciation of designed objects of a kind never recognized before: objects that resemble abstract sculptures, like the ball bearing on page 345, or that were created in a context in which only use distinguished the sculptor's object and the designer's object, such as the lighting fixture on page 346.

3. Richard Riemerschmid. Bottle. 1912. Molded glass, 11½ x 2¹³⁄₁₆" (29.2 x 7.3 cm). The Museum of Modern Art, New York. Phyllis B. Lambert Fund

4. Umberto Boccioni. *Development of a Bottle in Space.* 1912 (cast 1931). Silvered bronze, 15 x 23¾ x 12⅞" (38.1 x 60.3 x 32.7 cm). The Museum of Modern Art, New York. Aristide Maillol Fund

5. George Ohr. Pitcher. c. 1900. Ceramic, 4⅛ x 6⅛ x 3¼" (10.4 x 15.5 x 8.2 cm). The Museum of Modern Art, New York. Gift of Charles Cowles and Mary and David Robinson

6. Meret Oppenheim. *Object (Le Déjeuner en fourrure).* 1936. Fur-covered cup, saucer, and spoon. Cup, 4⅜" (10.9 cm) diam.; saucer, 9⅜" (23.7 cm) diam.; spoon, 8" (20.2 cm) long; overall height, 2⅞" (7.3 cm). The Museum of Modern Art, New York. Purchase

1 3 4 5 6

1. László Moholy-Nagy. *Nickel Construction*. 1921. Nickel-plated iron, welded, 14⅛ x 6⅞ x 9⅜" (35.6 x 17.5 x 23.8 cm). The Museum of Modern Art, New York. Gift of Mrs. Sibyl Moholy-Nagy

2. Aleksandr Rodchenko. *Spatial Construction no. 12.* From the series Light-Reflecting Surfaces. c. 1920. Plywood, open construction partially painted with aluminium paint, and wire, 24 x 33 x 18½" (61 x 83.7 x 47 cm). The Museum of Modern Art, New York. Acquisition made possible through the extraordinary efforts of George and Zinaida Costakis, and through the Nate B. and Frances Spingold, Matthew H. and Erna Futter, and Enid A. Haupt Funds

3. Kayserzinn Workshop. Meat Dish with Cover. 1902–04. Pewter. Cover, 7⅝ x 13⅝ x 7⅜" (19.3 x 34.5 x 18.8 cm); dish, 1½ x 16 x 8½" (4 x 40.5 x 21.5 cm). The Museum of Modern Art, New York. Gift of Manfred Ludewig

4. Egmont Arens. Meat Slicer. c. 1935. Steel, 13 x 17 x 21" (33 x 43 x 53.5 cm). The Museum of Modern Art, New York. Gift of Eric Brill in memory of Abbie Hoffman

5. Man Ray. *Cadeau.* c. 1958; replica of 1921 original. Painted flatiron with row of thirteen tacks, heads glued to bottom, 6⅛ x 3⅝ x 4½" (15.3 x 9 x 11.4 cm). The Museum of Modern Art, New York. James Thrall Soby Fund

6. Sven Wingquist. Self-Aligning Ball Bearing. 1929. Chrome-plated steel, 1¾ x 8½" (4.4 x 21.6 cm). The Museum of Modern Art, New York. Gift of the manufacturer

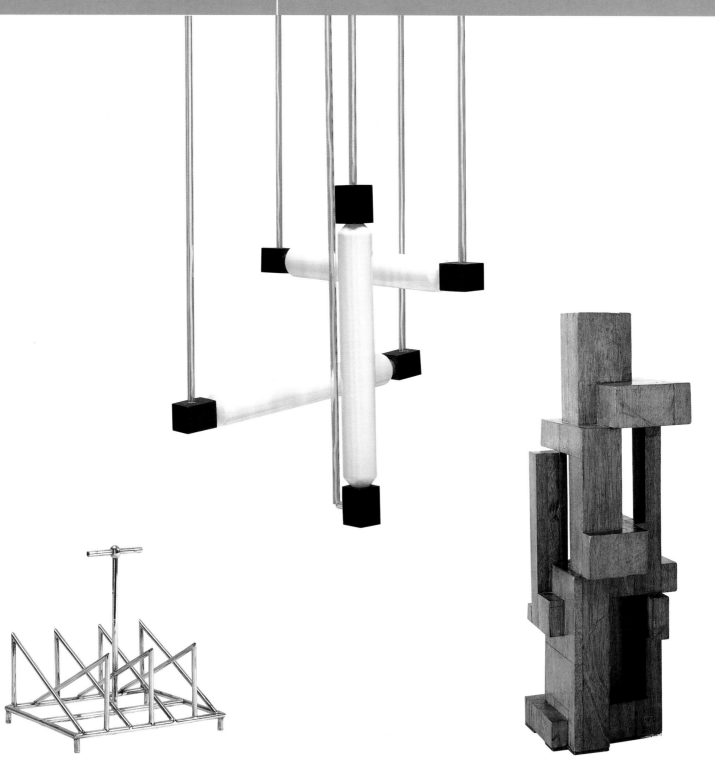

1. Christopher Dresser. Toast Rack. c. 1878. Electroplated silver, 5¼ x 5¼ x 4¼" (13.3 x 13.3 x 10.8 cm). The Museum of Modern Art, New York. Mrs. John D. Rockefeller III Purchase Fund

2. Gerrit Rietveld. Hanging Lamp. 1920. Incandescent bulbs, glass, and painted wood, 41 x 15¾ x 15¾" (104 x 40 x 40 cm). The Museum of Modern Art, New York. Emilio Ambasz Fund

3. Georges Vantongerloo. *Construction of Volume Relations.* 1921. Mahogany, 16⅛ x 5⅝ x 5¾" (41 x 14.4 x 14.5 cm), including base. The Museum of Modern Art, New York. Gift of Silvia Pizitz

Whereas the preceding plates in this section illustrate three-dimensional objects, the final two, which follow, illustrate two-dimensional representations of three-dimensional objects. A two-dimensional work of art is also an object, of course, and its object quality can be emphasized. However, it cannot precisely become an object that is a subject unless the work is nonrepresentational, or unless the work in its entirety represents an object in its entirety of similar shape and proportions to itself. Neither condition obtains for the following two photographs. In both, an object is the subject in the way that is traditional to two-dimensional representations, which, unlike sculptures, have long represented objects, both natural and man-made. But neither of these photographs is a traditional representation. At least, so it seems from a present perspective. Made fifty years apart, in 1872 and 1922, and therefore more than spanning the period to which this volume is devoted, they exemplify a famous early modernist precept: that it cannot be thought surprising that "the past should be altered by the present as much as the present is directed by the past."[1]

William Bell's photograph shows Perched Rock at Rocker Creek, Arizona (p. 349). It was done for the purpose of documentation. The rock was more or less centered in the frame, a hat was placed in the right foreground to give a sense of scale, and the photograph was taken. Then the glass-plate negative was labeled for some reason, near the hat, with the number 55. That was scratched out, and the number reinstated further back, near another number, 14, which is the number of the plate this photograph originally formed in the War Department publication *Explorations and Surveys West of the 100th Meridian*, recording an expedition of 1872 led by a Lieutenant George W. Wheeler. All this information can be elicited from the photograph itself and from the captions on the borders of the paper on which it is printed (not shown in the illustration here). Bell's photograph is as frank and precise as was technically possible, and its ambiguities—such as the tiny, pitted black-and-white spots along the bottom and the curious blurring of sky and land at the left—are either contemporary accidents or later degradations. The photograph sets out to show us what this natural wonder looks like; the big, abstract shape of the rock, on the one hand, and the mass of topographical detail, on the other, afford an appropriate sense of dense majesty and a rewarded invitation to visual inquiry.

Paul Outerbridge's photograph likewise offers itself as a frank and precise image of a big abstract shape, except that its frankness soon starts to seem questionable as the actual shape, size, material, weight, density, and texture, as well as identity, of the represented object are seen to be unfathomable (p. 348). Visual inquiry leads to perceptual uncertainty, not to the reward of documented facts. And the placement of this ambiguous object below, not simply before, the beholder only emphasizes that it was not simply seen by, but was within the proximate control of, its first beholder, the photographer, and may, therefore, have been manipulated by him. In any event, what we are actually looking at cannot be elicited from the photograph itself. We need to be told that this is a glossy Saltine crackers box, which Outerbridge set on a piece of heavy paper that curved up behind it to provide a featureless environment. Then behind and to the right of the box, he placed a flat, black film holder, which masquerades as a shadow. Finally, he illuminated his little stage set so as to cast multiple, real shadows of varying density, thus fragmenting the space in an illogical manner. The photographer described the enigmatically beautiful result as an "abstraction created for aesthetic appreciation of line against line and tone against tone without any sentimental associations."[2]

Bell's photograph, which shows a natural, organic object, may be thought to offer itself simply as a true record of a natural wonder, the photographer effectively saying, "I saw this." Outerbridge's photograph, which shows a man-made, geometric object, may be thought to offer itself cunningly as a fabrication, the photographer saying instead, "I made this." Only, we look at the former through the latter, the past of 1872 through the present of 1922. Seen from the vantage of 1922, the form of the representational as well as of the represented object shapes our knowledge of the subject. The old simplicity of depicting "Nature" had long disappeared.

Paul Outerbridge. *Untitled.* 1922. Platinum print, 3½ x 4½" (8.9 x 11.5 cm).
The Museum of Modern Art, New York. Gift of David H. McAlpin

William Bell. *Perched Rock, Rocker Creek, Arizona.* From *Explorations and Surveys West of the 100th Meridian.* 1872. Albumen silver print, 10¹³⁄₁₆ x 8" (27.5 x 20.3 cm). The Museum of Modern Art, New York. Purchase

NOTES TO THE TEXTS

"Making Modern Starts," pp. 16–31.

1. The guidebook imagery in the opening of this essay is indebted to Richard Francis and Sophia Shaw, "Negotiating Rapture: A Travel Guide to the Exhibition," in Richard Francis, *Negotiating Rapture* (Chicago: Museum of Contemporary Art, 1996), pp. 66–71, from which some of the following metaphors are adopted.

2. For this reason, we have decided to limit the number and extent of the endnotes to the texts to only the most essential collateral information and acknowledgments, and trust that all those whom we have drawn upon for information and interpretations will understand.

3. This and the following quotations derive from the useful essay by Malcolm Bradbury and James McFarlane, "The Name and Nature of Modernism," in their *Modernism, 1890–1930* (Harmondsworth, Eng.: Penguin, 1976), pp. 19–55.

4. Ibid., p. 33. The source for this quotation is "Mr. Bennett and Mrs. Brown" (1920), reprinted in Virginia Woolf, *Collected Essays*, vol. 1 (London, 1966), p. 321.

5. Leo Bersani and Ulysse Dutoit, *The Forms of Violence: Narrative in Assyrian Art and Modern Culture* (New York: Schocken, 1985), pp. vii–viii.

6. This paraphrases a statement by Irving Howe, quoted by Bradbury and McFarlane, "The Name and Nature of Modernism," p. 29.

7. See, for example, Hayden White, "The Value of Narrativity in the Representation of Reality," in W. J. T. Mitchell, ed., *On Narrative* (Chicago and London: University of Chicago Press, 1981), p. 5.

8. Ibid., p. 10.

9. See, for example, the summary in W. J. T. Mitchell, *Picture Theory* (Chicago and London: University of Chicago Press, 1994), pp. 231–35.

10. This gallery plan derives from Alfred H. Barr, Jr., *Painting and Sculpture in The Museum of Modern Art, 1929–1967* (New York: The Museum of Modern Art, 1977), p. 646.

11. The work by Sol LeWitt is, in fact, not precisely related to the section called People; it is a fully abstract work. We wanted to include it because its combination of linearity and curvilinearity is reminiscent of some of the more extreme, abstracted figural representation in the People section. (We do not presume, however, to suggest that the artist himself would think about it in this way.) Furthermore, we wanted the contrast to show how far modern art has changed since the abstracted figural representations included in this section of the project.

12. Richard Wollheim, *Painting as an Art* (Princeton, N. J.: Princeton University Press, 1987), p. 9.

13. Wallace Stevens, "The Ultimate Poem is Abstract," in *The Collected Poems of Wallace Stevens* (London: Faber and Faber, 1984), pp. 429–30.

14. Northrop Frye, *Anatomy of Criticism* (Princeton, N. J.: Princeton University Press, 1971), p. 29.

"Sol LeWitt," pp. 34–37.

1. Robert Rosenblum, "Notes on Sol LeWitt," in Alicia Legg, ed., *Sol LeWitt* (New York: The Museum of Modern Art, 1978), p. 19.

2. Quoted in Bernice Rose, "Sol LeWitt and Drawing," in Legg, ed., *Sol LeWitt*, p. 35.

3. Quoted in "Excerpts from a Correspondence, 1981–1983," in *Sol LeWitt: Wall Drawings, 1968–1984* (Amsterdam: Stedelijk Museum, 1984), p. 21.

"Representing People: The Story and the Sensation," pp. 38–47.

1. David Sylvester, *The Brutality of Fact: Interviews with Francis Bacon*, 3d enl. ed. (London: Thames & Hudson, 1987), p. 65.

2. Quoted by David Freedberg, *The Power of Images: Studies in the History and Theory of Response* (Chicago and London: University of Chicago Press, 1989), p. 1, introducing an important, broad study of reactions to mainly figural images.

3. Michael Podro, *Depiction* (London and New Haven: Yale University Press, 1998), p. vii.

4. See the excellent account in Philip Rawson, *Drawing* (Philadelphia: University of Pennsylvania Press, 1987), pp. 179–85.

5. If we take a look at the photographs in the chapter called "Posed to Unposed: Encounters with the Camera," especially those on p. 146, we will see that this very complex way of composing a picture has by no means entirely disappeared, although it obviously has been altered a great deal.

6. See Thomas Puttfarken, *Roger de Piles' Theory of Art* (New Haven and London: Yale University Press, 1985), p. 16. This comparison of modern and French academic compositional approaches is more fully discussed in my "Les Fauves et le faux départ," in *Le Fauvisme ou "l'epreuve de feu": L'irruption de la modernité en Paris* (Paris: Musée d'art moderne de la ville de Paris, in press).

7. See Michael Podro, "Depiction and the Golden Calf," in Norman Bryson, Michael Ann Holly, and Keith Moxey, eds., *Visual Theory: Painting and Interpretation* (Cambridge, Eng.: Polity Press, 1991), p. 175.

8. See the comments of Svetlana Alpers and Michael Baxandall on quasi-narrative incidents in the work of Giambattista Tiepolo: *Tiepolo and the Pictorial Intelligence* (New Haven and London: Yale University Press, 1994), pp. 40–44.

9. Whitney Davis, *Replications: Archeology, Art History, Psychoanalysis* (University Park, Pa.: Pennsylvania State University Press, 1996), p. 16.

10. Sylvester, *The Brutality of Fact*, p. 63.

11. See the wonderfully clear account in Julian Bell, *What is Painting? Representation and Modern Art* (London: Thames & Hudson, 1999), pp. 14–15.

12. Again, for an excellent account, see Rawson, *Drawing*, pp. 271–72.

13. See Dominique Fourcade, ed., *Henri Matisse: Ecrits et propos sur l'art*, rev. ed. (Paris: Hermann, 1992), p. 42.

14. Roland Barthes, *The Pleasure of the Text* (New York: Hill and Wang, 1975), p. 58.

"The Language of the Body," pp. 48–65.

1. For a discussion of the significance of gesture, see Jan Bremmer and Herman Roodenburg, eds., *A Cultural History of Gesture* (Ithaca, N.Y.: Cornell University Press, 1992).

2. For a discussion of Charles Le Brun, see Jennifer Montagu, *The Expression of the Passions: The Origin and Influence of Charles Le Brun's "Conférence sur l'expression générale et particulière"* (New Haven: Yale University Press, 1994), and Norman Bryson, *Word and Image: French Landscape Painting of the Ancien Régime* (Cambridge, Eng.: Cambridge University Press, 1981).

3. Paul Klee, *The Diaries of Paul Klee, 1898–1918*, ed. Felix Klee (Berkeley and Los Angeles: University of California Press, 1964), p. 184.

4. Frederick H. Evans, quoted in Beaumont Newhall, *Frederick H. Evans* (Millerton, N.Y.: Aperture, 1973), p. 10. From an article by Evans in *The Amateur Photographer* (February 11, 1908): 130.

5. Jürgen Glaesemer, "Klee and German Romanticism," in Carolyn Lanchner, ed., *Paul Klee* (New York: The Museum of Modern Art, 1987), p. 71.

6. Odilon Redon, quoted in John Rewald, "Odilon Redon," in *Odilon Redon, Gustave Moreau, Rodolphe Bresdin* (New York: The Museum of Modern Art, in collaboration with The Art Institute of Chicago, 1961), p. 23. From "Confidences d'artiste," May 1909.

7. Guillaume-Benjamin-Amand Duchenne de Boulogne, quoted in Klaus

Albrecht Schröder, *Egon Schiele: Eros and Passion* (Munich and New York: Prestel, 1995), p. 84. From *Mécanisme de la physionomie humaine ou Analyse électrophysiologique de l'expression des passions* (Paris: Baillière, 1876), p. 13.

"Expression and the Series: Rodin and Matisse," pp. 66–73.

1. Two publications, among the extensive Rodin literature, are devoted exclusively to this subject: Albert Elsen, with Stephen C. McGough and Steven H. Wander, *Rodin and Balzac: Rodin's Sculptural Studies for the Monument to Balzac from the Cantor, Fitzgerald Collection* (Beverly Hills: Cantor, Fitzgerald, 1973) and *1898: Le Balzac de Rodin* (Paris: Musée Rodin, 1998).

2. Auguste Rodin, Interview, *Le Matin* (July 13, 1908), quoted in Jacques de Caso, "Balzac and Rodin in Rhode Island," *The Bulletin of the Rhode Island School of Design* (May 1966): 16.

3. Rodin, quoted in John L. Tancock, *The Sculpture of Rodin: The Collection of the Rodin Museum, Philadelphia* (Philadephia: Philadephia Museum of Art, 1976), p. 432.

4. See *1898: Le Balzac de Rodin*, pp. 117–18, 310–11, for new documentation that raises the possibility of a stylistically anomalous date (1893?) for *Bust of the Young Balzac*. The association of this work and *Mask of Balzac Smiling* with specific contemporaneous portraits was first made in C. Goldscheider, "La genese d'une oeuvre: *Le Balzac* de Rodin," *Revue des Arts* (March 1952): 37–38.

5. Elsen, "Rodin and Balzac: Creators of Tumultuous Life," in *Rodin and Balzac*, p. 39.

6. *1898: Le Balzac de Rodin*, pp. 350–51, confirms this work as the final head study. It was cast in bronze in 1898 shortly after its completion, indicating that Rodin saw it as an independent work of art.

7. Alphonse de Lamartine, *Balzac et ses oeuvres* (Paris, 1866), quoted in Elsen, *Rodin and Balzac*, p. 5.

8. For the concept of the serial portrait in Rodin's oeuvre, see Leo Steinberg, "Rodin" (1962), reprinted in his, *Other Criteria: Confrontations with Twentieth-Century Art* (New York: Oxford University Press, 1972), p. 324.

9. Henri Matisse, as translated and quoted in Jack Flam, *Henri Matisse: Sculpture* (New York: C + M Arts, 1998), n.p.

10. For a discussion of the Jeannette heads in depth, see Jack Flam, *Matisse: The Man and His Art: 1869–1918* (Ithaca, N.Y.: Cornell University Press, 1986), pp. 315–18, 419–20; Pierre Schneider, *Matisse* (New York: Rizzoli, 1984), p. 562; Michael P. Mezzatesta, *Henri Matisse: Sculptor/Painter* (Fort Worth, Texas: Kimbell Art Museum, 1984), pp. 88–91; John Elderfield, *Matisse in the Collection of the Museum of Modern Art* (New York: The Museum of Modern Art, 1978), pp. 64–69, 191–92; William Tucker, *The Language of Sculpture* (London: Thames & Hudson, 1974), pp. 94–98; Albert E. Elsen, *The Sculpture of Henri Matisse* (New York: Harry N. Abrams, 1972), pp. 122–36; and Alfred H. Barr, Jr., *Matisse: His Art and His Public* (New York: The Museum of Modern Art, 1951), pp. 140–42, 148–49, 179.

11. On the relationship of Matisse and Rodin, see Flam, *Henri Matisse: Sculpture*; Elsen, *The Sculpture of Henri Matisse*; Albert Elsen, "Rodin et Matisse: Differences, affinités, et influences" in *Rodin et la sculpture contemporaine* (Paris: Musée Rodin, 1982); Tucker, *Language of Sculpture*, pp. 9–12, 85–90; and Yve-Alain Bois, "Preface," in Claude Duthuit, *Henri Matisse: Catalogue raisonné de l'oeuvre sculpte* (Paris, 1997), pp. 370–72.

12. Matisse, "Notes d'un peintre" (1908) and "Divagations" (1937), in Dominique Fourcade, ed., *Henri Matisse: Ecrits et propos sur l'art* (Paris: Hermann, 1972), pp. 52–53, 158.

13. Matisse "Notes d'un peintre" (1908), as translated in Jack Flam, ed., *Matisse on Art* (Berkeley and Los Angeles: University of California Press, 1995), p. 40.

14. Ibid., pp. 37–38.

15. See Elderfield, *Matisse in the Collection*, p. 64; Tucker, *Language of Sculpture*, p. 98; and Schneider, *Matisse*, p. 562.

16. The association between the Rochefort bust and the Jeannette heads is made in Schneider, *Matisse*, pp. 416, 545, and 552.

17. For the 1916 date for *Jeannette (V)*, see Flam, *Matisse: The Man and His Art*, pp. 419–20.

"Ensor / Posada," pp. 74–83.

1. With drypoint the image is scratched into a metal plate using a needle, creating rough burrs of metal on either side of the line that hold the ink. With etching the metal plate is covered with an acid-resistant ground through which lines are drawn with a needle. When the plate is placed in acid, the exposed lines are bitten while the protected surface of the plate is not. The bitten lines hold the ink for printing.

2. For further information, see James N. Elsh, *James Ensor: The Complete Graphic Works* (New York: Abaris, 1982).

3. Posada probably used two types of relief engraving. The white-line technique involves gouging a metal plate to create negative (white) space and the image in relief. The black-line technique involves drawing an image with an acid-resistant ink on a metal plate, then bathing it in acid that lowers the negative space. In both cases the raised surfaces are inked and printed.

4. For a recent publication on the Mexican artist, see Patrick Frank, *Posada's Broadsheets: Mexican Popular Imagery 1890–1910* (Albuquerque: University of New Mexico Press, 1998).

"Composing with the Figure," pp. 84–105.

1. Dorine Mignot, "Introduction," in *Gary Hill* (Amsterdam: Stedelijk Museum, 1993), pp. 8–9.

2. Françoise Cachin, *Paul Signac*, trans. Michael Bullock (Greenwich, Conn.: New York Graphic Society, 1971), p. 49.

"Unique Forms of Continuity in Space," pp. 106–13.

1. See, for example, the useful survey in Albert Elsen, *Origins of Modern Sculpture: Pioneers and Premises* (New York: George Braziller, 1974), p. 34.

2. The layout on the following pages is indebted to that in Herbert Matter, *Thirteen Photographs: Alberto Giacometti and Sculptures* (Hamden, Conn.: Ivens-Sillman, 1978), reproduced and discussed by Edward R. Tufte, *Visual Explanations* (Cheshire, Conn.: Graphics Press, 1997), pp. 18–19. The following text is indebted to Meyer Schapiro, "On Some Problems in the Semiotics of Visual Art: Field and Vehicle in Image-Signs [1969]," in *Theory and Philosophy of Art: Style, Artist, and Society. Selected Papers* (New York: George Braziller, 1994), pp. 22–26.

3. Henri Matisse, "Matisse Speaks to His Students, 1908: Notes by Sarah Stein," as quoted by John Elderfield in *Henri Matisse: A Retrospective* (New York: The Museum of Modern Art, 1992), p. 45, n. 188.

4. William Tucker, *Early Modern Sculpture* (New York: Oxford University Press, 1974), p. 12. See also William Tucker, *The Condition of Sculpture* (London: Arts Council of Great Britain, 1975), pp. 6–9.

5. See Michael Podro, *Depiction* (London and New Haven: Yale University Press, 1998), p. 64.

"Figure and Field," pp. 114–25.

1. Lee Friedlander, quoted in *E. J. Bellocq: Storyville Portraits. Photographs from the New Orleans Red-Light District, circa 1912*, ed. John Szarkowski (New York: The Museum of Modern Art, 1970), p. 15.

2. Pepe Karmel has remarked that the bodies and legs of the figures in *Two Nudes* may reflect the late-nineteenth-century attribution to prostitutes of an underlying masculine character. Karmel has also observed that the figures' proportions are anticipated in Picasso's drawings of young boys and girls from the summer of 1906, and may in fact allude to children who "have blossomed too quickly into sexual maturity." See Kirk Varnedoe and Karmel, *Picasso: Masterworks from The Museum of Modern Art* (New York: The Museum of Modern Art, 1997), p. 44.

3. Margaret Werth, "Representing the Body in 1906," in *Picasso: The Early Years, 1892–1906* (Washington, D.C.: National Gallery of Art, 1997), p. 278.

4. See ibid., p. 280.

"Actors, Dancers, Bathers," pp. 126–45.

1. This photograph was found by the dealer Curt Valentin in 1953 on the back of the mount of a Cézanne drawing of female bathers of about 1885 (A. Chappuis, *The Drawings of Paul Cézanne: A Catalogue Raisonné* [Greenwich, Conn., and London: New York Graphic Society, 1973], no. 517), and donated by him to The Museum of Modern Art. Peter Galassi dates the photograph to about 1860–80. The description of *académies* in this account broadly derives from John Elderfield, *The Language of the Body: Drawings by Pierre-Paul Prud'hon* (New York: Harry N. Abrams, 1996). On photographic *académies*, which are sometimes not easily separated from pornographic and ethnographic images, see the exhibition catalogue, *L'Art du nu au XIXe siècle: Le Photographe et son modèle* (Paris: Hazan/ Bibliothèque nationale de France, 1997).

2. See Kenneth Clark, *The Nude* (Harmondsworth, Eng.: Penguin, 1960), p. 32.

3. On this trope of reversal, see Norman Bryson, *Tradition and Desire: From David to Delacroix* (Cambridge, Eng.: Cambridge University Press, 1984), p. 172.

4. In a Cézanne drawing included in a letter to Emile Zola of June 20, 1859; Chappuis, *The Drawings of Paul Cézanne*, no. 38.

5. The ultimate source of this image is the central figure in Cézanne's first ambitious painting of Bathers in a landscape, the *Bathers at Rest* (three versions), of 1875–77 (John Rewald, *The Paintings of Paul Cézanne: A Catalogue Raisonné* [New York: Harry N. Abrams, 1996], nos. 259–61), from which other works also derive, including the lithograph reproduced on p. 136. Whether or not these earlier works also derive from the photograph must remain a matter of speculation. The particular association of the photograph with *The Bather* derives from the close conformation of the position of the feet in both works (Rewald, no. 555, arguing that the photograph served as the source only of this work, and illustrating a drawing for it with an arrangement of the feet closer to the earlier works, therefore presumably made—although Rewald does not say this—before the photograph was consulted) and the fact that the photograph was discovered attached to the mount of a drawing exactly contemporaneous with *The Bather* (see n. 1, above). *The Bather* cannot be proved to derive from the photograph, for it cannot definitively be traced back to Cézanne. Yet, the similarity in their treatment of arms and hands, discussed later in this text, strongly argues for their association, even more than does the position of the feet.

6. Technically, the pattern of lines so written in ancient Greek inscriptions is called a boustrophedon.

7. Cf. Theodore Reff, "Cézanne's Bather with Outstretched Arms," *Gazette des Beaux-Arts*, 6th ser., no. 1118 (March 1962): 303–09.

8. See Elderfield, *The Language of the Body*, pp. 62–66, from which this argument derives.

"Maria Fernanda Cardoso," pp. 166–69.

1. All quotations here are from a conversation with the artist on June 10, 1999.

"Modern Places: The Country and the City," pp. 170–79.

The authors wish to thank John Elderfield for reading an earlier draft of this essay and for his valuable suggestions.

1. Angelica Zander Rudenstine, ed., *Piet Mondrian, 1872–1944* (Milan: Leonardo Arte in association with the National Gallery of Art, Washington, D.C., and The Museum of Modern Art, New York, 1994), p. 162.

2. Robert L. Herbert, "City vs. Country: The Rural Image in French Painting from Millet to Gauguin," *Artforum* 8, no. 6 (February 1970): 45.

3. For a cultural history of landscape, see Simon Schama, *Landscape and Memory* (New York: Alfred A. Knopf, 1995).

4. Quoted in Stephen F. Eisenman, "Symbolism and the Dialectics of Retreat," in Eisenman, Thomas Crow, et al., *Nineteenth Century Art: A Critical History* (London: Thames & Hudson, 1994), p. 306.

5. For a discussion of the relationship between Symbolism and social divisiveness of the period, see Eisenman, "Symbolism and the Dialectics of Retreat," pp. 304–336, and John Elderfield, "The Garden and the City: Allegorical Painting and Early Modernism," *The Museum of Fine Arts, Houston Bulletin* 7, no. 1 (summer 1979): 7.

6. For a discussion of Gauguin in Brittany, see Gill Perry, "'The Going Away': A Preparation for the 'Modern'?" in Charles Harrison, Francis Frascina, and Perry, *Primitivism, Cubism, Abstraction: The Early Twentieth Century* (New Haven: Yale University Press in association with The Open University, 1993), pp. 10–27.

7. James Coddington and Magdalena Dabrowski, "The Installation of Kandinsky's Paintings Numbers 198–201," unpublished paper presented on February 24, 1996, at the College Art Association's annual meeting.

8. See the useful cultural and historical survey by Alan Bullock, "The Double Image," in Malcolm Bradbury and James McFarlane, eds., *Modernism, 1890–1930* (Harmondsworth, Eng.: Penguin, 1976), pp. 58–70.

9. Umberto Boccioni, Carlo Carrà, Luigi Russolo, Giacomo Balla, and Gino Severini, "Manifesto of the Futurist Painters, 1910," trans. Robert Brain, in Umbro Apollonio, ed., *Futurist Manifestos* (New York: Viking, 1973), p. 25.

10. See Meyer Schapiro, "The Crowd, the Stroller, and Perspective as Social Form," in his *Impressionism: Reflections and Perceptions* (New York: George Braziller, 1997), pp. 144–52.

11. Malcolm Bradbury, "The Cities of Modernism," in Bradbury and McFarlane, eds., *Modernism*, p. 100.

12. Quoted in Maurice Rheims, *Hector Guimard* (New York: Harry N. Abrams, 1988), p. 42.

13. Quoted and discussed in Stephen F. Eisenman, "Manet and the Impressionists," in Eisenman, Crow, et al., *Nineteenth Century Art*, p. 244.

14. Bradbury, in "The Cities of Modernism," p. 99, makes this point in connection with modernist, as opposed to realist, literature.

15. Quoted in ibid., p. 100.

"Seasons and Moments," pp. 180–89.

1. William C. Seitz, *Claude Monet: Seasons and Moments* (New York: The Museum of Modern Art, 1960), p. 52.

2. See John Elderfield, "The Precursor," in *American Art of the 1960s*, Studies in Modern Art 1 (New York: The Museum of Modern Art, 1991), pp. 65–95.

especially pp. 71–73, 90, for details of literature on the Monet vogue.

3. Leo Steinberg, "Monet's *Water Lilies*," *Arts* (February 1956), reprinted in his *Other Criteria: Confrontations with Twentieth-Century Art* (New York: Oxford University Press, 1972), p. 239. Steinberg's article refers to the *Water Lilies* painting that was destroyed by fire at The Museum of Modern Art in 1958.

4. On the titling of Kandinsky's paintings and their commission for a circular vestibule in a New York City apartment, see James Coddington and Magdalena Dabrowski, "The Installation of Kandinsky's Paintings Numbers 198–201," unpublished paper given on February 24, 1996, at the College Art Association's annual meeting. There is no evidence that The Museum of Modern Art's three-panel *Water Lilies* painting was conceived for an environmental installation, although, as Seitz (*Claude Monet*, p. 54, n. 57) points out, it is plainly a variant of the painting opposite the entrance door in the first of the two oval rooms in the Orangerie in Paris.

5. On these works, see Kirk Varnedoe, *Cy Twombly: A Retrospective* (New York: The Museum of Modern Art, 1995), p. 50.

6. See Denis Donoghue, *The Arts Without Mystery* (Boston and Toronto: Little, Brown, 1983), pp. 11, 21, in a stirring attack on "The Zealots of Explanation."

7. See Carolyn Lanchner, *Joan Miró* (New York: The Museum of Modern Art, 1993), p. 44.

8. On these works, see John Szarkowski and Maria Morris Hambourg, *The Work of Atget, Volume I: Old France* (New York: The Museum of Modern Art, 1981). See also John Szarkowski, "Atget's Trees," in *One Hundred Years of Photographic History: Essays in Honor of Beaumont Newhall*, ed. Van Deren Coke (Albuquerque: University of New Mexico Press, 1975), pp. 161–68.

9. On these works, see Robert Adams, *West from the Columbia: Views at the River Mouth* (New York: Aperture, 1995).

10. See Steinberg, "Monet's *Water Lilies*," p. 239.

11. Steinberg, p. 239, quoting Monet.

12. This is a fragment of the artist's brief commentary on this work in *Bill Viola: Installations and Videotapes* (New York: The Museum of Modern Art, 1987), pp. 38–41, which illustrates additional scenes from the video.

13. This characterization of Stevens's poems is indebted to Northrop Frye, "Wallace Stevens and the Variation Form," in his *Spiritus Mundi: Essays on Literature, Myth and Society* (Bloomington: Indiana University Press, 1976), pp. 275–94. It draws upon and expands the discussion in John Elderfield, *The Drawings of Richard Diebenkorn* (New York: The Museum of Modern Art, 1988), pp. 19–20.

14. Wallace Stevens, "So-And-So Reclining on Her Couch," in *The Collected Poems of Wallace Stevens* (New York: Alfred A. Knopf, 1985), p. 296.

"Changing Visions: French Landscape, 1880–1920," pp. 190–209.

1. On the development of landscape painting in late-nineteenth- and early-twentieth-century France, see John House et al., *Landscapes of France: Impressionism and Its Rivals* (London: Hayward Gallery, 1995); Kermit S. Champa et al., *The Rise of Landscape Painting in France: Corot to Monet* (Manchester, N.H.: Currier Gallery of Art, 1991); and Sophie Biass-Fabiani, ed., *Peintres de la couleur en Provence, 1875–1920* (Paris: Réunion des Musées Nationaux, 1995).

2. See, for example, J. D. Herbert, *Fauve Painting: The Making of Cultural Politics* (New Haven: Yale University Press, 1992).

3. See Champa et al., *The Rise of Landscape Painting in France*, pp. 15–78.

4. Pierre-Henri de Valenciennes, *Éléments de perspective practique à l'usage des artistes*, 1800, reprint ed. (Geneva: Minkoff, 1973).

5. See Robert Herbert, *Barbizon Revisited* (Boston: Museum of Fine Arts, 1962); *The Barbizon School and Nineteenth Century French Landscape*

(Greenwich, Conn.: New York Graphic Society, 1973); and Nicholas Green, *The Spectacle of Nature: Landscape and Bourgeois Culture* (Manchester, Eng.: at the University Press, 1980).

6. See, for example, Robert Herbert, "Method and Meaning in Monet," *Art in America* 67, no. 5 (September 1979): 90–108; John House, *Monet: Nature into Art* (New Haven: Yale University Press, 1986); John Hayes Tucker, *Monet in the Nineties* (Boston: Museum of Fine Arts, 1989–90); and David Bomford et al., *Art in the Making: Impressionism* (New Haven: Yale University Press, 1990).

7. Discussions and reproductions of such photographs appear in John Rewald, "The Last Motifs at Aix," in *Cézanne: The Late Work* (New York: The Museum of Modern Art, 1977), pp. 83–111; Rewald in collaboration with Walter Feilchenfeldt and Jayne Warman, *The Paintings of Paul Cézanne: A Catalogue Raisonné* (New York: Harry N. Abrams, Inc., 1996); *Les Sites Cézanniens du pays d'Aix: Hommage à John Rewald* (Paris: Réunion des Musées Nationaux, 1996); and Paul Machotka, *Cézanne: Landscape into Art* (New Haven: Yale University Press, 1996).

8. See Theodore Reff, "Cézanne and Poussin," *Journal of the Warburg and Courtauld Institutes*, no. 23 (1960): 150–74; Richard Schiff, *Cézanne and the End of Impressionism* (Chicago: at the University Press, 1984), p. 175 ff; and Richard Verdi, *Cézanne and Poussin: The Classical Vision of Landscape* (Edinburgh: National Gallery of Scotland, 1990), pp. 57–62.

9. Degas, a seasoned traveler, documented his journeys meticulously. On his trip to Diénay see Richard Kendall, *Degas Landscapes* (New Haven: Yale University Press, 1993), pp. 145–81.

10. See, for example, *L'Estaque: Naissance du paysage moderne 1870–1910* (Marseilles: Musées de Marseille, Réunions des Musées Nationaux, 1994).

11. See Judi Freeman, *The Fauve Landscape* (New York: Abbeville Press, and Los Angeles: Los Angeles County Museum of Art, 1990).

12. See John Richardson, *A Life of Picasso* (New York: Random House, 1996), vol. 2, pp. 123–37; Juan Perucho, *Picasso, el cubisme i Horta de San Juan* (Barcelona: Columma, 1993), pp. 205–26; Josep Palau i Fabre, *Picasso Cubism (1907–17)* (New York: Rizzoli, 1990); and Palau i Fabre, *Picasso en Cataluña* (Barcelona: Ediciones Poligrafa, 1966).

13. Henri Matisse, in "Matisse Speaks," in Jack Flam, *Matisse on Art* (London: Phaidon, 1973), p. 132. On Matisse's trip to Morocco see, for example, *Matisse in Morocco: The Paintings and Drawings, 1912–1913* (Washington, D.C.: National Gallery of Art, 1990).

"Landscape as Retreat: Gauguin to Nolde," pp. 210–19.

1. Gauguin, quoted in a letter to Daniel de Monfried, 1901; reprinted in John W. Ittmann, *Post-Impressionist Prints Paris in the 1890s* (Philadelphia: Philadelphia Museum of Art, 1998), p. 38.

2. For a thorough discussion of Gauguin's unusual woodcut technique, see Richard S. Field, "Gauguin's Noa Noa Suite," *The Burlington Magazine* (September 1968): 500–511.

3. In the nineteenth century, women were often perceived as closer to nature than men, who tried to control nature. See Robert L. Herbert, *Peasants and "Primitivism": French Prints from Millet to Gauguin* (South Hadley, Mass.: Mount Holyoke College Art Museum, 1995).

4. Around 1889 Gauguin amassed a collection of photographs that he used as source material, which included an image of a sculpted frieze in the Buddhist temple at Borobudur.

5. For more on the impact of French colonialism on Tahiti, see Kirk Varnedoe, "Gauguin," in William S. Rubin, ed., *Primitivism in the Twentieth Century* (New York: The Museum of Modern Art, 1984), p. 189.

6. Gauguin left several sets of the *Noa Noa* prints with his Paris neighbors

William and Ida Mollard. He was a musician and she a Swedish sculptor, and their apartment was a gathering place for French and Scandinavian artists, writers, and musicians, including Munch, Edvard Grieg, August Strindberg, Alfred Jarry, Edouard Vuillard, and Pierre Bonnard. Further, the publisher Ambroise Vollard, who released a second version of Gauguin's zincographs in the mid-1890s, is likely to have shown the woodcuts to Munch when he was in Paris making his lithograph *Anxiety* for the publisher's portfolio of *Album des Peintres-Graveurs* in 1895.

7. Edvard Munch, quoted in Roald Nasgaard, *The Mystic North: Symbolist Landscape Painting in Northern Europe and North America 1890–1940* (Toronto: University of Toronto Press, c. 1984), p. 9.

8. Between 1908–09 the *Brücke* artists sent Munch numerous invitations to join their group.

9. Dresden housed several sanitariums and health resorts, which promoted natural medicines and revitalization through nudity.

10. This print appeared on the cover of the influential Berlin art journal *Der Sturm*, an early disseminator of Expressionist ideas and one of the first publications to defend the work of the *Brücke* artists.

11. This print was editioned as part of a portfolio, *Eleven Woodcuts, 1912–1919, Erich Heckel*, and published by J. B. Neumann in 1921, during the flourishing postwar market for Expressionist graphics in Europe.

12. Kirchner, quoted in a letter of January 20, 1919; reprinted in Donald E. Gordon, *Ernst Ludwig Kirchner* (Cambridge, Mass.: Harvard University Press, 1968), p. 116.

13. Nolde, quoted in Clifford S. Ackley, Timothy O. Benson, and Victor Carlson, *Nolde: The Painter's Prints* (Boston and Los Angeles: Museum of Fine Arts, in association with the Los Angeles County Museum of Art, 1995), p. 291. Originally published in Nolde, *Jahre der Kämpfe* (1934), pp. 111–12.

"Hector Guimard and the Art Nouveau Interior," pp. 220–29.

1. Yvonne Brunhammer, "The Castel Béranger: Testing Ground of Hector Guimard, Architecte d'Art," in David Dunster, ed., *Hector Guimard* (London: Architectural Monographs and Academy Editions, 1978), pp. 43, 45.

2. F. Lanier Graham, *Hector Guimard* (New York: The Museum of Modern Art, 1970), p. 27.

3. Henry van de Velde, "Prinzipielle Erklärung," in *Kunstgewerbliche Laienpredigten* (Leipzig: Hermann Seeman, 1902), p. 188.

4. See Debora L. Silverman, *Art Nouveau in Fin-de-Siècle France: Politics, Psychology, and Style* (Berkeley, Los Angeles, and London: University of California Press, 1989).

"The Conquest of the Air," pp. 252–57.

1. Kenneth Silver, "Tricolorism Revisited," paper presented on April 17, 1999, at Self and History: A Symposium in Honor of Linda Nochlin, Institute of Fine Arts, New York University. Symposium proceedings to be published in 2001 by Thames & Hudson, New York and London.

2. Quoted in *Jacques-Henri Lartigue* (Millerton, N.Y.: Aperture, 1976), p. 6.

3. Quoted in Troels Andersen, *Malevich* (Amsterdam: Stedelijk Museum, 1970), pp. 116, 127.

4. From a May 9, 1913, letter from Malevich to Mikhail Matiushin quoted in *Kazimir Malevich, 1878–1935* (Amsterdam: Stedelijk Museum, 1988), p. 160.

5. John Welchman, "Here and Otherwise," *Artforum* 27, no. 1 (September 1988): 18.

6. On the painting's verso is an inscription by the artist reading "Airplane flies 1914 K. Malevich." See *Kazimir Malevich, 1878–1935* (Los Angeles: The Armand Hammer Museum of Art and Cultural Center, 1990), p. 208.

7. Kasimir Malevich, "Notes on Architecture," 1924, reprinted in *Kazimir Malevich, 1878–1935*, pp. 119, 121.

"Unreal City," pp. 258–79.

1. George de Maurier, *Trilby* (1894). In *Novels of George de Maurier* (London: Pilot Press and Peter Davies, 1947), p. 224.

2. The title of this essay, "Unreal City," is taken from T. S. Eliot's "The Waste Land" (1922), in *The Complete Poems and Plays: 1909–1950* (New York: Harcourt Brace, 1962), pp. 37–50.

3. John Milner, *The Studios of Paris: The Capital of Art in the Late Nineteenth Century* (New Haven and London: Yale University Press, 1988).

4. Marcel Duchamp, quoted in Katherine Kuh, "Marcel Duchamp," in *The Artist's Voice: Talks with Seventeen Artists* (New York: Harper & Row, 1962), p. 152.

5. Leon Battista Alberti, *De Pictura*, 1.19; reprinted in Joseph Masheck, "Alberti's 'Window': Art—Historiographic Notes on an Antimodernist Misprison," *Art Journal* 50 (spring 1991): 35.

6. See Rosalind Krauss, "Grids," in *The Originality of the Avant-Garde and Other Modernist Myths* (London and Cambridge, Mass.: MIT Press, 1993), pp. 8–22.

7. Henri Matisse, "Matisse Radio Interviews, 1942," quoted in John Elderfield, *Matisse in the Collection of The Museum of Modern Art* (New York: The Museum of Modern Art, 1978), p. 90

8. Edith Wharton quoted in Cynthia Griffin Wolff, *A Feast of Words: The Triumph of Edith Wharton* (Oxford and London: Oxford University Press, 1977), p. 263.

9. Theodor Adorno, *Aesthetic Theory*, trans. C. Lenhardt (London and New York: Routledge and Kegan Paul, 1984), p. 262.

10. Roland Barthes, "The World as Object," in Norman Bryson, ed., *Calligram: Essays in New Art History from France* (Cambridge, Eng.: Cambridge University Press, 1988), p. 108.

"The American Place: Landscape in the Early Western," pp. 280–89.

1. Willa Cather, *Death Comes for the Archbishop* (New York: Alfred A. Knopf, 1932), 95–96.

2. André Bazin, "The Western: Or the American Film Par Excellence," in Bazin, *What Is Cinema?* vol. 2, trans. Hugh Gray (Berkeley: University of California Press, 1971), p. 141.

3. Simon Schama, *Landscape and Memory* (New York: Alfred A. Knopf, 1995), p. 10.

4. John L. O'Sullivan originated the phrase "Manifest Destiny" in 1845. See Edward Buscombe, ed., *The BFI Companion to the Western*, rev. ed. (London: Andre Deutsch/BFI Publishing, 1993), pp. 180–81.

5. In "The Significance of the Frontier in American History," Turner declared that the movement to colonize the Great West, "the first period in American history," had ended. See Allan G. Bogue, *Frederick Jackson Turner: Strange Roads Going Down* (Norman: University of Oklahoma Press, 1998).

6. Raoul Walsh, *Each Man in His Time* (New York: Farrar, Straus, and Giroux, 1974), pp. 243–44.

"Michael Craig-Martin," pp. 292–95.

1. Michael Craig-Martin, "Taking Things as Pictures," *Artscribe*, no. 4 (October 1978), cited in Michael Craig-Martin, *A Retrospective 1968–1989* (London: Whitechapel Art Gallery, 1989), p. 112.

2. Michael Craig-Martin, *Michael Craig-Martin und Raymond Pettibon: Wandzeichnungen* (Düsseldorf: Verlag des Kunstvereins für die Rheinlande und Westfalen, 1997), p. 14.

3. See a useful account, "Michael Craig-Martin and Katja Blomberg—A Conversation," in *Michael Craig-Martin und Raymond Pettibon*, pp. 9–18.

"Common and Uncommon Things," pp. 296–303.

This essay reflects the substantial contribution of John Elderfield, whose insights and comments gave shape to the ideas presented here.

1. *Michael Craig-Martin und Raymond Pettibon: Wandzeichnungen* (Düsseldorf: Verlag des Kunstvereins für die Rheinlande und Westfalen, 1997), p. 14.
2. Ibid., p. 10.
3. Theo van Doesburg, "Schilderkunst van Giorgio de Chirico en een stoel van Rietveld" (Painting by Giorgio de Chirico and a chair by Rietveld), *De Stijl* 3, no. 5 (March 1920): 46. Symonds trans.
4. William Tucker, *Early Modern Sculpture* (New York: Oxford University Press, 1974), p. 107.
5. On the revival of interest in Dutch still-life painting in the late nineteenth century see Henri Loyrette, "Still Life" in Gary Tinterow, ed., *Origins of Impressionism* (New York: The Metropolitan Museum of Art, 1994), pp. 140–81.
6. Robert P. Welsh, "De Stijl: A Reintroduction," in Mildred Friedman, ed., *De Stijl: 1917–1931 Visions of Utopia* (Minneapolis: Walker Art Center, and New York: Abbeville Press, 1982), p. 23.
7. Mondrian's working method—executing the image on a horizontal plane—has been documented in a number of sources. See, for example, Michel Seuphor, *Piet Mondrian: Life and Work* (New York: Harry N. Abrams, 1956), p. 158.
8. Friedrich Teja Bach, Margit Rowell, and Ann Temkin, *Constantin Brancusi 1876–1957* (Cambridge, Mass., and London: MIT Press, 1995), p. 30.

"Ten Chairs," pp. 304–07.

1. Galen Cranz, *The Chair: Rethinking Culture, Body, and Design* (New York and London: W. W. Norton, 1998).
2. Frank Lloyd Wright, "The Art and Craft of the Machine," in Bruce Brooks Pfeiffer, ed., *Frank Lloyd Wright: Collected Writings*, vol. 1 (New York: Rizzoli, 1992), pp. 64–65.

"Tables and Objects," pp. 312–25.

1. Meyer Schapiro, "The Apples of Cézanne: An Essay on the Meaning of Still-life," in *Modern Art: 19th and 20th Centuries* (New York: George Braziller, 1978), p. 19.

"Objects / Words," pp. 326–31.

1. "I am indeed very interested in questions of language and the basic structures of experience," the artist Michael Craig-Martin has stated. "The great Modernists thought that the basics could be discovered through abstraction and the images of geometry. I think they are more likely to be found through the childhood experience of learning to recognize and name simple objects" ("Michael Craig-Martin and Katja Blomberg—A Conversation," in *Michael Craig-Martin und Raymond Pettibon* [Düsseldorf: Verlag des Kunstvereins für die Rheinlande und Westfalen, 1997], p. 16).
2. See W. J. T. Mitchell, *Iconology: Image, Text, Ideology* (Chicago: University of Chicago Press, 1986).
3. Norman Bryson, *Word and Image: French Landscape Painting of the Ancien Régime* (Cambridge, Eng.: Cambridge University Press, 1981), p. 3.
4. Ibid., pp. 9–10.
5. The smallness of this audience may be gauged by the fact that Guillaume Apollinaire's avant-garde journal *Les Soirées de Paris* never had more than forty subscribers in the years 1912 and 1913. This information appears on p. 152 of a very useful survey of this subject, which draws upon a broad range of recent literature: Francis Frascina, "Realism and Ideology: An Introduction to Semiotics and Cubism," in Charles Harris, Francis Frascina, and Gill Perry, *Primitivism, Cubism, Abstraction: The Early Twentieth Century* (New Haven and London: Yale University Press in association with The Open University, 1993), pp. 87–183. More extended accounts appear in Kirk Varnedoe and Adam Gopnik, *High and Low: Modern Art and Popular Culture* (New York: The Museum of Modern Art, 1991). I am grateful to Judith Hecker for sharing with me her research on the Museum's Cubist prints.
6. Likewise, the eponymous "Fox" and "Job" in the prints by Braque refer, respectively, to an artists' and poets' bar, and simultaneously to a brand of cigarette papers and to a nickname for the poet Max Jacob.
7. Quoted and discussed by Frascina, "Realism and Ideology," p. 103.

"Objects, Walls, Screens," pp. 332–39.

1. See John Elderfield, *Kurt Schwitters* (London: Thames & Hudson, 1985), p. 53.
2. Louis H. Sullivan, *Kindergarten Chats* (1901–02) (New York: Wittenborn, 1947), pp. 140–41.

"Objects as Subjects," pp. 340–49.

1. T. S. Eliot, "Tradition and the Individual Talent," in *The Sacred Wood: Essays on Poetry and Criticism* (1920) (London and New York: Methuen, 1980), p. 50.
2. Elaine Dines, ed., *Paul Outerbridge, A Singular Aesthetic: Photographs and Drawings, 1921–1949: A Catalogue Raisonné* (Laguna Beach: Laguna Beach Museum of Art, 1981), p. 27, for the foregoing information.

INDEX OF ILLUSTRATIONS